Art After Appropriation

Art After Appropriation

Essays on Art in the 1990s

John C. Welchman

University of California, San Diego

G+B ARTS INTERNATIONAL
Australia • Canada • France • Germany • India • Japan • Luxembourg
Malaysia • The Netherlands • Russia • Singapore • Switzerland

Amsteldijk 166
1st Floor
1079 LH Amsterdam
The Netherlands

British Library Cataloguing in Publication Data

A catalogue record for this book is available from the British Library.

ISBN: 90-5701-043-7

Cover: Mike Kelley, *Framed and Frame* (detail) 1999, Mixed media (287 × 485 × 409 cm). Photo: Andre Morin.

Contents

INTRODUCTION
Global Nets: Appropriation and Postmodernity

Art After Appropriation thinks through and attempts to move beyond the appropriative paradigms that so vividly marked the Western art world and its peripheries during the decade from the mid-1970s to the late 1980s. Nine chapters, each associated with a moment or plateau in the 1990s, examine how artists and institutions situated in different global contexts have inflected, recast and refused the cultures of borrowing and citation. In this introduction, I offer a critical history of appropriation, outlining first some of the wider issues caught up in the term, then sketching their relationship to allied notions in modern and postmodern art, and, finally, setting them alongside the sequence of issues and chapters.

Seen across one of its longest horizons, the term 'appropriation' stands for the relocation, annexation or theft of cultural properties—whether objects, ideas or notations — associated with the rise of European colonialism and global capital. It is underwritten by the formation of disciplines such as anthropology, museology and allied epistemologies of description, collecting, comparison and evaluation. Consideration of cultural appropriation has given rise to several sustained enquiries into the reach and restrictions of intellectual property, copyright law, governmental restitution and reparations, and questions of ownership and community rights. Ranging across art, music, narratives, symbolic systems, scientific knowledge, materials and land, these include studies of the aestheticisation and sheer consumption of cultural difference, whose exchange and mart has been understood as the great driving force of appropriation.[1] Thinking especially of the uneven flows of citation and taking instituted between Western and non-Western cultures, one measure of the impact of appropriation has been gauged through both the tangible and invisible damage it may inflict on local communities through various 'deprivation[s] of material advantage'.[2] Yet the notion of 'advantage' has become increasingly difficult to fix. Cuban writer, Geraldo Mosquera, is one of several Latin American commentators who have addressed the paradox that the globalised vortex of 'mixing, multiplicity, appropriation and resemanticising' takes place in a situation where 'all cultures "steal" from one another, be it from positions of dominance or subordination'.[3] In his view, a number of Latin American and Los Angeles-based artists have 'maximised the complexity of implications wrapped up in transcultural citation and appropriation', and, along with their associated critics, have therefore served as 'transgressors and transferers [*trasvasadores*] of meaning, developing a theory of appropriation as anti-hegemonic cultural affirmation'.[4]

Within the systematic deracination of property legitimised by colonialist discourse and the powers of capital, the museum has played a key role both

as a repository and an 'appropriating agency'.[5] In the 1990s, a shift has taken place in staging the historical self-consciousness of the museum or gallery and its parameters of exhibition. The first wave of institutional critique, arriving in the late 1960s and early 1970s, and concerned largely with exposing or ironising the structures and logic of the museum, has given way to more interactive, performative interventions, which also meditate on the question of appropriation itself. This first generation included the parodic counter-classifications of Marcel Broodthaers' *Museum of Modern Art* (1968–72).[6] Around the same time, Hans Haacke began a series of projects insisting that the museum should become an arena of declarative economic realism, a repository for art-assisted research on the social conditions and political implications of its own function—corporate sponsorship, trustee activities, the social profile of its visitors, the historical exchange-value of the objects it collects, and so on. Building on this base, more recent institutionally oriented practice, including work by Fred Wilson, Renée Green, Andrea Fraser, Barbara Bloom and others, has opened up new spaces for reckoning with the living history of the museum, its social outreach and pedagogy, and the itineraries it organises or presupposes. Some of this work reflects on the Eurocentric relocation of appropriated material and its relationship to Western art objects, and to the racial politics caught up between the museum's managers, workers and audiences.

The late 1980s and early 1990s also spawned a series of para-museums and reinterpretational centres, such as the Museum of Jurassic Technology[7] and The Center for Land Use Interpretation—the former located in Venice, California, the latter with an office there, and outstations and activities elsewhere. They also gave rise to a number of exhibitions, situated within and around conventional museums, that sought to interrogate 'the museum-culture of appropriation'.[8] *The? Exhibition?* aka 'The Curator's Egg' (Ashmolean Museum, Oxford, December 1991 – May 1992) offered one of the fullest of these reckonings, attempting to interrupt normative museum experience and display routines by reconfiguring interpretative labelling, juxtaposing popular cultural material with revered classical art objects, and deconstructing the exhibition space itself. The original objective of this show was to 'speak through... the museum's appropriative discourses: to prise them apart',[9] by making visible questions of curatorial etiquette and decision-making, challenging the devices that inscribe the visitor into the museum experience (comment books, marketing, finance, taste, classification) and disturbing the prescribed routines of silent contemplation, non-tactile interaction, and one-way routing. Prompted by the Ashmolean's ancient collection and historic location, a related focus suggested that the Western culture of appropriation had an origin in one of the greatest historical exercises of material repossession: the annexation and absorption of other European and Mediterranean cultures by the Roman Empire from

the second century BC to the third century AD. Within this regime of fragmentation, dismemberment, and plunder—and the scholarly sanctification that has often attended it—'The Curator's Egg' made it clear that '"Appropriation" is already written in the history of ancient objects'.[10]

Among the theorists of appropriation, it is Georges Bataille who offers the term perhaps its greatest, and most troubling, cultural extension. In his essay on the Marquis de Sade, Bataille correlates appropriation with bodies, unitary and collective, identifying 'two polarised human impulses: EXCRETION and APPROPRIATION' which follow on from 'the division of social facts into religious facts... on the one hand and profane facts... on the other'.[11] Excretion, he suggests, is associated with the heterogeneous expulsion of foreign bodies: with 'sexual activity... heedless expenditure... certain fanciful uses of money' and 'religious ecstasy'.[12] Appropriation, on the other hand, finds its 'elementary form' in 'oral consumption', and its process 'is thus characterised by a homogeneity (static equilibrium) of the author of the appropriation, and of objects as a final result'. Appropriational experience may begin with the ordering of foreign bodies through digestive incorporation, but it extends to analogous forms of additive material: 'clothes, furniture, dwellings, and instruments of production ... finally ... land divided into parcels'. 'Such appropriations', notes Bataille, 'take place by means of a more or less conventional homogeneity (identity) established between the possessor and the object possessed'.[13] In this reckoning, appropriation is aligned with what Gilles Deleuze and Félix Guattari describe as the striation of space with hierarchisation, convention, identity, classification and possession, while excretion is a form of becoming-animal staged in the smooth space of deterritorialised desire.[14] Like Deleuze and Guattari, however, Bataille refuses to lock his oppositional constructs into binary separation, for 'production can be seen as the excretory phase of a process of appropriation, and the same is true of selling', while the practice of 'heterology' 'leads to the complete reversal of the philosophical process, which ceases to be the instrument of appropriation, and now serves excretion; it introduces the demand for violent gratifications implied by social life'.[15] If the borderline 'philosophy' that Bataille calls 'heterology' can be redeemed in voiding and violence, no such gratificatory discomfort is associated with representation itself. For the desire to imitate, make or copy, is caught up in 'the persistence of a dominant need for appropriation, the sickly obstinacy of a will seeking to represent, in spite of everything, and through simple cowardice, a homogenous and servile world'.[16] This trenchant attack on the predicates of representation serves as a caution and a blindside. For the species of representation that the art world has for two decades called 'appropriation' invests, on its surface at least, in an even more extreme antithesis (more cowardly, obstinate, sickly and servile) to the heterological discharge elevated by Bataille.

The pressure of these larger questions of appropriation will be felt throughout the discussions that follow. First, I offer some more specific remarks on the history of appropriation as it has been developed in and around the domains of modern and postmodern art. I want to suggest several moments that might assist in this project, arguing that the strategies invested in appropriation must be seen, first, in a quasi-global context formed at the interstices of nineteenth- and early twentieth-century initiatives in the European avant-garde; then in the rehearsal or reappraisal of these traditions in the 1960s and 1970s, especially in the US. Such strategies are also inflected in a series of more recent 'post-appropriations' or 'counter-appropriations', arising in both Western and non-Western art worlds, including what I identify in my first two chapters as Soviet and post-Soviet—or Second-World—refusals of Western appropriation.

Beyond these more focused histories, there are several larger frameworks for the development of appropriation in modern art. Appropriation has a contiguous relationship to the longstanding debate between 'originality' and 'imitation' consistently foregrounded in academic discussion of cultural practice from the Greeks to the late nineteenth century. The terms in this debate, and the positions adumbrated with reference to them, are complex and historically specific. But while every age has reinvented the originality-imitation debate in its own image, modernism was largely predicated on the triumph of compositional 'originality'. Postmodernism appropriated and recast the discussion, installing something close to a culture of the copy in its shifting definitional core.

The history of visual modernity is crucially caught up in the formation and implications of 'ready-made' culture in ways that significantly exceed, and anticipate, the 'definitive' appropriational gestures of Marcel Duchamp in the 1910s. The technological developments of the nineteenth century, including photography, machinic mass-production and cultural commodification, gave rise to a discursive fixation on the coining, replication, take-over and redeployment of the units of production. Such attention constitutes a matrix for the force fields of visual modernism, which are formed in complex folds around the issue of appropriation. On the one hand, modernism's inaugural moments were aligned against pre-modernist notions of Romantic originality, religious transcendence and generic hierarchy. It is equally clear, however, that nineteenth-century academic conventions of copying, imitation, and the dominance of discursive over figural representation (of pre-existing text over the figurative components the image) give the appearance of anticipating the strategies, if not the contents, of what was only much later named 'appropriation'. Thus Realism can be interpreted as the appropriation—the cutting-out and unfolding—of scenes of everyday life supplied with excessive, or plenary, detail that naturalises and guarantees the cut. Serial image making, especially as

practised by Claude Monet in the 1890s, acts to minimise the 'originality' of a painting, cultivating a singular 'effect' or 'impression' as a residue of difference that Monet understood as a substantial trace of the weather. What is appropriated in such series is not simply the "reality" of a landscape, but a climatological "truth" registered and set out in a sequence of atmospheric changes that effectively re-order the motif (the cathedral façade, or grainstack etc.). Both Realism and Impressionist seriality are dependent on claims founded in appropriation for the production of their truth-'effects'.

In an attempt to move back from Duchamp—a retreat, even—I want to mark a signal instance in the nineteenth-century formation of the ready-made. Institutional and other orderings of culture achieved in the shadow of the European Enlightenment were already engaged in problematising social experiences that were increasingly 'made-ready', pre-issued and re-circulated by the new culture of commodities. In a previous study,[17] I suggested that the social organisation, textual structure and signifying implications of the *dictionary* can be understood as a key definitional trope of order and sanctioned usage that helps us to contextualise the irruption of the ready-made in the 1910s. Beyond this, it may also reveal something of the discursive centrality of the issues caught up in the question of appropriation from the 1850s to the 1980s. Gustave Flaubert and Charles Baudelaire focused the first modernist debates on appropriation through the notion of the 'received idea', one of whose most consequential returns is found in Flaubert's unfinished *Dictionnaire des idées reçues* and related passages in his satirical novel *Bouvard et Pécuchet* (1881). Of the origin of the dictionary project in 1843, Maxime du Camp once wrote that Flaubert wanted to confect a 'methodical grouping of commonplaces'. He describes it as an assemblage of 'ready-made phrases' convened under the conventional alphabetic rubric of the dictionary.[18]

The very title of Flaubert's elaborate, but ultimately doomed, dictionary enterprise, stresses the 'received idea', the accepted opinion, and the cliché, combining a kind of historicist flatness with notions of technological duplication.[19] The received idea is a blunt instrument of history; it is the rounded, weathered, over-circulated token of lingual commonality; languid in its generational exchange, it is at the same time everywhere available, standing as a hieroglyph of modern social intercourse. The related term, 'cliché', has come down to us as a metaphor from stereotypology, stemming from the 'metal cast' of a 'stereo or electro duplicate'.[20] In Flaubert's dictionary, the near-perfect duplication and repeatability of the phrase (or whatever), its transmission from text to context and from subject to object, rehearses one of the modernist avant-garde's iterated concerns with the found or ready-made text/object. The dictionary corrals the collection of socially pre-fabricated instants into the great, consensually designated ready-made of (national) languages—the subject/object of linguistic self-identity and self-expression.[21]

When Roland Barthes elaborates his non-'theological' theory of the text in 'The death of the author' (1968), he returns to Flaubert's satirical exercises as an authority for the claim that 'the book itself is only a tissue of signs':

> The text is a tissue of quotations drawn from the innumerable centres of culture. Similar to Bouvard and Pécuchet, those eternal copyists, at once sublime and comic and whose profound ridiculousness indicates precisely the truth of writing, the writer can only imitate a gesture that is always anterior, never original. His only power is to mix writings, to counter the ones with others, in such a way as never to rest on any one of them. Did he wish to *express himself*, he ought at least to know that the inner 'thing' he thinks to 'translate' is itself only a ready-formed dictionary, its words only explainable through other words, and so on indefinitely...[22]

The dictionary, and the models and metaphors that depart from it, offer to *delay*, or postpone, the delivery of an 'original' thought, gesture or mark. The project of making dictionaries clearly functioned as a 'delay' of ideas for Eugène Delacroix (the author of an earlier, incomplete, art world dictionary), just as it functions as a 'delay' in the Duchampian sense in the general circulation of concepts, as well as in Barthes' account of the making and reception of texts. In Flaubert's writing these ideas are already present, but they combine with other possibilities. Not only was the dictionary an 'old idea' that always 'returned' to him (as he put it in a letter to Louise Colet in 1852), but for Flaubert the dictionary is always doubly articulated. It serves the dual interests of both linguistic coercion and textual dissipation—taking on both the centripetal and centrifugal conditions of social language, the given and the invented. First, it is both the effect and the content of the bourgeois drive for an ultimate scheme of knowledge; secondly it is played out by Flaubert as a parodic apparatus, a satirical envelope that completes and contains (even as it disrupts) his own bourgeois/realist self-definition. With the dictionary as a scenic backdrop, Flaubert advances a passional, scatological and resolutely negative critique of Enlightenment values, revealing them to be simultaneously clichéd and reductive. The dictionary emerges as a project that is always taking refuge from a crossfire of debauchery, pessimism and folly. It is built to accommodate madness and to dismantle the sanity of received ideas: 'Spread out on the metonymic axis, signs in *Bouvard et Pécuchet* seem to become a *danse macabre* celebrating their emancipation from the maternal context of the library, or any other unifying context, and their subjugation to materiality and death'.[23]

In a letter of 4 September 1850, Flaubert writes:

> You do well to think about the *Dictionary of Accepted Opinions*. Such a book, covering the field completely [*complètement fait*], and opening

with a good preface in which we would indicate just how the work was intended to reconcile the public to tradition, to order and conventional morality, and written in such a way that the reader couldn't tell whether or not we were pulling his leg—that would perhaps be a strange book, and it might well have some success, for it would be very topical.[24]

In the course of this passage, and in the context of Flaubert's peregrinations in Egypt and the Near East, where much of his musing on the subject arose, the dictionary becomes an antidote to—but also a condition of—the tumult of travel and travel writing, the 'dizzy rate'[25] and the experience of being 'crushed and overwhelmed'[26] by the multitudes of the other. The totalising, encyclopaedic drive to 'cover the field completely' produces the dream of a 'completely-made' (the *complètement fait*) that would gather up the whole domain of individual 'ready-mades' and brandish them as evidence of the teeming mediocrity of Western bourgeois culture over and against the babel, confusion, abandon (and disease) of the Orient.

In the early years of the twentieth century, before the institutional triumph of modernism, the residue of the originality-imitation controversy that had raged for two millennia is clearly apparent. The term 'composition', for example, served the theory and practice of both Henri Matisse and the pioneer non-iconic abstractionists Piet Mondrian and Wassily Kandinsky as a conceptual model for the contemporary drive for sustainable originality. For Matisse, 'composition' was the preferred term to designate his decorative intensity. For Kandinsky, the act of composition spoke of what was most spiritual and individually unique (though presumed as communicable) in the increasingly non-identificatory mark-making of the painter. The word was specifically reserved to stand as the title for the eight large-scale signature works that summarised the development of his (mostly) pre-Bauhaus abstraction. For Mondrian, 'composition' was used as summary shorthand for the dynamic equilibrium that organised the universalist out-reach of his utopian theory-practice. For all three artists, the art of 'composition' stood against the materialism, mechanics and mundane deferrals of repeatable, everyday, culture. It was a bulwark against the depredations of the ready-made, the cliché, mass-production, or any of what were regarded as the dangerous collective reductions of commercial iterability.

It is apparent that the antagonism between originality and copy is rarely present as an absolute antithesis, and that there are gradients between the extremes they notate—pure origin or absolute subjective invention, on the one hand, and absolute tradition, perfect replication, or frictionless coining on the other. The interaction of these possibilities is clearly signalled in the development of visual Surrealism. As defined by André Breton in the 'First Surrealist Manifesto' of 1924, the movement purportedly had as its highest aim the unfettered appropriation of unconscious psychic activity ('pure psychic automatism'). Such energy would be transferred, unedited and

uncontaminated, from the recesses of the mind to the quasi-codified materials of visual/textual representation. The work, then, was proposed as a replay or relocation of oneiric, hypnotic, or hallucinatory experience. It was unmediated 'and appropriate' to the para-world of the unconscious. 'Chance' and the 'automatic' were the new names for appropriation's latest cut.

But if the predicates of automatist theory from mid-1920s Surrealism can in any way be likened to the cluster of attributes that meet in the discourse of appropriation, it is important to note Surrealism also elaborated a counter-appropriative theory whose central propositions resemble crucial formulations within the long-standing cult of originality and innovation. There are several of these reversions to authenticity in Surrealism, but perhaps the clearest is the alliance forged by the technicians of Surrealism, both 'automatic' (Miró) and 'verist' (Magritte), with the ineffable attributes of the poetic and the work of thought—what I have called elsewhere *poésie/ pensée*.[27] There was a common desire among many Surrealists to accommodate the signifying activity of the image or the word in a transcendent synthesis uniting the formative components of the work— consciousness, unconsciousness, materials (letters, images), even context—into a unified sign embodying a thought. Present in the counter-flow between title and painting set up by Magritte, and in the clusters of abbreviated symbols brought together by Miró, the thought-image is often constructed by the Surrealists as a replacement for that unity of disparate pictorial and subjective elements frequently conceived of by the pioneer abstractionists (even by Matisse) as resolved into the universalising sign-machine of compositional order.[28]

Although it did not become a dominant recourse for Magritte until late in his career (where it is apparent more in his writings than in the paintings themselves),[29] perhaps the most substantive of the sustaining myths of innovative generality invoked by the Surrealists was the bracketing of the 'plastic statement' into a *poetic* whole. For others in the visual avant-garde, however, a governing metaphor of the poetic, embraced in the 1910s and 1920s, became the preferred designation for the work of a broad spectrum of the Ecole de Paris.[30] It is in reaction to this key term that Peter Bürger understands and defends André Breton's injunction to 'practise poetry'. Bürger, of course, is the critic associated with the disapprobation of the panoply of post-World War II appropriative gestures he assembled under the rubric of the 'neo-avant-garde'. In his view, the (mainly American) avant-gardes of the late 1950s to the 1980s merely repeat, re-route or inauthentically redeploy the paradigm strategies of institutional disruption and visual innovation brokered by the 'historical avant-garde':

the automatic texts [of Surrealism]... should be read as guides to individual production. But such production is not to be understood as

artistic production, but as part of a liberating life praxis. This is what is meant by Breton's demand that poetry be practised (*practiquer la poésie*). Beyond the coincidence of producer and recipient that this demand implies, there is the fact that these concepts lose their meaning: producers and recipients no longer exist. All that remains is the individual who uses poetry as an instrument for living one's life as best as one can.[31]

While he goes on to admit that a certain 'solipsism' might arise in the enterprise of poeticisation, Bürger endeavours to disturb the connotations of Romantic ineffability that underwrite the 'poetic' in Surrealist usage, and transfer it to the practices of everyday life. Attempting to steer between the Scylla of pure innovation (poetic elevation) and the Charybdis of appropriation (artistic re-production, which eventually becomes repetition), he resists the pretensions of visual poetics to rely on a crude notion of 'poetry' as connotative and irreducible, even (according to a recently renovated thematic) 'sublime'.[32]

The Surrealist conjugation of autonomy and appropriation is a crucial component in the conflictual articulation of modernism and the avant-garde. In many senses, the theory of autonomy marks the highest point in the formalist-modernist quest for an aesthetic position that is radically separate from the productive contexts of the world. Appropriation, on the other hand, names a cluster of gestures and devices that explicitly abscond with the ready-made assemblage, such that the 'always already' of modern culture is fed back into the system of signs from which it was momentarily displaced. Appropriation is thus aligned with the 'exhibition value' associated by Walter Benjamin with the foliated history of reproducibility.

As alluded to by Peter Bürger, the appropriative gestures that emerged with such force in the international art world between the late 1970s and the late 1980s were already arranged along what we can term a second horizon of appropriation. The first horizon, constituted by the work of the so-called neo-Dadaists and the Pop artists of the 1950s and 1960s, marks a moment that both the critics (Bürger) and advocates (Andreas Huyssen) of these movements have claimed as the inception of postmodernism itself. These first gestures of appropriation in the US after World War II were founded in a rejection of the gestural and formalist painterly values of European-type modernism and American Abstract Expressionism during the 1950s and 1960s. Such resistance was focused through the intervention of rehabilitated photographic practice, first in the work of Robert Rauschenberg and Pop Art itself, especially that of Andy Warhol, then in Conceptual Art and, as a consequence of their documentary requirements, in Earth Art and Performance. These developments, which rendered the photographic acceptable and accessible to both the gallery system and to the critical

community, were emphatically taken up by the so-called 're-photographers'[34] (Sherrie Levine, Richard Prince, Cindy Sherman, Barbara Kruger and others) in the mid and late 1970s, a moment that also saw the ascendancy of pictorial Neo-Expressionism, with its differently predicated gestures of appropriation.

The first wave of postmodern appropriation, associated with this revalidation of photography, also correlates with the arrival and dissemination in New York of poststructuralist theories of reproduction and repetition that connected it to related discourses of institutional critique and debates, including Barthes', on the conditions of authorship. Appropriation's institutional landmarks were the 'Pictures' exhibition curated by Douglas Crimp at Artist's Space in 1977, and the loose group of artists that emerged with the founding of the Metro Pictures Gallery. This moment also saw the establishment of the journal *October*, by Rosalind Krauss, Jeremy Gilbert-Rolfe and Annette Michelson, where many of the key critical ideas associated with appropriationism found their first sustained expression. These concerns were augmented in a sequence of essays in *Art in America* written in the early and mid-1980s by Craig Owens and Hal Foster, and by the appearance of *The Anti-Aesthetic: Essays on Postmodern Culture* (1983), the influential anthology edited by Foster.[35] The work of Levine, Kruger and Prince, in particular, was accompanied by sustained criticism from these quarters, which opened onto questions of originality, gender, identity, representation, copyright and commercial and popular cultures, and which contributed, as much as anything else, to securing the dominant narrative of postmodernism in the New York art world at this time.

For Rosalind Krauss, Levine's photographs of illustrations of the photographs of Edward Western and others constitute 'an act of theft, which takes place, so to speak, in front of the surface of Weston's print, [and] opens the print from behind to the series of models from which it, in turn, has stolen, of which it itself is the reproduction'.[36] Levine's exacting, unrepressed copy and the punctured depth it opens up through and behind the image's surface, announces a final break with both modernist and avant-garde discourses of 'originality', by proposing what Krauss described as an 'explicit deconstruction' of them.[37] And in exposing so completely the associative line of borrowings and citations already operative 'behind' Weston's photographs—the historical syntax of appropriation—Levine's rephotography exemplifies 'a truly postmodern art'. In a similar vein, Hal Foster discusses Levine's images as a flourish of *re*-petitions and appropriations: a critical 're-presentation of modern art works', which acts to 'reframe the conventional image of the artist-as-expressionist' or to 'refocus … the expressionist image'.[38]

Howard Singerman teases out further implications of Levine's appropriations, arguing that her early work is not simply predicated on lack

Sherrie Levine, *After Walker Evans #2*, **1981,** black and white photograph, 20 × 25 cm.
Courtesy Paula Cooper Gallery, New York

and absence, but that, born in the prepositional 'after' (*After Walker Evans* (1981), *After Kasimir Malevich* (1984), 'after Egon Schiele' (*Self Portrait Masturbating* (1982) etc), 'is a specific regendering as well as an appropriation of the image'.[39] The critical texture of these paradigm appropriations is further complicated by Levine's contention in 1984 that 'for the last four years I have considered myself a still-life artist—with the book plate as my subject';[40] and by Krauss' description of the early pirated pieces as 'collages... because the image, scissored out of the pages of an art book, acquires along with its status as a readymade, the reified condition of the object'.[41] As with the work of Kruger and Prince, Levine's appropriative gestures are located in a wide field of social, gender, object and generic relations, whose effects, even after 1989, when Levine turned to 'sculptures' based on his work, are carefully distinguished from the Duchampian ready-made: 'The Duchamp effect she needed was not that of the readymade, which describes relations among commodities, and between commodities and their consumers, but that of the bachelor machine, which invokes the connection between part objects'.[42]

As with Levine, Prince's photographic appropriations have been posed within a double frame of nuanced citational actions supplied by a rhetoric of

obliquity and spectral evasion. In Prince's case the pluralisation of his appropriational techniques was stated most effectively in the artist's own description of 'the 8-track photograph', an array of overlapping procedures that divided up the appropriated photographic sign into the 'original copy, rephotographed copy, angled copy, cropped copy, focused copy, out-of-focus copy, black and white copy, color copy'.[42] Within and between these organising appropriations, Prince's work is situated as a series of deferrals from transparent signification. Thus, his status as an artist is held in suspension between generative and editorial functions ('somewhere between a creator and copyist'), and his artistic persona redefined as an 'almost me'.[44] The appropriated image itself, variously adjusted according to the 8-track regimen, and 'more a simulation than an expression', gives rise to 'a photograph that's *the closest thing to the real thing*' and whose effects include 'strange, disquieting presence'.[45] The paranormal status of the Prince image has been crucial to much of the criticism of this work. It was the leitmotif of Jim Lewis' account of hoaxes, special effects and scare quotes invested in images 'dissassociated from their original use like the glittering trinkets exchanged as currency by some mythical cargo cult'.[46] Such accounts seem always to return to the great figural refrain of appropriational critique, the delivery of the haunted spectre. Levine 'presents us with a copy doubly distant from its original—the ghost of a ghost';[47] Kruger suggests that the 'repetition of stereotypes[s]... results in a figure which is not embodied. Not an empty signifier, but a perpetual ghost with a perpetual presence';[48] and for Prince, too, 'the image just hovers there, separated umpteen times from nothing, like the shadow of a ghost'.[49]

Within these distinctions, the status of the 'deconstruction' argued for, explicitly or otherwise, by Krauss, Foster and others is crucial, and problematic. Indeed, the question of the relationship between deconstruction, institutional critique and appropriation, and issues of the social and political effectiveness of gestures exchanged between them, have been posed to the practitioners of appropriation—pictorial, photographic or object-based— wherever it has been practised, including art worlds far from New York, London and Berlin. It was a question, for example, put to the Australian appropriationist, Imants Tillers by Paul Foss in November 1986.[50] And it is a question that has been asked, urgently and provocatively, of appropriations of the style and motifs of Aboriginal representation.[51] What kinds of shift, then, are imagined in the move from 're' to 'de', from citation to critique, from quote to question? And are the conditions of copying adequately separated from those attending allusive reference, especially in Krauss' account of Levine? For unlike Levine, Weston does not copy an image, he makes relatively explicit reference to a tradition of images. The readings discussed above are vulnerable to several reservations. Deconstruction, for example, cannot be dependent on the suggestive critical work of a unitary

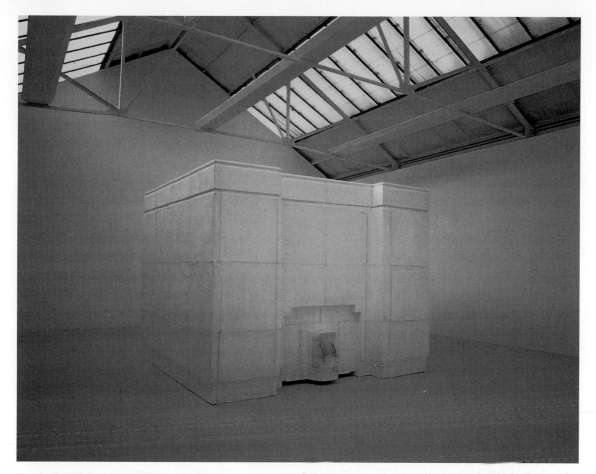

Rachel Whiteread, *Ghost,* **1990,** plaster on steel frame, 8'10" x 11'8" x 10'5". Saatchi Collection. Courtesy Anthony d'Offay Gallery, London

text or even of a series. Instead, it offers to relocate signification in the space between two texts or chains of discourses, as they are read through and against each other. In particular, 'history'—Edward Weston's relationship to Greek *kouroi* or Praxiteles, for example (an issue raised by both Crimp and Krauss), or Rodchenko's to the Russian Revolution of 1917—cannot serve as the silent partner of deconstructive assertions, and is abused when, as is often the case even in more considered discussions, a gesture of citation is held to return an act of deconstruction as an almost self-evident proposition.

To be fair, critics of appropriation have, on occasion, either argued against the deconstructive alignment of this work, or attempted, even if fleetingly, to reach for the richly conflictual texture of a deconstructive reading. In the catalogue of the Prince retrospective at the Whitney Museum of American Art, Lisa Philips suggests, with the hindsight of 1992, that 'the work was not just motivated by a deconstructive impulse. Overlooked were

expressions of fears, desires, and obsessions, not to mention the experience of visual pleasure'.[52] Crimp's discussion of Levine, in his essay 'The Photographic Activity of Postmodernism',[53] on the other hand, hints at a more subtly deconstructive reading of representation ('representation takes place because it is always already there in the world *as* representation'). Citing Weston's dictum, 'the photograph must be visualised in full before the exposure is made', he suggests that Levine's work on his photographs takes 'the master at his word, and in so doing has shown him what he really meant'. Showing Weston—or Plato, or Jean-Jacques Rousseau—what they really (might have) meant, or what emerges from underneath their assumptions, or tropological language, comes close, if only momentarily, to the textualist deconstruction practised by Jacques Derrida. But a real problem persists, for the taking and reframing of an image cannot be determined as an act of deconstruction either on its own recognisance, or when accompanied by brief critical 'assistance'.

A related difficulty questions the merits of the image, or a series of images, as sites of deconstruction. Discussions of Sherman's work have implicitly turned on this question. Some commentators suggest that the silence and withdrawal of her untexted, 'untitled' images do not 'deconstruct... the eroticised fetish' but 'merely reinstall' it. Others conceived of them as 'allegorical portraits' made up of 'speaking pictures'.[54] For Owens, Sherman's 'permutations of identity from one photo to the next'[55] propel the viewer 'through their diversity', so that 'the silence that invades the unitary image is dissolved into the competitive speech of a field of differences'.[56] But, whether we consider it as a methodology, a technique, or even a philosophy, deconstruction is played out through an intricate and elaborate meshing of texts, the counter-flow of metaphors, the coded eruption of historical referents, and the appearance of unconscious drifts and desires situated against the denotative or narrative grain of writing. Put rather crudely, deconstruction is predicated on embellished acts of textualist giving and meticulous intertextual readings, while appropriation is based on unitary or reduced gestures of taking. Deconstruction is thus performed through difference and imbrication, appropriation by sameness and implication. This divergence of practice and theory gives rise, I will argue, to an effect already noted: the recurrent association of appropriation with spectral doubling and of quotation with the haunting of the real. The ghost story is the deconstructive supplement of appropriation, the folded, parallel narrative it couldn't produce for itself.

While they variously expose or underline its issues, critical accounts of appropriation, including my own, often fail to make good their claims to 'deconstruct' authorship, gender positions or social identities and inscriptions. Sometimes, this is traced to a lack in the material and signifying co-ordinates of the work in question. In his later writings, Foster

points to one of these shortcomings, noting, of the early copies of Levine, that 'the image-screen [he is alluding to a Lacanian diagram of visuality] is almost all there is; it is not much troubled by the real nor much altered by the subject (artist and viewer are given little agency in this work)'.[57] At other times, as again with Foster, a more general dissatisfaction is expressed with the 'mixed enterprise' of appropriation.

Thinking through Kruger's signature negotiation between text, image and sociality, I have suggested that by incorporating the title in the image, or the image in the title, she stages a profound mediation between visual and textual signs that might be sufficient to deconstruct the specific 'little text' of the caption. I offered three arguments to support such a conclusion:

First ... [Kruger] folds the title-caption into the space of the image. An important compositional reversal results from this gesture, for the text is typically laid over the appropriated photograph, becoming, in effect, a 'figure' that stands out against the 'ground' of the image. Second, Kruger gives back to the title-caption a form of language to which it has never (or very rarely) been given access. This is the language of pronominal indeterminacy—the 'we', 'you' and other 'shifters'—whose critical dislocation has been noted by several writers.[58] Producing the caption as a form of address or announcement, an invocation or exhortation, and alluding in the process to the address-forms typical of commodity culture, Kruger lends her text an active voice [locked] in fundamental dispute with the titular passivity and subordination residual even in the lineage of poetic reverie cultivated for the title by artists from Symbolism to Surrealism and beyond. These are title-captions that require completion or interpellation by the subject positions that read them. The image-(maker) has grappled with the physical space and productive scene of the title, reworked the grounds of its entitlement and brought into indeterminate foreclosure the uncertain empowerments and paradoxical exclusions of the stereotype. Thus, what Owens reads as Kruger's contestatory—though non-moralistic—doubling of the stereotype, can equally be seen as a deconstruction of everything that is summed up in the caption. The subordination of the title—its life in that which is unchallenged, scarcely 'visible', always marginalised, though socially reproductive—is radically relinquished in a process that here goes so far as to throw its writing (its social inscription) back onto the viewer who reads it.[59]

I am uncertain whether these proposals are sufficient to make good the claim that Kruger's work is deconstructive. But the possibilities for deconstruction seem stronger when the singular images and collateral sequences of the appropriationists are read against their statements, brief

essays and other writings, which simultaneously situate, extend and, perhaps, confound them. I am thinking particularly of texts Kruger and Prince, who wrote and published most extensively. Clearly offered in dialogue with the captionated structure of her photo-text works, Kruger's aphoristic pieces amplify the logic of their address through indeterminate pronominal shifters ('you', 'we'), creating a supplemental cascade of subject-positions and everyday propositions on either side of what develops as a ramifying, even, circuitous, gender divide. A number of her pronouncements turn on different rationales for appropriation. On the side of collective identification, then, Kruger wrote in her catalogue statement for Dokumenta 7 (1982) that 'we loiter outside of trade and speech and are obliged to steal language. We are very good mimics. We replicate certain words and pictures and watch them stray from or coincide with your notions of fact and fiction'.[60] Here, the identificatory 'we' is caught up in obligatory acts of linguistic theft performed with voyeuristic mimicry from a marginal location, whose products are left in various contradictory states of defection from, or inscription of, dominant adjudications between truth and falsehood. As often in the two- or three-phrase maxims that make up the majority of Kruger's invocatory texts, an insistence on replication or repetition is paired with various forms of signifying indeterminacy in the staging and reception of the copied 'words and pictures'. Sometimes, this undecidability is associated with the 'we' (as here), sometimes—though for different reasons—with the 'you'. In the catalogue for Kruger's exhibition at the Mary Boone Gallery in New York (May 1989), for example, she deliberately turns one edge, or circumstance, of appropriation away from the positions of the 'we': 'although you continue to picture us, we have no desire to picture you. No desire to merely reverse positions and gel into gloomy authoritarian mimicry. No desire to appropriate your subjectivity only to sell you short into some seriously stunted objecthood'.[61]

The obligation to steal and mime is refused when the 'we' might be tempted to take over the appropriative representation of the 'you' for reasons of reversal or short-term gain. For in proportion as such citation plunders the subject-positions of the other, it attaches to the logic of what it strives to invert (in this case the other's—the 'you's—willingness to cut out, project and manipulate the image and implied interiority of the 'we'). Subjectivities, however positioned, Kruger intimates here, cannot be appropriated without doing violence to the lifted identity.

The fate of appropriation, already troubled by its allocation between Kruger's shifting pronouns, is further confounded when addressed from the side of the 'you'. In the final declamation of an early text, *Irony/Passion* (1979), she makes explicit the sure knowledge of the 'you' that the powers of appropriation are invested in speaking, labelling and gestures of indication: 'You are aware that saying, naming, and pointing are the handiest forms of

appropriation'.[62] And in *Job Description* (1984), a column of forty-three doubled subjects qualifying the opening line, 'Your *work* is about', we find the categories of 'privilege and the tyranny of exclusion' and 'quotation and the rhythm of stacked goods'.[63] In 'Not Nothing' (1982), a diarama of parodic, gender-coded nihilism, Kruger further complicates the idea of appropriation as theft, and attends to the issue of the imperfect copy: 'You ransack authority by stealing the work of others, but you are a sloppy copyist because fidelity would make you less of a nothing'.[64] If we again supply a generalised male referent to the 'you' addressed here, the statement commences with the ascription of appropriation to the side of a masculinity empowered to undermine authority through taking. But the quality and scope of the replication are immediately questioned on the grounds that the male subject cannot faithfully invest in absolute duplication for fear that it would compromise his aspiration to be nothing. The value of the 'nothing', and its association with masculinity, may be explained as a gender-specific annexation of the power of neutrality, that unencumbered, locationless position from which authority issues. As Kruger put it in *Job Description*, connecting the assumption of nothing with the trade of copies, this position turns on 'neutrality and the dealing of the double'.[65] Thus, the double negative of the title, *Not Nothing*, locked in dispute with neutral empowerment, is a surrogate both for the feminine and for a form of 'fidelity' that embraces the exactitude of the copy. A kind of true or absolute taking is now paired with subject positions that assert their defection from the myth of neutral location and the retreat and negativities loaded into 'nothing'.

It is clear from this matrix of overlapping and sometimes contradictory positions that Kruger's reflections on appropriation supplement the more circumscribed image-text photographs that have secured her reputation in the art world. Reflections on appropriation's genders and subjects, together with thoughts on the ventriloquising of history, and the 'dissembling', 'inverting' activities of appropriation in the service of political power, make good some part, at least, of Kruger's claim to 'think about inclusions and multiplicities, not oppositions, binary indictments, and warfare'.[66]

Photographic appropriation may have been the dominant form of appropriation in the 1970s and 1980s, and was clearly the object of the most sustained critical investment, but it was not the only medium in which postmodern citation and take-over were practised. We can identify two main forms of pictorial appropriation: Neo-Expressionism was roughly contemporary with the Metro Pictures photo-works; while 'simulationism' arrived with the 'generic' abstractions of the 1980s. There was, in addition, a post-sculptural group, also active through the 1980s, who appropriated commodity objects. To these we should add a more diffuse range of appropriations developed by artists working with installations, new media

and public art. By the 1990s, singular, or programmatic appropriation, focusing on the relatively unassisted citation of an individual image or object, was largely a thing of the past, and the language of postmodern appropriation, complete with a core of critical assumptions, had passed into something like general currency.

The international return to expressive-type painting in the 1970s—in Germany (Sigmar Polke, Jiri Dokoupil, Georg Baselitz, Rainer Fetting, AR Penck, Markus Lüpertz, Jorg Immendorff, Helmut Middendorf, Anselm Kiefer), Italy (Francesco Clemente, Enzo Cucchi, Sandro Chia, Carlo Maria Mariani, Roberto Barni) and slightly later in the US (Julian Schnabel, David Salle), France (Gerard Garouste), Britain (Christopher LeBrun) and elsewhere—was accompanied, and driven, by a wide range of stylistic, iconographic and even theoretical appropriations. Pre-eminent among these was the annexation of the palette, facture, and/or stylised figuration of German Expressionism, Marc Chagall, Chaim Soutine, the Fauves and/or Italian Futurism, which earned this generation of revisionist painters the sobriquet 'Neo-Expressionist'.

The neo-pictorial form of appropriation was subject to a crushing torrent of adverse criticism from the advocates of its photographic variant. In one of the more extreme attacks, Owens branded Neo-Expressionist citation violent and destructive. For, in Sandro Chia's pastiche, he suggested, 'quotation functions not as respectful *hommage*, but as an agent of mutilation'. Such work plays out the parodic liquidation of transgressive modernism, with expression itself shouted down by simulated signs of its own absence, and everything facetiously 'bracketed in quotation marks'.[67] Even qualified supporters of the return to painting, such as Thomas Lawson, impugned its '*retardataire* mimeticism' and 'wider cultural cannibalism', claiming—on account of an indiscriminate borrowing of images from Renaissance, Baroque and modernist art, Indian miniatures, and religious kitsch—that for the most part 'appropriation becomes ceremonial' in revivalist painting.[68]

But Lawson's attempted redemption of certain painters in this tradition (notably David Salle) rests on a number of suggestions in which he attempts to modify the concept of appropriation by situating it in a dialogue with photography and deconstruction. He claims, first, that painting is virtually deceased, that it has become (almost) as uninflected as mechanical forms of reproduction: Salle's images are 'dead, inert representations of the impossibility of passion in a culture that has institutionalised self-expression'.[69] Secondly, pictorial and photographic appropriations, though strategically different, are offered a recto-verso imbrication, based on a desperate negativity that sets them in a dependent relationship: 'Like any dispossessed victim [Levine] simply steals what she needs. Levine's appropriations are the underside of Schnabel's misappropriations, and the two find themselves in a

perverse lockstep'.[70] Thirdly, painting is transformed in Lawson's account into a version of camouflage whose very hiddenness, then emergence—as painting is appropriated by itself—is treated as a kind of deconstruction: 'It is painting itself, that last refuge of the mythology of individuality, which can be seized to deconstruct the illusions of the present'.[71]

The first New York-based movement to cohere after the success of photo-appropriation formed around new abstract-tending work, some of which was associated with Neo-Geo: Jack Goldstein's astral events; Levine's striped and checkerboard paintings done on plywood; the Day-Glo cells and conduits of Peter Halley; Ashley Bickerton's 'abstraction of contemporary social exchange'; Ross Bleckner's Neo-Op; Philip Taaffe's ironic neo-sublime; Peter Schuyff's diverted Surrealism; the abstracted computer graphics of James Wellings; and Meyer Vaisman's post-natural simulations. In Foster's stringent reading, these artists were involved, to varying degrees, with a posthistorical and 'conventionalist' recycling of signs, tinged with 'passive pessimism', 'melancholy' and opportunism. The results, 'more nihilistic than dialectical', he claimed, were often defeatist, and their signature 'reduction to style' revealed a general propensity for 'simulacra not copies'. Understood, then, 'as neither modern abstract painting nor (post)conceptual appropriation art', this work witnesses a signal shift from issues of representation, reproduction and copying to the evasive logic of simulation.[72]

Foster suggests that this simulational abstraction 'must be seen with its contemporary counterpart: the cute-commodity "ready-mades" of such artists as Jeff Koons and Haim Steinbach',[73] which introduced object- rather than image-based forms of appropriation. A discussion between Steinbach, Koons, Bickerton, Levine, Taaffe and Halley, moderated by Peter Nagy, at the Pat Hearn Gallery in May 1986, reveals some of the inflections now developed in the theory of appropriation, as well as the group's professed genealogical relationship to what Nagy called in his opening question, 'the Pictures generation of appropriators'. Bickerton describes the work of the previous artists as 'utopian', 'essentially deconstructive and task-oriented in its spectacular didacticism'. Against their 'programmatic' directives and 'particular deconstruction' he advocates a 'poetic' intervention staged between 'the formal elaboration of information' and 'its possible meanings'.[74] The restaging of mass-produced objects (Steinbach, Koons, Levine), of logos, decals and collective image-bites (Bickerton), or of simulated signs and info-systems (Halley, Taaffe) is realigned, as Steinbach put it, in complicity 'with the production of desire' and through the cultivation of an explicit 'pleasure in objects and commodities'.[75]

This new partnership with commodities led to a concomitant retreat from the wider social concerns addressed by some, at least, of the photo-appropriationists. While Steinbach, Taaffe and Koons spoke of their attempt to address a non-specialist public and their interest in blurring the

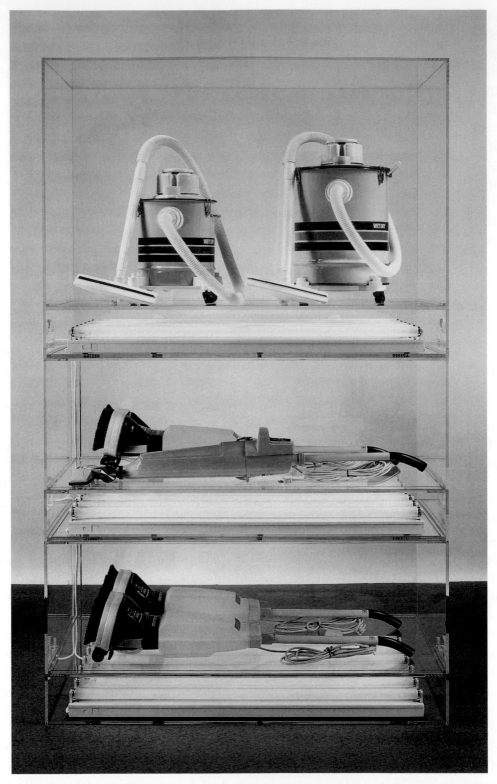

Jeff Koons, *New Hoover Deluxe Shampoo Polishers, New Hoover Quik-Broom, New Shelton Wet/Dry Tripledecker*, 1981–1987, 3 shampoo polishers, 3 vacuum cleaners, plexiglass, fluorescent lights, 91 × 54 × 28 inches. Courtesy Jeff Koons Productions

distinctions between 'elite' and 'general audience[s]', Halley acknowledged two forms of limitation that attended the production, reception and distribution of this work. First, the leading indicator among the 'postindustrial issues' he specified was 'the situation of the suburbanised middle classes in postindustrial countries'. Secondly, the audience he envisaged as encountering such concerns had in his view contracted to two main groups—'an audience primarily composed of artists and intellectuals', and one 'composed of collectors and dealers'.[76]

If the new sculpture traded in appropriated objects selected with pleasure and desire, some of its adherents appeared willing not merely to dwell with them in an underworld of cut-out, captured icons, but to fetishise the purloined commodity back to life. Koons imagines that 'in the objects we can see personality traits of individuals, and we treat them like individuals'.[77] The journey of the appropriated sign, which started out with the formal configuration and texted irony of pasted papers and continued with the cut-out anonymity of rephotographed media images, comes to rest in appropriation's pathetic fallacy: the attribution of a person-like quality to spotlit objects that have clearly been loved too much. Purged of much of the stylistic finesse of the simulationists—and most of the critique residual in their proximity to, and overlap with, the Pictures group—this spectascularist aspect of appropriation emerged as one of its leading forms in the early 1990s, particularly in the hip-pop appropriations of the new British art. It also spawned something that is very nearly its opposite — where found material is casually strewn, abandoned or dilated — in the appropriational forms associated with abject and 'scatter' art around the turn of the 1990s.

In *Modernism Relocated* (1995) I thought through several responses to the terms set out in 1980s appropriationism, drawing on artists, issues and locations that were relatively marginal to the constellation of works and positions featured in the writings of Foster, Owens, Crimp and others associated with the critical elaboration of appropriation. As my arguments form an important context for *Art After Appropriation*, I will review two central concerns, adding to them a third, briefly introduced there, which forms a point of departure for the opening chapters of the present study. My first discussion, in which I found myself using the terminologies of the 1980s somewhat against themselves, analyses the work of a New York-based artist whose photo-texts question the established parameters of appropriation, opening up issues around the historical productivity of recirculated images. The second looks to what have been termed the 'counter-appropriations' developed in non-Western visual cultures. And the third examines wider issues of state appropriation caught up in the command culture of the Soviet Union, and newly important in the aftermath of its dissolution.

The four-part panels in Warren Neidich's series *American History Reinvented* (1987) align two types of photographs with two species of text,

pairing each on either side of two moments of conflicted history: the period around the abolition of slavery in the US in 1861, and the Relocation Centres established for the 'internment' of Japanese aliens and Japanese Americans during World War II. The photographs and texts associated with the first period are 'invented' or simulated; those representing the second are appropriated from the Associated Press. While Neidich clearly draws on—and acknowledges—the procedures of appropriation, I argue that the emphatically unassisted appearance of the Associated Press panels combines with the over-coded conditions of the adjacent image-texts in a critical mode that signifies in a different register from the photographic activities we associate with either modernism, appropriation or re-photography.

The work refuses the 're-textualisation' and 'straightforward declaration'[78] informing most socially critical postmodern photographic practices. While never a singular strategy, common to many of the images of Kruger, Victor Burgin and Martha Rossler—to name three differently predicated bodies of work—is a metaphoric reinscription of a brief, resonant text, usually deployed over the surface of, or in close proximity to, a found, staged or otherwise interfered-with photographic image ensemble.[79] The signifying effect arising from the exchange between caption-text and singular image rests on what I term a 'unitary deconstruction', whose limits, co-extensive with the methodological reductions of deconstruction itself, converge on the implicit separation of visuality, textuality and history, and are underlined by a shared quest for redemptive social truth. Ashley Bickerton, we recall, identified in the Pictures generation a didactic tendency to 'break down... the process of the corruption of truth' in focused instances of 'particular deconstruction'.[80] Developing *American History Reinvented* in the same years as the new simulated abstraction and the object-appropriators, Neidich's contribution was essentially to question and open up the logic of the first wave of postmodern photo-appropriation. We thus encounter in his photo-texts a disturbance of 'binary oppositions'—achieved in this case by pushing them to extremes and making them multiple—that in Kruger, despite arguments, including my own, to the contrary, was developed most convincingly in her statements and writings.[81]

Neidich, then, partly rejects, partly restages the paradigmatic (and resolutely modernist) dislocation between the socially produced sign-systems of written language and photographic visuality, in favour of a syntagmatic seriality which, on one axis, places unadorned found images and texts side by side, while on the other, highly confected images and texts are configured in the same associative position. The result is a layered image-system that does not privilege the allure of metaphoricity above the ordered series, the sequentialities of everyday history. But neither is the conflict—the clash—of the two planes or events that meet in the metaphoric, denied. Types of otherness (signalled in the terms of the day as 'yellow' or 'black'), moments

of history (c 1861, c 1943), and modes of representation (the press photograph, the imaginary tableau) are juxtaposed across the central divide of the series—and between this and other series. Neidich offers a clash of histories and codes, which enables the viewer to acknowledge the actual labour of the making of the visual in and on behalf of ideological formations. He uses appropriation as one of his strategies, but finds a way to interrogate the implications of the cutting off, taking over, and re-presentation of found material. A politics of difference can only be effective when it begins at the point where the neutrality of the appropriative gesture is transgressed, the point at which the 'taking' is over-taken—by historical context, critical debate, or contestation. What interested me in this work was the way it opened up the operational assumptions of appropriation, giving us access to a relay between types and experiences of ideologically regulated otherness, constructed and imposed through social determinations of 'racial' difference. The extenuating circuit on which the exploitation of so-called marginal cultures by the agencies of the governing order depends, is registered in Neidich's works as a sub-text of ghost-like traces annotating the two key moments of racial coercion brought together in the diptychs. This work is not without its own limitations—notably in the gap that separates and joins the fact and aftermath of slavery with the reflex xenophobia of the Relocation Centres. But within these traces, strategies of appropriation are engaged, reformulated and supplemented—though they are never quite forgotten.

Time and again in the 1990s we witness surprising new orders of influence, imitation and social circulation, especially between once 'remote' and metropolitan cultures. Materials, traditions, subjects and strategies are folded—sometimes delicately, sometimes willfully—back onto the histories that formed them, and exchanged between so-called First and Third Worlds, margins and centres, along conduits that are ever more hectic, disruptive and efficient. Perhaps even more than for the Western avant-gardes that preceded them, appropriational activities seem aligned on the side of an elite, First World, urban culture, their core theorisation and exemplary exponents being supplied by a small coterie of artists, critics, journals and art schools located, overwhelmingly, in New York and Los Angeles, or derivative of them.

Even when held to criticise or undermine the codes and institutions of the big-city art world—exhibition practices, masterpieces, dominant masculinities, cults of authenticity and expression, the market system and its values—the appropriation practised in these venues is at the same time unthinkable without them. As Pierre Bourdieu demonstrated of the modern art system in general, gestures of taking, quoting, citing and the act of relocating that which is appropriated within the highly controlled context of an art world is clearly predicated on the power and prestige of a self-

affirming cultural nexus. Indeed, the generic substitution of taking for making places a particular premium on the arbitrating mastery of the 'theft', even—perhaps especially—when the scene of its re-presentation is claimed as 'subversive' or undecidable. There is, in other words, always a violence implied in appropriation; and the violence of the cut is always accompanied by the aggravated wound of separation. Further, the moment of appropriation must be associated with a wholesale return of vanguard art to the museum and gallery network—a process to which Bickerton referred as an 'aggressive assertion'—after a decade or so when the relatively uncommodifiable projects of Earth Art, Performance and Conceptual Art led the way back to interventions in the landscape, time- and audience-oriented activities, and the putatively immaterial domain of ideas.[82]

This leads us to a second concern of *Modernism Relocated*, one that I develop in different terms in Chapters 5, 8 and 9 of the present study: the proposition that dominant appropriationism was subject to a set of feedbacks, reversals and tactical reformulations from outside the economic and geo-political precincts of its formidable power-bloc. The permissions it granted and strategies it opened up, allowed—on occasion at least—the ideas, products and contexts of the appropriators to be appropriated back. Such processes, random and capricious, or issued in ironic homage, pay little respect, of course, to the founding theorisation of appropriation. Instead, they annex materials, fragments and interpretations, turning them into physical armatures or conceptual shell structures for the presentation of hybrid local content.

Recent cultural anthropology has attended to the concerns that lie behind this inversion, suggesting that indigenous forms of representation can no longer be secured within a rhetoric of 'contextualist authenticity' that fixes and preserves them in line with Western ethnographic logic. Writing of Aboriginal painting in Australia's Western desert, Eric Michaels discusses the multiple layers of exchange operative between Western representations and what, until the postcolonial period, was termed 'primitive' art, establishing several contexts for the 'counter-appropriation' carried out among Aboriginal dot painters. First, he identifies the two modes of display of non-Western artifacts: colonialist exhibitions—where they were set up as voyeuristic curiosities, scientific specimens or as mere treasure and booty—and 'ethnographic' galleries and modernist art exhibitions taking place during the opening years of the twentieth century. While both were deeply inscribed within imperialist and formalist discourses, at the same time they offered up encounters that were powerfully interruptive in relation to Western viewing etiquettes. Artists of the historical avant-garde, including Picasso, Derain and Matisse, were motivated by a set of modernist visual concerns and not necessarily, or exclusively, by a kind of ethnographic fixation on the objects they saw, appropriated and occasionally collected. Operative here, he claims,

was a form of 'separation of artistic content from ethnographic content'.[83] Secondly, Michaels criticises the *mise en discours* that constructs the Aboriginal object as an effect of 'originality' arising within the general context of 'pan-aboriginalism'. But he also defends the attempt to understand the 'specific pleasures' of particular Aboriginal practices at the calculated risk of 'reasserting authenticity'.[84] Michael's contribution is a powerful reminder that the places of Aboriginal representation may also be sites for the feedback of a 'counter-appropriation' in which Western desert paintings 'emerge in a dialogue between the painters and the market, their critics, advisors, and their experience of contemporary culture as a whole'.[85] Such work is simultaneously vulnerable and empowered. It circulates between the non-First-World points of origination, and the Western art-world system; it takes on Western strategies by strategically deforming them; and it outflanks the conditions of unitary deconstruction encoded in the US appropriationism in ways that are complementary to the First-World reformulations imagined by Warren Neidich and the 'Second-World' refusals discussed by the Russian-born critic, Boris Groys.

My third concern, then, thinks through how the Second World returns a model of appropriation that exceeds and ironises the often complacent political assumptions of the Western art world. Only in the context of the post-Soviet order, perhaps, can the Western avant-gardist fantasy of appropriative criticality effectively be revealed. As with Michael's reading of Aboriginal art, Boris Groys' refutation of New York appropriation is prepared by a re-reading of modernist history—here, the relationship between the advanced Western art world and the Party-state in the USSR. Groys argues that post-Revolutionary, avant-garde projects such as the theory-practice of Kasimir Malevich, the 'phonetic trans-rational language' of Victor Khlebnikov, the anti-aesthetic of Productivism, and critical positions adumbrated in the journals *Lef* and *Novi Lef*, were caught up in a view of the world that was necessarily 'total and boundless'.[86] Instead of construing the avant-garde as embarked on a mission of rational and utilitarian reconstruction, Groys points instead to its collective irrationality, its surrender to ritual and its conception of artistic-political change as driven by a kind of demiurgic will that is finally and triumphantly exterior to the work and its productive context. The avant-gardist plan to conquer the material world must, he insists, be conjugated with, rather than crudely opposed to, Stalin's desire to construct and impose a totalitarian political aesthetics.

Groys suggestively contends that the measure of the West's desire to polarise and antagonise the avant-garde 1920s and the Socialist Realist 1930s and 1940s is founded on its privileging of the museum or gallery as the ultimate locus of meaning. The West's attachment to what Walter Benjamin called the 'exhibition value' of cultural work reveals a dependency on the object as irredeemably cordoned off from the 'real world'—from politics, life

and the everyday—that is effectively antithetical to the total, instrumental, social efficacy of the always-already politicised image. It was this type of image that the avant-garde theorised and desired; at the same time it was precisely this kind of image that was implemented by Stalin and his cultural acolytes in the 1930s.

Soviet avant-gardes, especially Constructivism-Productivism, did not trade in the soft, conceptual, inventionless readymades of Duchamp. Instead, they attempted to reinvent the relationship between the worlds of art and production. Art was dissolved into intervention in the productive series, its discrete functions eclipsed behind the blueprint and the product. In a sense, art was sublimated into clichés, understood either as the reproduction of utilitarian objects, or the circulation of useful propaganda and social messages. The double bind of the invention-originality debate was undone, and art redefined as the directory of productions. Henceforth, cultural practice was neither original nor unique. Instead, it was considered useful and inevitable. It was subject to one will: that of the Party state; and it could neither be 'made' nor 'appropriated', for it had no history, being a function only of a present crossing over into the future.

In one of several striking reversals of conventional wisdom, Groys claims that the post-utopian unofficial Soviet art of the 1970s and 1980s actually 'completed' (rather than refuted or repudiated) the Stalinist project by foregrounding its 'internal structure', thus 'enabling it to be grasped for the first time in its entirety'.[87] His powerful reading of Erik Bulatov's painting *The Horizon* (1972) demonstrates the ironic equivalence of an appropriated Suprematist form with the Stalinist bureaucracy through the morphological ambivalence of its looming horizon-bound shape, which at first suggests the floating rectangles of Malevich, but which on closer inspection turns out to be a different appropriation—of a representation of the Order of Lenin.

Groys' speculative conclusions concerning the relationship between the revisionary context of Soviet cultural production and the philosophy of postmodernism are provocative. First, dogmatic Socialist Realism is defined as already 'postmodern': 'beginning with the Stalin years... official Soviet culture, Soviet art, and Soviet ideology become eclectic, citational, "postmodern"'. What this culture represented was in fact the 'victory of the avant-garde'. On this view, Stalinist visuality witnessed a restructuring of the entire Soviet life environment under the influence of the avant-garde. The formula that Groys uses to clinch his revisionary argument suggests that Second-World, or 'Eastern post-utopianism', 'is not a thinking of "difference" or the "other" but a thinking of indifference'.[88] This is the first of the two 'shocks' that structure the cultural politics of the post-Khrushchevian Union. The second is the realisation that the USSR cannot simply take its place in a Western history that has been waiting for its re-emergence. The West has

entered into a transhistorical moment. Its markets and technologies have become globalised. Its teleology is either complete or is vanquished. Softly buffeted by the loss of history and rendered dissolute by the necessary indifference of the post-totalitarian moment, the artists of the post-utopia are not susceptible to the 'mistakes' of Western postmodernists. 'Quotation, simulation and the like' are the tokens of a 'thoroughly utopian... zero move... dictated by' a particular 'sociopolitical oppositionality' for which Groys has nothing but implicit disdain.[89] This argument is as thoroughly sceptical about the political claims of the New York 1980s art world as was Peter Bürger about the critical impact of what he called the 'neo-avant-gardes' formed in Europe and the US after World War II. The difference is that Groys has another history to tell. In its very Nietzschian pessimism and political irreverence there is a germ of cultural optimism that convinces (if not consistently) precisely because this is one history that the West cannot claim back, one narrative that it cannot effortlessly appropriate.

New York appropriation has, of course, been subject to many other forms of dispute and refutation by critics—including those who helped define it—from across the spectrum of both the old and new Lefts and Rights. Attacked on the one hand for its multiple lacks and insufficiencies—of authenticity, originality and intrinsic formal value—it has also been associated with social passivity and political disengagement or overstatement. While large claims have been made about the achievements and critical edge of appropriation, the first generation of New York writers who established the basic terms for the interpretation of postmodern art in New York were usually more circumspect. In his essay on the ready-made abstractions of the 1980s, Hal Foster defines appropriation as 'art engaged in a sometimes critical, sometimes collusive reframing of high-artistic and mass-cultural presentations'; and, as we have seen, concludes that its 'critique of representation ... is a mixed enterprise'.[90]

The reframing of appropriation's unitary deconstruction that I identify in the work of Warren Neidich is just one platform around which the activities of appropriation can be widened or focused. While other artists have developed related strategies, contributing to a kind of institutionally critical, appropriation-oriented art that still continues, there was a general sense in the early 1990s that many paradigms inherited from the 1980s needed to be rethought. Impatient with both the abstract simulations and object appropriations of the 1980s, Foster looks forward (from 1986) to a time when 'all this work will be challenged by an art that *develops* rather than inverts the deconstructive techniques of the past decade or two',[91] somewhat as I claim for Neidich. Writing of a new generation of women artists whose 'strongly feminist critique of the politics of sexual difference moves away from the binary deconstructions of 1980s feminist appropriation art', Amelia Jones points to another aspect of this reorientation.[92]

If Foster and Jones called for different means of recasting the logic of appropriation, other critics—and artists—took a more radical stance. I will sketch two of these contestations, one implicit, the second polemical. Rejecting the closed, interior space of the art gallery in order to stage 'symbol-attacks' on public buildings, Krzysztof Wodiczko's series of 'Public Projections' turned the leading assumptions and strategies of the Metro Pictures appropriationists upside down. Rather than permanently 'taking' photographs from the media domain, he gives them back to communal public space in the form of temporary projections. The transience and communality of this gesture has implications for the art of citation, for the last section of Wodiczko's manifesto of 'Public Projection' constitutes a 'Warning' that the 'Slide projectors must be switched off before the image loses its impact and becomes vulnerable to... appropriation by the building as a decoration'.[93] The scene of appropriation here, is not dominated by the decision-making logic of the artist or the etiquettes of the gallery, but is lodged instead in the physical consituency and historical consciousness of public-institutional space itself. Only in this brevity and reversal, Wodiczko suggests, can the degeneration of the appropriated image/object into a decorative effect be resisted.

According to Sylvère Lotringer, secondly, much of the theoretical ballast for New York appropriation was supplied by casual misreadings from New York of French theory in general and the writings of Jean Baudrillard in particular. He attacked the triple compound of 'Soulless abstraction', 'Critical intelligence' and 'Appropriationism' associated with postmodern Neo-Conceptualism on the grounds that it failed properly to reckon with the semiotic and poststructuralist theory it imported from France. It was also, he claimed, uncritically dismissive of the German and Italian Neo-Expressionism that emerged at the turn of the 1980s. In the end, he states, 'The only difference between so-called "progressive" (American) and "regressive" (European) reappropriations... is that German or Italian icons still have content—communal, historical, cosmological—whereas American representations squarely belong to the commodity-form, a pure orgy and semiurgy of signs, all the more seductive for their empty formality'.[94] What Crimp, as we will see below, identifies as the ghostly strangeness of appropriated media images, their mobilisation of an intense presence through the structures of absence, is, for Lotringer, little more than 'a mirage of critique'.[95]

One way of situating the veil of theoretical vacancies laid by Prince and others over the significance of their appropriations is to consider how, on the one hand, they rely on rarified variants of Marxist and neo-Marxist ideas of negativity, false consciousness, ideological inversion, disguise and other strategems of making-seeming-being; and how, on the other, they were conceived against the activist, interventionist, socially diagnostic art predicated

on social clarity and transparency to the real, defended by Benjamin Buchloh, Allan Sekula and others. Appropriation effectively dissolves the condition of making into the opaque space between seeming and being, and it succeeds best when the bracketing categories are blurred into the gap that separates them. In one sense, this apparent opacity (named by its adversaries as 'liberal obfuscation') is the anthithesis of what Sekula called for in the name of 'critical representational art', or 'a truly critical social documentary'.[96] It would also seem to oppose what Buchloh (writing about Sekula) saw as a '"factographic" approach' that insists 'on the necessity to explore and clarify the construction and operation of representation within present day reality and to make that reality transparent rather than mythify it'.[97] Considered another way, the polarity reaches across its own divide. For most of the proponents of what Sekula dismisses as the 'parasitical "mannerist" representation of mass-culture',[98] suppose it to be oppositional, and to appeal to muted, New Left versions of a common Marxism. Secondly, for better or worse, appropriation is based on—or at least always connected to—the representation of 'facts'—images, objects, situations.

By the early 1990s, three strands of attention to the appropriation debate are visible. First, the continuation, modification and eventual dilution of the legacy of the Pictures generation; secondly, the first emergence and definition of 'post-appropriation'; and thirdly, a series of moves that complete the first, as appropriation's reliance on rhetorics of negativity or obliquness merges with a strand of anti-academic counter-theorising, popularly correlated with the material profusions of the grunge aesthetic and the textualist disinclinations of the 'slacker generation'. This last emergence of art after appropriation, then, takes over the gestures of taking, but assumes that the selected presentational facts and self-evident appearances are now remaindered outside of any political or critical predisposition, or effect. Objects and their spreads are supposedly made or found, installed and viewed outside the shell of any theoretical dependence—or even, at the extreme of this tendency, beyond reference itself.

Time and again in the first years of the decade, artists and those defending them chased the tail of a deconstructive postmodernism that was itself haunted by its own excesses and foreclosures. Christopher Wool's books and catalogues, for example, supposedly 'deconstruct his own paintings and reproduce them in formulas from which they may have originally emerged'. In this instance, the pressurised circuit of deconstructive self-reference is accompanied by 'aggression... anger, even rage', as the instability and auto-consumption of this logic becomes almost viscerally attenuated.[99] But Wool's anxious struggle with the critical legacies of the 1980s at least has the merit of engagement, reflection, and possibly of passion. Other work from this moment is less fortunate, supplied as it so often is by rehearsals of a formulaic, deconstructive avant-gardism according

to which the latest installment in an identifiable lineage of art issues is held simply to take on and undemonstrably 'deconstruct' what a previous artist or movement has already deconstructed. The 'issue' thus appears in increasingly mute relation to a recessional tradition—or origin—where that which is vaguely contested was once uncritically assumed. Thus the 'white-on-white' pieces and inscriptive surfaces of Maria Eichom made between 1987 and 1991 are held in a critical suspension according to which the artist 'has adopted the strategies of appropriation, but at the same time, she deconstructs the strategies on which these premises are based'.[100]

In a related sublimation, more direct critical allusion often tends, sometimes parodically, sometimes willfully, to work against the grain of the position to which it refers. Eric Troncy, for example, wrote a letter to the editors of *Flash Art* in 1991, claiming that his exhibition 'No Man's Time' in France was 'based on no particular concept and is without any theoretical scheme'. Instead, the show provided a setting for a 'spectacular' art, loosely conceived after the social effects criticised by Guy Debord in his book *La Societé du spectacle* (1966).[101] According to the title of a now-famous and controversial exhibition, in Britain, the YBAs (Young British Artists) transposed this inverted spectacle into a yet more attenuated display of 'Sensation'. In a perverse, but doubtless unintended, echo of Buchloh's new factography, the anti-heroic postures, exhausted materials and casual formats of 'No Man's Time' championed a 'series of non-theoretical facts'—barely separable from other facets of life—based on hanging narratives and locked into 'a kind of "justice" or "balance" of temporary truth'.[102]

Such travesties of the spectacle, which solicit shock and sensation largely for their own sake, must be set alongside a number of sometimes more reflexive attempts to render and account for events and visual intensities experienced as catastrophic, excessive, perverse or paranormal: closely confessional narratives; 'deviant' sexualities; gender transgressions; posthuman hybridities and new corporalities, including what I discuss in Chapter 3 as the 'techno-grotesque'; polymorphous, or narcissistic self-pleasuring and auto-referential abandonment (reviewed in Chapter 6); extreme abjection; sado-masochism and self-mutilation; the traumas of birth, death, medical intervention and vehicular accidents; and, rather more occasionally, historical tragedies such as war, genocide, totalitarian and colonial repressions, and ecological despoilation.

Such shifts toward spectacles of the excessive constitute one of the most insistent markers of the 1990s, both in the art world and wider visual cultures. In high, or art-world, culture (I'm thinking of shows such as 'Spectacular Optical' at Thread Waxing Space, New York, 1998),[103] theorisations of the spectacle are appropriated, while its effects are simulated or borrowed. Symptoms of this new fixation include the post-mortem photography of Joel-Peter Witkin, the documentaries of Joe Berlinger,[104] and

discussions of 'wound culture' and artistic trauma.[105] In popular culture, on the other hand, shock-value plays out its own mini-series in slow, incremental (and avant-garde-like) transgressions of broadcast or on-line censorship regimes. The new TV regimen of the 'shockumentary'—including shows such as Fox's 'When Stunts Go Bad', 'The World's Scariest Police Chases/Shootouts', 'When Good Pets Go Bad', 'The World's Most Shocking Moments Caught on Tape' and 'Prisoners Out Of Control' (which was too graphic to air)—develop the 'established trope' of 'the highlight sports reel' and 'the all-climax porn compilation... and transform it for reality-based television'.[106] The results are 'ratings juggernauts' made out of 'recycled images' in 'a new pop format' enabled by the proliferation of found real-time footage solicited from 'surveillance cameras, home video cameras, nanny cams, [patrol-car] dash cams, and the helicopter "cowboys" who roam LA's skies', and are driven by their provision of what have been termed 'real special effects'.[107] In both art and popular domains, real-life appropriations are cut and pasted from the more mundane sequences of everyday activity, isolated and enframed, or strung together in racy 'machine-gun' intercuts. What results is a scree of prurient, voyeuristic indulgences that offer little beyond the gratification of a popular taste for taboo and fetishisation. It may be, however, that by introducing what he called 'the demand for violent gratifications implied by social life',[108] this scene of appropriation would come closest to the excretory heterogeneity vaunted by Bataille.

Of the three shifts identified above, the emergence of 'post-' and 'counter-' appropriations may have been the most significant. This development took quite different forms as it was proposed and debated in New York on the one hand and in regional or non-Western centres (such as the Central Desert of Australia) on the other. By the end of the decade, a series of highly postured exhibitions organised and theorised by Tricia Collins and Richard Milazzo between 1984 and 1989 (put on in commercial galleries in New York's East Village, university art galleries, and commercial and alternative spaces in Europe and Canada) had converged in one of the earliest formulations of 'post-appropriation'. Moving from postmodern genre shows, including 'Still Life With Transaction: Former Objects, New Moral Arrangements, and the History of Surfaces' (International with Monument, New York, 1984), to the distillation of vanguard thematics such as 'The New Capital' (White Columns, New York, December 1984), 'Paravision' (Postmaster's Gallery, New York, May 1985), 'Extreme Order' (Lia Rumma Gallery, Naples, Italy, May–July 1987) and 'The New Poverty' (John Gibson Gallery, New York, October–November 1987), Collins and Milazzo sketched out a theory-driven curatorial move to dispute the spectral hold of quotation art on the recent past. They sought to break 'the spell of picture theory art [and] the spell of appropriation', which were both caught up in what they viewed as 'the spell of a self-maginalising radicality'.[109]

Though seldom ventured without confounding provisos and rhetorical feints, a loose terrain of reiterated attributes associated with post-appropriation can be discerned in the catalogues and essays of Collins and Milazzo. They argue, first, for the reappearance of bodily form, tempered expressionism, reconceptualised 'value' and the restoration of an 'originality... disallowed' by 'the determinism of appropriation' and its 'cultural authoritarianism'.[110] Around 1986–87, they identified the 'paradigm' of their curatorial project with 'immediacy, actuality, desire, Nature, the elemental, and Value'.[111] Secondly, while they positioned post-appropriation across 'the abstract void of the Social',[112] they also attempted to secure it within local history as the logical outcome, or 'culmination' of 'commodity discourse and The New Poverty discourse'. Post-appropriation emerged, then, at the head of a flourish of after-effects, so that: 'the dialectical critique (use and use-value) of the media, which was so necessary to picture theory art in the late 1970s and early 1980s, would be usurped, in the early to mid-1980s, by the post-dialectical discourse (surplus value) of commodity art, and, in the late 1980s, by the post-ironical, post-critical activity of the post-media and post-appropriation discourse, and ultimately or prospectively, by the post-neo-conceptual work of the 1990s'.[113] In an exhibition described as the 'hyper-culmination of all these issues',[114] Collins and Milazzo reckon, thirdly, with a wider history of post-appropriation, contending against the conventional argument that 'appropriation is in many ways perhaps an extension of Pop'.[115] They suggested in 1989 that the then-current generation of post-appropriationists (they had in mind Robert Gober, Ross Bleckner, Doug and Mike Starn, Annette Lemieux, Meg Webster, Suzan Etkin and others featured in 'Pre-Pop Post-Appropriation', an exhibition at Stux Gallery, New York, held in February 1989, that rounded out their curatorial intervention) took their lead not from Pop, Minimal or Conceptual Art, but from the moment between Abstract Expressionism and Pop, when Jasper Johns, Robert Rauschenberg and Salvatore Scarpitta opened up questions of the body and the mass-media that the first-generation appropriation artists merely reified or closed down in the name of a failed critique.[116] Acknowledging the 'romantic' suggestions that veined their collectivisation of post-appropriation—as, for example, in the assertion that Starn's 'post-appropriation photography, like post-appropriation discourse, in general, accesses the tenor of the elemental and the human element'—Collins and Milazzo claim that appropriation itself perpetuates a 'romance' by virtue of its 'self-righteous' refusal to engage with desire, value and abstraction. In the catalogue essay for 'Pre-Pop Post-Appropriation' we glimpse the beginnings of a neo-humanist attack on critical and artistic self-reflexivity, which effectively terminates their enterprise in the act of delivering a 'content' for post-appropriation discourse that 'belongs to the unreflexive ontological instrumentality of the extended body'.[117]

Whether we consider it as an art-world movement, a style, or a strategy, appropriation is identified closely and specifically with the interests and institutions of the New York, and allied, art worlds. Yet, given its European avant-garde antecedents, on the one hand, and its explicit trajectories through increasingly multi-national gallery and commodity circuits, on the other, variants of appropriation have made themselves known in all corners of the Western-oriented art world from Auckland to Amsterdam. Exported appropriation has given rise to interventions in each of the idioms identified above—Neo-Expressionist, photo-based and simulational—as well as inflections of them combining appropriation's global currencies with local issues, histories, techniques and materials. Further, while post-Minimalist, Performance and Conceptual works are generally reckoned as the first Western movements that spawned imitations and collaborations in metropolitan art centres around the world, including Asia and South America, it can fairly be claimed that appropriation, in unstable alliance with postmodern, postcolonial and poststructuralist theory (which were in turn locked in conflicted dialogues with each other), became the first quasi-global language of international vanguard art. With increasing frequency throughout the 1990s, one encountered at galleries or biennials in Sao Paulo, Istanbul, Seoul and Caracas, wall-bound works, mixed-media projects and installations that borrowed, parodied, copied or argued with the forms and languages of what has become international appropriationism. Indeed, some of the strongest and most provocative work emerged from these centres, or from artists associated with them but working in the West. What results, of course, is often staged in fraught and controversial relation to both Western 'prototypes' and local conditions. And it is therefore a little easy and optimistic to suggest, as Thomas McEvilley put it at the beginning of the decade, that 'The intermingling of different cultures' image banks as part of the postcolonial project is thus a sign of a deeper interpenetration of their identities'. 'This', McEvilley continues, 'was the inner meaning of '80s appropriation and quotation and so on, which prepared the way for the multicultural '90s'.[118]

In *What's It All About, Bongo!*, a mixed-media installation with four TVs broadcasting simultaneously (shown at Central Space, London, in 1991 during the Gulf War), Rasheed Araeen, a Pakistani-born artist and activist — and founder of the journal *Third Text* — treated the TV transmission as a critical ready-made. According to Jean Fisher, the installation 'appropriates the globalised and commodified languages of Western culture (among which I would include "high art"), contaminates them with another voice, and displaces them from their "proper place"'.[119] While its logic and assumptions align Araeen's piece with the social- and gender-critical media appropriations of the late 1970s (for example, Dara Birnbaum's *Technology/ Transformation: Wonder Woman*, 1978–79), its reference structures are

expanded to pose the Western newscast as both origin and object of a newly satirical citation. This work is vulnerable to many of the criticisms levelled against the photo-appropriationists, but it opens up different, arguably more relevant, spaces for its purported deconstruction of Western information and control systems. Such extensions of appropriation outside of and/or against the sanctioned centres of vanguard art, remain one of its most important, and conflicted, legacies.

The installations and mixed-media pieces of Jaune Quick-to-See Smith and the photo-texts of Lorna Simpson also function within and against the appropriative paradigms reviewed here, crossing them with issues of race and gender, and turning them back on themselves. Using a wide range of appropriated materials, including high-art icons, found photographs and objects, scientific illustrations, cartoons etc, Smith's *Paper Dolls for a Post-Columbian World with Ensembles Contributed by the US Government* (1991) explores 'the retail vending of stereotypical Native American identity as a consumer commodity'. Other works engage the figure of trickster, and strategies of 'playing Indian', to conjure effects whose 'coyote backtwist' makes a 'pastiche of parodic representation'.[120] Working with a less profligate array of materials and methods, Simpson too takes from the languages of high (Minimalism) and vernacular cultures (wigs and hairdos), posing questions about a key social threshold for the image/text combination: her 'marriage of image and text reappropriates one of the signal tropes of anthropology, an invidious taxonomy which sorts, grades and classifies objects in stark arrangements with terse commentaries attached'.[121]

Further reviewing these developments outside Western art worlds is beyond the scope of this introduction; and I am not equipped to address them with the kind of expertise and detail required in the discussions that follow. But in Chapters 1 and 2 on photographies in the USSR, and Chapters 8 and 9, which look, respectively, to the post-appropriational work of Korean-American artist Cody Choi and the critical problems attending art practices in a global, medialised and complexly embordered environment, I discuss specific aspects of this challenging situation. The implications of the collision of transnational capital, First-World metropolitan art discourse, and local art and critical activities will be crucial for contemporary visual practices in the next millennium, whether in China, the new republics of the former Soviet Union, or regional America.

Some critics have proposed that the relationship between recent art in Europe and the US hinged on different attitudes toward appropriation. Donald Kuspit, for example, suggested in 1990 that 'Where American artists—such as those who simulate abstract paintings and the neo-Duchampian specialists in commodity objects [...] — appropriate the past as a *fait accompli*, regarding it as a finished fact [...] European artists are themselves appropriated by the past, which never stops unfolding and

tightening its hold on the present'.[122] Dependent on an unworkable notion of history as an appropriating agent, this was a doubtful generalisation ten years ago, and its relevance has further diminished by the end of the decade. But Kuspit's comment pointed to an important and contextually variable hinge in the practise of appropriation. For the gesture of taking always results in the relocation of a context (whether national, ethnic, gendered or class-based) as well as an object, image or event.

With this in mind, I will limit myself here to two comments on the appearance of appropriation in the English-speaking world outside of the US, one brief, the second addressing a significant reinflection of appropriation in the UK. I want to suggest, first, that the tendency in New York to separate out 'correct' photo-appropriation and 'incorrect' painted variant, produced divisions that were somewhat dissolved elsewhere—notably in Australia, where appropriation-oriented artists were seemingly possessed of a more unstinting, rambunctious sense of humour, irony and critical wit. Indeed, it could be said that such correctnesses were reversed, in that some of the strongest appropriational gestures down under are found in the painted and mixed-media works of artists such as Juan Davilla and Imants Tillers.

Secondly, in the UK, home to the most persuasive—and hyped—avant-garde cluster of the 1990s, appropriation reached a denouement and a dead end. Marked out by a succession of exhibitions running from the mythical 'Freeze' show, curated by Damien Hirst in 1988, through Andrew Renton's 'Technique Anglaise' (1991), Charles Saatchi's five exhibitions of young British artists (beginning in 1992), 'Brilliant!: New Art From London' (at the Walker Art Center, Minneapolis), 'General Release' and 'Corpus Delecti' (all put on in 1995), and culminating in the Royal Academy's 'Sensation' (1997), most of the artists, dealers and critics associated with the YBA phenomenon were sceptical of the academicism and critical orientation of New York 'issue-based art' in general, and appropriation in particular.[123] In turn, YBA's detractors, attacking its 'cultural introspection' and 'private obsessions',[124] claimed the phenomenon was motivated by anti-theorisation, social withdrawal, public disinclination, fashion-driven opportunism, febrile transgressivism and frank puerility.[125]

Its defenders, on the other hand, attempted to rescue what one of them viewed as the vigorously intrinsic content of the new work from any form of critical predisposition. The result is a ghost-story for contemporary art in which the invading contaminants of theory and history must be exorcised from its body. If 'Art's old haunted house capacities' give rise only to 'shows ghosted and transcended by luminous and creepy "idea" ideas', it becomes urgent to clean house, purging the display of art of every vestige of criticality, implicit or otherwise. In this view, any disposition towards social or critical reference that lingered around the self-declarative work would be vapourised by art's self-appearance as art—a process driven and secured by

basic, openly acknowledged ambitions for fame and financial success. Theory, art-as-idea, anything from the outside that might bear with it anterior knowledge, are expelled from the vigorously self-substantial body of contemporary art, and remaindered as the ghostly spirit of an irrelevant past that does nothing more than haunt the professionalised paradigm of the artist-theorist.[126] This is an extreme view, but it helps to clarify one of the destinies of citational postmodern art in the 1990s. The dead end for appropriation is evident—and literal. Its often chronic dependence on theoretical pretexts, advanced forms of 'reading-in', curatorial cross-referencing and ventriloquised critique becomes nothing more than a spectre posed in front of the mass grave of appropriated image/objects.

The 'Sensation' catalogue unselfconsciously plays out the evacuation of critical appropriation in the very process of simultaneously laying claim—and paying homage—to a (hand-me-down) version of its general assumptions. In the opening essay, aptly titled 'Everyone a Winner!', each genre represented in the show is supplied with a cursory, capsule formula that attempts to secure its relationship either to historical appropriation, or to its re-photographic and commodity-based neo-avant-garde variants. Thus the Goldsmiths painters, Ian Davenport, Gary Hume and Fiona Rae 'delighted in their borrowings from the past... used quotation and deconstruction and levelled high with low'. Drawing on a promiscuous range of readily available sources, this form of taking is modish, immediate and almost infantile. Material arrives from here and there and is shaken together like a cocktail. Thus Hume 'grabbed iconic images from style magazines as well as art history and gave them a figurative/abstract mix'. Glenn Brown rummages through his 'pick of the past', copying paintings as a graphic style, giving them the aura of an 'Athena'-style poster. Richard Patterson, so the catalogue claims, generates 'original art from quotation and a dreamy nostalgia for suburban life'. Rae is singled out for taking appropriation furthest, then cavalierly negating its implications: 'over the years she has mismatched many styles and sources without continually having to acknowledge their quotation and appropriation'. The sense of obligation and permission—lost or found—suggested by Rae's not 'having to acknowledge' and in Brown's simply taking his 'pick of the past', is a not-so-subtle whisper from the institutional wings that clears the stage of critical responsibilities and ushers in a new cast of hip, laddish art-makers unencumbered by any referential duty beyond the cultivation of surface, sensation and effect. The sculptures and installations in 'Sensation'—including the 'found objects and readymades' of Michael Landy and Damien Hirst—are also labelled with lightweight appropriational tags. In this case, however, it is not only a vox-pop variant of citational reference that is grafted onto the various found, composite and assisted objects. In addition, a febrile clip from the politicised rhetoric of New York appropriation is used to brand the bread crates and

costermonger's barrow redeployed by Landy with a criticality predicated on 'the object as a tool of class visibility'[127]—one strategy within what has been identified as a more general 'appropriation of the popular as a form of proletarian dissonance'.[128]

The sum of these reductions is grounded, finally, in a confounding localism, waved like an anecdotal red herring in front of the international histories and near-global reach of appropriation. 'The British imagination', so the story runs, 'haunted by Carl Andre's bricks, has continued to be puzzled by how the Duchampian readymade and untransformed object could be art'.[129] The reference here is to the exhibition of fire bricks by Andre at the Tate Gallery in 1976, which occasioned a flurry of hostile criticism and a series of no-holds-barred debates, played out for the most part in the popular press, about the constituency and effectiveness of contemporary (Minimalist) art. This reprise of a scandal, now a quarter of a century old, functions in several ways. First, it crosses the history of the Duchampian ready-made with that of the Minimalist object, suggesting that the current work will deliver the delayed promise of both. Secondly, it raises the spectre of the 'philistinism' of the British public, a subject much debated in the 1970s and recently revived.[130] We don't need to read too closely to realise that yet more circular knowledge lies close to the surface of these references. For the older philistinism of 'puzzlement' that obscured the public reception of Andre's bricks is now replaced with a more advanced or enlightened form of the same ignorance, only, so the implicit logic runs, to be seduced into new relevance by the louder and more glamorous appearance of appropriation as sensation.

As should now be clear, the same logic that condemns the assumptions of appropriation to death, gives rise to its epiphany. It was a prefabricated assumption among the generation of artists in 'Sensation' that 'the artifacts of today's mass culture' constitute a field of almost self-evident 'Duchampian readymades'.[131] The denouement of appropriation, then, is a kind of quotation without predicates, a surrender to the ineffable thereness of signs remorselessly cut out and abstracted from their popular cultural contexts. The disinterested idealism on which this aesthetic rests is, of course, as old as modernism itself: art is conceived and viewed without an 'end', 'independent of, and ideally distanced from, the immediacy of its own reception'.[132] The defiantly unhindered, immanentist YBA art that arose around this new tabula rasa courts a special kind of provocation that we can view as an assertively vivid antithesis to the greyness of the contextual ghosts that haunt it. The off-stage spectre of critical assumption is immaterial, quasi-invisible (difficult to sight or locate), transient and drained of colour. In transatlantic art-world terms, its equivalent would be the earlier, post-Conceptual, black and white, photo-based appropriations of Prince, Levine, Kruger and Sherman's film stills. Contending against these

Jake and Dinos Chapman, *Zygotic acceleration, Biogenetic de-sublimated libidial model (enlarged × 1000),* **1995,** mixed media, dimensions unknown. Photo: Jay Jopling, London

unending greyscales, fighting back against the phantom limbs of their critical extension, the YBAs took refuge in images that solicited the spectacular, the monstrous, the hyper-subjective, or trawled in the off-beat margins of the suburban everyday. The domain of appropriated objects and signs is not engaged for the purposes of critique, or even, as Steinbach claimed of his sectioned shelves, as a function of pleasure in, or desire for, commodities themselves. Instead, the gestures funding the appropriation have become implicit, almost invisible, as if the predicate of taking had become simply a material, like paint, canvas or marble; while the effect of the appropriation is largely to signify stirring effects, or, in the language of the times, gory, giddy, eerie, poppish 'sensations'. Appropriated objects, substances and persons have two destinies in this work. They become curios or extravagences: Hirst's dead, neatly severed, pickled animals; Chris Ofili's elephant dung; Ron Mueck's prostrate, naked, quarter-scaled, silicone and acrylic *Dead Dad* (1996–87); or Mat Collishaw's *Bullet Hole* (1992–93), a gridded sequence of Cibachromes mounted on fifteen advertising light boxes that convene a photographic close-up of a gun-inflicted head wound. Or they are aligned with that 'ventriloquising [of] the amateur and the "incompetent"' that serves the YBAs 'as a means of resisting and subverting what they see as the professionally overdetermined protocols of critical postmodernism'. But 'the new art's appropriation of amateurism' results only in a collapse in the distinction between 'the aesthetic subject and the consumer of popular culture'.[133]

Finally, in the work of a Saatchi-exhibited American artist, appropriation is administered its extreme unction, becoming a joke, a travesty and a pun, and in the process, perhaps, disappearing back to its Duchampian origin. I am thinking of Tom Friedman's *Hot Balls* (1992), a little assemblage of 'approximately 220 balls stolen from various stores over a six-month period'. In this piece, appropriation is facetiously linked both to real-world theft and art-world success, and the purloined objects, simultaneously basic geometric volumes and common children's objects, are overwritten, then exploded, with crude sexual innuendo and masculine bravado.

Now, against this parodic evaporation of the tradition of citing and quoting, and the serious charges levelled against it, we can discern a lineage of subtle modifications and inflections of appropriation among several differently situated artists around the turn of the 1990s. Considered together, these testify to something like the expansion, or 'development', of appropriation after the Pictures generation called for by Foster at the end of the essay in which he lamented its reduction—and disabuse—into stylistics or simulation. Except that their reorientation tends to work more on the means through which appropriated materials can be clustered and merged, than on specifically extending the 'deconstruction' of representation or the more direct modes of social critique identified by the *October* critics with the

Levine/Kruger generation. These developments testify to an opening-out and reappraisal of appropriation in the Western avant-garde, which, while usually more inward looking, is complementary to its extension in what must still be viewed as the para-Western art world. Such reconsiderations add to the art of citation a refreshed ironic distance, layered fields of reference, and a wave of theoretically deflated sampling. They are figured more through the innovative use of material, scale, and visual structure than in relation to an exfoliation of critical pretexts.

Several claims have been made on behalf of this renovated appropriation, not all of them equally convincing. Western observers of appropriationism working outside the metropolitan art world have sometimes been rather more generous in their assessments than New York insiders or non-First-World critics. Ventured almost as an aside in the course of an interview in 1986, Julia Kristeva contends, for example, that the newly sacral content of the artistic appropriation of 'popular images' may have a kind of 'therapeutic impact'. Far from resounding in a void of simulations, postmodernism, she argues, may actually have a reintegrative function, drawing together the fragments of mediated culture in an 'eclectic unity'.[134] A similar position has been advocated by Thomas Crow, who looks to Phil Cohen's psychological theories of subculture, which emphasise its 'symbolic and compensatory rather than activist functions'.[135]

We can also identify a number of artists who have quietly but resolutely refurbished the parameters of appropriation. Some are identified with the scatter art of the turn of the 1990s, whose 'low-tech, slapped together, nuts-and-bolts, cut-and-paste approach',[136] while configured squarely against the signature crispness of commodity appropriation, at the same time offers its own subtle commentary on the culture of citation. Dubbed the queen of 'mis-appropriation', Jessica Stockholder, for example, makes pieces that 'are made up of found objects—but they look like "readymades" of things that could never exist'.[137] Robert Gober's installations cross appropriation with an intimation of its opposites: sentiment and fabrication. Diffidently hiding the traces of what is made, his citational strategies offer up oblique references to systems of ready-made images, rather than specific found objects. We encounter in Gober's puncturing drains, then, a shadow economy of the Duchampian appropriation of plumbing that takes neither the original, its representation, nor its contemporary issues, at face value.[138]

In a similar vein, Charles Ray works through the historical orders of appropriation to achieve the clarified idiosyncrasy of its surrogate extension—though here, a leading predicate is the supposed immediacy of the self, rather than a field of objects clustered as a system. If Ray's mannequin-selves are hallucinatory simulations based on 'readymade representations of the self as culturally manufactured',[139] that which is appropriated here, the superficial shell and variable dimensions of the body,

its blank, identifiable 'look', becomes the empty core of an infinitely presentational self. Ray touches on the critical codes of subjectivity and authoring associated with 1970s appropriation, but refuses to deliver their message. In Ray, too, we catch another glimpse of that phantom doubling of appropriation that seems almost infallibly to attend its postmodern inflections. Here, however, spectral appropriation haunts the effects of 'grandstanding' and 'sensationalism' to which, according to the artist's own candid confession, he is irresistibly drawn.[140] Reflecting on his *Unpainted Sculpture* (1997), 'a ghostly replica of a big American car, crunched and mangled from what looks to have been a major collision', purchased from a police auction, disassembled, and then cast in fibreglass and painted 'flat primer grey', [141] Ray recalls that:

> One day, I don't know why, I was thinking about ghosts—I was wondering, if there was a car wreck, would the ghost haunt the topology or would it be more important to haunt the metal, the actual atoms at a particle level. I decided that if it were a ghost, it would definitely go with the topology of the structure.[142]

Ray's rhetorical question about the precise location that is haunted in his reconstructed wreck can only be answered by looking to wider spectral issues in the postmodern art world. For what he calls 'the topology of the structure', we can redescribe as the shape of the real caught in the trauma of a doubled declaration that haunted the indexical sign, and finally became its 'art effect'. Ray's 'flat primer grey' is a mark of allegiance to the colouristic despectralisation of the spectre, its desire for neutrality or quasi-invisibility, that we can trace back to the 'ultra-minimalist de-materialisation' of early Conceptual Art: 'There are images here, pictures here, representations, icons, allegories, symbols, aesthetics, but they were ghosts'.[143] Ray's greys are clearly associated more with ironising 'the grey vistas of post-structuralist endism',[144] but they take their place in a lineage of post-Conceptual grainyness, including photocopies, black and white and re-photography, and amateur appropriations. Camouflaged behind the real, the ghostly shock of its emergence is rendered all the more intense.

One of the fullest reassessments of appropriation at the end of the 1980s arrived with Mike Kelley's rehabilitation of craft objects. Consideration of this work also grants us access to a different formation of the spectralism so often associated with the photographic or citational sign; returns to the more disturbing aspects of appropriation proposed by Bataille; and offers an important critical narrative across the divide between the 1980s and 1990s. Kelley's found, stuffed-toy animals, afghans and rugs, offered a reversion to the blank or invisible object that, as he insisted from his student days at Cal Arts, substituted for the reductivism of the Conceptual aesthetic (with its

imageless art works) and 'the making of blank things'.[145] Cut out of an Oedipal triangle in which Kelley's mother made quilts, cosies and pillows, and the adolescent Kelley took up sewing largely to snipe at his father's desire for a manly son,[146] craft-type soft stuff made its first appearance with the felt banner of *Janitorial Transcendence* (1980) and the funny frog doll projected as part of the slide show in *Confusion* (1982). As Kelley began to accumulate thrift-store materials, he built a double sense of profusion and singularity into the first of several overlapping waves of work with craft objects initiated by *More Love Hours Than Can Ever Be Repaid* (1987), which I discuss in the context of the gift and the rebate in Chapter 5. A second phase of Kelley's craft work moved away from wall-bound hanging pieces that invested his found objects with pictorial individuality. The 'Arena' and 'Dialogues' series posed objects on covers and blankets in order to solicit— and sometimes thwart—interactive exchange with the viewer. Finally, the 'blunt' taxonomic organisation of *Craft Flow Morphology Chart* (1991) made another explicit move against the persistent association of Kelley's craft objects with nostalgia and infantile recidivism. Laid out on 32 folding tabletops according to their size and iconography, and photographed against a ruler, like archeological bones or shards, the congregation of found, homemade stuffed animals was reconfigured as material units and conferred with sculptural sheen. The work took on the restoration of analytic 'order' to objects whose 'culturally unconscious production modes' had always tended to resist inquiry and dissolve into affect.[147]

Mobilising the unsung, labour-intensive, personal-yet-anonymous investments of craft, long vilified or disparaged by the high-art tradition, Kelley moves through a key terrain in what I have already referred to as post-appropriation. For in addition to posing emblematically kitschy material in counter-nostalgic, non-heroic aggregates, Kelley's floor pieces engage in a specific dialogue with the 'classical',[148] enshelved commodity objects of Haim Steinbach. The two bodies of work are locked in an unremitting dialogue of differences and overlays, rare if not unique in Kelley's career. Sited on the floor (and later hanging from the ceiling), the afghans, blankets or other ground covers refuse to raise up the stuffed animals and rag-dolls dwelling on them to the at-arms-length commodity platforms of Steinbach's unearthly para-Minimalist shelves. Instead, they work with the other hand. Their stitching, knitting, plucking, throwing, tinkering gestures, issued from rural, suburban or working-class cultures, are clenched in a retort to the *noli me tangere* seduction of the mass-produced commodity and the metropolitan vitrine. As we read between the lines of these appropriations, however, all is not what it seams.

In one sense, the 'arrangements' and conversational postures of Kelley's pieces, assembled in witty confrontations and loopy scenes of mutual address, are every bit as organised as Steinbach's pristine products. As if to emphasise

this through a form of retreat—crossing it with the idea of invisibility already associated with craft in general—Kelley sometimes relocates his menagerie (or rather, what we assume are his animals) under the covers, creating an undulating landscape of hidden protrusions. These revisions of the Surrealist object efface the now-unseen appropriated material with a cover, or ground, that is itself appropriated. Such a removal of the primary object underneath its own cover resembles the infant's adoption of special objects in its journey to the Not-Me symbolic order. The piece of blanket, symbolic of the mother's breast, becomes in Kelley's work both the transitional object (not yet a whole teddy bear, or whatever) and its territory, that which wraps around it. It is, simultaneously, the figure and ground.

Worn, chatting, furry, sometimes unstitched—but always spinning their yarns — Kelley's creatures stage their encounter with hard, unsoiled commodities on the unraveled underside of Steinbach's perfectly beveled shelves. They are tossed, thrown, kicked and played with, while Steinbach's are stacked, polished, balanced, eyed-up—and possibly, though gingerly, handled. Moving from Steinbach to Kelley allows us to trace the difference between the abstraction and concretion of exchange, predicated on symmetrical moves from hands-on to hands-off production. Kelley's fluffy poseurs are props, characters and subjective residuals. We invest them with

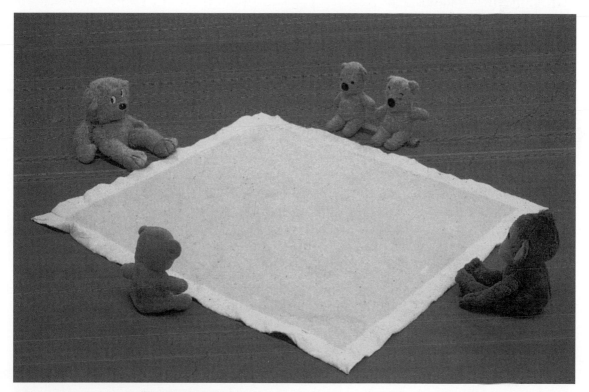

Mike Kelley, *Arena #7, 1990*, mixed media, blanket, 66 × 50 inches. Courtesy Metro Pictures Gallery, New York

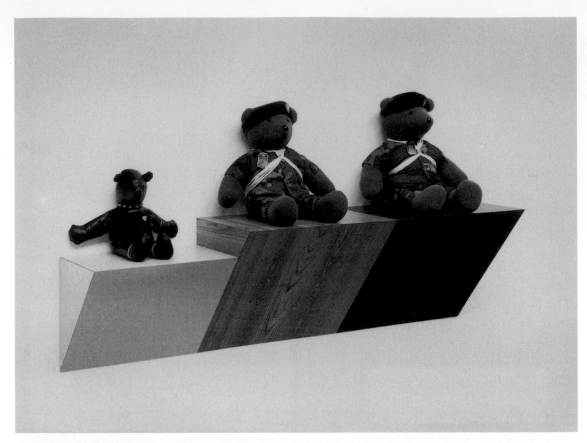

Haim Steinbach, _basics_, 1986, plastic laminated wood shelf; polyester, plastic and foam "Parabears" dressed in linen camouflage uniforms and felt hats; vinyl bear, $30 \times 53 \times 12.5$ inches. Courtesy David Lubarsky

a kind of pathetic sublime, while they engulf us in retroactive infancy. Steinbach's objects radiate iconic prestige, and upward mobility; Kelley's are worn, discarded and inept. Both are recycled, Steinbach's simply through their disposition; Kelley's across generations, as they pass through thousands of hours of mauling, desire and abuse. Steinbach's commodities seem obedient only to their decracinated origins, finally coming to rest in an ineffable double market as their art-bound afterlife replaces an imaginary sell-by shelf-life.

In an important sense, Steinbach is interested in object positions and social simulations, Kelley in object relations and interpersonal dynamics. According to clinical psychologist DW Winnicott, transitional objects broker the 'sequence of events which starts with the new-born infant's fist-in-mouth activities, and that leads eventually to an attachment to a teddy, a doll or soft toy, or to a hard toy'.[149] Like Kelley's soiled playthings, they are often 'dirty and smelly', and may be left unwashed to preserve their associative and future symbolic values. Both Kelley and Winnicott are especially interested

in the move to a social afterlife that starts out at the trailhead of the remaindered object. In what Winnicott refers to as the 'health' situation of normative decathecting (psychological relinquishment), transitional objects are subject to decisive but memorial abandonment: they are, he says, 'not forgotten and not mourned'. The terrain shared between Kelley's arrangements and the observations of clinical psychology both splits and converges around the transitional object. Kelley's preoccupation with the 'failure'[150] of the craft object (signaled by its soiled imperfection) to live up to the ideals encoded in the manufactured commodity, crosses with psychological outcomes of the child's negotiation with these key forms. The transitional object, successfully abandoned in the art arena, forms a horizon for Kelley's encounter with subjective and art histories, popular culture, deviance, criminality and the 'differences' encountered in and between them. These coordinates reappear as functions of post-object behaviour as Winnicott thinks through the socialized afterlife of the transitional object. Founded in the administration of 'illusion', the childhood use and post-infantile 'distortion' of transitional objects embraces the individual's capacities for the 'intense experiencing' that belongs to 'play', 'artistic creation', 'religious feeling' and 'dreaming'. At the same time, a regressive actualisation may result in adult 'fetishism' and criminality—'lying and stealing' as Winnicott has it. The play of the transitional object 'gives room for the process of becoming able to accept difference and similarity',[151] lifelong activities that also form the symptomatic axes, props and stage, of Kelley's whole associative drama.

The decay and resurrection of Kelley's folk cosmologies are always embodied, not rationalised; performed not taken, experienced not proven, and projected rather than encoded. They thrive not in an abstract geometry of opinion but in that special arena he has made his own, formed between mainstream and alternative popular cultures as they self-consciously meddle in the production of art. But Kelley presses further, merging this intersection not only with the empirical insights of object relations but also with Bataille's notion of heterogeneity. Bataille associates 'homogenous reality' with the domain of 'inert objects', 'with the abstract and neutral aspect of strictly defined and identified objects'. Like Kelley, Bataille is less interested in 'the specific reality of solid objects' than in 'symbols charged with affective value' located in the 'passage' of a 'force or shock' — 'as if the change were taking place not in the world of objects but only in the judgements of the subject'.[152] This is the final arena in which the craft objects function, a territory of exchanges, transitions, shocks, and affective forces that catch the subject in process and reveal how its judgements or desires rise, and fall.

How do these positions relate to the narratives of 1980s postmodern appropriation we have already developed? Kelley identified his relationship

to the New York Pictures generation as founded in their assumption of different disguises or masquerades. While Prince, Sherman and company, he suggested, 'adopted media personas, I tended to adopt different subcultural personas'.[153] Another way to come at this difference, crucial to Kelley's location in the East Coast dominated theorisation of 1980s visual postmodernism, might be to address the different referential outcomes of their strategies of appropriation. In both cases, these turn on a form of troubled, almost invisible, or ghostly, re-formation of a quoted sign. The ghost-like residua glimpsed in canonical postmodern appropriation is invested in the palpitation of the solid referent. Such work trades in the contraband aura of things with hard edges, whether the vibrational side of the found object or the definitional chemistry of a recycled photograph. Douglas Crimp, for example, writes of the 'Hitchcockian dimension' of 'stangeness' brought on by Prince's rephotographed photographs as they are invaded by the 'ghosts of fiction'. The 'brutal familiarity' of their initial appearance is short-circuited in this reading by the arrival of 'an aura... not of presence but of absence'. Their originless inauthenticity gives rise, then, to a moment in which 'the aura has become only a presence, which is to say a ghost'.[154]

Kelley's spectral vision works almost in reverse. His realization of ghostly forms starts out with vivid caricatures of literal spirits, moves to an ironic mimicry of the kind of psychological cliché 'which explains the child's attraction to such conventionalized images of horror as ghosts', and ends in spectral extremity.[155] Rather than metaphorising ghostly effects as an apparition of doubled meaning, he offers us mock seance and social parody, crossing these with an associative commentary on the implicatons of 'possession'. At the centre of his contribution to *The Poltergeist* (1979),[156] a collaboration with occult Conceptualist David Askevold, and Kelley's most obvious repository of ghoulish forms, he posed a set of four black and white, pseudo-vintage photographs, each representing the artist as a transported subject exhausting faked ectoplasm from the nose in streaming upward torrents, and surrounded by a rim of off-beat choric text—'carnal baggage left behind on a trip to the spiritual'. Flanking these are two drawing-texts, *Bo Bo Cuck is a Ventriloquist* and *Energy Made Visible*, which associate the force of the poltergeist with the disturbed eruptions of adolescence, for the 'Poltergeist is a force and not a being like a ghost...'.

Kelley offered the piece as a kind of revenge on the poker-faced factographic enquiries of Conceptually oriented photo-texts and socially critical 'documentary'. Gaming in the conditions of fake and truth, and absconding with the perfervid simulation of the turn of the century (rather than the knowing one at the end of it), Kelley routes his phantom history from an overcoded popular cultural transcendence to the extenuations of adolescence. In each of these appearances, however, as well as in further

metaphors and allusions suggested in the accompanying texts, the spectral is an emanation, a literal (if faked) stream of substance, or an uncontrollable flow-and-blockage system of juvenile desire and guilt. Tied to eruptive physicality and its symptoms, found material is never fully sequestered from its context, as with much of the appropriation art of the 1980s. Or at least not for long. It is a mark of Kelley's borrowings that they operate in a dense switch-system of embedded allusion which shuttles reference between histories (*fin-de-siècle* occultism and post-McCarthyite fantasy), genres (spirtualist documentation, the comic strip), subjects (the possessed, the juvenile), and affects (the rush of the poltergeist, the swings of adolescence). This to-and-fro referential exchange is not only plural and mobile, it is also unbuffered: Kelley releases the effects of his pieces to collide and collude together, delivering something of the shock of their appearance and reformulation in a manner altogether different from the restraint and formal order of most New York appropriation and its critical predicate of 'unitary deconstruction'.

Signs of the revitalisation or reorientation of appropriation are also visisble in other art worlds. Writing on the 1996 'Primavera' exhibition at the Museum of Contemporary Art in Sydney, an annual showcase of emerging Australian art, Jeff Gibson noted clear indications that 'ironic appropriation has been completely overtaken by a potentially expressive language of reconstructive sampling'.[157] By the mid-1990s, in fact, re-evaluations of this order had become commonplace, even *de rigeur*. Another critic noted of an exhibition of young Japanese artists at the Power Plant in Toronto in 1995, that their 'formal processes of incorporation' were 'moving from mere appropriation to salient transfiguration of cultural forms'.[158]

Where it circulates around questions of race or gender, appropriation has usually taken more extreme or determined forms, sometimes deferring to its conventional definitions, sometimes refuting them entirely, and, more rarely, offering the traditional view a form of critique or social extension. Considerations of the first kind often assume that the deficiencies of appropriational logic can be compensated for entirely through the art work's reference to either a postcolonial or (post)feminist agenda. Araeen's TV appropriations rely on this, in part at least. For what I described above as their keen 'urgency' was driven by the horrific events of the Gulf War slaughter and the racialist backlash perversely engendered by its media representation. In a different register, the shift among younger women artists and curators around the turn of the 1990s from didactic deconstruction to 'bad girl' provocation was accompanied by a critical rhetoric that either turned its back on appropriation or flaunted its assumptions by literally 'taking' them to extremes. In *Real Fake* at the Neuberger Museum of Art, (State Unversity of New York, Purchase, 1996), for example, the curator assembled work by five women artists (Lutz Bacher,

Kathe Burkhart, Nicole Eisenman, Deborah Kass and Marlene McCarthy) whom, she suggested, 'utilise and manipulate images taken directly from the discourse of mass culture' to produce '"fake" or "altered"' copies. The critical assumptions that fuel these appropriations are bracketed in a simplified and unreflexive repetition of 1980s articulations, and resemble, more than anything else, the ritual appropriationism sent into orbit around the *Sensation* show.

I have argued that appropriation can only be understood as a set of historical reactions to the determining events of social, industrial and political modernity; that its shadow is cast well beyond Duchamp and the ready-made; and that even this terminology, which has dominated all others in the appropriation debate, was not invented in the 1910s (though it surely enjoyed what Deleuze would term a 'plateau' or rhizomous extension at that moment). There are many horizons of appropriation—thousands, in fact—from the academic debate on copying, originality and imitation, to the aestheticist opprobrium levelled at the culture of clichés and the ready-made itself; from the development of photographic theory and new technologies, and their feedback into art-world practice, to Surrealist automatism; and from the first- (Neo-Dada, Pop) and second- (Neo-Expressionism, re-photography, Neo-Geo) wave neo-avant-gardes to their denouement in the 1990s. Wrapping around these horizons is the ultimate appropriative gesture, as argued by Boris Groys, according to which the totalitarian Party-state appropriates all cultural messages in its own image and effectively produces all art as ready-mades of the state. This is the ultimate 'completely-made' (*complétement fait*) ambiguously dreamt by Flaubert almost a century and a half ago. It is the final 'horizon' of Eric Bulatov's powerful work of the same name. Looking at it candidly, there just may be too much irony, too much politics in the 'cultural politics' of its fervent imaginary for the West to bear.

Art After Appropriation begins with two chapters discussing photographic discourse in the Soviet Union in the years immediately before and during the counter-Revolution of 1991, an event that as surely as any other marks the first bracket of the decade. These chapters attend to issues related to the cultural appropriation of museums discussed earlier. But they do so somewhat across the grain of the questions raised in recent critical museum studies. Consideration of the production, institutional display and circulation of common art and documentary photographies in the late and immediately post-Soviet years reveals that Western models of social criticality and avant-garde experiment cannot adequately be mapped onto the representational regimes of either the declining Socialist state or our still-unfolding intimations of what is replacing it. I suggest here that even when late Soviet photographers looked explicitly at the discursive models available in the West (when they dared, or it was permissible to do so), their appropriation was never more than an allusion. Conversely, Western photographic theory,

inflected by social art history and postmodern criticism, never spoke quite enough, or appropriately, to the complexly mediated photographic activities of the USSR. I attempt to connect the spaces marked by state-political power, photographies and appropriation through a different set of points, showing, further, that even these were provisional and emergent as they arrived and were dissolved in the transition from the USSR to post-Soviet, para-capitalist, statehood.

Chapters 3, 6 and 8 discuss various forms and expressions of the body, attending, in particular, to the visualisation of shifting images and performances of the self. Such scrutiny of the conditions of selfhood clearly continues the interrogation of gendered and ethnic identities suggested by Sherman's photographs or the projects of Adrian Piper, but moves them into a frankly less stringent domain, which I describe in Chapter 6, '"Peeping Over the Wall": Narcissism in the 1990s', as a kind of critical narcissism. Responding to the mediated incorporation, political abstraction, and theatrical elaborations of the 1980s, the artists I consider here explore how facial associations, conversational exchange and mirror images open pathways from interiority to social exchange. While not necessarily more successful or convincing than their predecessors, the effects of these works are usually quieter, more humorous and less unswerving or abject than the issue-oriented serial work of the 1980s. The figures they return participate in that reassessment of subjectivity, with its 'open redefinition of the body', called for by Félix Guattari in his final writings.[159]

Chapter 3, 'The Medical Venus and the Techno-grotesque', explores related aspects of the renewed attention to the body in the 1990s. Looking to the installations of Hungarian-American Orshi Drozdik, and to Tony Oursler's talking video-sculptures, I am concerned here not so much with bodies that are abject or debased, or dissolved into the abstractions of virtual reality, but with the ways that gendered bodies are caught between historical formations and present pleasures (Drozdik) and with the ways that common bodies both simultaneously resist and play out their technological co-production (Oursler).

In Chapters 4, 'Faces, Boxes and *The Moves*: On Travelling Video Cultures,' and 8 'Culture/Cuts: Post-Appropriation in the Work of Cody Hyun Choi', I foreground the work of two challenging artists: Steven Fagin's experimental narrative videos, and the sculptures and installations of the Korean-American, Cody Choi. Both have made significant contributions to key issues in the cultures of the 1990s, and I offer detailed readings of their work in an effort to explore different aspects of how creative subjects are caught up in international relations. Recasting his body in irreverent Pepto Bismol statuettes, rendered after the heroic bronzes of Auguste Rodin, and recomposing his body-parts as hollows of negative energy, Choi set up in his sculptures an important dialogue between postmodern appropriation, the

bodily presentations outlined in Chapter 3 and the cultural transversality of his relocation from Korea to the United States. Far from reaching a happy accommodation with his split identities, Choi binds them together in a chain of self-deprecating anxieties and off-colour irony. Modelling his own distress as increments of social indigestion inset with pockets of segmented somatic power, Choi organises a striking drama of diffidence and displacement that refuses the inherited critical framework of his initial gesture of appropriation, converting it from the logic of material or stylistic annexation into a continuous, experiential, incorporated event.

By layering the genres of ethnography, documentary and travel, and crossing them with fictive performance and social improvisation, Steve Fagin has reassembled the parameters for experimental narrative video in the 1990s. Using *Zero Degrees Latitude* (1993), his quasi-documentary on the effects of religious proseletisation in Ecuador, and James Clifford's theory of 'travelling cultures' as points of departure, I map out the components of a 'travelling video'—activities of moving-image production that make and imagine movement, whether migrations, travels, adventures, or enforced relocations. My discussion ranges the proponents of travelling video—including Jean Rousch, Trinh T Minh-ha, Chris Marker, Robert Gardner and Fagin himself—against the counter-travelling universe of Federico Fellini's Italian labyrinths of home and John Cassavettes' American familial dramas. It also sets them against dominant forms of international video installation, where, I argue, appropriation is transformed into a phenomenology of difference. Attempting to account for the cultural supplements and imagistic intensities of Fagin's mediation between home and away, I offer, finally, a meditation on Walter Benjamin's striking notion of a 'materialist physiognomy', showing how experiences of face-to-face encounter, strongly allied—though never subordinate—to research-based media experimentation, precipitate a new model for 'travelling video', which I term the 'face-to-place'.

Chapter 5, 'Public Art and the Spectacle of Money: An Assisted Commentary on *Art Rebate/Arte Reembolso*' thinks through the logic and social extension of the *Art Rebate* project developed by Louis Hock, Liz Sisco and David Avalos in San Diego's North County in 1993. Their 'rebate' of $10 bills to undocumented immigrant workers engaged in agricultural labour in the vicinity of Encinitas, CA, raises an intricate and important set of questions for public art in the 1990s, a period of retrenchment, defunding and conservative attack that has left the National Endowment for the Arts, and numerous state and local initiatives, in crisis. I relate the idea of the rebate to theorisations of the money system and public 'munificence' initiated by Aristotle, and to non-Western notions of the gift. I also examine *Art Rebate*'s relationship to earlier representations of money and exchange in modern art, including Marcel Duchamp's *Monte Carlo Bond* (1924), Andy

Warhol's dollar bills and Robert Morris' *Money* (1969). This history crosses with the controversial media reception of *Art Rebate* in a striking series of inversions, loosely paralleled by the strategies of web 'hacktivism', which oblige us to reconsider the categories of both 'public' and 'art'.

In Chapter 7, 'Parametrology: From the White Cube to the Rainbow Net', I shift focus from particular artists and projects, exploring modernist and postmodern visualisations of the cube to consider questions of dimensionality, institutions and aspects of what has been termed—not altogether accurately—the post-Mininalism of the 1990s. I attempt to open up some other sides to issues raised in Rosalind Krauss' essay, 'Grids' (1985), joining these with Paul Virilio's suggestion that 'against the history of aesthetics (coming from *esthesis*, meaning "unmeasured"), metrology, or the science of measurement, allows us to observe the history of referents and successive standards...'[160] From its origins in Cézanne and Cubism to its agonistic climax in Minimalism and the iconic gallery spaces explored in Brian O'Doherty's essay 'Inside the White Cube', I argue that the cube can be considered as modernism's final format. From the later 1960s it was multiplied, deflated, parodied—and exploded—in a lineage of works by Donald Judd, Robert Morris, Sol LeWitt, Daniel Buren and Robert Smithson. And, in the 1990s, these annexations were hyper-appropriated and perhaps definitively undone by Rachel Whiteread, Andrea Zittel, Janine Antoni, Julia Scher, Rasheed Araeen, Mona Hatoum and others.

Chapter 7 also introduces a final concept for *Art After Appropriation*: a counter-monumental, unenclosed and polyvalent space of becoming that I term the 'rainbow net'. I associate the shredded cubes of this impossible figure with the medialisation of contemporary culture. My final chapter, 'Some Horizons of Medialisation: The Rainbow Net', outlines the recent history of, and suggests some futures for, art made in and about the media. Essential to this endeavour are the stakes of local practice worked out in relation to global information technologies and economic shells. Looking to recent events in the Balkans, in China and elsewhere, I also suggest some of the ways in which political events and social protests, both in the streets and on the World Wide Web, have been informed by conceptual provocations and 'performances' once associated with the art world—and now appropriated back.

As will be clear from the different strategies and effects of the artists discussed below, and the quite different readings and languages I use, the 'after' lodged between art and appropriation does not signal a cultural present—or future—within which borrowing, allusion and citation are summarily abandoned. I want to suggest, rather, that some of the abstractions, excesses and assumptions of the 1980s, and the often programmatic critique that animated them, have been replaced by art practices that renovate subjectivities, produce cultural differences as events, and risk interventions that were off-limits to the critical imagination of the

0s. We will find that in the 1990s, the lessons, mistakes, indulgences, en the euphorias of the 1980s are engaged, debated, digested and refashioned—though there are also occasions, as with the acritical rhetoric sustaining the YBAs, when they are unsystematically dismantled or rejected wholesale.

Foster, Crimp and other commentators on the 1980s, we recall, often supplied their position-papers addressing New York postmodernism with sustained reference to the achievements and contradictions, as well as the limits and failures, of previous art movements. Foster's essay on the double agenda of Minimalism, for example, exemplifies their careful negotiation with the recent past.[161] And Crimp, shifting a decade, suggests that while Performance, with its sense of duration and spectatorial presence, was the dominant 'aesthetic mode' during the 1970s, the photo-based interrogation of representation, with its 'predicate of absence', which began to replace it around 1976, in fact delivered up an 'extraordinary presence', available only in and through its correlate and seeming antithesis. In a similar vein, Crimp also raises the 'question of subjectivity' around photography that was embedded in discourses of the originless copy and authorless production.[162]

The Derridian sleight of hand that produces this dialectical exchange returns us, finally, to those ghost stories told in the firelight of the New British Art, and forever echoing around the body or object of appropriation. Crimp, as we have seen, narrates the effects of postmodern photographies with his own version of phantom history that—even though we catch him reading backwards—stands the unseen on its head. In New York in the early 1980s, everything that was on the side of the spectral in London a decade later—everything on which art might be predicated—is lodged in the site of representation. Crimp's determination that Prince's rephotographs attain a 'Hitchcockian dimension' of 'strangeness' as they are invaded by the 'ghosts of fiction', and his avowal that their originless inauthenticity gives rise to a moment in which 'the aura has become only a presence, which is to say a ghost',[163] offers the spectral effect as a retort to the Bataillian dismissal of appropriation as the most weak-willed and servile form of representation— which is itself in the service of sickly order and social constraint. In the later 1980s and 1990s, revisionist scholarship and the critical avant-garde of the art world would find an external referent for the spectral effects that Crimp has subtly internalised, routing them from the mechanics of appropriation to a reflexive drive for inclusion that gave rise to what Clifford Geertz once referred to as 'haunted reflections on Otherness'.[164]

Art after appropriation is staged on the horns of this dilemma over presence, aura, simulation and borrowing. It is creatively caught between an art of unanchored, multiply mediated signs, and an art that cannily trades in unmitigated sensations, searching for 'something', Kruger once suggested, 'located between theory, laughter and the concretion of things'.[165] Conscious

of both extremes, it knows only that neither will do on their own—and that the stories about them told in New York and London are being rewritten elsewhere with new characters, parallel narratives and different endings. My arguments in the pages to come suggest that the most provocative art—and the most convincing criticism—of the 1990s not only refuses the absolutes of this polarity, but shuttles among them and feeds on their in-betweens with a ravishing conviction that the only things to materialise in the hybrid embodiments of millennial art are vivid particulars among the ghosts of presence, and cogent generalities grafted from the *a priori* demons of critique.

NOTES

1. See Deborah Root's *Cannibal Culture: Art, Appropriation and the Commodification of Difference*, Westview, Boulder, 1996, a somewhat meandering 'topography of the West's will to aestheticise and consume cultural difference… organised around the central image of the legendary cannibal monster who consumes and consumes, only to become hungrier and more destructive' (p xiii). If appropriation is thought as an exchange value, already implicated in commodification, its borrowings are invested with a strong sense of return, not of that which was appropriated, but of the cultural interest raised from newly hybridised products (see p 68). Relevant also, in the sphere of writing and publication, are theories of 'intertextuality', especially those advanced by Julia Kristeva, who suggests that 'any text is constructed as a mosaic of quotations; any text is the absorption and transformation of another': 'Word, Dialogue and Novel', in *Desire in Language: A Semiotic Approach to Literature*, trans Thomas Gora, Alice Jardine and León S Roudiez, Columbia University Press, New York, 1980, p 66. See also, Martha Woodmansee and Peter Jaszi (eds), *The Construction of Authorship: Textual Appropriation in Law and Literature*, Duke University Press, Durham/London, 1994. For discussion of intertextuality in the visual arts, see Wendy Steiner, 'Intertextuality in Painting', *American Journal of Semiotics*, vol 3, no 4, 1985, pp 57–67.
2. See Bruce Ziff and Pratima Rao (eds), *Borrowed Power: Essays on Cultural Appropriation*, Rutgers University Press, New Brunswick, 1997, esp p 14f, where the legal judgement for seven Aboriginal painters against a manufacturer of patterned carpets who appropriated their designs is cited from an Australian court ruling.
3. Gerardo Mosquera, 'Stealing From the Global Pie: Globalization, Difference and Cultural Appropriation', *Art Papers*, vol 21, March/April 1997, pp 13–14.
4. Ibid, p 14. See also, Nelly Richard, *La estratificación de los márgenes*, Francisco Zegers, Editor SA, Santiago (Chile), 1988.

5. Susan Pierce (ed), *Museums and the Appropriation of Culture*, 'New Research in Museum Studies 4', Athlone Press, London, 1994, p 1.

6. Initiated in 1968, the *Musée d'Art Moderne, Département des Aigles, Section XIXe Siècle* (the full title of the project according to the letterhead specially prepared by Broodthaers) continued in a series of exhibitions and installations culminating in *L'Angélus de Daumier* at the Palais Rothschild in 1975. See Benjamin Buchloh, "The Museum Fictions of Marcel Broodthaers" in *Museums by Artists*, ed. A.A. Bronson and Peggy Gale, Art Metropole, Toronto, 1983, pp 45–56.

7. For a brief, early (1991), account of the MJT, see Ralf Rugoff, 'The Museum of Jurassic Technology', collected in *Circus Americana*, Verso, New York, 1995, pp 97–100. Rugoff emphasises the MJT's 'romantic' inversions, 'cognitive dissonance', sedimentations of a fugitive past, and its role in the revelation of 'the bizarness of our cultural institutions'. Its clarified packaging of borderline disinformation 'belies the coherent identity of any museum collection', (p 100).

8. Ibid, p 7.

9. Mary Beard and John Henderson, '"Please Don't Touch the Ceiling": The Culture of Appropriation', in ibid, pp 7–8. However, instead of being able to speak through these issues, the exhibition eventually became 'an exploration within the museum's own culture and language: an exploration of the values, the claims to value, the legitimation of value, that the museum supports; a questioning of the voices to be heard within the museum… ; a meditation on 'what we see' there, on the ways that vision is policed, on the museum's appropriation of its visitors' eyes; a question mark plac[ed] over the museum as a whole –whose museum? whose objects? whose story? whose questions?', p 8.

10. Ibid, p 12.

11. Georges Bataille, 'The Use Value of DAF de Sade', in Allan Stoekl (ed), *Visions of Excess: Selected Writings 1927–1939*, trans Stoekl, with Carl R Lovitt and Donald M Leslie Jr, University of Minnesota Press, Minneapolis, 1985, pp 94.

12. Ibid, p 94.

13. Ibid, p 95.

14. See chapter 14, "1440: The Smooth and the Striated" in Gilles Deleuze and Félix Guattari, *A Thousand Plateaus*, vol. II of *Captitalism and Schizophrenia*, trans. Brian Massumi, University of Minnesota Press, Minneapolis, 1988, pp. 474-500.

15. Ibid, pp 95, 97.

16. Ibid, p 98.

17. See John Welchman, 'Moderisme à Larousse', Chapter 1 of *Modernism Relocated: Towards a Cultural Studies of Visual Modernity*, Allen & Unwin, Sydney, 1995. The following paragraphs draw on this text.

18. Maxime du Camp, *Souvenirs Littéraires*, vol 1, Hachette, Paris, 1882, pp 230–31.

19. The most useful edition of the Flaubert text is that edited by Lea Caminiti, *Dictionnaire des Idées Reçues: Edition Diplomatique des Trois Manuscrits de Rouen*, Liguori, Naples, 1966. This edition also collects most of the references to the dictionary in Flaubert's writings and in those of his correspondents.

20. *Concise Oxford English Dictionary* (1934 ed), under 'cliché'.

21. Françoise Gaillard offers some useful meditations on the notion of the cliché, the *idée reçue*, and the platitude in Flaubert, describing the *idée reçue* as: 'the idea which has received its definitive form and which, once struck like a medal, would be exchanged without being changed... in order to be the unifying agency which it is, stupid language has to erase all traces of its origin'. See 'A Little Story About the *Bras de Fer*; or How History is Made', in Naomi Schor and Henry F. Majewski (eds), *Flaubert and Postmodernism*, University of Nebraska Press, Lincoln, 1984, pp 87, 98.

22. Roland Barthes, 'Death of the Author', in Stephen Heath (ed and trans), *Image, Music Text*, Fontana, Glasgow, 1977. p 146.

23. Charles Bernheimer, 'Fetishism and Allegory in Bouvard et Pécuchet', in *Flaubert and Postmodernism*, op cit, p 171.

24. Gustave Flaubert, *Correspondence*, ed Jean Bruneau, Paris, Gallimard, 1973; trans in Francis Steegmuller (ed and trans), *The Letters of Gustave Flaubert 1830–1857*, Belknap/Harvard, Cambridge, Mass, 1980, p 127. The French text reads: *Tu fais bien songer au Dictionnaire des Idées Reçues. Ce livre complétement fait et précédé d'une bonne préface où l'on indiquait comme quoi l'ouvrage a été fait dans le but de rattacher le public à la conviction générale, et arrangée de telle manière que le lecteur ne sache pas si on se font de lui, oui ou non, ce serait peut-être une oeuvrage étrange, et capable de réussir, car elle serait toute d'actualité.*

25. To Louis Bouilhet, 14 November 1850, in *Letters*, op cit, p 129.

26. Ibid, p 128.

27. There are numerous other references by Flaubert in his correspondence and elsewhere to his drive for encyclopedic totality, and his fear of omission. Writing to Madame Roger des Genettes on 24 January 1880, Flaubert mentions that his 'pile of notes is eight inches thick'; to Guy de Maupassant on 1 February of the same year he wrote: 'I still have a dozen books to read before beginning my last chapter. I'm now in phrenology and administrative law, to say nothing of Cicero's *De officis* and the coitus of peacocks'. Ibid, pp 263, 265.

28. See *Modernism Relocated*, op cit, Chapter 3, 'After the Wagnerian Bouillabaisse: Critical Theory and the Dada and Surrealist Word-Image'.

29. For a discussion of the development of the theory and practice of 'composition' from Symbolism (via Matisse) to non-iconic abstraction, see 'Composition I: Naming the Non-Iconic in the Work of Piet Mondrian and Wassily Kandinsky', Chapter 6 of John Welchman, *Invisible Colors: A Visual History of Titles*, Yale University Press, London, 1997.

30. In addition to the texts from the later 1950s already cited, see 'L'inspiration', first published in *Magritte: Paintings, Gouaches, Collages, 1960–62*, Iolas Gallery, New York, May 1962; reprinted in André Blavier (ed), *René Magritte: Ecrits Complèts*, Paris, Flammarion, 1979, p 557.

31. Guillaume Apollinaire admonishes Picabia: *comme un peintre de tableaux je lui conseille d'aborder franchement le sujet (poésie) qui est l'essence des arts plastiques*, ('as a painter of pictures, to address himself to the subject (poetry) which is the essence of plastic art'); in 'Peintres Nouveaux', part II of LC Breunig and J-C Chevalier (eds), *Les Peintres Cubistes: Méditations Esthétiques*, Collection Savoir Hermann, Paris, 1965/80, p 108; first published Figuière, Paris, 1913.

32. Peter Bürger, *Theory of the Avant-garde*, trans Michael Shaw, Minneapolis, University of Minnesota Press, 1984, p 53.

33. Recent attempts to reinvigorate the concept of the sublime have included Jean-François Lyotard's 'The Sublime and the Avant-Garde', *Artforum*, vol 22, no 8, April 1984; Robert Nikas, 'The Sublime was Then (Search for Tomorrow)', Phillip Taaffe, 'Sublimity Now and Forever, Amen', and Peter Halley's untitled contribution, all in *Arts Magazine*, vol 60, no 7, March 1986, pp 14–21. For a rebuttal to Lyotard see Meaghan Morris, 'Postmodernity and Lyotard's Sublime', *Art and Text*, no 16, Summer 1984, pp 57–59. See also my 'Image and Language: Syllables and Charisma', in Howard Singerman (ed), *Individuals: A Selected History of Contemporary Art 1945–1986*, Los Angeles, Museum of Contemporary Art; and New York, Abbeville, 1986, pp 262–83.

34. The terms 're-photography' and 're-photographers' have been used most extensively by Hal Foster, especially in his collected essays (most of which were originally published in slightly different forms in *Art in America* between 1982 and 1984); see *Recodings: Art, Spectacle, Cultural Politics*, Bay Press, Port Townsend, Washington, 1985.

35. Owens' essays are collected in Scott Bryson, Barbara Kruger, Lynne Tillman and Jane Weinstock (eds), *Beyond Recognition: Representation, Power and Culture*, University of California Press, Berkeley, 1992; and Foster's *Recodings*, op cit, and *The Return of the Real*, MIT Press, Cambridge, Mass, 1996. See also Hal Foster (ed), *The Anti-Aesthetic: Essays on Postmodern Culture*, Bay Press, Port Townsend, Washington, 1983.

36. Rosalind Krauss, 'The Originality of the Avant-Garde' in *The Originality of the Avant-Garde and Other Modernist Myths*, MIT Press, Cambridge, MA, 1985, p 168.

37. Ibid, p 170.

38. Foster, *Recodings,* op cit, pp 36, 72, (emphases mine).

39. Welchman, *Invisible Colors*, op cit, p 341; see also Howard Singerman, 'Seeing Sherrie Levine', *October*, no 67, Winter 1994.

40. Sherrie Levine, cited in (ex cat) *Sherrie Levine/Matrix 94*, Wadsworth Atheneum, 16 April—21 June 1987 (np).

41. Krauss, 'Bachelors', in (ex cat) *Sherrie Levine*, Mary Boone Gallery, New York, 9 September—14 October 1989 (np).

42. Ibid

43. Richard Prince notebook, c. 1980, cited in Lisa Philips, 'People Keep Asking: An Introduction', in (ex cat) *Richard Prince*, Whitney Museum of American Art, New York, 1992, p 25.

44. Ibid, p 27.

45. Ibid, p 28 (Richard Prince, un-published typescript, 'The Closest Thing to the Real Thing, 1982); and ibid, p 27.

46. Jim Lewis, 'Oustide World', in *Richard Prince*, op cit, p 61

47. Paula Marincola, 'Stock Situations/Reasonable Facsimiles', in (ex cat) *Image Scavengers: Photography*, Institute of Contemporary Art, Philadelphia, 8 December—30 January 1983, p 25. The idea of spectral self-haunting appears to be Levine's. C Carr notes that '[Levine] likes to think of [her twenty drawings after Schiele and Malevich, transferred via transfer paper and retouching, exhibited in *1917* at Nature Morte in 1984] as ghosts of ghosts', 'The Shock of the Old', *Village Voice*, 30 October 1984, p 103.

48. See 'Barbara Kruger: Words and Pictures', interview with Jeanne Siegel, *Arts Magazine*, vol 61, no 10, June 1987, pp 17–21.

49. Jim Lewis, 'Oustide World', in *Richard Prince*, op cit, p 65.

50. See Paul Foss, 'Mammon or Millennial Eden: Interview with Imants Tillers', *Art & Text*, nos 23–24, p 126.

51. See eg Sue Cramer (ed), *Postmodernism: A consideration of the Appropriation of Aboriginal Imagery*, Institute of Modern Art, Brisbane, 1989.

52. Ibid, p 33.

53. Douglas Crimp, 'The Photographic Activity of Postmodernism', in Howard Risatti (ed), *Postmodern Perspectives: Issues in Contemporary Art,* Prentice Hall, Engelwood Cliffs, NJ, 1990.

54. See Krauss, 'Cindy Sherman: Untitled' in *Cindy Sherman, 1975–1993*, Rizzoli, New York, 1993, p 207; and Steven Melville, 'The Time of Exposure: Allegorical Self-Portraiture in Cindy Sherman', *Arts Magazine*, vol 60, no 5, January 1986, pp 17–21. For a discussion of the

implications of the untitled image in the work of Sherman, Kruger, Levine, Jenny Holzer and others, see 'On the Other Side of the Proper Name: Untitling, Anonymity, Gender, and Power', *Invisible Colors*, op cit, pp 339–48.

55. Craig Owens, 'Allan McCollum: Repetition and Difference', in *Beyond Recognition*, op cit, p 119.

56. See *Invisible Colors*, op cit, pp 340–41.

57. Hal Foster, 'The Return of the Real', in *The Return of the Real*, MIT Press, Cambridge, MA, 1996, p 146.

58. See eg, Owens, 'The Medusa Effect, or, the Specular Ruse', in *Beyond Recognition*, op cit, esp pp 192–93.

59. *Invisible Colors*, op cit, pp 342–44.

60. Barbara Kruger, catalogue statement for *Dokumenta 7*, Kassel, Germany, 1982; reprinted in *Remote Control: Power, Cultures, and the World of Appearances*, MIT Press, Cambridge, MA, 1993, p 216.

61. Kruger, 'Untitled', catalogue essay for one-person exhibition at the Mary Boone Gallery, New York, May 1987; reprinted in *Remote Control*, pp 229–30.

62. Kruger, 'Irony/Passion', *Cover*, vol 1, no 1, May 1979; reprinted in ibid, p 228.

63. Kruger, 'Job Description', 1984; reprinted in ibid, p 234.

64. Kruger, 'Not Nothing', *ZG*, 1982; reprinted in ibid, p 210.

65. Kruger, 'Job Description', op cit, p 234.

66. Kruger, 'Incorrect', 1982, reprinted in ibid, p 220. Kruger's thoughts on history are cited from the introduction to *Remaking History* (with Philomena Mariani), 1989, in ibid, p 12; and on power and appropriation from 'Quality', 1991, in ibid, p 10, where she observes how 'power can dissemble and invert lived experience, how it appropriates slogans, struggles and bodies', Kruger expressed her antagonism to binary oppositions with a consistency approaching a refrain. In a text written in 1991, but first published in *Remote Control*, she disparages 'the clichés of binary oppositions', in ibid, p 223. In 'Arts and Leisures', written for the *New York Times*, 9 September 1990, she explores the 'filters of rigid categorisations, and binary oppositions' that adjudicate the disposition of 'arts' and 'leisure' in the *Times* itself, in ibid, p 5. And in 'Untitled', 1987, 'the tired militarism of binary oppositions' are one of three conditions that 'We keep one eye on', in ibid, p 229.

67. Craig Owens, 'Honor, Power, and the Love of Women', *Art in America*, January 1983; reprinted in Richard Hertz (ed), *Theories of Contemporary Art*, Prentice Hall, 2nd ed, Engelwood Cliffs, NJ, 1993, pp 61–62.

68. Thomas Lawson, 'Last Exit: Painting', *Artforum*, October 1981; reprinted in *Theories of Contemporary Art*, op cit, p 85.

69. Ibid, p 86.

70. Ibid, p 88.

71. Ibid.

72. See Hal Foster, 'Signs Taken for Wonders', *Art in America*, vol 74, no 6, July 1986, pp 80–91, 139.

73. Ibid, fn 21, p 164.

74. Ashley Bickerton, in David Robbins (ed), 'From Criticism to Complicity', discussion between Haim Steinbach, Jeff Koons, Sherrie Levine, Philip Taaffe, Peter Halley, Ashley Bickerton (moderated by Peter Nagy), *Flash Art*, no 129, Summer 1986, pp 46–49; reprinted in Charles Harrison and Paul Wood (eds), *Art In Theory 1900–1990: An Anthology of Changing Ideas*, Blackwell, Oxford, 1992, p 1081.

75. Haim Steinbach, in ibid, p 1081.

76. Peter Halley, in ibid, p 1082.

77. Jeff Koons, in ibid, p 1083.

78. Lawson, 'Last Exit', op cit, p 89.

79. A recent interpretation of the works of Barbara Kruger by Mignon Nixon attempts to make the case for a plurality and mobilisation of image positions in her work that argues against my own understanding of them as bound up with the allures of metaphoricity. 'In order to use masochism subversively', Nixon claims, 'Kruger establishes its multiplicity, even within the constraints of stereotypical images and poses'. The middle section of her essay is sub-titled 'Pleasure in Movement'. It argues for a persuasive multiplicity in Kruger's image-making managed by linguistic shifters, masochistic/sadistic inversions, 'oscillating frameworks', (p 70), decentred speaking positions, the contingencies of spectatorship, etc. See 'You Thrive on Mistaken Identity: Female Masochism in the Work of Barbara Kruger', *October*, no 60, Spring 1992, pp 58–81. Yet the rhetoric (visual and textual) that sustains these indeterminacies is itself indeterminate, unfixed and abstracted. It is obliged, finally to refuse historical specificity and contextual particularity. Identities and subject positions, gender, sexuality, ethnicity, cannot be given, they can only be imagined, (mis)represented, and fantasised. This may be the point, but it also risks missing the point.

80. Bickerton, 'From Criticism to Complicity', op cit, p 1081.

81. The insufficiencies of the photo-text works of Kruger and others have been noted by several critics, including Thomas Lawson, whose view, cited above, is that the critical, postmodern, media-based work of the 1970s and 1980s was in general 'too straightforwardly declarative' and 'safe'. In 'Crowding the Picture: Notes on American Activist Art Today', *Artforum*, vol 26, no 9, May 1988, pp 111–17, Donald Kuspit criticises Jenny Holzer's installation for the 'Skulptur Projekte' in Munster in

1987 for its one-dimensional critique, and cautions that Kruger's image-texts fail to be 'transformative' because they look too much like the work they appropriate.

82. Bickerton, op cit, p 1084: 'After years of pulling the object off the wall, smearing it across fields in the Utah desert, and playing it out with our bodily secretions, the artwork has not awkwardly but aggressively asserted itself back into the gallery context: the space of art—but this with an aggressive discomfort and a complicit defiance'.

83. Eric Michaels, 'Postmodernism, Appropriation and Western Desert Acrylics', in Sue Cramer (ed), *Postmodernism: a Consideration of the Appropriation of Aboriginal Imagery*, Institute of Modern Art, Brisbane, 1989, p 33.

84. Michaels, *For a Cultural Future: Francis Japurrurla Makes TV at Yuendumu*, 'Art & Criticism Monograph Series', vol 3, Art & Text Publications, Sydney, 1989, pp 14, 15.

85. Ibid, fn 2, p 33.

86. Boris Groys, *The Total Art of Stalinism: Avant-garde, Aesthetic Dictatorship and Beyond*, trans Charles Rougle, Princeton University Press, Princeton, N.J., 1992. The arguments put forward here were first developed in my review, *Art & Text*, Sydney, no 45, May 1993.

87. Ibid, p 75.

88. Ibid, pp 108–9.

89. Ibid, p 111

90. Foster, 'Signs Taken for Wonders', op cit, p 139.

91. Ibid, fn 21.

92. Amelia Jones, 'Negotiating Difference(s) in Contemporary Art', in *Theories of Contemporary Art*, op cit, p 204; first published in *The Politics of Difference: Artists Explore Issues of Identity*, University Art Gallery, University of California, Riverside, 12 January—8 March 1992. In 'Appropriated Sexuality', *M/E/A/N/I/N/G/*, no 1, December 1986, Mira Schor attacks what she calls David Salle's abusive appropriation of female pornographic images.

93. Krzysztof Wodiczko, 'Public Projection', *Canadian Journal of Political and Social Theory/Revue canadienne de théorie politique et sociale*, vol 7, nos 1–2, Winter/Spring 1983, p 187.

94. Sylvère Lotringer, 'Third Wave: Art and Commodifiaction of Theory', in *Theories of Contemporary Art,* op cit, pp 98–99; first published in *Flash Art*, May/June 1991.

95. Ibid, p 99.

96. Allan Sekula, 'Dismantling Modernism: Reinventing Documentary (Notes on the Politics of Representation)', *The Massachussetts Review*, vol XIX, no 4, December 1978; reprinted in Allan Sekula, *Photography Against the Grain: Essays and Photo Works 1973–1983*, The Press of the

Nova Scotia College of Art and Design, Halifax, Nova Scotia, 1984, p 57 and passim; the phrase, 'liberal obfuscation' is Sekula's, p 55.

97. Benjamin Buchloh, 'Since Realism There was... (on the current conditions of factographic art)', in *Art & Ideology*, The New Museum of Contemporary Art, New York, 1984, p 10.

98. Sekula, 'Dismantling Modernism', op cit, p 55.

99. Bruce W Ferguson, 'Patterns of Intent', *Artforum*, vol 30, no 1, September 1991, fn 1, p 98.

100. Bojana Pejic, 'Openings: Maria Eichom', *Artforum*, vol 30, no 1, October 1991, p 120. Pieces discussed here include *Wall Writing (Wandbeschriftung*, 1990) and *Whitened Room with View out of the Window* (1991).

101. Eric Troncy, 'No Man's Time', *Flash Art*, November/December 1991; reprinted in *Theories of Contemporary Art*, op cit, pp 245, 248.

102. Ibid, p 248.

103. 'Spectacular Optical' took place at Thread Waxing Space, New York, 28 May—18 July 1998, and travelled to the Museum of Contemporary Art, North Miami October—November, 1998, and CU Galleries, University of Colorado at Boulder Fall 1999; the catalogue, with essays reprinted from Slavoj Zizek, Jean Baudrillard, Kathy Acker and others was published by TRANS arts.cultures.media and Thread Waxing Space.

104. See Aperture (Special issue: 'Dark Days: Mystery, Murder, Mayhem'), no 149, Fall 1997.

105. See Mark Selzer, 'Wound Culture: Trauma in the Pathological Public Sphere', *October*, no 80, Spring 1997, pp 3–26.

106. Tom Vanderbilt, 'When Animals Attack, Cars Crash and Stunts Go Bad', *New York Times Magazine*, 6 December 1998, p 50.

107. Ibid, pp 52, 54.

108. Ibid, pp 95, 97.

109. Tricia Collins and Richard Milazzo, *Hyperframes: A Post-Appropriation Discourse*, vol 2, Editions Antoine Candau, Paris, 1990, p 6.

110. Ibid, pp 63, 103, 102.

111. Ibid, p 66.

112. Collins and Milazzo, *Hyperframes*, vol 3, 1991, pp 44-45, (authors' xerox copy/mock-up).

113. Ibid, p 70.

114. Ibid, p 63.

115. Dan Cameron, 'A Conversation: a Salon History of Appropriation with Leo Castelli and Elaine Sturtevent', *Flash Art* (International Edition), no 143, November/December 1988, p 77.

116. 'Pre-Pop Post-Appropriation' was at the Stux Gallery, New York, in collaboration with Leo Castelli, 3 February—4 March 1989. For a dissenting view of Collins and Milazzo's critical logic, see David

Rimanelli's review in *Artforum*, vol 27, May 1989, pp 150–51, which concludes that the shift from the late 1950s to the late 1980s was based on a 'reactionary' recoding.

117. Collins and Milazzo, 'Pre-Pop Post-Appropriation', Stux Gallery, New York, 1989, np.

118. Thomas McEvilley, 'Enormous Changes at the Last Minute', *Artforum*, vol 30, no 2, October 1991, p 87. McEvilley claims that the most important event of the 1980s was 'the opening up of the concept of art history to a global scale'.

119. Jean Fisher, 'An Art of Transformation', in (ex cat) *Rasheed Araeen*, Fukuoka Art Museum, 1993, p 12; cited by Guy Brett in 'Abstract Activist', *Art in America*, vol 86, no 2, February 1998.

120. Erin Valentino, 'Coyote's Ransom: Jaune Quick-to-See Smith and the Language of Appropriation', *Third Text*, no 38, Spring 1997, pp 28, 32.

121. Okwui Enwezor, 'Social Grace: the Work of Lorna Simpson', *Third Text*, no 35, Summer 1996, pp 43–48.

122. Donald Kuspit, 'European Sensibility Today' in Richard Hertz (ed.), *Theories of Contemporary Art*, op cit, p 121; originally published in *New Art International* (1990).

123. The genealogy of YBA is traced by Simon Ford in 'The Myth of the Young British Artist', in Duncan McCorquodale, Naomi Siderfin and Julian Stallabrass (eds), *Occupational Hazard: Critical Writing on Recent British Art*, Black Dog, London, 1998, pp 130-41.

124. Lynn MacRitchie, 'Their Brilliant Careers', *Art in America*, vol 84, no 4, April, 1996, p 132.

125. For a rehearsal of this position, see Peter Suchin, 'After a Fashion: Regress as Progress in Contemporary British Art', in *Occupational Hazard*, op cit, pp 94–110.

126. See Matthew Arnatt, 'Another Lovely Day', in ibid, pp 45–50; my citations are from p 49.

127. Martin Maloney, 'Everyone a Winner!: Selected British Art from the Saatchi Collection, 1987-97', in *Sensation: Young British Artists From the Saatchi Collection*, Thames and Hudson, London, 1997, pp 26–31. The exhibition was put on at the Royal Academy of Arts, London, 18 September—28 December 1997.

128. John Roberts in 'Livin' it Large', in S Eibmayr (ed), *Zonen der Verstörung/Zones of Disturbance*, Stierischer herbst, Graz, 1997, p 37.

129. Ibid, p 29.

130. According to Roberts in 'Livin' it Large', ibid, the characteristics of the new anti-intellectualism of 'a generation who have come [sic] to reject the interventionism of critical postmodernism' (p 33) include forms of 'post-conceptual disregard' (p 33), and 'a self-consciously restricted range of critical expectations and cultural references' (p 34). Tracy

Emin, for example, is viewed as a 'disenchanted post-conceptual artist' who identifies 'with the perceived "authenticity" of the non-specialist and non-professional' especially in casual popular cultures (p 34).

131. MacRitchie, 'Their Brilliant Careers', op cit, p 84.
132. Ibid.
133. Roberts, 'Livin' it Large', op cit, pp 34, 35.
134. Julia Kristeva, 'Interview with Catherine Francblin', *Flash Art*, no 126, February–March 1986, pp 44–47.
135. See Thomas Crow, *Modern Art and the Common Culture*, Yale University Press, New Haven, 1996. Cohen's theories are highlighted in Marcia E Vetrocq's review of the Crow, *Art in America*, vol 86, no 3, March 1998, pp 37–41.
136. Jerry Saltz, 'Mis-Appropriation', *Arts Magazine*, vol 64, April 1990, p 21.
137. Ibid, p 21.
138. See David Joselit, 'Poetics of the Drain', *Art in America*, vol 85, no 12, December 1997, pp 64–71.
139. Virginia Rutledge, 'Ray's Reality Hybrids', *Art in America*, vol 86, no 11, November 1998, p 142.
140. Charles Ray, 'Anxious Spaces', interview with Robert Storr, *Art in America*, vol 86, no 11, November 1998, p 143: 'All my worst qualities are there—like grandstanding, sensationalism, showing off a little—but they are a counterpoint to the work's best qualities, like the complexity of the form and the quiet artistry'.
141. Rutledge, 'Ray's Reality Hybrids', op cit, p 143
142. Charles Ray, 'Anxious Spaces', interview with Robert Storr, op cit, p 143.
143. Art & Language, 'Moti Memoria', in John Roberts (ed), *The Impossible Document: Photography and Conceptual Art in Britain*, 1966–1976 Camerawork, London, 1997, p 61.
144. Roberts, 'Livin' it Large', op cit, p 37.
145. Interview with John Miller in William S Bartman and Miyoshi Barosh (eds), *Mike Kelley*, Art Resources Transfer, New York, 1992, p 7.
146. For details see Marsha Miro, 'Mike Kelley destroys all art preconceptions', in *Destroy All Monsters: Geisha This*, [compilation of the first six issues of *Destroy All Monsters* magazine 1875-79], ed Cary Loren, Oak Park, Michigan, Book Beat Gallery, 1995, np; interview with John Miller, op cit; and Mike Kelley, 'Some Aesthetic High Points' (1992), in *Mike Kelley*, Los Angeles, Art Resources Transfer, 1992.
147. Interview with José Álvaro Perdices, 'My Universal System is a Dystopian One', *Sin Título*, No. 5, 1988, Centro de Creación Experimental, Cuenca, Spain, p 22.
148. See interview with John Miller, op cit, p 19, where Kelley explains that he was 'trying to put all the things into them [his 'arrangements on the blankets'] that I felt Haim left out of his [works]'.

149. DW Winnicott, 'Transitional Objects and Transitional Phenomena' (1951), in *Through Paediatrics to Psycho-analysis*, Basic Books, New York, 1975, p 229.

150. Mike Kelley and Julie Sylvester, 'Talking Failure', *Parkett*, no. 31, 1992, p 100.

151. Winnicott, 'Transitional Objects', op cit, pp 232–4, 242.

152. Georges Bataille, 'The Psychological Structure of Fascism', in *Visions of Excess: Selected Writings 1927-1939*, ed Allan Stoekl, trans. Stoekl, with Carl R. Lovitt and Donald M. Leslie, Jr., University of Minnesota Press, Minneapolis, 1985, p 143.

153. Thomas Kellein, 'Mike Kelley/Thomas Kellein: A Conversation', Cantz Verlag, Stuttgart, 1994, p 15

154. Ibid, p 139.

155. Mike Kelley, *We Communicate Only Through Our Shared Dismissal of the Pre-Linguistic* (1995), case no. 2, 'John P'; reprinted in *Mike Kelley*, Phaidon, London, 1999, p. 132.

156. 'The Poltergeist: A Work Between David Askevold and Mike Kelley', Foundation for Art Resources, Los Angeles, 1979.

157. Jeff Gibson, review of 'Primavera 1996', at the Museum of Contemporary Art, Sydney, 1 Sepember—1 December 1996, *Art & Text*, no 56, February/April 1997, pp 92–93.

158. Joshua Decter, review of 'The Age of Anxiety', at the Power Plant, Toronto, *Artforum*, vol 34, February 1996, p 90.

159. Félix Guattari, *Chaosmosis: An Ethico-Aesthetic Paradigm*, trans Paul Bains and Julian Pefanis, Indiana University Press, Bloomington, 1995, p 117.

160. Paul Virilio, *The Lost Dimension*, trans Daniele Moshenberg, Semiotext(e), New York, 1991, p 36.

161. See Foster, 'The Crux of Minimalism', in *Individuals*, op cit; a modified version appears as Chapter 3, in *The Return of the Real*, MIT Press, Cambridge, MA, 1996.

162. Crimp, 'The Photographic Activity of Postmodernism', in Howard Risatti (ed), *Postmodern Perspectives: Issues in Contemporary Art*, Prentice Hall, Engelwood Cliffs, NJ, 1990, p 136.

163. Ibid, p 139.

164. Clifford Geertz, *Works and Lives: The Anthropologist as Author*, Stanford University Press, Stanford, CA, 1988, p 16.

165. Kruger, *Remote Control*, op cit., p 231.

CHAPTER 1
Photographies, Counter-revolution and Second Worlds: Allegories by Design, 1989

This is the first of a two-part meditation on the making and reception of photographies in the USSR at the end of its history.[1] My points of departure are two exhibitions of photographic and related material staged in the late summer and autumn of 1989, immediately before mass protests and Party resignations shattered the political status quo of Eastern Europe. These exhibitions focus my discussion of the crisis and re-imagination of both state and 'private' productions of photographic knowledge in the USSR. In Chapter 2, I look at wider issues in the understanding of the post-totalitarian visual field—problems of avant-gardist visuality, of public visual space, of the Western and non-Western televisualisation of social change, and of the representation of sexuality.

The historical moment in which the exhibitions were staged is crucial. Late 1989 was the heyday of *glasnost*, the very last period in which it still seemed possible that the political mechanisms of the USSR could be opened out on the basis of a liberalised, capitalised, but still Party-based and centripetal model of Socialist polity. It would be nearly two years before the *putsch* of August 1991 precipitated the final dissolution of both Party and Union. Late 1989 was both the final moment of fullness, and a nostalgic point of failure in the imagination of Gorbachevian reformism; a time when the political and representational practices of the Soviet Union were being stretched to their limits, but had not yet cracked or fallen. I begin, then, in the historically poignant hiatus immediately before the onset of an entropic tailspin in the project of universal Socialism.

Sketching something like an archaeology of this recent past, I am concerned with the cultural and institutional conditions of possibility for a set of representational practices that deferred neither to the dominant constructions of Western theory/practice, nor to the emergent counter-centrist discourses of the 'Third World'. This will lead to a consideration of what I want to call *the second-sites of difference*.[2] In the domains of Soviet photography, visual art and exhibition practice during the years around 1989, there is much that needs to be forgotten and much that must be re-articulated. Western articles and reports on this moment of profound social and cultural transition have tended in the main to colonise, appropriate and package the art of *glasnost*. They have tagged it with Western European or American art labels, offering a capital bridge for the accreditation of erstwhile despised and unmarketable Socialist Realism and its parodic aftermath, egregiously seeking out 'the new' in the great 'lost' metropolises of Europe. Citizens who read Deleuze have been found (or invented).

In Moscow and other capital cities of the former Union, the invisible high-priests of postnational culture were administering the last rites to the late modernist avant-garde. Eagerly assisted by the (understandable) contrivance, in various forms, of Russian artists and photographers, they were backed by the dubious resources of a new class of cultural managers who made perhaps the most obvious mark on the day-to-day cultural life of urban Russia at the end of the 1980s.

Amidst the resultant spectacle of purportedly buoyant mercantilism, however, there is a somewhat neglected social context; one fraught with cynicism, opportunism and sheer material deprivation, which in my view overwhelms the uncritical avant-gardist narratives of the Western press. Artists have been visited, spot-lit and formally appraised, 'movements' and 'tendencies' discerned, the relatively few group exhibitions found and reviewed. Yet the arbitrariness and groundlessness of these forays is everywhere revealed by a poverty of understanding that fails either to account for their historical production or adequately assess their place in the dense and tangled network of 'returns' that characterise the last Soviet moment. Assisted by its sheer market and media power, Western criticism has attempted doubly to appropriate late- and post-Soviet image production—first, by literally taking it over; and, secondly, by imagining that a filament of appropriationism secures Soviet representation to its ideological past according to Western-style logic. In what follows, I dispute the historical and theoretical assumptions that predicate both of these appropriative paradigms.

As Soviet culture was unevenly released from the Stalinist cultural blockade of the 1930s, the late 1980s spawned a diverse assemblage of practices. Some were glimpsed, though seldom fully visible, in the flicker of the Soviet 1960s, but most had never really had their day. In 1989 we are witness to a barrage of abstractions, figurations, parodies, erotica, performances and conceptualisms that weave in and out of an intermittently discerned Western art history and across the margins of an even more sparsely documented Soviet cultural and political past.

Instead of reporting on individuals, or attempting to bundle them together under the rubric of an 'avant-garde', I want to examine the contents, selection and display policies, and the larger social context of two exhibitions. The first was an 'official'—or semi-official—show offering important insights into the structural changes that took place in the cultural policy of the Soviet Union: 'The Age of Khrushchev', installed in The Central Palace of Youth (Komsomol), Komsomol'skiy Prospekt, Moscow and running from August to September 1989. The second, discussed in Chapter 2, was one of several internationally circulated exhibitions that attempted to intervene in the generic reconstruction of Soviet and post-Soviet art and documentary photographies.[3]

The Khrushchev Allegory

For Western viewers, exhibition-going in Moscow involves a certain loss, for we are offered significantly fewer bearings than in the exhibition systems of Europe or the US. The material displayed is differently staged, differently framed, differently received and takes its place differently within the constitution of the metropolitan social fabric. Yet our disorientation prompts important questions: how does a contemporary, large-scale, late-Soviet exhibition produce its meanings? How does it signify in different ways here from there? In what, precisely, does its difference from a Western 'blockbuster' consist? And what kind of knowledge can we gain in—and out of—the West from such interrogations? I want to begin with an interpretative reconstruction of 'The Age of Khrushchev', presented as a tour around it. The exhibition lends itself to such discussion as its modular organisation and curatorial strategies were developed as an allegorical hybrid of revisionary history, social nostalgia, national self-affirmation and informational sponsorship. Unlike an 'art' exhibition staged in the West, 'The Age of Khrushchev' was arranged not around artists, their significant works and related documentation, but as a sequence of historical nodes and thematic clusters whose contents and structures were threaded together as a subtle cultural commentary on the achievements of Soviet reformism.

Consider this: a modular aluminum grid lit by two angle-poise lamps fronts a grainy, elongated, black and white photograph of Nikita Sergeyevich Khrushchev declaiming at a podium before the Supreme Soviet. In the months following, Khrushchev will replace Bulganin as Premier (1957) and take upon himself the headship of both State and Party. Behind the assembled representatives in the photograph is an out-sized statue of Stalin, his hand cupped, his legs locked in a pseudo-Hellenistic forward gait, his head angled and slightly uplifted. Khrushchev rests his hands wide apart on the lectern and leans into the microphones. The delegates strike the accustomed poses of ranking bureaucrats at their business. At the base of the photo-tableau (which is loosely tied with string to the pristine, moulded aluminum) is a triangle of white plastic exhibition material rising six inches from the floor like a giant step. On it, sheets of broken glass overlay the yellowing front pages of *Pravda* from 1956 and 1957, headlined with denouncements of Stalin, the Stalinist regime and Stalin's political acolytes. Around the apex of the triangle are miniature statues of Stalin, lying chipped and prone; one is lassoed around the head and hung from an aluminum girder, another is balanced on one of the dictator's severed arms. Stalin's body-parts are interspersed with scattered nails and twine, and sit in an irregular brocade of what looks like designer scuffmarks.

Or consider the widened corridor space separating the two antechambers of the exhibition, which offers a selective resumé of the

Stalinist epoch from the early 1930s until his death in 1953. We become surrogate tenants relocated amid the ragged domestic appurtenances of a mid-century Muscovite apartment: underfoot is a tattered fringe of standard carpet; we look over to grimy acanthus wallpaper (read: the squalour of domesticated neo-classicism); stained washbowls (signifying the indeterminacy or absence of water-flow) and junked wooden cabinets; we cook on a stove that has barely made it beyond the primus; we look at ourselves in a tarnished mirror set under a strangled light bulb. We dwell in a cove of un-mod-cons. The space is 'decorated' with a twig lodged in a soup-pot, a black and white nuclear family snapshot, and a brownish *grisaille* head-and-shoulders image of the benign Leader, referred to in this posture as Soso (Stalin's diminutive). An unpainted wooden window gives onto a backlit photograph of one of the seven Stalinist *pirok* ('wedding-cake') mid-rises that framed the urban panorama of mid-century Moscow.

A different coefficient of modernity is present throughout the exhibition in the form of an aluminum entablature, though it is minimized to a few out-of-the-way, light-bearing brackets. The 'look' and effect of the installations and their design quotients are evasive. In Western terms (that historically, of course, have no place) we might say that Ed Kienholtz meets Ilya Kabakov under the semi-official auspices of the state in an astonishing project that emblematises the un-Socialist reality of everyday life by simulating it as it was. Nostalgic realism substitutes for the Real of Socialism, now forever on hold in a phantasmal past.

Adjoining this 'preamble', the main body of the exhibition opens into a spacious hall. Iterated images of the death and deprivation of the pre-1953 years give way to literal and allegorical representations of social, political and cultural reconstruction; and to the first appearance of a 'new world' of multiple colours after the symbolic ubiquity of black, white and red. We are bathed in the glimmer of a new moment of internationalism, openness and expectation that is imaged around us in a plenitude of affirmatory documentations, reconfiguring the stark, alienated anonymity of the mid-century Soviet through the calculated provision of a glowing nimbus of historical optimism. The photographic effect is efficiently transformed from a fragment of communal death to a gloss on life in the future perfect.

The archival photographs we encounter offer an exuberant, polychrome St Basil's, glittering in the afternoon sun; a vaguely smiling conference of women tractor-drivers; a candid shot of students at a lecture, attentively leaning forward, sporting wrist-watches and paisley shirts; an image of mass-gymnastics so angled that it undermines the expected messages of order, symmetry and uniformity; people with suitcases in unobstructed transit; dozens of bird's-eye views of wooden nineteenth-century Moscow shanties passively giving way to the faceless geometries of modernist urban renewal; bridges, hairdressers, children beaming on their potties, the Melbourne

Olympics, a snatched kiss. The photographic register is soft *LIFE*. This is the Soviet 1960s, organised obliquely to simulate, if not explicitly to vie with, the American age of Pop.

In the complex political scenography that supersedes these upbeat generic indices of people and places, the archival Khrushchev is incessantly returned as the demiurge of Soviet internationalism. Alongside Nasser, sitting with Eisenhower, chatting with Pittsburgh steelworkers, posing with Nixon in 1959: a whole galaxy of inter-territorial moments subtends Khrushchev's accumulation of the credentials of world diplomacy. These are some of the captions of the day: 'Khrushchev thanks an Indian peasant for his gift of a table' (1960); 'Roswell Garst falls in an attempt to throw a cornstalk at newsmen' (during Khrushchev's visit to Garst's farm in Iowa, part of his 1959 trip to the US)

The repetitious language of the Soviet leader's various poses (of attention, studied informality etc), which catch those thousand interludes between 'events'—and define the very project of photo-journalism—is relatively unencumbered by the formal and dramatic concern of Western magazine photography for the unusual, the unitary or the untoward. For the Western viewer, this results in one of many powerful disorientations. There is almost no arena in the West in which an assemblage of contextually and photographically uninflected images can be reconvened (not in the newspaper with its field of separated singular images, nor in the museum exhibition with its curatorial accent on difference and sensation). The effect of this repeated grid of normative scenes, therefore, is to engender a kind of seductive factography—a strong fantasy-image of the political real that paradoxically out-manoeuvres the slicker, speedier sequences of cathartic actions that circulate in the West. In the midst of this particular effort of real politik, then, the theatrical connotations of the famous incident at the United Nations in 1960, when Khrushchev pounded a lectern with his shoe during a speech by the Spanish delegation[4] (graphically imaged in the show), are readily deflected to the service of righteous indignation. The moment of unconstructed passion is not lost in a garland of constructed flourishes.

The remainder of the Khrushchev-era show was organised in half a dozen thematic booths and cul-de-sacs, which radiated from a modest central repository of Soviet industrial effects culled from the turn of the 1950s: a bicycle with a put-put engine, a dinosaur gramophone, sundry plastic radios and an oversized TV unit with minuscule screen and *in situ* magnifying glass. These unseductive commodities constitute the allegorical as well as the literal centre of a highly coded exhibition: in the second age of openness (Gorbachev's *glasnost*) there is the hope (if not the assurance) of a repetition, or rather a delayed realisation, of the production values of the first (Khrushchev's semi-Socialist 1960s).

The booths re-presented both the totems and taboos of social life in the

USSR under Khrushchev. The 'Kosmos' section featured a doggie oxygen tank and space suit; and a real (stuffed) space dog (the much-beloved Strelka) staring at a model sputnik. Yuri Gagarin was imaged as the darling of a hundred official space fêtes, and the first woman astronaut (Valentina Tereshkova) confirmed as a runner-up star in the implied domestic space race—ranked somewhere, the chronology seemed to suggest, behind both man and dog. All the booths contained objects, documents and 'arrangements', but none were presented with such bravura as the heap of junked icons that held the middle ground of the 'religion' compartment.

Stalin Pantocrator

Against what official, historical modes of photographic representation is the Komsomol exhibition articulated? And how can we measure its distance from the orthodox modalities that are parodically laid out in the show's complex structure-as-commentary? Such questions demand specific attention to the many forms of public photographic display deployed by the Stalinist Soviet (and by Stalin's successors up to and including Gorbachev). These include the informational exhibition; the political iconography of the public photo-portrait (whimsically interrogated in the work of Vassili Kravtchouk, see below); the dissemination of photographs in the 1930s 'carnivals'; illicit, private or amateur photographs; and the circulation of photographic images published by the State-controlled presses and appearing in official newspapers, journals and other publications. Each of these appearances has its particular economy of production and reception, though all, of course, were intended to reflect the will of the Party-State. In order to think through the political saturation of visual signs in the USSR, I will outline the shape and implications of one genre of Party-State-sanctioned photography represented by *Sovetskoe foto iskusstvo* (*Soviet Art-Photography*), a photo-album published in Moscow in 1939 on the occasion of the 100th anniversary of photography in Russia/USSR (1839–1939).

Prefaced by photographic portraits of Lenin in 1919 and a paternal Stalin (lighting his pipe) in 1936, *Soviet Art-Photography* convenes some 68 photographs by 36 named photographers. Only three photographs are dated, two to 1936 and one to 1935. The album is an image repertoire produced on behalf of the Stalinist political machine at the moment of its most intense social repression—forced collectivisations, ethnic relocations, political and ethnic purges. The photo-album is concerned to organise an affective sequence of decontexualised or otherwise socially subdued images that insistently signify the mythological well-being of the system whose products and achievements they celebrate—the exemplary personalities and concomitant social benevolence of the USSR's Party-State apparatuses. (The typology of these images later helped to construct a photographic discourse of humanitarian universalism in the West, which found its most visible forum in

the internationally touring exhibition 'Family of Man', 1955.)[5] The repertoire is, of course, rigorously limited, although, at the same time, it can enfold strange nuances. Let me unfurl this scroll of archaic Socialist representations.

There is the leader (often caught at a moment of benign-seeming leisure); the spectacle of mass affirmation (the rally, the anniversary, the parade); the heroic persona of the over-productive worker (cotton-picker, miner, pilot); the staged political scenario of convivial well-being (happy balloters, the allegorical season); athletic health and diverse ethnic contentment (swimmers, the drummer for the Central Asian Collective Farm, sundry regional physiognomies); images of work and the workplace (bucolic or mechanised pastures, factories suffused with pseudo-Baroque

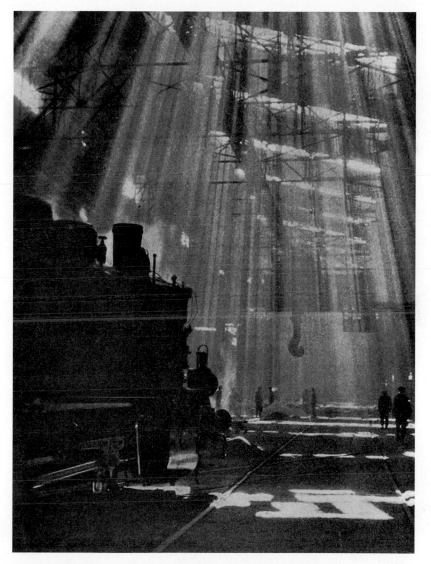

Artist unknown, *Sun Plant,* from the album *Sovetskoe foto iskusstvo* (*Soviet Art Photography*), 1939

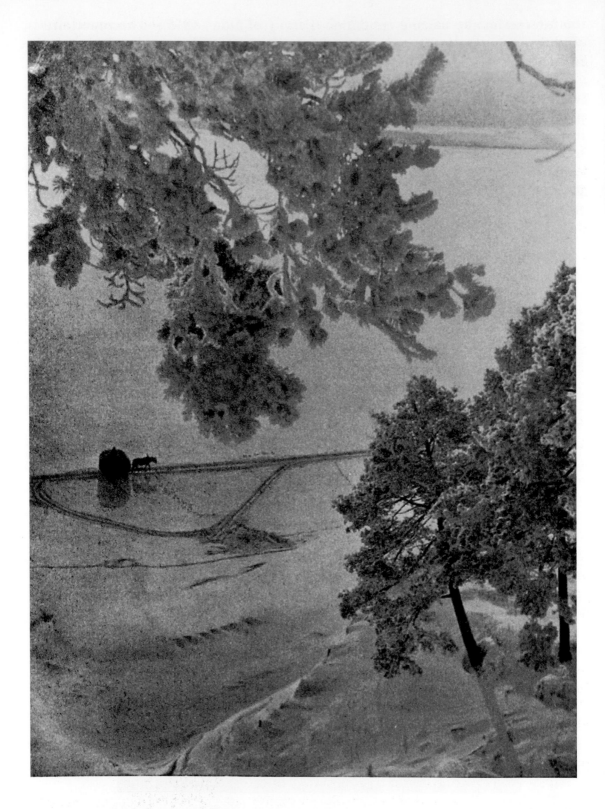

A. Skurikhin, *Winter,* from the album *Sovetskoe foto iskusstvo* (*Soviet Art Photography*), 1939

luminescence); occasional lyrical effusions (calendar-style snowscapes, an off-duty romantic pose); concrete achievements (the Moscow-Volga Canal, the Stalinist mid-rise); neo-bourgeois tableaux (the concert, the music lesson); military photo-compositions (planting the flag, reconnaissance in the Pamir mountains, soldiers in rank); and a slew of would-be innocent, cloyingly sentimental photographs of children and motherhood to round off the album.

This inexorable sequence returns a world imaged through the censored indulgences of totalitarian fantasy. The parameters of the dream are territorial (nothing can be imaged outside of Soviet culture, either geographically or historically); ideological (nothing can be imaged that militates against the 'truth' of the *doxa*); and utopian (nothing can be imaged that does not somehow suggest the inevitable construction of a happy future).

The Exhibition as Political Design

Set out, as they must be, against the 'control photography' of a Stalinist orthodoxy that is both literally and figuratively present in the show—but also transposed, as we shall see, into pictorial value—the contents and structure of the Khrushchev exhibition pose some disturbing questions to received ideas about the public display of images and texts in the West. For, what is experimental or avant-garde at Komsomol is not the material itself (even in the oblique, attenuated section devoted to the film, music and visual art of the 1950s and 1960s), but the actual mode of its presentation. The coloured backdrops, display units, and uncommentaried constructions and installations are visible carriers of allegorical texts and subtexts indicating that even in 1989, the USSR was still a culture of dissimulation and vigorous intimation. In the West, by contrast, even a gallery installation will not normally be 'interfered with' by its own environment: the culture of the 'white cube' has not really been supplanted even by work that explicitly challenges the art-frame itself, let alone in the 'official' domain of the corporate museum. Put another way, Western modernism has always had a tacit pact with the curator/dealer such that the organisation and display of art is neutral and deferential to the object-as-commodity.

But we are not comparing like with like. The Soviet exhibition is not an art exhibition. The conventionally defined art works it presents are for the most part a sequence of execrable sub-realist oils—of a Stalinist banquet in the preamble; of Brezhnev at the end; of happy urban construction in the 'Arts' section. There are also a couple of Western-style, 1950s abstractions, along with a bronze sculpture in the 'Kosmos' section that binds a slightly distorted cosmonaut in a geometric frame. Elsewhere, the typology of art practice is subordinated to the content level of the dominant photographic discourse, and re-registered as a function of the design ensemble.

To gloss this somewhat elusively mediated set of 'art' references encoded in the exhibition's photographs, we can conclude that they are focused on the

cautious but implicit identification of Khrushchevian reformism with the archetypal morphology of modernist experiment. This is figured most insistently in Khrushchev's grave monument by Ernst Neizvestny, in which a portrait bust of the Soviet leader is locked in a tessellation of geometrically shaped blocks. An image of the monument constitutes the finale of a sequence of funeral photos. But this subtextual identity is also fostered by the geometric design elements in the exhibition's Stalinist anti-monument (described above), and in the culminating installational gesture of the show (set up as a kind of coda to match the constructions of the 'preamble'), which pits a photograph of Khrushchev framed between a red square and two black triangles, against a gaudy portrait of Leonid Brezhnev strangely mounted on a backdrop of raw canvas. Canvas, painterly realism, visual pomp and ostentation are revealed as backward and decadent when measured by the finer modern standards of semi-candid reportorial photography and the functional linearity and overt internationalism of modern design.

The photographic material that dominates the exhibition consitutes another crucial issue in its unusually intricate, message-bearing apparatus. As already noted, this material can adequately be defined as neither 'art' nor 'documentary' photography, at least, not as these terms are understood in the West. It is emphatically a photography of the press, yet not one that would find a place in the Western photo-journals of the 1950s and 60s. The Soviet press images lack the dramatic specificity of the *LIFE* tableau or the vivid aura of reportorial presence that informed the Vietnam era.[6] They have, instead, the mannered quietism of the provincial newspaper; and for the most part they bracket the photographic in a desire to promote the confined situational dramas of their iterated protagonist. Yet Khrushchev is at once at the centre and the periphery of the photography that represents him. It is the moment of India, the place of Cuba, that is the real subject—or rather their subject is the exemplification of political internationalism in particular situations. This may make the exhibition's primary field of signification sound rather dull and unpromising, but the sequences of such thematically associated images elicit from Western viewers a peculiar alienation from their normative expectations of 'aesthetic' or dramatic focus. There transpires, in fact, a peculiar negotiation in and out of the cult of the leader; a hollowing out of a (modernist-derived) drive for the unitary exaltation of form, a concomitant stopping-up of the authorial voice and a reorientation toward the factography of political dissemination.

We have no equivalent for such an exhibition in the West. Its nearest relative might be found in the kind of interested political self-representation undertaken by the circulating exhibitions of government agencies such as the United States Information Agency. Yet such a similarity is superficial for several reasons. Most important is the fact that a USIA show is explicitly

constructed in order to export a particular image of America. Accordingly, its contents thrive on the evacuation of context necessitated by its reception elsewhere. As we have noted, however, the reception of the Komsomol exhibition functions in reverse. It engenders an evacuation of aesthetic value and dramatic specificity, yet is consumed by a visiting public whose social history has been intensively produced precisely across the scene of the exhibition—more intensively and ideologically produced, perhaps, than the West can imagine from under its panoply of infinite simulacra.

We have moved from an outline of the complex allegorisation of Khrushchev, through a reprise of the Stalinist power-cult, to an understanding of the exhibition as political design. In fact, we have confronted a moment of photo-social circulation in *glasnost* that might be termed 'hyper-allegorical'. Remembering that a specific deployment of allegory-as-propaganda was already a defining feature of the high Socialist 1930s,[7] the annexation and redeployment of allegorical strategies bears witness to a sophisticated expansion of the political instrumentality of the Party-State. In a sense it offers a reversal of the allegorical internality of the Socialist Realist image, which was predicated on the vigorously enframed allocation of sanctioned messages that were socially relevant, typical, and visibly didactic. This is allegory as transparency. Each of its motifs, suggestions, referents, is caught in a manipulative field so simultaneously nuanced and exact that anything sanctioned could signify the Socialist Truth, yet at the same time, could be reproduced as deviant. At Komsomol, allegory functions as a peripheral, decodable opacity, for it is design, context, structure and social exteriority that are the bearers of allegorical information.

Allegory here is an explosive reconjugation of historical memory with a deep imagination of unknowable change. It springs from a political futurology that knows only a traumatic past and the utopian modernist present. It is an allegory so fine it opens itself to a destiny that for once the Master-Allegoriser does not control—one that for the first time is not already known. I want to suggest that there is an empowerment in this hyper-allegorical space, even though much of its social identity was constructed in the passage of a totalitarian past. Encoded in the Khrushchev exhibition is a way of bearing the political into the everyday, and connecting the cultural with the social, that the West does not and cannot know. The factors fuelling the pressure of these enjoinings are unfortunate: they are grounded in the controls and vivid oppressions of the Party-State. But this residual history offers a glimpse of how what was once a terror might be made over into a liberatory space for collective identities, rather than collapsed into an abject imitation of 'free-market individualism'. The exhibition is a complex machine for the adjudication of the political past and the negotiation of a social future. By now, time has told against such reinventions. Perhaps they were only possible as an unwitting nostalgia born from the very special conditions of

1989. Certainly, when the West's exhibition system takes on the generic construction of late-Soviet photographic identities, everything that was powerful and challenging at Komsomol is effortlessly dissolved. Impelled by the Western will, all the strengths in a fading tradition come forward from within the images themselves. All that is 'designed' merges with the understanding of First-World history. For, as we shall see in Part II, the everything that is the context is the West.

NOTES

1. This chapter brings together material researched during the last decade. Parts of it have been published in the US, France and Australia: 'Glasnost Revelations', *Art International*, no 9, Paris, Winter 1989; 'The Photograph in Power', *Arts Magazine*, vol 64, no 8, New York, April 1990; review of Boris Groys' *The Total Art of Stalin: Avant-garde, Aesthetic Dictatorship and Beyond*, trans Charles Rougle, Princeton University Press, Princeton, 1992, in *Art & Text,* no 45, Sydney, May 1993. Preliminary efforts to conjugate my interest in Soviet and post-Soviet photographies were published as 'Photography, Glasnost and the State: the Historical Margin East/West', in a special issue of *Agenda*, Melbourne, December/January 1992/93; and in 'Photographies, Counter-Revolution and Second Worlds, Part I: Allegories by Design', *Third Text* no 27, London, Summer 1994; and 'Photographies, Counter-Revolution and Second Worlds, Part II: Releases and counter-appropriations' *Third Text* no 31, London, Fall 1995.

2. This section was originally written just before the events of autumn 1989 in Eastern Europe. The second section, however, which takes as its point of departure the Western-curated exhibition of photographs, 'An Insight into Contemporary Soviet Photography' (see note 3, below), pays close attention to the powerful implications of these events. I have not modified section 1 because the particular divisions now maintained between the Soviet experience of *glasnost* and the massive and sudden social and political deregulations in Eastern Europe are not inappropriately signalled by this transition. The cultural sector of Moscow, for example, was as much a spectator in respect of mass demonstrations in the Eastern European theatre as its counterparts in New York or Los Angeles. What had happened, slowly and unevenly, in the USSR was in some sense left behind by the dissolution of Party bureaucracy and the promise of 'democratisation in East Germany, Czechoslovakia etc. The movement between the sections of this article hopes to mobilise and foreground some of this political tectonics.

3. *Un Regard sur la Photographie Sovietique Contemporaine: 1968-88*, organised by the Comptoir de la Photographie, Paris, was exhibited at the Museum of Photographic Arts (MoPA), San Diego, October—November

1989, as *An Insight into Contemporary Soviet Photography: 1968-88*, where it formed part of the San Diego Arts Festival: 'Treasures From the Soviet Union'.

4. See Roy A Medvedev & Zhores A Medvedev, *Khrushchev: The Years in Power*, WW Norton, New York, 1978, p 84.

5. Its first venue was the Museum of Modern Art in New York. Allan Sekula's 'The Traffic in Photographs', in *Photography Against the Grain: Essays and Photo Works 1973–1983*, The Press of the Nova Scotia College of Art and Design, Halifax, Nova Scotia, 1984, offers a useful discussion of this exhibition.

6. As I suggest, briefly, in chapter 2, not all the photographic practices of the Stalin years can be bracketed in this generalisation. Walker, Ursitti and McGinniss, for example, argue that the 'honest and moving' World War II images of Arkady Chajhet 'are an exception to the massive stifling of photography' and constitute 'effective documents of the war': see 'Photo Manifesto' in *Photo Manifesto: Contemporary Photography in the USSR*, co-ordinated by Joseph Walker, Christopher Ursitti and Paul McGinniss, Stewart, Tabori & Chang, New York, 1991, p 26.

7. See Wolfgang Holz, *Allegory and Iconography in Socialist Realist Painting*, Manchester University Press, Manchester, 1993: 'It might be argued that the most striking semiotic strategy in Socialist Realist art is the principle of allegory...' (p 73). Drawing on an idea developed by Boris Groys, he writes of Socialist Realism in the 1930s 'as a complex allegorical device, helping to transform communist society under the Five Year Plans into a unified ideological and psychological space, a *Gesamtkunstwerk*, in which state and art could mix indissolubly' (p 79).

CHAPTER 2

Photographies, Counter-revolution and Second Worlds: Releases and Counter-appropriations, 1989

One good lesson is enough to know a city. A single photograph chosen out of hundreds can stand for Paris, Berlin, London, Moscow.

(Pierre Mac Orlan)[1]

On Gogol Boulevard, along the inner of Moscow's two concentric ringroads, is an unassuming structure housing the Photocentre for the Union of Journalists of the USSR. This was the venue for the first of what became a rash of exhibitions—touring from the capital to the provinces and then to various Western cultural centres—examining photographic practice as it has developed in the Soviet Union during the last 150 years. The photos in 'Russian Photography: From the end of the 19th to the Beginning of the 20th Centuries' (Autumn, 1989), were almost entirely drawn from the Central Archive of Cinematic and Photographic Work of the USSR, one of the most formidable repositories of photographic material in the world.

In Chapter 1, I discussed a photo-mediated historical exhibition, staged in a semi-official space, which constructed an allegorical image of the 1960s to be read by a Russian public moving into the 1990s. The layered strategies of this Komsomol show returned a complex conjunction of historical memory, situational social change, and strongly residual Soviet polity. But it was, of course, a quite specific manifestation of the new circulations of photographic knowledge released during the later 1980s in the former USSR. Other exhibitions, including Photocentre's, are more clearly associated with the dominant mode of visibility for the photographic image at the end of the *glasnost* years: that of revelation. The knowledge brokered by this revelatory experience is made available in a combination of shock and pleasure as a public hitherto blindfolded by an elaborate censorship regime encounters the release of persons, circumstances and social events unseen or otherwise closed off for several generations.

At first sight—from a Western point of view, at least—the photographs selected at Photocentre appeared radical in neither form, technique, nor content; and the layout of the exhibition entirely lacked the subtle informational subtexts and design agendas of the Komsomol show. But such a response fails to account for the specific impact of the exhibition. The renegotiation of historical memory achieved at the Photocentre developed—and in some sense clinched—a crucial difference in the deployment and reception of the institutionalised photographic between the First and the new Second World. For in Russia, much of the 'release' in this exhibition was

experienced as a passional data-bank weighted with immense historical significance for the crowds who gathered to see it. The photographs heralded a revelatory appearance of repressed or obliterated moments in the grandiloquent and constantly evasive narrative of the Soviet past. They bore representations of profoundly lost or altered moments—fresh historical fragments that landed with unspeakably more pitch upon the imagination and everyday life of the Soviet people than, say, an archival image of the faltering Chamberlain, or an action shot presenting the pious banalities of a Cold-War Congress might have had on the popular imagination in Britain or the United States. They force us to remember that the Soviet people often lived and died on behalf of what they had not seen. This was the pre-eminent effect of the exhibition: more than half the historic photographs had never been seen by the general public before.

The images, depicting events that took place over some quarter of a century on either side of the Revolution (1870–1940), were strung up like a repertoire of celestial bodies shedding almost unconscionable light on the dark side of the Russian moon of history. For most of the Soviet century, vast

Vasilev, *Volga Boatman*, 1904, black and white photograph. Courtesy Photocentre, Moscow

swathes of visual knowledge were off limits to the general citizen. Representations of the Tsarist aristocracy that did not instantaneously denote some recognisable and manifestly culpable decadence were never circulated; notable protagonists—political, scientific, cultural—were blotted out of the history books and airbrushed from the media; episodes in the social and economic struggles of the young Soviet State—famines, natural disasters, inter-ethnic conflicts—achieved their only public dissemination in the rumour-mill. All were comprehensively banished from state-sanctioned photo-reportage.

For the late-Soviet exhibition-goer to be confronted with an unexaggerated group shot of the family of Tsar Alexander III in 1892, or an image of the spectacular derailment of the flower-bedecked Imperial train near Kharkov in 1888, was a source of intense fascination and surprise. For that viewer to encounter the photographic spectre of women and children savagely emaciated by the mid-1920s famines in the Volga and Ukraine, or a long line of women and children bearing canteens outside a Moscow grocery store in 1919 (betokening the beginnings of institutionalised shortage), sparked a powerful shock of the secret horrors of stolen history. But perhaps the most intense responses were directed at photographs of Trotsky (officially vilified and long effaced from Soviet memory), one of which pictured him atop a wooden bench in Red Square, at the heart of the Revolution in early 1919, pausing in the utterance of some fiery declamation.

These abrupt returns from a profoundly repressed past were intermingled with a number of more sanctioned representations—though many of their protagonists had also fallen victim to official disfavour and suppression. There was a brooding Boris Pasternak photographed in 1928 (only in 1988 was his *Doctor Zhivago* published in Russia—it was written in 1955 and first published in Italy in 1957); Vladimir Mayakovsky sitting with Lily Brik (the former driven by disillusionment to suicide in 1930, the latter one of the most enduring survivors from the avant-garde 1920s); and the experimental director Vsevolod Meyerhold in his Moscow studio in 1930 (he fell victim to a Stalinist purge around 1940). These were set amidst semi-sanctioned, though still startling, images from the Soviet Republics and Russian hinterland: a scene of farm workers from a Volga Collective gathered round a haystack listening to their first wireless broadcast, intently gazing at the mechanical chicanery of the device's operatives (1930); an agitprop 'Kinematograph' (a Soviet cinema wagon) crowded out by Ukrainian women wearing scarves, its entrance painted with decorative iconic columns and tripods bearing the symbolic flame of the Soviets, against the backdrop of a massive rising sun and a flag-wielding worker (1919); a wooden church and its early twentieth-century congregation at Pskov; two completely shrouded Tadjik women seeking advice from their *mullah* in a tented, cushion- and book-filled interior (1931); a photograph from the Central Asian Republic of

Artist unknown, *Agit-train "Lenin"*, **1919,** black and white photograph. Courtesy Photocentre, Moscow

Tadjikistan showing a squad of agit-bicycles lined up on a mud street in 1936, bearing mug-shots of in-favour 1930s leaders, pamphlets, poems and rolls of ominous-looking lists.

A few curious architectural photo-documents from the late nineteenth century aside, almost everything in the exhibition centred on the body. There were no artful landscapes, no still lifes, no object-based abstractions. The enormous human struggle of Soviet modernity was re-envisioned in an assemblage of mostly anonymous prints that lacked even the shallow penumbra of 'style' and dramatic specificity that inhabits the social photography of, say, Dorothea Lange, in the US documentary tradition. There were no traces of the grandiose technical mastery over mute nature rendered by Ansel Adams—whose spectacularisation of the natural occludes the densities of human interaction, and whose rigidification of physiognomy seems to foreclose any context for the expressive lineaments of the human face.[2]

In a sense, the photography at Photocentre was even further distanced from its historical function, as defined and practised by the West, than that set out at Komsomol. Its revelatory parameters help focus the implications of

the vast home-coming of images in Russia and the former Union, assisting in what Mikhail Ryklin terms the 'rehearsal of a new visuality, a replacement of iconic, by photo-vision',[3] as the social dominance of the slogan, the motto and the Party Word begins to fade. The two modes of photographic display foregrounded at Photocentre and Komsomol—revelations from the archive, and nuanced factographic exhibition practice—remind us that if we are truly to understand new genres of representation as they develop in Russia and the former republics, both the photographic medium itself and the exhibition structures that organise and display it, will have to engage with and make accessible a social history that is as yet only implicit in the first wave of post-Soviet exhibitions. In order better to understand what such a history might look like, and how it differs from the assumptions and structures of the West, I want to outline two early moments in its formation—remembering that when reviewed from the first years of the new millennium, the drama of difference once promised by the changes set in motion at the end of the 1980s is ever more suspended as the dreams of *glasnost* scatter and fade.

My first example of the specificities and wider contexts needed for the reconstitution of photographic discourse in the Soviet Union arrived in the form of the some 150 Soviet photographs that made up the exhibition *Un Regard sur la photographie Soviétique contemporaine, 1968–88 (An Insight into Contemporary Soviet Photography, 1968–88)*, shown in France and the US in 1989.[4] But before examining the contents and implications of this exhibition, I want to suggest a larger, more complex, frame than that of the exhibitional export of a selection of images. This context obliges us to rethink the whole history of splits and rapprochements that issued from the political and economic separation of an East and West in Europe from 1917: the collapse, expansion and rearticulation of this division in the early 1940s; the 1960s thaw; the uncertain reintegration signalled by the events of the Autumn and Winter of 1989/90; and the final dissolution of the Union in 1991. It carries, in addition, far-reaching implications by virtue of its return of a partial commentary on the cultural and political constituency of the post-totalitarian moment. While not forgetting the individual images that foreground this discussion, I am particularly concerned to look across and between these several frames—institutional, Western, post-totalitarian—so that something, at least, of their crucial disarray and mutual crisis can be discerned.

Even if it finally escapes the institutional networks and rubrics that engendered it, *Insight* is symptomatic of the appropriative and reconstructive impulses that so often characterise the encounter of the Western curatorial system with non-First-World visual culture. A prefatory essay by the exhibition's French curator, Marie-Françoise George, casts the show as a narrative of exploration according to which our loss of cultural bearings is

set against a final discovery of 'new' and 'unknown' territory. Her self-conscious inscription of the exhibition into the discourse of cultural adventurism asserts that outside the primal scene of the West (the only scene that can beget photography), the 'unknown' photographic activity of the Soviet other is 'searched' out and rearticulated. In fact, it is literally hunted down and 'captured' in an arduous, yet 'exciting' reconnaissance expedition,[5] whose exotic fruits are exhibited for the voyeuristic pleasure of an image-hungry audience in the Western homeland.

What is merely explicit in the catalogue's preface becomes overbearing in its critical essays, where we are told, of a contributor's 'travels in the Soviet Union', that they 'have always overwhelmed me with marvellously absurd visions'.[6] The exhibition flags itself as a photographic travelogue that collects curious aberrations from Soviet everyday life, selecting and enframing them according to the happily alien imagination of a Western cultural emissary. At the same time, it is an avowed concern of the show that its images should be understood as a newly aestheticised 'art' supplement that confronts, or rather displaces, the hitherto dominant documentary conditions of Soviet photography. The exhibition seeks to draw the curtains on official, mainstream photographies and to go to work in the repressed wings of photographic discourse in the USSR. The discoveries it touts are, of course, never merely 'found', but always co-produced.

The gesture of throwing light on the Dark Continent of recent Soviet photographies is partly undermined and partly exonerated in the catalogue essay by Victor Misiano, the only Russian-language writer represented among the exhibition's critics and curators. While acknowledging the dissociation of 'the history and technical background of photography' from the domain of 'the history of art' in the 1970s and 1980s, he proposes that the 'cultural activity' of photography in the USSR should be thought of only as the product of a minor 'subculture'.[7] For Misiano the subcultural status of the experimental photograph is now eclipsed by its production and reception as 'an art form'. It is as a subculturally originated aesthetic practice, then, that this mode of image-production is engendered by provisional, 'self-taught' practitioners whose differently predicated activities will—finally—converge on the repudiation of the parameters of 'truth-telling' reportorial photography. Three possibilities form the grounds for such a repudiation: the 'socially aware' deployment of the narrative 'cycle or series'; the 'autonomy of the photographic image'; and a photography that, while generically variable, mediates between the first two grounds.[8]

Though less crudely formulated than that of others belonging to the new class of cultural managers, Misiano's dream seems to be that Soviet 'art'-photography should transcend its marginality and subcultural minority ('is Soviet photography bound to remain an essentially regional phenomenon?' he asks), so that it can take its place more efficiently in 'an international

context'.[9] Misiano's closing comments stage an ironic return to the rhetoric of exploration set out in the adjacent text by the French curator. His plea is issued from inside the pale of a newly spectacularised practice, asking that its condition as 'a marvel or a paradox'[10] not be held against the gravitational pull that seduces this newly seen photography to invest itself in the control systems of the centre—the Western photo-art market and Western art-critical discourse.

In a sense, however, these narratives of discovery and revelation, predicated on historical loss or absence, have their measure of appropriateness. While originating from particular institutional situations and couched in a rhetoric sufficient to evacuate all other contexts, they respond to the same crucial lacuna in Soviet cultural practice that up to the early 1980s had largely eviscerated all traces of the non-objective Socialist Real, save those conceived and distributed underground. They raise the question of how we can recover and critically reassess the assemblage of stylistically diverse photographic images in the exhibition, without merely submitting them to the canonical Western avant-garde typology with which they, in fact, erratically, and sometimes self-consciously, tangle.

Untying some of the knots of interest, engagement, distinction, imitation and repudiation staged between the photographic idioms collected in *Insight* and those in the West to which they allude or defer, or of which they are knowingly dismissive or simply ignorant, will add another profile— complementary to the design allegories of the Komsomol exhibition—to the photographic layering of the Soviet/post-Soviet scene. Thought of as a series of generic debates, these layers help us measure the space between Western and Second-World constructions of photographic knowledge. In an overview of the Soviet photographic scene, Valery Stigneev describes the influence of Henri Cartier-Bresson's 'decisive moment' photographs—some of which were published in the magazine *Soviet Photo*—on the generation of Soviet photographers in the 1960s able to respond to the cultural thaw that followed the Twentieth Party Congress (1956). Work by Cartier-Bresson and Walker Evans also appeared in the Czech/Russian language *Revue fotografie*, edited for more than a decade and a half in the 1960s and 1970s by Daniela Mrazkova. And Alexander Trofimov, long resident on the River Ob in Siberia, taught himself photography after encountering Cartier-Bresson's photographs in reproduction, before emerging as one of the anthologised photographers of the post-Stalinist era.

For Stigneev, the 1970s witnessed a move toward experimentation with the photographic medium itself. The two interests he summarises—'photo reportage' and 'capturing the moment' on the one hand, and subjective response, technical experiment, and the 'undecisive moment', on the other (which are not mutually exclusive), correspond loosely to the two poles that frame the factographic gradient I develop below. It was only in the 1980s,

however, that 'advanced' photography emerged from the underground. Stigneev notes the official designation of works produced before 1986 by photographic groups in Kazan, Cheboksaray, and Novokuznetsk as 'negative photography'.[11] He also notes that the post-*glasnost* period gave rise to a blurring between 'official culture and unofficial subculture'. Amongst the idioms he outlines are the 'aesthetic of defect' (where 'the scratches, spots, and glare are all signs of the truth of the picture as a document'); the simulated amateurism of neo-naive and 'anonymous' photography; and conceptual photography, which 'stems from the exploration of the technical and physical characteristics of the photographic medium and of the psychological games within the photograph', animated by captions, superimpositions, and other textual adjuncts.[12]

Of the several deep veins of photographic discourse foregrounded in *Insight*, perhaps the most insistent are variants on the genre of the candid image. While showing 'subjects at the edge of conventional society',[13] and promoting the photographic as a kind of assisted reflex that exposes a conflation of the social real and the socially deviant perceived together in an instant, the exhibition's candid images did not conjugate the marginal and the untoward as a kind of graphic memorial to the human detritus of the capitalist system—its rejects and casualties, its unmarketable curios—in the way of the West. Instead, it was their voluntary resistance to any explicit cultivation of the offbeat and 'weird' that rendered the relation of the Soviet images to everyday life even more ghostlike than the phantasmic presences and grotesque caught moments read by Western viewers from, say, the works of Diane Arbus or Garry Winogrand.

Photographs from the 'Country Celebrations' series (1975)[14] by the Lithuanian photographer Romualdas Pozerskis, for example, typically incorporate a full-length 'portrait' of a rurally located individual. The protagonist, or small group, is not usually formally posed, and controls only one sector of the image. The woman and her daughter in *no 25* of the series, for example, have both momentarily abandoned their focus on the camera— the mother looks askance into the middle distance, while the daughter cradles her head under her mother's arm and closes her eyes with a half smile. The peripheries of the image—two fragments of an automobile, a motorcycle and sidecar, the backs of a thin crowd—come forward as if to compensate for the relinquishment of specular control by the portrait subjects. Contrary to personality-fixated Western idioms, the context of a provincial moment of shyness and distraction is not closed off by the dramatic self-possession either of the foreground figures or of the photographer. We can go further, suggesting that the context actually eclipses the subject-conditions of the photograph, signifying as a co-equal zone. Such effects were not achieved in the belaboured way returned by a formalist reading (where textural and other elements of the work are fused in a

Romualdas Pozerskis, from the series
Country Celebrations, No 25, 1976,
photograph. Courtesy MoPA, San Diego

misprision of context), but rather through the tentative posture of the image,
its tacit knowledge that the figures it uncovers are in process in their
environment and not snatched from it photographically. This kind of
message-bearing is underlined by the far away look of the mother and the
sheer interiority of the girl, both of whom refuse the here and now of a
momentary enframement.

A second series, 'School is my Home' (1980-83) by another Lithuanian,
Virgilijus Sonta, maintains even less control over its found moments: a small
boy peeps from under the cover of an institutional cot, holding a domino
over his eyes (*no 55*); groups of children are caught at play, swinging on a
tree bough (*no 20*), rioting on each others' shoulders (*no 50*), fixed in half-
blurred images by what look like little more than momentary upward
gestures of the camera. A third Lithuanian,[15] Pozerskis' mentor Aleksandras
Macijauskas, orders his series, 'Village Markets' (1978–84) with more graphic,
formal and content-oriented deliberation. Like Pozerskis, Macijauskas uses
an array of wide-angle effects. In one photograph, the head of a calf
protrudes surreally from a stack of burlap (*no 107*); another captures a

moment of modest drama in the mercantile arena as a vendor and a customer haggle over a sale (*no 125*). Such work should be located on the threshold between the candid and the composed, a borderline whose vast hinterland, and two extremes, are everywhere explored, if somehow never defined, in the exhibition.[16]

What we confront here amounts to a directory of photographic resistances to particular discourses and genres as they have been differently received and developed in the East of Europe and the Western world. For the Soviets, this resistance was staged in relation to a now-distant legacy of formal and quasi-formal experiment undertaken in the 1920s, and, more formidably, across and through the dominance of fact-based photographies, and their various dilutions and distortions, developed from the 1930s to the 1950s, then inflected by the cultural politics of the Khrushchev era.[17] The playing-out of the later incarnations of this dominant discourse seems to have left a much more visible trace on many of the images in the exhibition than the historical memory of photomontage from the 1920s, or of Alexander Rodchenko's single-image experimental viewpoints ('from below up and from above down')[18] shot in the late 1920s and early 1930s. Yet this trace is present as an inversion. For the unremitting, vigorously enframed publicness of high-Stalinist official photography is formally reinscribed to register the insistently private, and hitherto under-represented (casual, domestic, everyday, alienated, sexual) conditions of contemporary Soviet experience. With these provisions in mind, we can say that the register of the photographies in this exhibition is aligned on a kind of 'factographic gradient'.

At one extreme are unflinchingly candid reportorial sequences, such as Vladimir Viatkine's May Day shots of Vladimir prison (eg *Very Dangerous Recidivists, May 1st. 1988*);[19] the factory interiors of Alexandre Grachtchenkov (including *Ukraine, the 'Azovstal' factory, 1978*), or the 'hard, unadorned'[20] studies of locality in Edouard Gladkov's documentary series, 'The Village Tchachnitsi and all its Inhabitants', begun in 1982. Most, if not quite all, of these more documentary photographers had experience with official news and photographic organisations such as the Novosti Press Agency.

In the middle of the 'factographic gradient' is a diffuse range of images that are neither explicitly documentary nor self-consciously experimental. Some of these are variants of the 'candid' photography discussed above. Others offer the corners and odd angles of the city or the country as moments of 'found poetry' or escapist reverie. Set alongside his series on Soviet leisure (which include 'Beach', 'Dance', 'Park'), ex-basketball player Vladislav Mikhailov's series, 'Commemoration' (1980), is perhaps the most suggestive of these.

At the other end of the extreme are frankly experimental images such as Boris Saveliev's 'polyphonic'[21] urban textures (the only colour photographs in

Vassili Kravtchouk, *Tcheliabinsk, Revolution Square, Preparation for Festivities, November 5th,* **1985,** photograph. Courtesy MoPA, San Diego

the exhibition); Aurimas Strumila's Precisionist-like factory-landscapes; Vassili Kravtchouk's surreal plaza views incorporating dislocated fragments (banners, placards etc) of Soviet visual propaganda (eg *Tcheliabinsk, Revolution Square: Preparation for Festivities, November 5, 1985*); or the Neo-Expressionist-tending photo-distortions of Igor Makarevitch (*Modifications*), Ilia Piganov (works from 1988 of half-naked women with a variety of faintly exotic appendages, partly obscured under a blizzard of textual, pictographic and photo-manipulated marks) and Evgueni Ioufit (whose absurdist photo-tableaux are sometimes supplied with pseudo-Freudian titles, such as, *I Quit Mummy to Join Daddy's Corpse*, 1984).

These photographs (the last category in particular) are located in a politically virtual space of production and reception that offers fractal-like breaks between the Western photo-genres that dominate both the larger domain of public image-making and the smaller art world. Now, the generically interstitial location of the *Insight* photographs is unique neither to this exhibition, nor to the historical period it subtends (from the 1970s to the end of the 80s). The photography of Yevgeny Khaldei, for example, made before, during and after World War II, exemplifies another moment of

stylistic inbetweens in Soviet cultural production. Emphasising 'human drama and suffering'[22] they can be squarely aligned neither with Socialist Realism, journalistic documentary, nor international Surrealism. Instead, the language of this photography participates in all three discourses, some works being sheerly confected in the best tradition of Socialist stage-management, others appearing as modestly dramatic 'found' moments, while others still rely on documentary panoramas to document the urban devastation of the war.

The virtual space of the *Insight* work, however, has a specific complexity formed from borders and split-ends laid across socially critical documentary; photo-appropriation; 'commodity critique'; formalist self-reference; the idiom of candid provocation; and the photograph as conceptual document[22] or as a tableau of theatrical self-presence—the discursive formations of photography with which the West is most familiar. Yet, while they occasionally appear to imitate, parody or otherwise dilute particular genres from this—necessarily incomplete—list of Western-originated types, the *Insight* images, within their different fields of signification—and despite the clear curatorial gesture that assembled them in proportion to how they at first glance might appear to return such Western 'conventions'—actually refuse, contest or evade these codings.

I do not mean to suggest that an ineffable or superior 'quality' inheres in the Soviet photographs, or that they are produced and received according to a generalisable Second-World 'logic' measured against a set of Western norms. I want to insist, instead, that they were made and received in a productive scene that is specifically different from the contextual predicates of US or Western-European originated photo-genres. In this scene are inscribed a number of crucial conditions: those of Soviet photographic technology; the experience of social change between Brezhnev and Gorbachev; the contingencies promoting and militating against cultural 'expression' in the transitional moment of *glasnost*, and the differential, and, in this case, almost one-way pressures set up in the global circulation of photographic images and their institutional margins. Though they might directly engage Western photographic idioms, these images never fully escape the parameters of their inscription in the Soviet scene of production. We must also remember that the chronological frame of the exhibition spans the two decades between 1968 and 1988—a period of uncertain and frequently reversible slackening in the state control of cultural production (the 1970s), followed by an acceleration in the decline of this interference under Gorbachev. But they do not (quite) include any representation of, or response to, the dramatic changes set in train in Eastern Europe during the fall of 1989.

I want to shift focus from the specific imagery of pre- and post-*glasnost* photographs to the greater context in which they are configured: the discursive domination of the US and Western Europe. Though all-but

invisible behind the acriticality of its catalogue texts, what seems especially important about *Insight* is the challenge posed by large-scale structural changes in Soviet photographic institutions, and by the emergence and redefinition of 'amateur' practice, to the construction of photographic history and theory as it has been set down in the West (implicitly or explicitly on behalf of the rest of the world, which is its technological—and discursive—client). Thus, even in attentive Western accounts of the relationship between photography and society, such as that, for example, set out in the essays of Allan Sekula, non-Western photographic practices are not only strangely absent, but are implicitly yoked to a theoretical frame proposed for what is assumed to be a universalising Western photography. Emerging from another scene, and the product of a different history, *Insight* forces us to look again at these ideas—to re-examine the conditions that supposedly inform 'a truly critical social documentary', as Sekula puts it.[23]

Deploying a string of historically diverse examples from 1839 to 1955, Sekula's essay, 'Traffic in Photographs', sets out to interrogate the universalist assumptions implicit in photographic discourse. Yet, the rethinking of photographic history suggested by *Insight* (and by other recent exhibitions and publications foregrounding photographic material in the USSR, Europe and the US)[24] must be produced at precisely that point in Sekula's—apparently teleological—argument where it is suggested that the determining conditions for photographies were structurally related to the class interests of 'an ascendant industrial bourgeoisie': 'By the turn of the century, then, photography stands ready to play a central role in the development of a culture centred on the mass marketing of mass-produced commodities'.[25]

While Sekula is unwilling to understand photography merely as a '"reflection" of capitalist society',[26] the position of a photography that was not exclusively, or mostly, predicated on the marketplace, as was the case in the USSR after 1917—more emphatically after c 1929—subverts the generalising relevance of his remarks. While traces of the double proclivity of industrial bourgeois photography to 'coldly rational scientism' and to 'a sentimental and often antirational pursuit of the beautiful' are everywhere apparent (though also everywhere restated and reinflected) in Soviet photographic practice, the whole working out of photographies there was subject to different social, cultural, economic and political conditions. The dogmas of Socialist Realism, the production and maintenance of the State Archive, the squashing of modernist experimentalism, and the suppression or censorship of non-Soviet mass-circulated products of mechanical reproduction, necessarily challenges the social theories and efficiencies of what are effectively Western photographic values.

Thus, if 'advertising' is comprehended as 'the fundamental discourse of capitalism',[27] a state-culture not simply or directly predicated on either the domination of capital or its spiralling self-production through the commodity

seductions of the media will give rise to systems of images driven by very different causes and effects. The Soviet situation, however, marks a special ambiguity in the theory of photographic production spoken to by Sekula. On the one hand, its cultures are partly European and, as such, inherited the formative nineteenth- and early twentieth-century discourses that he discusses. On the other, as capital in the USSR was collapsed into state-production and advertising into propaganda, the identity of its photographies cannot be predicated on the discourse of capitalism. In fact, the photographs in the exhibitions discussed here signify in the space between these historical and social determinations—though precisely how they do so is not immediately evident.

Remembering that the global capitalist system is a crucial agency in the formation of photography as a technological practice, a significant question is now revealed: if photography and capital are necessarily complicit, how is this relationship returned in a society that is ostensibly formed in antagonism to the dictates of Western mercantilism, and in which the very sinews of its anti-capitalist oppositionality were eroding? One response is to observe that the hyper-centrist Party/State in its totalitarian condition is able simultaneously to repress and to simulate the consequences of particular discourses as they are worked out by culture-under-capital. This is effected by the attempt to regulate and bracket all the signifying functions of a discursive material that exceed the locative requirements of central ideology. The most obvious of the extraneous supplements to the minima of official transmission come under the aegis of the 'modernist formalism' that was hounded down by state cultural machineries in the USSR during the late 1920s and 1930s, glimpsed again in the Khrushchev era, but whose complex and compressed return is only now apparent.

It might be argued that the almost total eclipse of experimental modernism from the 1930s to the 1950s severely compromised the politics of the realist image, photographic or otherwise. But how, then, did this propagandistic, anti-capitalist, non-experimentalism relate to the call for political representational practices from the Western left? And is the photography of the Soviet mid-century to be disregarded as an egregious 'essential[ist] realism', 'as both product and handmaiden of positivism'?[28] If we could once have answered this last question in the affirmative, recent developments suggest that the situation is not so simple—neither in relation to historical realism, nor to its recent parodic return.

The first response (associated with the Stalinist heyday) proposes that capital was always, historically, simulated—but in such a way that its system and method were never quite identical to Western capitalism. The second (associated with the recent changes and their cultural anticipation) thinks the overlay of capitalism on top of theories and practices that were already simulated. The paradox of this distressed, emergent, capitalism marks recent

Soviet/post-Soviet photographies in several ways. For when seen in the shadow of the historical events that immediately post-date their production, *Insight*'s rather restrained glimpse at the image repertoire of pre- and proto-*glasnost* photography raises fundamental questions concerning the status of the experimental culture recently released (and about to be released) in Europe's East. The 'postmodern scene' of the West, as constructed by its critical celebrants, will be haunted by the very conditions of real change, reinvention and repudiation that now characterise the Eastern Europe it has reckoned with in recent times only as an oppositional margin. The photographs considered here, along with certain contemporary writers and performers newly marked by the troubled, multi-ethnic constituency of Russia and the old republics, mark a powerful moment in the reconstitution of identity in this enormous region. It is an extremely fragile moment, as a society comes out of its cultural repression, as its hectic and materially deprived cultural practices negotiate between Western theoretical and practical models that both stand ready and are anticipated, and between the accumulated cultural wreckage of a long generation.

If *Insight* exceeds and denies its packaging, and unsettles Western conceptualisations, it does so in large part because the exhibited photographs bear witness to the social formation of new Soviet subjects. The economistic language embraced by the West to mark the changes of 1989–91 spoke for the most part of Eastern Europe and the former USSR 'catching up' with the West, becoming 'competitive', finding (or being given) a new set of capital production values. This language is progressively dominating the cultural sector with almost as much inevitability as in the economic; but in the early 1990s the victory was not yet assured. Western cultural domination was at the door, but momentarily on hold. There were too many 'uncertainties', not enough 'names', too few guaranteed channels of communication. There was, in short, still no (official) cultural exchange value, just as there is barely an official (convertible) monetary exchange value. While in many sectors it has been superimposed, the West has not yet successfully taken over the East of Europe.

We can go further: there actually prevails a remarkable situation in which economic value is invested (ventured) in the European East as dollars flow in to prime the economy, while cultural 'returns' (and the spectacle of 'democratic' reforms, and demonstrative military disarmament) are the only counterflows. The cultural 'bridge', then is both the guarantee and the token of economic return. It operates, for the moment, in defiance of Western cultural systems, even as it annexes and parodies their modes, styles and languages. It is a defiance because for the most part the burden of its signification is too dense, conflictual and convoluted (coiled in its own history) to be successfully consumed in the West. It will instead be misread in its own image by the West. The map of this misreading constitutes one of

the crucial icons of denial that Eastern Europe and the former Soviet Union have in their power at the outset of a momentous era of transition. This is why Russia's postmodernism looks as if it will be a postmodernism first to haunt and only later to simulate the postmodernisms of the Western metropolis.[29] It is forcing a moment of 'avant-garde' release in which 50 years of Western high modernism and postmodernist rupture is telescoped into half a decade; a moment in which 50 years of almost pure repression will suddenly spin its fantasy, or knowingly stand still. This call against order is taken on through a monumental regression and through the complexly mediated production of particular historical memories.

While the Western system is as yet a hallucination of the future, let us hope politically (which 'democratic' system, which 'aid'?); socially (which agency, what 'freedom'?); culturally (whose 'postmodernism', whose 'theory'?) that these questions—some of the most important of our time—are kept open for as long as possible, and that our responses to them do not betoken the political, social and cultural vassalage of Eastern Europe to the West. It is the responsibility of the Western intellectual not merely to colonise the cultural practices of Eastern Europe, but to help articulate their difference, to allow them to develop their own frames.[30]

'Pornoangelism' and the Post-Totalitarian Visual Field

Don't talk to me about communality, I've already been burned by that.
(Vadim Zakharov)[31]

How can the cultural politics of visual representation in the former Soviet Union be addressed a decade on from the Fall of the Union? These concluding comments will move beyond photographic images and institutions and briefly address other representational practices. I suggest some priorities and respond selectively to a wider set of problems, including the powerful historical illusionism taken on in the imaging of the post-Soviet present and the imagination of its future.

First, while regulators of the Western gallery and exhibition systems will surely not concur, critical commentary might usefully dispute with the privilege habitually accorded the high-art constituencies that have achieved such success in the art markets of Germany and the US, in particular, since the late 1980s. While not forgetting such internationally significant *glasnost-*assisted neo-avant-gardes as Moscow Conceptualism or the 'new' Soviet photographies themselves, it is the visual economies of the everyday with which we ought to engage in any understanding of emergent Post-Soviet culture. Below, I attempt to make a move from the parameters of the dissident art world to the more public conditions of the visual field.

Secondly, discussion should be offered not only of the visual practices undertaken in the relatively Westernised metropolises of Moscow and

Leningrad/St Petersburg, but also of activities in rural and provincial Russia; Soviet Central Asia (the new republics of Uzbekistan, Tajikistan, Kazakhstan, Kyrgyz and Turkmenia); and the new Caucasian and Baltic states. Thirdly, focus should be micro- and macroscopic by turns. The idea that we can determine some kind of structure of visuality for the entire former Soviet Union (an obviously absurd project in respect of the largest and most ethnically diverse inter-nation on earth) must be supplemented by local analysis. However, the visual environment, no less than the complex of centrist institutions that still regulate and determine life at all levels in the decayed Union, is still crucially mediated by the archaeology of forms and types developed in the social formation of the Socialist State.

This leads us to an important issue. Historically the Party State has written the Soviet environment in a double inscription. During the 60 years from the mid-1920s until the onset of *glasnost* after 1986, visual aspects of the social world were imagined and constructed by one or other of an apparently infinite series of central committees whose common goal was to re-produce the graphic environment as a huge ideological vista saturated with hortatory propaganda. The flat tops of the eight-to-ten storey apartment buildings; vast acreages of inner-city hoardings; the brocades of Soviet civic monumentalism; suburban assembly points; and the rural intersection—all these panoptic sites (precisely those being reclaimed by the capitalisation of the USSR as the new advertising field)[32] continue to yield their archaic sediments of socialist visual instrumentalism.

The sloganisation of the built environment is only the most visible stratum of a centrist power that conceived of the entire socius as a construction site to be planned and diagrammed in a pure articulation of the productivist-socialist utopia. The headlong rush to reconfigure the complete economy and total habitus is summarised by Khrushchev, remembering his days on the Moscow City Party Committee in the 1930s when he was responsible, with LM Kaganovich (deceased at 97 in July 1991), for overseeing the construction of the Moscow metro:

> It was a period of feverish activity, and stupendous progress was made in a short time. A hundred important projects seemed to be proceeding all at once: the construction of a ball-bearing factory, the enlargement of the Dux Number One aviation factory, the installation of oil, gas and electricity plants, the excavation of the Moscow-Volga Canal and the reconstruction of the bridges over the Moscow River—to name just a few... A competition [began] among Politbureau members to see who could 'claim' [as Khrushchev put it elsewhere, 'put his name on'] the most factories, collective farms, towns and so on.[33]

The means by which the dissident—then tolerated, now sanctioned—Soviet metropolitan avant-garde found to exorcise the total exteriority of State

Ilya Kabakov, *The Man Who Flew Into Space From His Apartment*, 1981–1988, from *Ten Characters*, 1988, mixed media installation. Courtesy Ronald Feldman Fine Art Inc, New York. Photo: D. James Dee

Cultural Form was mediated by an unco-ordinated series of strategic retreats from the public domain planned, built and signed by the committees.

From the early 1970s, Ilya Kabakov, for example, initiated a project of allegorical interiorisation and unearthly transcendence that culminated in the simulation of (and eventual escape from) Soviet communal domestic space (as represented by the 'room' environments of the later 1980s).[34] The text that accompanies his *The Man Who Flew Into Space From His Apartment* (from the series 'Ten Characters', 1981–88) speaks of the 'dream of a lonely flight into space' and of the desire to 'hook up with these streams [of cosmological energy] and fly away with them'. The installational appropriation and simulation of Soviet domestic environments is routed through a giddy combination of enforced narcissistic detachment crossed with intimations of the most grandiose measure of the USSR's competition with the West symbolised in its space programme.

At about the same time, Vitaly Komar and Alexander Melamid inaugurated their parodic reconfiguration of Socialist Realist symbology,

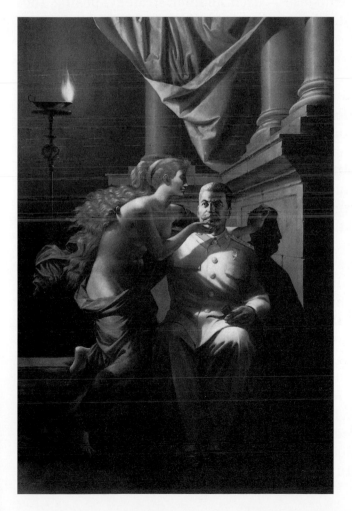

Komar & Melamid, *The Origin of Socialist Realism*, 1982–1983, oil on canvas, 72 × 48 inches. Private collection, courtesy Ronald Feldman Fine Art Inc, New York. Photo: D. James Dee

participating in perhaps the most important non-Western inflection of what the New York art world later termed 'appropriation'. In a context where propaganda and violence substituted for the media and regulation, Komar & Melamid appropriated not the literal products of Soviet visual culture, but its official styles and social effects. Their species of appropriation was usually less literal or wholesale, and more varied, 'assisted' and interpretative than the re-photography, citationism and simulation associated with New York's Metro Pictures artists in the mid- and late 1970s. Melamid reminds us that the works produced while the duo was still in Russia were always 'national paintings', images that reckoned with the overbearing inevitability and fixture of Socialist Realist style or the dogmatic, deadpan diffusion of Soviet public slogans. The artists responded in several registers to the ubiquity of textual propaganda posted on banners and billboards throughout the Union. In works such as *Our Goal—Communism* (1972) and *Onward to the Victory of Communism* (1972), they simulated sloganeering banners using white paint on red cloth, to which, in a parody of the Socialist environmental signing recollected by Khrushchev, they attached their names. *Quotation*, also from 1972—and also part of the 'Sots Art' series—used another strategy, posing 166 white rectangles in a 12 x 14 grid on a red ground, with quotation marks substituting for the first and last rectangle, and 8 smaller rectangles set in the bottom-right corner in place of a signature or attribution. What results is a humorously cunning amalgam of Minimalist design and blank repetition that signifies as an illegible writing pattern. In addition, the painting's geometry glances at Malevich's floating, Suprematist rectangles, while its total iconic shape forms something like the letter 'Q', standing in for the quotation of the title and the questions it solicits.

In other work by Soviet avant-garde artists, a version of the negativity I associate with Western appropriationism is transformed into lived experiences of withdrawal and absence. Collaborations such as the Collective Actions Group (Kollektivnye Deistvia or K/D) performed in 'bucolic and remote' extra-urban 'abstract' space,[35] were often completely removed from the conditions of everyday life through a series of 'aesthetic-psychological' 'voyages into Nothingness' dedicated to the 'study' of 'emptiness' and 'empty action'[36] Similarly, though somewhat in reverse, Francisco Infante claims that while Malevich's geometries were situated on a white ground that signified 'inattainable' or 'metaphysical infinity', in his own Artifacts (e.g. *Artifacts Series I*, 1977–87), 'infinity is embodied in nature...' and 'the forms, or artifacts, which comprise nature and which are significant for us — the sky, the forest, water, grass, etc. — occupy the space of the entire globe.'[37] Eric Bulatov, on the other hand, commenced an elaborate deconstruction of texted propaganda, which simultaneously, iconised and displaced the political solidity of the Public Word. While for Medical Hermeneutics it is, again, the 'gaps', 'contradictions' and 'minus-

declaration[s]' of 'the canon of emptiness' that animates their more abstrusely theorised intertextuality.[38]

Within the high culture of gallery and museum art installations and performances, however, the re-socialisation of practice has not yet achieved any clear discursive form. It is for this reason above all, perhaps, that the Moscow/St Petersburg avant-gardes have been so effectively 'claimed' by the proselytising zeal of Western (or émigré) postmodern theorists, and that such take-over bids are now increasingly sustained by readings and exchange within the First City cultures of Russia itself. The conditions of citation, parody, repetition, simulation, contextlessness and interiorisation are perfect for the practice of what might be termed a non-social Situationism: an eventuality that in some senses substitutes a voluntary, 'underground' proclivity for the repressed marginality enforced during the state-Socialist era.

Some of these gestures of remove and displacement relate to the re-emergence of private or non-public social discourse in the late 1980s: mystical Slavophilia; Orthodox and heterodox religiosity (Buddhism, Krishna, scientism, neo-shamanism); *fin-de-siècle* occultations; and sundry naturist 'back-to-the-woodsisms'. The Collective Actions group, in particular, has explicitly cultivated references to Eastern religions. But experimental avant-garde or high-art practice is not yet mediated by a set of national public structures (exhibitions, museums, institutions, patrons, critical discourse, etc), although aspects of this work have, of course, been successfully exported (and appropriated) by the postmodern culture industries of Europe and the United States.[39]

Soviet experimental art in the 1990s, then, is located at the intersection of two disempowerments, two retreats from the social: the first is the product of its own strategies of disengagement; the second a consequence of the lack of sustenance it finds in the public domain.[40] There are signs that the coming decade will witness a significant reversal of this retreat; one that will probably be both hindered and assisted by the new social architects of the visual field who are busy surveying their horizons once again after the best part of a century of censorship, closure and control. The visual sphere is subject to powerful reinvention: by the release of archives; the spectacularisation of broadcast television; the compulsive desire to generate a visual erotica; the beautification of the body (with simulated and imported Western fashion, style, cosmetics); the re-envisioning of an ecological landscape; and the drive to preserve, restore and even to postmodernise the built environment. As Mikhail Ryklin puts it, the 'orgy of communality' inherited from 'the canon of communal speech [and visuality] peculiar to Stalin's epoch' has issued on the one hand in 'the reproduction of the phantasmified signifiers of the market, and on the other (on the level of mass culture), [in] a phenomenon which I would like to term

pornoangelism... the simulation of that which endangers the survival of collective bodies'.[41] I want briefly to develop two items in the expanded field of post-Soviet 'pornoangelism'.

Sexuality

Totalitarian control over the visual domain was powerfully antipathetic to any vivid morphology of the body that transgressed the healthy (virile/radiant) representation of the sanctioned ethnic type figured in an appropriate occupation (labour) or caught at a moment of permissible and seemly leisure. For National Socialists and Stalinists alike almost any manifestation of sexuality was repudiated as a bourgeois/modernist deviation.[42]

Predictably, the return of this repressed has been the most speedy of the reversals to Western-type standards of any in the visual field. The *bouquinistes,* who occupied the tunnels and passageways of Khrushchev's metro in the early 1990s, hawked an astonishing range of Soviet *Joys of Sex,* 'true confessions', flash-torso playing cards, and pencil-illustrated tantric sex pamphlets. In the early days of *glasnost*, sex was diagrammed as a new knowledge to be carefully acquired (a precious technology like those in the stacks of out-of-date car and computer manuals on which the newly seeable sexology invariably rested). The Soviet representation of sex has fulfilled its aspiration to emulate the paradigms of Western erotica. In early 1990, a few months after its central HQ in Moscow was home to the Khrushchev exhibition with which I began this essay, a Komsomol branch office in Riga, Latvia, suspended the pretence that the organisation was still modelled on something like a cross between the Boy Scouts and a church youth club, and opened its doors to the production of *Eroticon*, the former Union's first, wannabe-glossy, soft-core sex mag.

TV

There are two stages to this final comment. The first rests on quite familiar concerns newly released and made newly problematic by the West's representation of the Fall of Soviet Communism. These remarks were written watching TV in London, Melbourne and New York. The second reflects briefly on the televisual scene that is emerging after the events of 1991. These were written watching TV in Moscow and the republics.

Western TV: The moment (The Fall) before us in the USSR is too obtuse for representation. It cannot readily be subjected to synthesis, or to reportage, or, in a second order analysis, to commentary. Yet, although it has, in fact, quite obviously been synthesised, commentaried and reported, and while reporters are the most arterial of the veins of knowledge that have shuttled information into the West, I want to insist that it cannot be scooped up or gathered in or documented in the way of a crisis/event in the West (or

a crisis/event in which the West is in any significant way 'present'). In great part this is because the Western media has already produced much of the scenography for the entire horizon of mega-news events across the majority of the market-oriented globe. These events are made over into consumable images of 'the news' by means of a graphic disbursement and rhetorical formatting that stitch together the geo-political image-text (the coup, the earthquake, the eco-crisis, the summit) so that even their shock value still secures the place of the event in the Western imaginary.

The event's sublime is thus abstracted and incubated by the soft recesses of the studio-editorial system. It is nurtured, rerun and augmented as a compliant televisual spectacle. Thoroughly mediumised, it is fed through the symbolic tessellation of the screen such that its life becomes caught up in the formation of its afterlife, transformed into *our* event, beamed in on *our* medium.

But I don't want to offer another requiem for the media. Most of us, anyway, had no option but to scan the events of the 1991 *putsch* on TV, radio and in newsprint. I want to suggest that we can, in fact, 'read through' the media. We can strategically assert, and thus simultaneously deny, its transparency. We can refuse to read in the available light of the polarities of the 'chronicle' and the 'editorial'. We can refuse the factography of Western journalism and the parameters of editorial commentary. As with the photographic image, so also with television journalism, the crucial differences and ghostlike similarities between the First and the Second Worlds offer the conditions of possibility for such a reviewing of the screen.

There is no way, of course, that the machineries of knowledge engendered in the Western TV system can ever be forgotten. But they can be scrutinised and intensified. They can be supplemented and reconstrued. They can be exceeded and denied. But by what means and for what reasons might this be undertaken? The negative reasons are easiest to assert. This is not an exercise that sets out to deconstruct Western media, to interrogate and criticise its structures of knowledge and technologies of power. No doubt some of these critical pretensions will be spun off as effects here and there, but this is not my point of departure. I would even claim that efforts to measure the ideological proclivities of the Western system of news representation against non-Western news values has often revealed a sort of mediumistic narcissism and political self-reference that eclipses or renders merely instrumental the traumatic events of another scene, a scene that is always not ours.

Conversely, and equally, it is not my intention to claim access to some ulterior, more complete and better-referenced 'truth'. I have no aspiration, for example, to render the productive scene of the events of August–September 1991 more palpable and vivid than the media morphologies of

CNN or the BBC. I claim no privileged access to the reality-conditions of the Soviet people, to the experiential totality of the *obivatel* (the 'everyday person') or the much-mythicised *Homo Sovieticus*—even if I was there.

Instead, I am struck by what I can only describe as the convolutions dominating the matrix of representations that mediated the coup and its aftermath. More reductively, it seems to me that the West has busily ordered a sequence of events that it has not really *known*; which it has for the most part not seen, not registered and not been in any position to interpret. It has visualised and imagined 'the events' through a shifting calculus of social, political and linguistic ignorance.

What, then, should be substituted for the ritualistic voyeurism of voice-over and copy by 'correspondents' and 'experts'—what added to it, and what taken away? Thinking through a response to such questions leads me back to the beginning of this coda. The Western intellectual might undertake to re-deploy the visual field of information—whether TV, contemporary photographies, publications, archival images etc—in order to reconvene the non-voluntaristic ethnic diversity of the former Union; a diversity of peoples, that is, which was not immigrant, but subject, and which though recently 'independent' is now doubly dependent in ever more complex ways on the Old Empire and the new Globalism; a diversity that is probably the most diffuse and potentially explosive on earth.

The TV documentary, *The Second Revolution* (1991, directed by Mark Anderson) makes me read through the heads of power in a hopeless bid to reconstrue the physiognomy of the counter-revolution. Thought against the parliamentary chambers of the West, the transitional USSR offers us the auditorium—a space configured for the delivery and inculcation of the Party *doxa* within which the audience is always subject to and not a participant in the oratory of the centre. It comes across as a TV telemachy, an assembly of gods each with their attributes. Most mesmeric are the special or upper gods of the Party whose speech is imbued with confidence and gravitas, the aura of a power both fetid and possessed. Thin nuances of popular contempt, the god-as-machine shuttling across the Styx to the rhythm of a sheer repetition of the Position, posed before physiognomies of dreadful blandness, eyes that go nowhere, like the empty sockets of Poseidon. The deputies who now contend against Yeltsin are full of fearsome absence. They are like medieval hierarchs, rapt by the inundation of some originless efficacy. They are enveloped in the unworldly like cold hermits intermittently released from the fridges of governance.

I think of the places they come from, and in some sense, represent. How will the extra-metropolitan consciousness, the legislators of the *gubernia*, play out in the centre? In the end it will be through these minds that the uncollectivisation of the USSR, both in its psychic and material economies, will, eventually, pass.

Boris Mihailov, *Untitled.* **From the series** *"U Zemli" (On the Ground),* **1991,** toned gelatin-silver print, 4.75 × 11.25 inches. Courtesy The Museum of Modern Art, New York. Anonymous purchase fund

Power has whistled audibly out of the Communist balloon. The centre has imploded and started out again. The Organization has collapsed into what Baudrillard once called the 'hell of connotation'.[43] Everyday life is played out in the aporias of the already simulated shadows of consumptive power. We cannot be too dramatic about it and we cannot be dramatic enough. This is our problem in the West. We have witnessed the beginning of the next thing through the deathly convolutions of the old. The speed and suddenness of events has its own temporal compulsion. We have witnessed the speed of a chute, a Lapse, a Great Fall. Perhaps we are finally at the end of the era of protraction, that historical moment where the modernist technologies that conducted power had not yet out-paced the instrumental participation of the masses. The future is on pause. But long live the future.

Post-Soviet TV: In Moscow, the same images that were cut and manicured by the BBC are tethered in front of me in steppe-like profusion and horizonless stretch. The TV reaches into non-sight. The unseeable is efficiently machined in the electronic transmission of mass-circulated images. The repressed archives of historical vision, and the hitherto unformulated imagery of the uncontrolled body, were central protagonists in the televisual theatre of *glasnost*, and have remained so since the Fall.

As with the incitements of the erotic image, much of the machinery of the visual format imitates or appropriates (or literally pirates) that of the West: the spectacle of exchange (the debate, the 'chat-show'); the exposé; the 'consumer' report; the 'minority' opinion; the MTV graphic montage. Yet the hard-currency deficits of the state-run system are such that, at least as far as second-order news and topical items are concerned, the presentation of

material is bound to a kind of *TV povera*—an improvised scene of production allied with a series of unsystematic (probably unofficial) guerilla raids on the promo and clippings economies of TV distribution elsewhere. In a sense, this is the most extraordinary of the *glasnost* reversals. Total ideological control on pain of social excommunication, extradition to the Gulag, or simple death, is replaced by a magpie-like gathering up of the shards of Western broadcasting, of the shiny things flapping in the margins of the airwaves. This is pornoangelism among the satellites; a sad clipping of the new Soviet wings of desire.

NOTES

1. Pierre Mac Orlan, Preface to *Atget, Photograph de Paris*, E Weyhe, New York, 1930, trans Robert Erich Wolf, in Christopher Phillips (ed), *Photography in the Modern Era: European Documents, 1913–1940*, Metropolitan Museum of Art/Aperture, New York, 1989, p 46.
2. For further discussion of the representational conditions of the face see John Welchman, 'Face(t)s: Notes on Faciality', *Artforum*, vol XXVII, no. 3, November 1988, pp 131-38.
3. Mikhail Ryklin, 'Metamorphoses of Speech Vision', in *Between Spring and Summer: Soviet Conceptual Art in the Era of Late Communism*, Tacoma Art Museum, Washington and the Institute of Contemporary Art, Boston, 1990, p 140.
4. The exhibition was shown in the US at the Museum of Photographic Arts, San Diego, October—November 1989, and the Museum of Contemporary Photography, Chicago, November—December 1989.
5. Marie-Françoise George, Preface to *An Insight into Contemporary Soviet Photography: 1968-88*, Editions 'Le Comptoir de la Photographie', Paris, 1988, pp 8, 9. The catalogue texts are presented in French, English and Russian; the English translation is quoted here.
6. Elizabeth D, 'Matriochka', in ibid, p 16.
7. Victor Misiano, 'Art Photography in the USSR Between the Years 1970 and 1980', in ibid, p 12.
8. Ibid, p 13.
9. Ibid, p 14.
10. Ibid, p 15. In *The Conquest of America: the Question of the Other*, trans Richard Howard, Harper & Row, New York, 1984, Tvzetan Todorov offers a full account of the rhetoric of 'astonishment' that attended the discovery of the 'New World'. In a review of Jean Baudrillard's *Amérique*, Editions Grasset, Paris, 1986, I discuss the return of this rhetoric in the European theoretical rediscovery of the (signifying conditions of the) United States: 'both Baudrillard and the Spaniards negotiate their sheer astonishment at an alien social and cultural order

through a recourse to the language of fables and romances, and to the conundrums of their available metaphysics': ('"Here, There and Otherwise", John Welchman on Elsewhere', *Artforum*, New York, October 1988, p 11.

11. Valery Stigneev, 'Soviet Artistic Photography', in Joseph Walker, Christopher Ursitti and Paul McGinniss (eds), *Photo Manifesto: Contemporary Photography in the USSR*, Stewart, Tabori & Chang, New York, 1990, p 61.

12. See ibid, pp 56–67.

13. David Elliott, Introduction to *Another Russia: Unofficial Contemporary Photography from the Soviet Union*, Museum of Modern Art, Oxford, 1986, np.

14. Serial work is a characteristic of many of the new photographies in the former USSR. Among those whose work is collected in the *Photo Manifesto* anthology, for example, Alexei Rosenthal, Vladimir Filonov, Igor V Savchenko, Algemantes Kunchus, Galina Moskaleva, Sergey Kozhemyakin, Gennady Slabodsky, Alexander Sinyak, Vladzimir P Parfianok, Gennady Rodikov, Valery D Lobko, Sergei Sukovitzin, Alexey Pavluts, Aleksey Ilyin, Yury Matveev, Andrey Chegin, Tak, Valentin Simankov, Valery Potapov, Alexander Ignatjev, Sergey Leontiev, Alexander Sliussarev, Tania Lieberman, Igor Moukhin, Alexey Shulgin, Boris Mihailov, Ludmila Ivanova, Edward Stranadko, Nicholai Bacharev, and Alexander Lavrentiev all work in this idiom. The recourse to seriality may be accounted for in several ways. It is, first of all, a gesture of (critical) continuity with the strategies of the earlier Soviet avant-garde. In this sense it represents another of what Margarita Tupitsyn describes as the 'restagings' of 1920s avant-gardism undertaken in the post-Khrushchevian art world (see note 16). One might also suggest that the preference for image sequences represents an insistence on the implicit narrativity of the photographic project, and a desire to undermine any unitary, 'auratic' investment in the singular image. Grant Kester's 'A Western View', in *Photo Manifesto*, op cit, p 74, describes the 'additional narrative possibilities opened up by work in grids and sequences' as 'thicken[ing] the level of social reference around the photograph'.

 The narrative and social claims made for seriality need to be offered with caution, however, as a good many of the photographic practices that have emerged in the 1980s and earlier 1990s in the former USSR have clearly thrown in their lot with the spectacularisation and individualisation of their subject matters. Indeed, many photographers apparently work in both of these directions simultaneously, a fact that marks another of the many differences between First- and Second-World photographies.

15. Elliott, op cit, notes that 'The Baltic republics of Latvia, Lithuania and Estonia were at this time [after Stalin's death] particularly influential in giving expression to a new and authentic lyricism and it was in clubs and circles established there that photography was nurtured as a medium to be enjoyed for itself, independent of the didactic aims of state commissions or the Press.

16. Stigneev considers Macijauskas' (the name is transliterated as Alexander Matsiauaskas in *Photo Manifesto*) works from the 1970s, along with those of 'Vladimir Filonov from the Ukraine, Peter Tooming from Estonia, and Leonid Tugalev from Latvia' as 'individual reinterpretations' of [Victor] Schlovsky's device of moving away' as developed in his writings for LEF: Left Front of the Arts in 1920. See Stigneev, op cit, p 59.

17. Benjamin HD Buchloh's essay 'From Faktura to Factography' offers a useful account of the historical development of 'factography' in Soviet photographic discourse during the 1920s and early 30s; *October*, no 30, Fall 1984, pp 83–120. See also, *Sowjetische Fotografie, 1928–1932*, Rosalinde Sartorti and Henning Rogge (eds), Carl Hanser Verlag, Munich, 1975.

18. Alexander Rodchenko, 'Puti sovremennoi fotograffi', *Novyi lef*, no 9, 1928; trans John E Bowlt, in *Photography in the Modern Era*, op cit, p 256.

19. At least one of these images (*May-Day in the Vladimir Jail, May 1st. 1988*, reproduced on p 57 of the *An Insight...* catalogue), seems explicitly to set up a dialogue with Rodchenko's emphasis on high- and low-angle shots. Here, a single soldier or guard looms vertically in the left foreground while prison buildings tilt irregularly around him.

20. Daniela Mrazkova and Vladimir Remes, in *Another Russia*, op cit, np.

21. *An Insight*, op cit, p 72.

22. Alla Rosenfeld, 'Photography as Art: Contemporary Russian Photography in the Yuri Traisman Collection' in *Forbidden Art: The Postwar Russian Avant-Garde*, Los Angeles/New York, Curatorial Assistance/Distributed Art Publishers, 1988, p 178.

23. In 'Veil on Photo: Metamorphoses of Supplementarity in Soviet Art', *Arts Magazine*, vol 64, no 3, November 1989, pp 79-84, Margarita Tupitsyn offers an overview of the 'competition' between photography and painting in the Soviet Union during the late 1920s and 1930s, and of its 'restaging' by conceptualist-oriented Soviet artists in the 1970s and beyond.

24. Allan Sekula, 'Dismantling Modernism', in *Photography Against the Grain: Essays and Photo Works 1973–83*, The Press of the Nova Scotia College of Art and Design, Halifax, Nova Scotia, 1984, p 57.

25. Of recent reconsiderations of Soviet photography, the anthology of images and texts, *Photo Manifesto,* op cit, is perhaps the most considerable. However, the reductiveness of its central thesis—that

'contemporary photography in the USSR displays the dismantling of the Soviet apparatus and reflects the new freedom, the return to individual expression from the state as author' (p 29)—is apparent in relation to the complexities and layering of Soviet and Western photographic discourses considered here.

26. Sekula, op cit, p 96.

27. Ibid: 'to suggest that the practice of photography is entirely and inseparably bound by capitalist social relations would be reductive and undialectical in the extreme'.

28. Sekula, 'Dismantling Modernism, in *Photography Against the Grain: Essays and Photo Works 1973-83*, The Press of the Nova Scotia College of Art and Design, Halifax, Nova Scotia, 1984, p 56.

29. Ibid.

30. Although he writes in his opening paragraphs about the potential destructiveness of 'the evaluation standards of market-driven Western criticism' (p 69), Kester's conclusions to his discussion of recent Soviet photography are in this respect disappointing: 'Soviet artists seem almost preternaturally drawn to explore the very issues of subjectivity and ideology that have come to dominate current Western art under the rubric of postmodernism', op cit, p 79.

31. This 'allowance' is being made in some quarters. See, for example, Barrett Watten's discussion of 'Post-Soviet Subjectivity in Arkadii Dragomoshchenko and Ilya Kabakov', unpublished paper, 1992, which concludes as follows:
[The] Sovietisation of cultural horizons—an opening up from the oppositional politics of the Cold War to the reality of collective horizons—is a hopeful reason to reject Kabakov's integration into the explicit theme of the MoMA [Museum of Modern Art, New York] show as an imperial trophy collected under the banner of Western postmodernism.

32. Cited in Margarita and Victor Tupitsyn, 'The Studios on Furmanny Lane in Moscow', *Flash Art*, no 142, October 1988, p 103.

33. Sergei Bugaev ('Africa') has actually responded to the inevitability of the shift from the socialist slogan to the seduction of advertising. As David Ross notes: 'Africa proposed an American advertising campaign commodifying life as lived by his friend Sergei Anufriev', 'Provisional Reading: Notes for an Exhibition', in *Between Spring and Summer: Soviet Conceptual Art in the Era of Late Communism*, Institute of Contemporary Art, Boston, Mass, 1990, pp 20–21. The Boston ICA catalogue also illustrates Africa's *The Orthodox Totalitarian Altar in the Name of Anufriev* (1990, mixed media).

34. Edward Crankshaw (ed), *Khrushchev Remembers*, trans Strobe Talbott, Little, Brown, Boston, 1970, pp 63–64, 70, 119.

36. One of which was 'exhibited' at the Ronald Feldman Gallery in New York in 1988.

37. See Margarita Tupitsyn, *Margins of Soviet Art*, Giancarlo Politi Editore, Milan, 1989, p 52.

37. Kollektivnye Deistvia (K/D), 'Trips Beyond the City', Moscow, 1983, trans Victor Tupitsyn, in *Margins of Soviet Art,* op cit, pp 148–50.

38. *Francesco Infante: A Contemporary Moscow Artist* (ex cat), International Images, p 17; cited by Alla Rosenfeld, 'Photography as Art' op cit, pp 184-85.

39. 'The Medical Hermeneutic: The Inspection of Inspectors, *Flash Art* no 147, Summer 1989. A longer discussion of these artists can be found in Tupitsyn, op cit.

40. Notable exhibitions in the US examining aspects of Soviet and post-Soviet visual practice since the 1960s include 'Between Spring and Summer: Soviet Conceptual Art in the Era of Late Communism', Tacoma Art Museum, Washington and the Institute of Contemporary Art, Boston, 1990; 'Sots Art', New Museum of Contemporary Art, New York, 1986; and regular exhibitions of the work of Komar and Melamid (beginning in 1976) and Ilya Kabakov at the Ronald Feldman Gallery in New York.

41. Several of the contributors to the catalogue of 'Between Spring and Summer', op cit, point to the emergence of individual contestations of the 'hermeticism' that characterises the various strands of Moscow Conceptualism—in particular to the formation of feminist and non-Russian ethnic practices.

42. Ryklin, op cit, p 138, 139. In fn 9, Ryklin adds that 'pornoangelism does not know the temptation of the transcendental; it is entirely immanent in culture. Its dissemination in Soviet culture is logically related to the fact that its profession stands extraordinarily close to the mainstream of mass culture'. While clearly related to other attempts to account for the instrumentalist shadows of Soviet power, Ryklin's concept is somewhat more accommodating to the possibilities of feedback and dissonance in the relationship between state power and cultural politics—Benjamin Buchloh, for example, writes of 'the perspective of governance and control, of the surveillance of the rulers' omnipresent eye in the metaphor of nature as an image of a pacified social collective without history or conflict'; 'From Faktura to Factography', in *October: The First Decade*, MIT Press, Cambridge, Mass, 1988, pp 76–114.

43. Andrei Zhdanov and Karl Radek (1934): 'It is the presence of "forbidden" aspects of sexuality in the works of Soviet and Western modernists which is the common denominator of their banishment from Soviet life during the Stalin era, no matter how the criticism of these works was clothed [sic] in the rhetoric of pseudo-Marxism'; cited in *Margins of Soviet Art,* op cit, p 109.

44. For a discussion of this term, see Steve Baker, 'The Hell of Connotation', *Word & Image* 1, no. 2, April—June 1985, pp 164-175. The title of the article derives from Baudrillard's discussion of Bauhaus design in *For a Critique of the Political Economy of the Sign*, trans. Charles Levin, Telos Press, St. Louis, 1981, p 196.

CHAPTER 3

New Bodies: The Medical Venus and the Techno-grotesque, 1993–1994

Passion After Appropriation

She never undertook to know
What death with love should have to do,
Nor has she e'er yet understood
Why to show love, she should shed blood
Yet though she cannot tell you why,
She can love, and she can die.
> (Richard Crashaw)[1]

Here is the rubber figure of a woman, a surrogate raised on a steel support. Here, plates in steel with love letters engraved on their palms. There is a knife, and over there, a pearl necklace. They are watched by a frieze of anatomical photographs, purloined throughout a decade of observation in European medical and natural history museums in Vienna, Florence and Budapest. The photographs were made among the vitrines, as the photographer poured over the dim lineaments of a thousand inconsolable isolates.

Imagine first cutting into the body, then demonstrating the power and knowledge of the cut, the wound of science. Imagine a model of the 'body-self' prone for observation—for looking, but also for taking, for wounding, and for knowing—a body always conscious of the invisibility of its interiors. Imagine stretching out and tensing into the history of the anatomical body; having oneself operated upon by this history. Imagine being watched from the gallery by a row of anointed organs, and, like the model here, raising your knee. This body-self is not simply trussed up in a 'technology of gender', it also imagines its own bondage.[2] The environment around it is an extension of the model's imaginary, with the body as a surrogate subject and history as its simulated skin. Instruments are gathered near to the model: a precious adornment, a cutting machine (for better and for worse), and flat utilities that are also images and writings. Flesh is rubber, gesture is frozen, the knife is available, the necklace is cold, the letters are metallic, and the body parts a congregation. Drozdik has created the concourse of a detective story. We are drawn around the corpse and invited to speculate about the motives and causes of its revelatory death.

We are looking at moments from 'Manufacturing the Self' a series of installation projects by the Hungarian-born, New York-based artist, Orshi

Orshi Drozdik, *Dystopium 0309*, from *Adventures in Technos Dystopium*, 1985, photograph. Courtesy the artist

Drozdik, which she began in 1991, following her decade-long enquiry, 'Adventures in Technos Dystopium'. Each series unfolds in a counter-narrative of site-specific exhibitions conceived around desires, knowledges and bodies. As part of 'Adventures in Technos Dystopium', Drozdik invented the Natural Philosophy of Edith Simpson, the pseudo-persona of an eighteenth-century female scientist, an illegitimate daughter of Benjamin Franklin who was born in a whorehouse. *Morbid Conditions* (shown at the Tom Cugliani Gallery, New York, and Arch Gallery, Amsterdam, in 1989) interrogated the historical romanticisation of disease (syphilis and TB). It was in this installation that Drozdik first began to use models of her father's brain. *Morbid Conditions* was followed by *Fragmenta Naturae* (1991), posed in an ironic relation to the taxonomic formalism of Carolus Linneaus, founder of the binomial system of modern scientific classification and author of *Systema Naturae* (1735), and *Cynical Reason* (which put simulated brains on wheels, on doormats and—at the 1993 Sydney Biennial—in high heels).

So far, five selves have emerged in 'Manufacturing the Self': *The Body Self* (Kilchmann Galerie, Zurich, 1994); *Medical Erotic*, 1993/4 (Gallerie d'Arts Contemporains, Herblay, Tom Cugliani Gallery, Anderson Gallery, Virginia); *The 19th Century Self* (Tyne International, 1993); *The Non/Nun-Self* or *Convent*

(1993) installed at the Centre d'Art d'Herblay, Maubuisson Abbey, near Paris—a cloister for women destroyed in the French Revolution); and *The Virgin-Self* or *The 'Hairy Virgin'* (at the 1994 Sao Paulo Biennial).

This chapter thinks through Drozdik's photo-based installations, setting them in relation to another recent intervention in the production of new body-spaces: the video-projection installations of Tony Oursler. The Medical Erotic of Drozdik and what I will call the 'techno-grotesque' of Oursler, offer to re-examine the more programmed and dogmatic bodies of the 1980s. The pleasures, risks and irascibilites of these projects, their elaborate histories and their willful futures, return scenes of the body that are at once more somatic and more virtual than the allusions, simulations and masquerades that filled the bodily templates of the previous decade. The bodies of Drozdik and Oursler are not naturally expressive or overtly sexualised in the manner of performative traditions inherited from the 1960s and 1970s. They owe little, again, to the allegorically recoded figures of pictorial Neo-Expressionism, or to the aggressively gendered or politicised recitations of the 1980s. On the other hand, both Drozdik and Oursler resist that 'eclipse' of the body 'by our own technology', or 'ceding our outdated flesh, blood and neutral tissue to integrated circuits and the mechanistic progeny'[3] eagerly anticipated in recent accounts of robotic surrogacy or pure virtuality. Nor are they associated with the apocalyptic envisaging of inexorably posthuman bodies whose corporeality is collapsed into mutant monstrosity or the uncanny fade-out of neo-hyper-realism. Seen, heard and performed as melodramatic, eerie, anxious, compassionate, tender and hermetic, Oursler's bodies are 'hybrid subjects' alternately caught and launched 'in choric stages of technopsychosis'.[4] Drozdik's body-selves, on the other hand, begin with a narcissistic appropriation of the artist's own surfaces and end with their relocation in multiple scenes of production, analysis and desire. We catch her negotiating with history in a series of gestures that form a singular relation to the emerging logic of 'post-appropriation'. In this work, historical forms of science and body-production are projected onto her surrogate self, and incorporated within it, so that she bears the marks of their presence—and passage—like stigmata. Moving from plural represented selves to a dialogue with early scientific knowledge that is both subtle and ironic, the technique of appropriation is folded over and over again, finally emerging as a flipbook of corporeal production.

Did Drozdik offer a seduction here? Or will she? Is there an 'uncanny lure' of death—such as Bataille imagined for Manet's *Olympia*, a body 'blown up', as a contemporary critic remarked, like 'a grotesque in India rubber'. Is her Venus an exquisite corpse or a 'cadaver fantasy',[5] a locus of allegorical knowledge or an embodiment of chance and desire? One thing is clear: there is no masquerade under the skin, no artful decoding of the violence of the male gaze. One cannot imagine here, as has been imagined for *Olympia*, that

Orshi Drozdik, from *Manufacturing the self, body self* and *Medical Venus*, **1993.** Courtesy the artist. Photo © Orshi Drozdik

the scene exposes the construction of 'woman' as a fetish object for capitalist consumption.[6] There is no lesson. There is no aggregation of artifice and cross-gender misrecognition (as promised by Baudrillard).[7] But there was a seduction here.

Of course, the parts of the installation also belong to a case. They are traces: evidence, weapons, witnesses. So, the viewer may be a detective or a criminal or a jury. The environment is re-lined as a drawing room, a gathering place for the items and the body, which are already there, and the suspects, who are not. We are chasing, or avoiding, the truth of an action. Perhaps this is the truth of the first cut.

The first person to think seriously about dissection was Galen. Among his lectures, written to accompany his demonstrations on anatomy and physiology (delivered in Greek in Rome, 177 AD, and not improved on until the publication of William Harvey's *On the Movement of the Heart and Blood in Animals* in 1628), Galen made a note on the 'the particular uses of dissections':

> Anatomical study has one application for the man of science who loves knowledge for its own sake, another for him who values it only to demonstrate that Nature does nought in vain, a third for one who provides himself from anatomy with data for the investigation of a function, physical or mental, and yet another for the practitioner who has to remove splinters and missiles efficiently, to excise parts properly, or to treat ulcers, fistulae, and abscesses.[8]

According to Galen, there were several uses for dissection: it functioned as pure knowledge, Natural Law, empirical enquiry and as an occasion for the extraction of missiles. Michel Foucault would seem to concur, at least with the first of these propositions. 'Pathological anatomy', he writes, 'was given the curious privilege of bringing to knowledge, at its final stage, the first principles of its positivity... the corpse became the brightest moment in the figures of truth'.[9] Unlike the landscape, however, the body never had its Romantic epiphany. Its sublime was choked by the probe of a double technology, the machines of the interior (dissection, the X-ray), and the outside (photography). Drozdik reinscribes the body-corpse with its lost dignity, laying it to rest in something like its virtual sublime.[10]

Let us move through the genealogies of the rubber figure, the key appropriative contexts dreamed of by the recumbent artist's surrogate self. The first is historical, and can be summoned up in Clemente Susini's anatomical wax sculptures, which originated as dummies for medical instruction made for the Cabinet of Physics and Natural History in the Pitti Palace, the Grand Duke of Tuscany's 'gigantic encyclopedia of organic facsimiles'.[11] These ceroplastics focus the displaced desire, the simulated

cadavers, the ecstatic self-identifications, and the contrapuntal violence of Drozdik's installation.

The second, and most extensive, genealogy is caught up in the representational history of Venus herself. For inside the *Medical Venus*, packed into her organs and parts, is the remembered knowledge of all the Venuses ever made. I will introduce the Venuses, that unnervingly seductive brigade of reclining women who have waited, prone and poised. Their recumbency joins with the violence and subjugation of all figures that lie. But how beautiful and terrifying they are as selves.

When she was called Aphrodite, Venus mainly stood. She was veiled. Then she was undressed and a Greek deity became a woman with allure and charm. Her sexuality is defended by the *pudica* gesture. When she crouched to tie her sandal, the stoop or squat was immediately caught up in representation. Distant from the gods, she is henceforth associated with water, with bathing, with a centuries-long torsion of the body whose classical finesse will issue in the savage spectacularisation of Picasso's dislocated Cubist figures.

Binding her sandal, playing with her hair—the last is Venus Anadyomene, literally 'rising from the sea'—she becomes a Venus of balance and privacy. Soon she is 'natural', charged with 'turgid emotionalism' and 'gentle divinity', witnesses both to the triumph of charm over religion. If there were anything like a Hellenistic Rococo, whose figures were written through with gaiety, irresponsibility, technical facility, decoration, then it was manifested in the Venuses. And here too is 'that kind of charm called genre'.[12]

Botticelli's Venus still stands, in a shell, on the water (*The Birth of Venus*, c 1482). She is Eve and John the Baptist imagined under the influence of Plato. Titian's (so-called) Venus, on the other hand, reclines (*Urbino Venus*, 1538), in an epiphany of sensuous control, fleshly beauty and pictorial abandon. But look at Marat (Jacques-Louis David, *The Death of Marat*, 1793). Look at the long new table knife to the left, at the bottom. Look at the quill and the death letter. Propped in a medicinal bath, swathed in sheets and a turban, Marat is an adulterated Venus with a tiny incision-like wound. The body is flat and closed up. The wound is Marat's necklace. Could he be the transsexual Venus of the Revolution?

For the nineteenth century, Venus becomes the preferred icon of sanctioned dissipation (Alexandre Cabanal, *The Birth of Venus*, 1863). The world of pictures swirls with lying Venuses. The Odalisques emerge rubbing their rubbery, ivory whiteness against the luxurious tassels and pleats of the Orient (Ingres, *Odalisque with Slave*, 1839-40). Then the Courtesans arrive. Manet's *Olympia* (1863) is nicknamed 'Venus with a Cat'. In the Salon of 1863 there were three versions of the *Birth of Venus*, including Cabanal's.[13] The Venuses splinter and take off: the Whore, the Virgin and the Hysteric.

Gauguin puts down Tahitian Venuses—*Manao Tupapao: Spirit of the Dead Watching* (1892) lies on her stomach with her feet crossed. Cézanne makes almost all his bathers un-Venus-like. Matisse twists out a blue Venus (*Blue Nude: Souvenir of Biskra*, 1907). Picasso startles with the edge-long, pseudo-reclining figures of the *Demoiselles d'Avignon* (formerly *The Philosophical Brothel*, 1907). Modigliani pampers his nudes with smooth creases.

In 1926, André Kertész photographs a *Satiric Dancer* in Paris. A statue sits on the table, and a painting or a photograph of a standing figure hangs on the opposite wall. The standing and prone Venus figures reach us in a vertiginous splay of postures. The photographer games with the order and perspective of the arms and legs. Decorum is untrussed, as all four limbs are skewed in contrapuntal directions. There is no simple availability here: the codes of recumbency are electrified by over-action.

When the Surrealists (Man Ray, for example, or Raoul Ubac) photographed the nude, they retreated to the rapturous closed-eye female, or to the *nue debout* surrounded by a giddy entourage of male Surrealists. Alberto Giacometti shatters the Venus into a bronze flytrap, and lays her out on the floor, where she is opened up again—though this time at the neck (*Woman with her Throat Cut*, 1932).

We are closer to the perpetual recumbencies of Henry Moore and the late Matisse; the material scatology of Jean Dubuffet (*Olympia (Corps de Dame)*, 1950); the painterly sensorium of de Kooning (*Woman I*, 1950–52); the American Dream Venuses of Tom Wesselman. But, where are the Venuses of our age? After the boy-made loafing Venuses of Eric Fishl and David Salle, or Cindy Sherman's prosthetic self-Venuses, it's clear that the Venuses have come home to die. Hannah Wilke photographs herself as an 'Intra-Venus', a lymphonal body invaded by the tubes of medical science, scarred with bone-marrow harvesting. Here the tactile dying Venus disputes the 'aesthetic distance' of Cindy Sherman's 'made-for-the-camera grotesqueries or Andres Serano's morgue pictures'.[14] From now on, the Venus has no choice but to surrender her normative allure and recultivate it against the grain of her gender. We reach the cross-dressed *Venus Xtravaganza*, a black Femme Queen featured in Jennie Livingston's documentary *Paris is Burning* (1990), who fantasises for herself the real whiteness of 'a spoiled, rich, white girl living in the suburbs'.[15] The coquette, the caryatid, the Madonna and the drag queen: these are the final poses struck by the terrible atrophy of a post-Expressionist narcissism.

The third genealogy is formed from the self. Drozdik stages the poeticisation of her dream-encounter with the Medical Venus as an erotic revelation that precipitates a 'love letter'.[16] I read the letter as an allegory of that intersection between biology and fantasy that is love; as a parable of that cut-out place between the love of the self, self-love, and love of the other. For the artist it is the place between Pygmalion and Narcissus.

The scene is imagined in Vienna, in the autumn, in 'cool sunshine' and under slatted light. A body is recumbent and centred in the room. The encounter gives rise to a 'shattering... shivering... embarrassment'. There is unbearable ecstasy, spectacle and seduction. In the encounter, the looking self, who is also a photographing subject, gazes onto a scene of self-identification whose thickness is the medical sensation of the body. The observant spine, Drozdik suggests, doesn't 'tingle' (in the way of spines that are merely written about), instead it is transformed into the palpability of a 'stick.'

In a vertigo of reflections, the observer spins out of visual contact, only to return to the Medical Venus as a mesmeric voluptuary, perhaps as a slave. The body of the Medical Venus is open to the transport of adoration and pining. In the openness are beehive lungs, an arterial heart and a womb with a foetus. The nipple hangs over the arm, arrested only by a sliver of uncut muscle. The studied gaze of the photographer-observer fixes on the interior body and then images it in black and white, shooting round the body.

The body of the Medical Venus is transformed into the exaltation of a sensual memory that transcends eroticism. Such memory is not suggestive, but enforcing. It squeezes out a metamorphosis, a projection and internalisation of the body of the Medical Venus into the self-body. The sensation of the spine-stick becomes an incarnation. Cells and organs are inseparably relocated, and a pearl necklace strung up around a different neck.

Years are months in the gestation of the photographer-foetus-self. Her ecstasy is different from the passion of Venus. The pain of that difference is the pain of the non-medical world in all its horrifying blankness and debauchery. The photographer becomes the sculptor of a smile and the architect of self-confusion, erasing the distinction between the 'not you' and the 'me'. Is it Pygmalion or Narcissus? How can the wound of the Medical Venus be healed? Why does she smile as the knife rips her open?

Here are conjugated the self-other of death, a screen memory of trans-rational inner being, and the disabled parts of a body-of-organs looking down (with pity) onto the body-without-organs. This is the threshold of a fable about the auto-production of the self, of how the photographer-self was aborted into selfhood from the open body of the Medical Venus.

One can think of it like the ecstasy of Santa Teresa, substituting for the sensual-devotional pre-Enlightenment body of the Christ-adoring saint the post-Enlightenment medicalised body of the self-imagination. The transfiguration of the Catholic saint becomes the dislocated scientific affect of the Eastern European subject. The internal sections of the Medical Venus are transportations of the secreted flows of devotional ecstasy, the tears and moistures of holy rapture. Richard Crashaw's prohibition against the unrapturous death of the ecstatic saint is transformed a hundred years later

into its mirror image, as the spectacle of the ripped anatomical cadaver becomes the love-object of secular self-identification. The ghosts that protect Santa Teresa against the depredations of the 'cut' are exorcised in the laying bare of its device—the process of its becoming-surgery—that attends the scientific revolution. Drozdik relives the space between these moments, and renders it intense:

> Blest pow'rs forbid thy tender life
> Should bleed upon a barb'rous knife;
> Or some base hand have pow'r to race ['slash' or 'slit']
> Thy breast's chaste cabinet, and uncase
> A soul kept there so sweet...[17]

Answering Back

Tony Oursler, *P.O.V. (Point of View)*, 1993–1994, cloth, green lamp, video projection, 254 × 44 × 35 cm. Courtesy Lisson Gallery, London

In a 1994 exhibition at Metro Pictures,[18] Tony Oursler balanced his flopping bodies on distressed needles of perfect projection. Little machines backed by tiny causeways of wire threw up a congregation of vivid, hyper-real face-surfaces onto the 'dummies, flowers, altars, clouds and organs' that titled the show. These zones of reception line up as the inverse co-ordinates of Drozdik's edgy clinical drama. Soft, improvised mannequins blur the solid outlines of the life cast that centres the Medical Erotic; projection replaces incision; while the encountered scene is not a detective story presided over by historical enigma, but a mischievous round of garrulous monologues locked up in a video-tape loop. Everyday declamation substitutes for poetic symbols, compulsive verbalisation for the accretions of history, and fractious improvisation eclipses the tumultuous layering of genealogy. Oursler's projected bodies also talk us back and draw us forward to some of the leading issues I associate with art after appropriation. In particular, they conjoin that ghostlike second skin of reference that seems to sediment wherever appropriation makes over the real with a delirious self-reference that continually feeds itself back at the listening viewer. Oursler's 'tragicomic universe' is, then, 'overrun with phantom representations' and spectral persons: 'Narcissistically fixated by the glare that animates them, they take on hallucinatory appearances reminiscent of phantoms, poltergeists, grotesques and ghouls'.[19]

The exhibition was perfect—and pointed—because it transformed ten years of pirating and pidgin, apportioned between voice, performance, video, screen and body, into a seductively formatted idiom that stacked its parts like Russian dolls. The pieces were obsessive, knowing, funny and technically hard-won. Sound or tape loops—spoken/acted by Tracy Leipold, Catherine Dill, Steve Boling, Constance De Jong and the artist himself—were merged with untoward places of reception (post-screens, if you like), from which they also appeared to emanate. Assemblage, video-sculpture, installation, performance and voice pieces, or glove-puppetry for the head—no matter how these talking sculptures are named, each participates in a dimensional collage of distinct performative spaces, each is supplied with its pool of projected light creating, created by, and usually deriving from, the face, and each is equipped with a scroll of sound that envelopes its immediate context with vocal stroboscopes of silence and harangues, low-voiced introspections, and gestural chatter. The result is a family of switch-people, human-object machines, who stand, or lie, replete with the grudgingly mysterious identities of the 1990s, playing out diffident, off-beat dramas of self-possession, ennui and alienation.

In the middle of it all is a small, Donald Judd-like cube called *Movie Block (Sony)*, (1994), two of its sides immaculately filled with projected street-life tele-surf, shot outside a multiplex cinema in lower Manhattan. This cube is an ironic hub, allegorising television. But it also performs a quietly

choric commentary on conditions of the body—as they meet and dissolve in electronic projection—which are conceived, almost willfully, against the angular abstractions of the Minimalist environment. In this sense, Oursler's figures form clarifying antitheses to the cube-bound African-American persona, locked in a geometric cell, and calmly refuting the logic that has already produced him, of Adrian Piper's *What It's Like, What It Is, No.3* (see Chapter 7). For all around the cube, soft, hanging, occasional figures, winsomely dominated by their flickering screen-visages, are dispersed like spokes in a darkened gallery. An ovoid, performing self-portrait is crammed into the transparent concavities of an Oldenburg-scaled headache capsule. Here, a crushed, pixilated face pokes out from under a mattress, dispensing invective as readily as a motel Coke machine sheds its cans. Over there, an unclothed, palm-sized woman lunges cyclically from the hem towards the unattainable summit of the dress that doubles as a projection screen to co-produce her. In the basement gallery a single table supports five jars filled with animal organs pickled in formaldehyde. A pair of projectors at either end beams a male and female face into adjacent vessels, where their fleshy lips commingle with the jellied folds of inside parts, making us eavesdrop their down-home small talk on domestic nurture. Giving the video image a flaccid depth, letting it seep around the peripheries of basketball- or fist-sized pads, or into specimens of offal, was a sensational stroke that threatened to rupture the dull hegemony measured out by the stolid interiority of cube-bound TV. As Oursler once remarked, his method of personification treats video 'like water', offering restitution to a 'completely ethereal form that's been boxed for forty years in a television'.[20]

The heads are blown up and distended, the bodies limp, crushed or prone. The faces stand in for lumpish clichés, lounging confessionals, or bubble-bound Krazy Kat musings. Following the recent designations of the artist we find some of their talking spirits are 'hysterics', some are dummies of the 'horrorerotic', or bound into an ineffable 'waxy catatonia' and bled into the polyfibres on 'cloud #9'.

Others have been named *White Trash* and *Phobic*. Together, they flap with speech and awkward pauses, making up a cacophony of self-deluded anguish, irreverent paranoias, and general world-scoldings. The cumulative effect of Oursler's cabinets of facial curiosity suggests another destiny for the talking head. The old-time, simulated realities of the waxen surrogate, or the mechanical automaton, or the stitched-up mannequin, are displaced by digital makeovers supported on flippant rag-doll bodies, floral stansions, torso-sized caplets, or bottled organs. Oursler's angels flicker into a monitor afterlife, offering gifts of consciousness and duration to the snapshot metaphoricity of the Pop generation.

If Oursler's pomo misericordes cannot be lined up alongside the automaton, the doll or the waxwork dummy, with what might they be

Tony Oursler, *White Trash/Phobic*,
1994, 2 figures human scale video
projection, cloth, $190 \times 50 \times 30$ cm.
Courtesy Lisson Gallery, London

Tony Oursler, *System for
Dramatic Feedback* (detail),
1994. © The Museum of Modern
Art, New York. Photo: Courtesy of
Metro Pictures

associated in the figurative imagination of the West? I want to suggest that they contribute to a more aberrant and various tradition of ludic commentary that reaches back to the capital-heads, leaf-faces and gargoyles of the Romanesque. Described as 'the slang of architecture',[21] these grotesques were colourfully secularised, counter-theological investments against the immeasurable fullness of the dome-filling Pantocrator, radiating his features from the curved sky of the metaphoric cathedral worlds of the early Middle Ages. They were graphically humorous interruptions in sacred space, whose effects are not unrelated to the diversions of later technologies: the popular print, the comic book and satirical aspects of broadcast TV. All rejoice in suggestive effigies of commonality and exaggerated character. What I want to hold on to in this brief genealogy—and connect with Oursler—is a kind of popular-cultural disdain quite at odds with the post-Enlightenment tradition of rational, mechanical bodies, whose progeny in our time includes corporeal virtualities, posthuman simulations and cyborg hybrids. The performative chatter and hapless materials that animate Oursler's personages sets them apart not only from the lineage of robotic surrogates, and the Duchampian hyper-realism of Robert Gober, but also, and equally, from the debased or formless conditions associated with the reinterpretation in the 1990s of the abject body (associated with the later work of Cindy Sherman, and the substance-emitting figures of Kiki Smith, among others).

It's not that the voices, organs and faces we encounter in this exhibition have nothing to do with abjection. While they flirt with its meanness and base reduction, or even arise from its matrix, they are seldom lost in abject pathos, or trapped by its self-reference, nihilism, and "indifference."[22] Oursler's faces participate fully neither in the negativities of the abject, nor in the related conditions of a body-doubled uncanny. I want to suggest, instead, that they engage in the mixed enterprise of the *techno-grotesque.* As we move from earlier formations of grotesquerie to Oursler's thin crowd of cloth, cloud, organ and electronic persons, we surely encounter some form of social attenuation. Their contemporary carnival is caught up in flourishes of medical whining, communities of entrapment, not festive release, futile gestures of ascent, crass repetition and irascible, post-Existential monologue, whose odd interiorities are somehow more socially recondite than the leering visage of a priapic friar or the satiric pulpit reveries of Reynard the Fox. Perhaps this is because technological space and its machines of vision are even smoother than theological space, and the ironic eruption of dissent or counter-artifical actions, even more difficult to adjudicate. But what Oursler gives us, nevertheless, is a miniature *son et lumière* of imperfect everyday consciousnesses talking back, sometimes only to themselves, against the flimsy conditions lost and found in their technological labyrinth: a garrulous vox pop grounded in soft pixels that simply cannot be quietened.

Once more, the box on the floor offers a clue about the unprogrammatic social and aesthetic redirection aspired to by the artist. For, not only is it brimful with reverse TV, it also proffers the muted suggestion that we think back to two key moments of twentieth-century commentary on the container and its emanations: the thin line traced from Duchamp's *With Hidden Noise* (1916)—a ball of twine, with an unknown object inside, sandwiched between two metal plates—to Robert Morris' *Box with the Sound of its Own Making* (1961). Morris' simple wooden box housing a tape-recorder playing a loop of the sounds made during its fabrication, translates Dada enigma into the semi-cool of Process; and in both works the (artist) persona is present only as an imagined absence substituted by noise: as a mystery (Duchamp) or as a maker (Morris). The distance negotiated by Oursler's electro-humanities from these avant-garde evacuations is a reverse journey from the tantalising restraint of the fashioned cube to the pop-up personalities and jack-in-the-box release inhabiting the era of Windows. His is the carnival-face stuffed into a pill of the 90s, a triumphant instance of the Chip World turned-upside-down as the head is swallowed by the capsule, and Every Viewer is invited to think they're on Prozac. In addition to his zestful reinvention of the electronic soul, Oursler also suggests a gainful forfeit in respect of the screened image. He has substituted a cannily abject grotesque for the spiritually autocratic post-Minimalist videoising of the 1980s—those video-Rothko expanses, big-screen seas, and corridors of austere visual riggings, coupled with a habitual TV dress code of peopleless, Euro/downtown greyscales—videos that wilt the will with their aesthetic neo-sublime. Oursler's trajectory is quite different. He offers us vague recollections of the Poppy, live-wire crack and flicker of pioneer Nam June Paik, and a trace of the body-video pulp that followed. But what he has finally issued after a decade or so of intimations is a disembodied platform of earthily spectral personages. Some of these might be identified as cantankerous incarnations of Miró's Surrealist whimsy; others are street-wise regroupings of the comic-strip miniature; and some (like the organs) have been launched into the free-fall orbit of the post-Cal Arts absurdum.

In a not unrelated sense, Oursler's face-people underline the long-standing identification of video-life—at least outside its narrative-in-a-tube traditions—with the flowers of narcissism, with infantilism and other regressions to littleness and the close to home. But this underlining is also a deletion. For the face-lit, electronically-organed creatures offer their secret profiles, their satires on guilt, their Polyannas and confessions, their lip-sync bawdiness and Pentium-era slapstick, with their virtual tongues digitally planted in their cathode-ray cheeks. Shining on and on, their bright frippery offers a more telling commentary on our obsessions and social culpabilities than the muzzled inferences of 1980s art-world moralism. They help us remember that our latter-day contra-saints and anti-angels are made up of

cable arteries, pixel-pores and light-emitting countenances: for in the techno-grotesque, the face is collapsed into its social nimbus, and its voluminous identities are arranged on a needle's edge.

NOTES

1. Richard Crashaw, 'A Hymn to the Name and Honour of the Admirable Saint Teresa: In memory of the virtuous and learned lady Madre de Teresa that sought an early martyrdom', 1624, lines 19–24.
2. The allusion here is to Teresa de Lauretis, *Technologies of Gender: Essays on Theory, Film and Fiction*, Indiana University Press, Bloomington, Indiana, 1989. De Lauretis borrows the idea of gendered technology from Michel Foucault's discussion of the 'technology of sex' in the first volume of his *History of Sexuality*. I want to suggest that Drozdik's scientifically aware installations offer sites of resistance to the discursive 'implants' of sexual practices and behaviours by post-Enlightenment institutions and disciplines; see *Technologies of Gender*, pp 12–13.
3. Colin McGin, 'Hello, Hal', *New York Times, Book Review*, January 3 1999, p 11 (reviewing Ray Kurzweil's *The Age of Spiritual Machines: When Computers Exceed Human Intelligence*, Viking, New York, 1998; Hans Moravec's *Robot: Mere Machines to Transcendent Mind*, Oxford University Press, New York, 1998; Neil Gershenfeld's *When Things Start to Think*, Henry Holt, New York, 1998).
4. Martha Schwendener, 'Tony Oursler: dummies, flowers, altars, clouds and organs', *Art Papers*, vol 19, January/February 1995, p 59.
5. See Georges Bataille, *Manet: Etude bibliographique et critique* (first published 1932). The two citations occur in Charles Bernheimer, 'The Uncanny Lure of Manet's Olympia', in Dianne Hunter (ed), *Seduction and Theory: Readings of Gender, Representation, and Rhetoric*, University of Illinois Press, Urbana, 1989, pp 13–27.
6. See ibid, p 24.
7. Jean Baudrillard, *De la Séduction*, Galilée, Paris, 1979.
8. *Galen on Anatomical Procedures*, trans Charles Singer, Oxford University Press, Oxford, 1956 (for the Welcome Historical Medical Museum), p 34.
9. Michel Foucault, *The Birth of the Clinic: An Archeology of Medical Perception*, trans AM Sheridan Smith, Pantheon, New York, 1973, Chapter 8, 'Open Up a Few Corpses', pp 124–25.
10. Barbara Stafford argues that the discourse of anatomical intrusion and the proto-Romantic cult of ruins, especially in Piranesi, are in fact predicated on similar theories of mediated interiority: 'The model's sequentially removable nesting organs, the constant dialectic between somatic interior and exterior, the doubling overlay of immediate and

remote structure, and the contrived cavities [of the 'scientific exhibition of automata'], all operated like Piranesi's masonry apertures'. *Body Criticism: Imaging the Unseen in Enlightenment Art and Medicine*, MIT Press, Cambridge, MA, 1991, p 67.

11. Ibid, p 64. Stafford writes that 'the fame of these lifelike models, not decayed by the customary preservation in alcohol, transcended the frontiers of Florence and Bologna. Examples found their way into collections in Vienna, Montpellier, Pavia, Paris and London'. We might add Budapest to the list, for it was here, in her home town, that Drozdik encountered the first 'sculpture' that motivated her decade-long fascination with the Medical Venus and scientific-medical imaging—though it was in Vienna that the artist's transfiguration occurred.

12. See Derickson Morgan Brinkerhoff, *Hellenistic Statues of Aphrodite: Studies in the History of their Stylistic Development*, Garland, New York, 1978, p 126.

13. See Theodore Reff, *Manet: Olympia*, 'Art in Context', Penguin, London, 1976, pp 52–53.

14. Photographs by/of Hannah Wilke made during the last two years of her life were shown at the Ronald Feldman Gallery, New York and reviewed by Roberta Smith in the *New York Times*, Sunday 30 January 1994.

15. Cited in Judith Halberstam and Ira Livingston, *Posthuman Bodies*, Indiana University Press, Bloomington, Indiana, 1993, p 6. Halberstam and Livingston consider Venus Xtravaganza, tragically murdered before Livingston's film was completed, as an exemplary postmodern body.

16. The letter is written by Drozdik, and etched onto silver plates in her installation. In the interpretation that follows I use her text *Lettre d'Amour à la Vénus Médicale* ('Love Letter to the Medical Venus'), 3 March 1993, in Orshi Drozdik, *Manufacturing the Self*, Les Cahiers des Regards, Cahiers de Maubusson, Abbaye de Maubisson, Centre d'Art d'Herblay, 1993).

17. Crashaw, op cit, lines 69–73.

18. Tony Oursler, 'Dummies, flowers, altars, clouds, and organs', Metro Pictures Gallery, New York, November 1994.

19. Lynne Cooke, 'Tony Oursler: alters', in *Parkett*, no 47, 1996, p 40. At the beginning of her essay, Cooke refers to the dictinction drawn by David Joselit between two forms of narcissism associated with video practice—Rosalind Krauss' notion of 'intrasubjective' narcissism, put forward in her 'Video: The Aesthetics of Narcissism' (1976), and what Joselit terms its 'intersubjective' variant, predicated on self-referring loops and instant feedback. For Cooke, these forms are 'imbricated' in Oursler's work from the early to mid-1990s onwards (p 39).

20. Tony Oursler, interview with Michael Ritchie, 'Tony Oursler: Technology as an Instinct Amplifier', *Flash Art*, January/February 1996, p 76.

21. T Trindall Wildridge, *The Grotesque in Church Art*, William Andrews, London, 1899, reprinted by Gale Research Co, Detroit, 1969, p 2.

22. Hal Foster offers one of the most telling critiques of the social 'indifference', political 'fatigue', and fetishisation of the traumatic subject, that emerge alongside what he terms 'the cult of abjection' in the late 1980s and 1990s. See 'The Return of the Real' chapter 5 of *The Return of the Real*, Cambridge, Mass, MIT Press, 1995, esp pp 153–168.

CHAPTER 4

Faces, Boxes and *The Moves*: On Travelling Video Cultures, 1993

Travelling (Video) Cultures

I want to pose a number of questions about the relationship between filmic fiction and documentary, and about what lies near and beyond their boundaries. I ask, in particular, how documentary genres negotiate with the fantasies, moralities, stories and pleasures that dangerously stalk its concern for presentational 'truth'. In order to sketch some responses, I will turn my more theoretical argument around several issues in the videos of Steve Fagin that confront and work through these encounters—concentrating on two works from the early 1990s—*The Machine that Killed Bad People* (1990) and *Zero Degrees Latitude* (1993).[1] Using Fagin's work as a point of departure, and joining it with other projects—different and related—I want to ask how can we speak about, and in what contexts can we locate *moving images*—representations of cultural movement? Wider issues in this discussion include the relationships developed between Hollywood as an image-home and its various extensions on 'location'; the camera as a technology of retrieval—bringing images back; and the many related questions caught up in the representational imperialism of film as it reins in the world (from Dziga Vertov's *kino*-eye to the *National Geographic* documentary and beyond). While I venture briefly into some of these areas, I want to privilege one aspect of the broader debate suggested in Fagin's work: the idea of 'travelling video'—activities of moving-image production that make and imagine movement: relocations, migrations, translations, the flows of information, the projections of fantasy, the hard 'realities' of location, the vicissitudes of the voyage, the stubbornness of adventure. How can we mark a space for representing or ordering such *moves*?

While there is much to move around, we should not be unaccountably obsessed with the strictures of location or the prophetic immanence of 'dwelling' (of which Heidegger has become the Poet and Master).[2] Nor should we succumb to the inertia arising from the logic of a postcolonial morality that sometimes refuses the possibilities, empowerments and pleasures of moves—whether by selves, others, or the others of others. The refusal of encounter is not a solution to the problem posed by forced locations, by encounters with no account, by repositions that are blind to their motivations, consequences, or disruptions. The problem is in moving itself.

For travel is always, simultaneously, a transgression and a surrender. It is always marked by desires and needs. It is always a rupture formed of

several violences to place—the separation or splitting off from 'home'; the vector or passage between, or through; and the continuous intrusion of arrivals. A 'travelling video' would take place in an arena whose outsides are made up of travesties of these moves. It must pass by the immanence of dwelling, localist moralities, the imaginary *frisson* of pure 'flow', and the vertigo of transgressive surrender — all those sometimes perverse ambitions to represent that assert themselves against the grain of really moving. I want to suggest that in his videos Steve Fagin—while often, perhaps necessarily, getting caught on the ropes of all these imaginations (and prohibitions) of travel—has struggled with unusual passion and energy to move away from the confining edges of this lore of movement to image conditions inside the arena.

The 'inside' is dense and compacted. Not that Fagin produces precious or hallowed objects of displacement (as in some aesthetic, 'installational' *moves* developed in the art world). Rather, a primary consequence of Fagin's weave of moving images is that its complexities and folds, its structures of reference and provisional asides, its dialogues and diversities, confound the partial or reductive allocations of a critical narrative, just as they might saturate or overflow particular spectatorial horizons. There is a kind of sumptuary risk in this plurality: for even as the running-on of references is multiplied to excess, even as they move apart and together in serial sequence and metaphoric overlay, their hatch-work of sightings opens too many depths, punctures too many apertures-for-knowing in the little box of sound and light from which video comes.

Let me suggest some of the ways in which Fagin has staged and overcome this risk, how he has balanced profusion and restraint, hears and theres, dreams and ideologies, heres and theirs—how he has produced a vision of *the moves*. Rather than describing, or analysing individual works, I want to draw Fagin's videos alongside various understandings of relocation and travel as they have been played out in three recent discussions or sites of image-production: in postmodern anthropology (especially in the new 'visual anthropologies'); in aspects of post-war film and experimental video; and, briefly, in the art world. In conclusion, I will suggest how Fagin's visualisations of encounter produce what I want to describe as a 'post-physiognomy' of place. Faces, boxes and *the moves*.

A travelling video might pass by a similar range of incitements, revisions, old dangers, new pleasures and recontested politics as those confronted in what James Clifford described as 'travelling cultures'.[3] Clifford argues that such cultures have arisen in relation to a number of 'travel conjunctures' focused on the transition from anthropological 'informants' to 'hybridised', postmodern counter-travellers—those travelling in their own way and along their own routes (which might include 'ours'), who are encountered on the way by the sense-making machines of 'advanced'

anthropologies. This transition is predicated on the shift from 'informants' and static research, to 'participant observation' (after Malinowsky)—a sort of dignified getting down with the natives, which went on to include the technics of living and language immersion (like a second baptism into the new life of the other culture). But 'participant-observation' still offered a form of 'co-residency' rather than travel, one in which the anthropologist (who might also be a filmmaker, and would almost certainly be a photographer or draughtsperson) sought a one-way exchange of homes with the native settlement—an 'exchange' based on the anthropologist 'moving in' for long periods, probably uninvited and usually unannounced. Such behaviour, of course, has no reciprocal issue in the West, it being—for the most part—quite inconceivable that even a family member could stay in Western-style domestic space for months or years without mutual negotiation or clearly specified invitation.

The place of classical anthropology is identified by Clifford as one of the sides that close off his mobile arena of 'travelling cultures', for 'fieldwork' must be understood 'as a special kind of localized dwelling' undertaken by 'homebodies abroad'[4] who invest in complex imaginary relationships to local languages, rituals, everyday life etc., which they *observe*. The vectors and machines of travel are ignored in this account, capital cities and national contexts erased; the original home of the researcher, and the many sites and operations of translation (mostly between languages, but also between customs, manners, religions etc), forgotten or marginalised. The control system of anthropological experiment is thus incubated from the contaminants of social and political context—local, national or global. Searching for a renegotiation of this problem, Clifford suggests that the people who used to be positioned as 'informants' might instead be seen to 'write' and 'travel' culture back. The new anthropology turns home truths into away provisions. It looks, for example, at beaches, shores and interiors, not at 'autonomous' islands, or cut-out communities; it affirms the 'multiple authorship' of other cultures, and not their definitional reduction to a singular ethnographic trait or dominant language/group. It will encounter conflict and non-consensuality, rather than smooth its 'results' into a homogenous form or cumulative pronouncement.

As with the more convincing aspects of emerging visual anthropology, Fagin's representation of 'travelling cultures' is neither illustrative nor instrumental. But while his videos cannot be simply inscribed within the new anthropologies, or even—more abstractly—within their trans-disciplinary paradigms, they clearly cut across the suggestions, desires and the investments of such para-academic discourses. Their location, if you like, is to travel through the materialised thought of 'travelling cultures', producing only what anthropology could never be—even in its newly imagined futures suggested by Clifford. One measure of the virtual intersection between Fagin and the new

anthropology emerges from the places in Clifford's text where the possibilities of 'travelling cultures' are imagined in the form of projects, itemisations, or parentheses. One of his roll-calls of specific subject-positions, some marginal to the concerns of anthropology, reads like a cast list from Fagin's *Zero Degrees Latitude*: 'missionaries, converts, literate or educated informants, mixed bloods, translators, ethnographers, pilgrims...'.[5] With the single—and notable—exception of 'ethnographers' (who do, in fact, have an off-stage presence in the piece), these are precisely the people seen, encountered, interviewed, researched, simulated, imagined and videoed in Fagin's recent work. It is thus that his images might find a provisional definition as one of the 'new representational strategies' or 'notes for ways of looking at culture (along with tradition and identity) in terms of travel relations' that Clifford recommends.[6] While Clifford's discussion goes on to privilege—and also to problematise—the category of 'ex-centric natives', or 'travelling "indigenous" culture-makers', Fagin is more concerned about the ways that cultures are travelled to and around, both historically and televisually, and how these representations circulate, and are exchanged and overlaid.

Thinking through these representational strategies, Clifford begins not with postmodern anthropological writing, whose problematics and possible reformulations he has discussed elsewhere,[7] but by addressing particular kinds of overlap between travelling cultures and filmic representation. His delivery of 'travelling cultures' to the threshold of cinema encourages us to cross over into 'travelling film' and again to travelling video. Clifford alludes to three positions, which considered together could form a preliminary matrix—the other sides of the arena—for the working-out of a critical travelling video. First, he outlines 'the story of dwelling-in-travel' located around the Moe family, a Hawaiian performing group, whose migrations, he suggests, prompt the possibility that a filmwork-in-progress about the family would be able to deploy excerpts from the 'home' (really 'road-home') movies made by travelling family member Tal Moe. The folding of family-produced footage into an ethno-documentary production—interesting and provocative though it might be—speaks, however, to only one dimension in the conjunction of film/video, travel and ethnic difference. This is a confessedly unusual instance of a local group continuously 'exporting' and reinventing their local knowledge while in transit among the entertainment routes of the late twentieth century.

Secondly, Clifford introduces a film by Bob Connolly and Robin Anderson, *Joe Leahy's Neighbors* (1988), which follows the movements and hybrid sociality of a mixed-blood inhabitant ('the sort of figure who turns up in travel books, but seldom in ethnographies') of the New Guinea highlands. Here, a kind of 'both... and...' (or 'neither... nor...') syncretic figure is imaged through his conflicts, memories and accommodation, as lived—and moved—in the space between cultures.

Clifford turns, finally, to a historical antecedent of 'travelling film' in the *ethnographie vérité* of Jean Rouch, especially his *Jaguar* (1953–67), which unfolds as a journey between Mali and the 'Gold Coast' in West Africa. This 'wild, picaresque swoop through Francophone Africa',[8] is an 'ethno-fiction' of 'social change and displacement' narrated and 'performed' by three young Songhay men. In the touching of film and ethnography the work of Rouch makes a crucial gesture—both historically and critically. Rouch was a graduate of the Ponts et Chaussés, and a student of Marcel Griaule, the controversial anthropologist who organised the Dakar-Djibouti mission (1931–33)—the focus of Michel Leiris' *L'Afrique Fantôme* (1934)—and who installed the first cinematheque in the Musée de l'homme in Paris. Rouch navigated the Niger river in 1946–47 (in whose notorious Boussa rapids Mungo Park met his death), and was also, until around 1960, a writer-researcher of interpretationally unadorned anthropological texts, and a maker of travelling-images.[9] An autodidact who conjugated the moving image with aspects of late Surrealism and the camera-eye theories of Vertov, Rouch produced a 'participatory cinema' in which the maker would embark on an interactive journey with the film's 'subjects'. This was most obvious in the films of migration and travel, including *Jaguar* and *Moi un Noir* (about a dock-worker in the Ivory Coast port of Abidjan). In his earlier years, Rouch often rode on horseback between villages in the Songhay and Dogon country around the Niger river, with a Bell and Howell camera strapped to the saddle. He would record 'found' situations by improvisational means. And it is in this sense that he has been seen by his sympathetic critics as a 'cinematic griot', as a participant anthropologist who finally 'became part of contemporary Songhay cosmology', but equally as a maker of images who merged with his camera in a moment of epiphanic unity that somehow answered to the native rituals of 'possession' that obsessed him.[10] In this reading, Rouch is made over as a 'radical empiricist for whom lived experience is a primary component of fieldwork', and whose visionary-real camera actions constituted a kind of sympathetic magic, or 'artistic anthropology' actually capable of 'solving... ethnographic mysteries'.[11]

Such devotions have the merit, at least, of showing how Rouch stands at the apogee of the ethnographic tradition of 'participation'—becoming a borderline subject of his places of relocation—yet at the same time clearly reveal that Rouch's substitution of co-production for 'participation' transgressed the disciplinary bounds and counter-interactive moralities that still dominate the pursuit of academic, and even para-anthropologies. The relatively recent history of 'visual anthropology'—for which Rouch's films constitute a set of representations, though not always uncritically—is a case in point. Most of the earlier accounts of ethnographic film establish, or subscribe to, rigid exclusionary models that administer clear bounds and limits in the specific and privileged association of 'scientific' ethnography and

film. Karl Heider, for example, sketches a categorical defense of 'ethnographic integrity' from which all 'errors' of 'cinematic aesthetic' must be refused or purged. This position is the direct offspring of the assumption in traditional anthropology that there must be a 'deep professional commitment to the integrity of cultures'.[12] According to the same exclusionary logic, ethnographic film must dissociate itself from 'jump-cuts' and 'subjectivity'; it must zealously pursue an utter minimisation of anthropological 'presence', and it must indulge in no 'artifice' of any kind. It must have nothing at all to do with the bastard lineage of 'Flaherty's igloo'.[13]

This purist position often resulted in the production of 'anthropological films' with the grain and mono-dimensionality of government-sponsored 'social guidance' films of the 1950s. Much subsequent debate in the emergence of 'visual anthropology' has been variously preoccupied with sullying the transparency of the ethno-filmic image, engaging on the way, little by little, developments in 1970s and 1980s film theory, Derridean-influenced spacings between 'visuality' and 'textuality', and a whole range of renegotiations with modernist and colonialist authority collected from the endgame of postmodern and postcolonial theory.

Here, again, the work of Rouch marks a necessary moment of pause in the recent call, taken up in the very different projects of Robert Gardner and Trinh T Minh-ha, for a 'move within anthropology from representation to evocation'.[14] This call, and 'progressive' suggestions from younger anthropologists and others concerned with the visual field, often seems either to leap too far into the celebrated unknowability of 'the poetic', or fall too short. Crudely put, the problem is one of combinations and multiplicities—though emphatically not of the 'surrender' to them, nor of any abandonment to some postmodern euphoria of exchange.

Subtle negotiation with a range of postures between the too much of the poetic and too little of anthropological stricture, is another measure of the profuse balance achieved in Fagin's work. Perhaps we can think of his videos as stacked like dreams in the unconscious of the more radical exponents of visual anthropology, from which—in the manner of Clifford's text—they occasionally escape in the compressed form of lists and slips and asides (devices that Fagin convenes with relish). In this condition, they are what is desired, but never quite stated; or, alternatively, what is thought but never quite produced. It soon becomes clear that Fagin has worked like a video-spider making webs from the little catalogues and possibility-strings that Clifford and others have built into a tentative pocket Larousse of 'travelling cultures'.

One of the corners thus webbed over is the place of historical travel and its kinds. Both Fagin and Clifford ask how histories of movement (migrations, evacuations, tourism, adventure, emergencies, refugeeism, pilgrimage and so on) are invoked, and how they merge and interfere with the structures and

experiences of 'home' in the present, when and if there is one. In another little list—of 'letters, diaries, oral history, music and performance traditions'[15]—Clifford opens a fresh parenthesis onto the supporting discourses and resources of travelling knowledge and confession that fed into Fagin's earlier videos, which dealt with historical literary travellers such as Flaubert and Roussel.

Beginning with its title, *Zero Degrees Latitude* speaks to the peril of diminishing returns as visual anthropology thinks through the dangerous correlation between 'documentary' and 'fiction'. As Dai Vaughan puts it: 'some people would argue that any distinction between documentary and fiction diminishes rapidly to zero as film increases in complexity'.[16] *Zero Degrees Latitude* offers an ironic allegory of the zero-complexity in the question of latitude and reach between site, archive and imagination.[17] It forms a dialogue with the careful attempts of Trinh T Minh-ha to negotiate between the possibilities (and demands) of 'documentary' and 'fiction', not by making recourse to conventional antagonisms ('being merely "anti-"'), but by questioning the 'specialised, professionalised "censorship" generated by conventions'. This results not in the denial or negation of such 'categories and approaches', but rather in an 'extension' of their reach in projects that continuously work at their limits or edges.[18] Moving through what Judith Mayne refers to as a 'resistance to categorisation',[19] and Trinh T Minh-ha herself describes as a 'desire not to simply mean', she underlines a commitment to 'stories, songs, music, proverbs, as well as people's daily interactions'.[20] Such 'stories' include 'Western writers' (such as Bachelard, Cixous, Heidegger and Eluard), as well as local traditions: 'for the place of hybridity is also the place of my identity'.[21] As Walter Benjamin argued of his project to represent a visit to Moscow, there is an effort here to put 'theory' in a kind of vivid suspension within and around the processes of travelling-writing-(filming). It is not and cannot ever be forgotten, but, equally, it is never a privileged 'safe place' of pronouncement cordoned-off from experience—or confusion.

There are several contributions to questions of ethnography and the techniques and strategies of visualisation—as there are in the rethinking of anthropology at large in which Clifford has figured so prominently—that shift discussion (and imagination) in a direction in which I am claiming Fagin and a small company of others have already begun to move. While he is not directly connected with the journals and recent debates organised around visual anthropology, I want first to mention the work of Eric Michaels, who died of AIDS in 1988. In a recently published collection of essays, *Bad Aboriginal Art: Tradition, Media and Technological Horizons*,[22] Michaels refuses to see the arrival of new visual technologies in remote communities as a form of assimilative 'culturecide' for the indigenous. Instead he writes of, and assists in, not only the reception, but also the making of TV, video

and paintings among the Walpiri of the Australian Western Desert. The various pressures of the international art market, of government-supplied institutions, materials and policies are not necessarily, for Michaels, so many dangerous supplements; they can also contribute to a hybrid empowerment. Yet Michaels does not dance down some yellow-brick road spiralling between the satellites and the oldest continuous culture on earth. A para-anthropologist traversing the spaces between media and cultural institutions and local communities, Michaels contributes different knowledges according to his many appearances (as a guerilla activist and deviant ethnographer, a post-commune Toyota-driver, dissident academic and sometime policy polemicist).

Most significantly, his critique is always operational. Refusing an instrumentalist cultural politics of the Other, he argues for critical interaction and responsible intervention. The folds and contradictions of the discourses he drives by—from *bricolage* to Baudrillard, from acrylic aesthetics to the asystematicity of Aboriginal prohibition, from the mannerisms of traditional anthropology to the convolutions of postmodern theory—are caught up in a horizonless counter-monument to the often misrepresented local-global communalities of the late twentieth century. Michaels' commitments mark out a crucial set of shifting, experimental possibilities for the moving image. He believed in meanings that are assisted, but not compromised. He offered cultural respect but always refused reverse fetishisation. And, above all, he was convinced that images developed co-operatively could become formations of empowerment.

Working in related contexts, David MacDougall engages with the 'complicities of style' that might attend an 'intertextual cinema'. Such a cinema would traduce the monopoly values of older ethnographic film: it would speak to multiple voices in multiple cultures, and deploy plural codes. But for such strategies to be effective, fundamental issues in the construction of Western points of view need to be openly acknowledged—or actively dispensed with. One of the most complex and obtrusive of these concerns the social, cultural and cinematic function of the close-up, that powerful and peculiar gesture of direction that brings the immediacy of the face and its expressive dimensions into a suggestively magnified relation to the viewer. In a thought that runs in the opposite direction to the occasional film theory written or spoken by the 'anti-travelling' Federico Fellini (for whom the face functions as his leading fetish of 'home', and serves as the dwelling place of national emotivity), MacDougall proposes a number of restraints to Western ways of seeing fixed in the moving image. He is particularly concerned with `the assumption that characters will assert their personalities and desires visually, in ways that can be registered in close-ups of the face'.[23] Drawing attention to the forms of subject-position caught up in the Western encoding of the close-up, which has a theoretical point of origin in Béla Balázs's

emotive hyper-facialisation of the filmic world,[24] offers a useful 'corrective'. But it should not result in wholesale prohibition. The films of Trinh T Minh-ha show the way to a reimagination of Western-non-Western 'reassemblages' of the face.[25] While Fagin's videos take on a related concern with the physiognomies of location.

Moving from the reasonable suggestions of MacDougall and the concerns of visual anthropology to the videos of Steve Fagin, is like shifting from a textual collision between 'two texts of life' (in MacDougall's terms), to interactions in a global-social space that are more desiring, more abstract and more layered. It is to move from the anxious influence system that flickers between 'texts' to the catastrophic encounter of discourses, or systems and clusters of flowing texts. *Zero Degrees Latitude* is inscribed across a hybrid fusion of (local) religious world-views, merging missionary, evangelical Protestantism (overlaid with Cold War calculation) with a syncretic native Catholicism, and various local religions and 'animisms'. It might be that Fagin also shares MacDougall's fears: the consequences of 'cultural relativity run wild' or 'mirrors within mirrors and unending nesting boxes'. Just as they are recognised to be necessary conditions in the unequal exchange between cultures, capital and powers, such threats of signifying entrapment or abandon are, for Fagin, more an incitement than a hindrance to representation. And in the same way that she searches for new possibilities with the close-up, so Trinh T Minh-ha also finds a redemptive strategy for the conditions of mirroring, showing how it is possible, (and necessary), to make a 'commitment' from the magical monitor she calls 'the mirror-writing box'.[26]

The hybrid, travelling subjects and recorded journeys of postmodern anthropology locate several co-ordinates for the possibility of travelling film/video. But joining up these positions offers only a sketchy outline of its reach and resources. Fagin has exceeded, and in part denied, the parameters suggested here. He has taken up with (some of) these departures, negotiated several more, and then pressed further still in staging the encounter between the displacements of moving images (moving moving images we might say), the creative 'sprawl' of 'multi-locale ethnography',[27] and the necessary reformulations of 'travel' experience. When Clifford addresses the limitations caught up in the theory and practice of 'travel' (especially in respect of those who cannot be the active agents of volitional movement that the Western inflection of this term connotes), he proposes instead some of the 'different modalities of things that pass powerfully through—television, radio, tourists, commodities, armies'—subsuming in the process another set of technologies, experiences and social movements that are foregrounded in Fagin's video-travel. As Patricia Mellencamp suggests, *The Machine that Killed Bad People* is organised as an extended meditation on the time and travel machine of TV, and the flow and counter-flows between news, global imaging, and the local operations of power.[28]

Steve Fagin, *Zero Degrees Latitude,* **1993,** video still. Courtesy the artist

Sketches

As *Zero Degrees Latitude* (1993) begins, the camera moves in on an old-style map of the Americas, written over with pseudo-archaic calligraphy. We zoom in on the equator as it passes through Ecuador. The film transports us to this place, posing as its central question the issue of going, and examining the cultural remainders of Western missionaries who went before.[29] The map is not an allegory, or at least, not quite. Fagin is a maker and surveyor of maps, but his are maps spun together from travel-machines, visual codes and a roll call of fragrant travellers, connoisseurs of displacement, and virtual mountaineers.

Fagin's first video, *Virtual Play: The Double Direct Monkey Wrench in Black's Machinery* (1984) offered a remarkable relocation into the life of Lou-Andreas Solomé, a psychoanalyst, dreamer and lover, who precipitated obsession in several great 'men of the mind' in the early twentieth century. It was followed by *The Amazing Voyage of Gustave Flaubert and Raymond Roussel* (1986), an imaginary video-quest undertaken by Flaubert and Roussel, woven together from letters, diaries and real and imaginary bodies. *The Machine That Killed Bad People* (1990) reflects on the Marcos regime in

the Philippines by feeding back refreshed ideas of documentary, violence, catastrophe and the spaces of privileged private lives against the dominant codes of TV news.

Zero Degrees Latitude (1993) supplements these discussions with *verité-* style glimpses of the ongoing effects of religious prosletisation in Ecuador—looking back to the activities of the Summer Institute of Linguistics in the Amazon region from the late 1950s to the 1980s. Questioning relationships between North and South, the piece enfolds one of Fagin's great leaps of imaginative space, opposing the quasi-documentary footage, shot in the Ecuadorian highlands, with an extraordinary psycho-sculptural machine supplied with a vocal armature in the form of a floating missionary voice. The contraption simultaneously incubates, explodes and entraps the woman inside it—in an epiphany of conscience, guilt and desire. *Zero Degrees* asks: what is development and how is it experienced? How do missionary actions control, inflect, empower or destroy the lives of local people? What happens to local imaginations under the monopoly spiritual capital of the Christian scriptures? Finally, what latitudes are there in the zero degree?

Fagin is always mapping, making space, listening to it, even coiling up around it. Just as there are cartographic connectivities suggested in our *fin-de-siécle* telegeographies, in non-Western spirit-worlds and among the written-down trade winds represented by the adventure-colonists, so Fagin gives and takes his video-spaces with spirit and virtuality, adventure and social inscription, so that they are always spaces making meanings, part-places, part-objects that simultaneously refer to and refuse an assemblage of 'bigger pictures'.[30] Fagin's maps stack up like a 'magic encyclopedia' of travels (the phrase is Walter Benjamin's, ventured in relation to the folds, layers and epiphanies of his library), of removals and displacements. Their leading figure is the 'amazing voyage'. But his voyages (and amazements) are of many kinds, spaced out in the post-hallucinogenic world beyond the magical mystery tour, where they are aligned in three merging experiences: literary travel, ethnographic travel and cinematic travel. Some of these goings are oneiric or imaginary, made in rooms with the blinds down (like Roussel); some follow the move across missionary positions, or media displacements; others shunt to and fro inside the brackets of language, or under the cover of travel surrogates like photographs, movies and TV.

We see travelling TV, video-on-the-road, homemade runarounds and Flaubertian escapades in which visual delicacies substitute for the writer's sonorous periods, even passages of modified exotica (as in the Ecuadorian Amazon). There is studio-travel in which the prop and the backdrop substitute for places and bring them wildly home; and editorial travel of unimaginable splices and mergers. There is the lustful, dusty stasis of archival travel, and the moral travel of purpose and commitment. All are driven forward by a percussive assemblage of machines of travel. Think of

Steve Fagin, *Zero Degrees Latitude*, 1993, video still. Courtesy the artist

the chamber-bound Tinguelyesque confection that stomps forward by the
inch in the studio sequences of *Zero Degrees Latitude*; and the intimate-text/
fragment-image machine of the postcard. Or, think of the Trojan Horse of
television, whose monitor-face is neither quite perspectival nor just a black
and white surface system, but a jukebox of Poppy colours and struggling,
little dimensions. Think, again, of the real-delusional travel of the dream;
and the vectoring machines of the walk, the run, the pursuit, the drive, the
crossing and the flight.

All these are driven forward under the parallel time-harness of genres
and codes: the real-space, probe-time of the documentary, where the camera
is taken in, lofted into an 'authentic' site. Suddenly, we are in a breakwater,
or on a hill walk, where photography enframes the candid explosions of a
religious physiognomy. The throw-up, throw-away loop of *verité*, the soliloquy
and the voice-over are the personae of Fagin's hyphenated generic
miscegenation.

Then, there are the codes of travel itself, and Fagin depends on them
and rips them off in equal measure. For he tilts against the grandiosity of the
odyssey, the bigotry of the pilgrimage, the picturesque voyeurism of the tour,

the inconsequentiality of the strolling *flaneur*, the abstract mission of the adventurer, the unmagic encyclopedism of the ethnographer, the terror of the runaway, the bar-codes of the reporter, the grandstanding of the modern aerialists (the pilot, the balloonist, the cosmonaut), the banality of the commuter and the counter-sensuality of virtual travel (by the hacker, or the cyber-surfer).

And there are the travellers—the crew of persons (verifiable, invented, found and imagined) that inhabit *mondo* Fagin. We meet a guest-list of circa end-of-the-century voyagers, including Gustave Flaubert, Roussel, Lou Andreas-Salomé, Rimbaud, Walter Benjamin, Jules Verne and Pierre Loti. These negotiants with the onset of the twentieth century meet with a more generic cast of mildly millennial types obliviously living out the different dramas of its opposite end: TV reporters, CIA operatives, presidential entourages, missionaries, camera operators, a young woman lost in the jungle.

But as Clifford, again, insists of his own negotiations between types, genres and styles, all 'this is not a nomadology'.[31] It doesn't desire so much abstract subversion, and its multiple instances (codes, persons, histories, image-types) take the place of multiple theorisations. Fagin's discretionary universes of cross-culturated travel transform the stolid interiority of TV's chamber into a rainbow net of movements. They are studies, or *ébauches*, that meet the as-yet 'sketchy' demands for 'a comparative cultural studies approach to specific histories, tactics, everyday practices of dwelling and travelling'.[32]

Films, Suns, Circuses: Counter-travelling Selves

These locations around the theory and practice of some 'postmodern ethnographies', and recent discussions developed in visual anthropology, intersect with only one aspect of Fagin's work. As we begin to think through other connections and refusals, we encounter a series of projects whose sites between the contemporary cultural politics of the art world, experimental film and video, and postcolonial and gender studies, issue in an especially intricate assemblage. Each weave in Fagin's magic carpet is tied in to one of the many levels of video production—script, 'location', theory, 'performance', historical context, editing, sound, screening and reception.
One place within these formats, one way of thinking through their scales and redemptions, is to consider Fagin's relationship to canonical and experimental film or video traditions. The question of 'travel', as problematised by Clifford and others, again provides a point of entry. For it is not only traditional anthropology that 'has privileged relations of dwelling over relations of travel'.[33] Special investments in the static conditions of 'home', 'dwelling' and 'origin' have also marked film production in the post-war years in ways that are instructive for any consideration of *the moves*.

How can we identify Fagin's place in cinemas that take on, or passively contest, the effects of travels and displacement? This question needs more consideration than is possible here; but I want to offer a few points of departure. Fagin's work is clearly remote from the quasi-allegorical, historic-montage of DW Griffith's *Intolerance* (1916), or later epic reconstructions of global narrative legends done in Hollywood drag. But his 'travelling-video' also sounds against the interiorising closures loaded into mainstream and experimental film, from the post-war US comedies of 'social relevance' to Woody Allen; from Antonioni's colourfully decomposed suburbs, to Fellini's Italian labyrinths of home; from the interiorites of John Cassavetes' *Faces* (1968), or Aleksandr Sokurov's nineteenth-century Russian interior-city, to the in-your-face structural closure of Michael Snow's loft (where *Wavelength*, the famous 45 minute forward zoom, was shot from a fixed camera in 1966). Of the several possibilities here, the comparison with Federico Fellini is especially revealing. For among Fellini's films and in his miscellaneous commentaries on and around them, we encounter a whole thesaurus of precious investments in the conditions of 'home', national identity, domestic tourism and the contra-travelling self that mark the antitheses to Fagin's hybrid relocationism. Such vigorous attachment to location and origin is by no means exclusive to Fellini — his Italy, his characters, and his authorship. Something similar is present in the works of Michelangelo Antonioni, John Cassavetes, Ingmar Bergman and other new-wave filmmakers in the 1960s; and it extends the long history of modernist disquisition on the postures, anxieties and dilemmas of the alienated modern self.

In the 'family-centred, domestic, work-a-day world' inhabited by Cassavetes' obsessively scrutinised protagonists, for example, local, interior space seethes with endless permutations. As Raymond Carney puts it, 'there is nowhere to run to' outside the hard-ended parentheses of constant emotional adjustment: for 'if characters run off to construct and temporarily inhabit imaginative worlds, "worlds elsewhere", they and their creators only care about experience insofar as it can be brought back home to those who stay at home. That the American sublime can be domesticated is indeed the dream of America'.[34] Here, even other worlds that are 'imaginative' and 'temporary' cannot be grasped by a neo-sublime subtracted from the landscape and the outside only to be reconvened around a suburban dining-room table.

Antonioni offers us both a philosophy of filmic alienation and internality and a more literal view of the lost cartography of elsewhere. 'Every day,' he once suggested, 'we live an adventure, ideological or sentimental.' But this 'drama is non-communication and it is this feeling that dominates the characters in my film, which I preferred to set in a rich environment because feelings there are not dependent on material circumstances.'[35] A more concrete emblem of this exchangeless 'adventure' is found in *Red Desert* (1964). At the height of her obsessions, Guiliana sits on the floor with a map

of South America (showing Patagonia) on her lap: 'Who knows', she laments, 'if there's a place in the world where we would be better off'. The map slips and the globe dissolves. The only non-suburban territory the film unfolds is a dreamscape of distraction, social dismemberment and placelessness. Places that are only memories or desires, the middle-class evaporation of the social necessities of emigration, the modernist obsession with the labyrinth of the inner self, and isolated, ego-centred voyaging—all are remaindered in Antonioni's lusciously painted cuticles of film as the map of somewhere else falls away.

That which simply slips and fades in Antonioni, is radically disabused by Fellini. For he is the engineer of a face-travel-machine whose interiority is the obsessional obverse of what we will see (in the final section) is Fagin's physiognomy of relocation and cultural encounter. Fellini is emphatically not a traveller, in film or in life:

> I dislike traveling, and am ill at ease on journeys. In Italy, I can manage it: curiosity is aroused, I know what there is behind all those faces, voices, places. But when I'm abroad, this bores me: I no longer know what anything means, I can no longer make anything out, I feel excluded.

> All the same, there is always an atmosphere of travel around me. Arrivals and departures, farewells and welcomes. I love this movement around me.

> My friends are fellow travellers.[36]

In a condition where the non-travelling subject is orbited by surrogate satellite travellers, we traverse a Felliniocentric universe that circles around the xenophobic imaginary of the creative artist. While he adores local transport (especially trams and bicycles), Fellini cannot endure the thought and experience of international transit: for such movement is discomforting, alienating, difficult, obscure and exclusionary. The trouble with travel is that it gives rise to situations that contradict originary experience; the face-to-faces it envisages are blank and empty because they are not formed by bonds of identity, nor can they be satisfactorily controlled, manipulated, or even adequately decoded by the privileged spectator who demands empowerment over them.

In the pseudo-impressionist moments of origin—chanced upon during his picturesque wanderings in his car—ascribed by Fellini to his films, the face is aligned with other, elemental, components of visual experience as the primary particle of filmic possibility: 'That floating, wandering without a goal past things, colours, trees, sky, and the faces that silently filed past the

windows of the car always had the power to gather me up into an ineffable still point, where images, feelings, and intuitions are spontaneously born'.[37] In Fellini's thought, the 'alembic' metering of everyday life in terms of fast cars and capricious gestures gives way to the sensuous exclusivity of locative requirements that are necessary to measure the fullness of the productive context. For Fellini, film is only possible through the specificity of his places, memories, and faces. That's why he could never go to America, not even to make *The Daughter of King Kong*. It's why *La Strada* (1954) must always be the Italian road, and none other, just as *Amarcord* (1973) is always a memory of his home town of Rimini filtered through a Roman dialect. For Fellini, however, even home can be simulated in the blank disengagement of 'tourism'. Despite its association with Mussolini ('the beach chosen by the Duce') he said that he liked to visit the Roman port of Ostia 'because it is an invented Rimini... it is a filmic reconstruction of the town in my memory, into which I can penetrate—how shall I put it?—as a tourist without being involved'.[38]

Fellini demanded that certain conditions frame his film experience: the cinematic self, the 'ready-made' faces of character-actors, memories, dreams and vivid epiphanies. Fellini ordered these ingredients with the passionate abandonment of a distracted tourist. The dominant places in his filmic mind derived from the memory-driven dreamscape of his Italy, and the amniotic 'hovel of Theatre 5' at Cinecittà: 'Whenever there I am protected from falling off the cliff by the capacious net consisting of my roots, my memories, my habits, my home: in sum by my laboratory'.[39] Fellini knows only home-travel and imaginary home-style transit—got up in the manner of the motorcycle-cum-tent-house inhabited by Zampano and Gelsomina in *La Strada*. He even distinguishes his incestuous intimacy with 'Italian reality' and its 'systems of representation, among newspapers, television, publicity, winks of an eye, and the syntheses of images common to us all...' from the experience of middle European emigré Jews, such as Milos Forman and Roman Polanski, who can 'absorb like vampires the history, culture, memories of others'.

Elsewhere, Fellini confessed the cut-off nature of his sense of travelling through the world: discussing his response to ecological catastrophe and the repressions attending 2,000 years of 'Catholic harassment' he said: 'it seems to me that the whole business is a matter of selfish enthusiasm about getting on another Noah's ark and travelling through the centre of the disaster with a chosen few and some animals'.[40] If Fellini seals himself from Catholicism and ecological degradation in an ark of Italian manners, Fagin examines how religions themselves have landed their arks in volleys of salvation on the Ararats of the non-Western world. Fellini's abandon is like the final pre-dawn showdown for the dream of the nineteenth century—the dream of pure European locality, in which all the rest of the world is only oblivion or

spectacle. He willingly abandons himself to the seductions of human 'innocence' and 'beauty', while feeling only 'indifference' or 'listlessness' in relation to the natural world. For Fellini, the only pressing reality of mountains is their theatrical simulation in Cinecittà, where the director-demiurge has them 'fused together... with silk and gelatin'.[41]

'I am', said Fellini, 'like a curious yet bored tourist, a passerby, someone who is and isn't there'. He is a director who doesn't 'play', who doesn't take vacations, who doesn't 'understand anything about boats'; who (the opposite of Walter Benjamin, the scholar-gypsy of mechanical reproduction) is 'not capable of possessing, collecting, storing', and who cannot even cook ('I have never turned on the gas: I am ignorant of what to do to light the flame').[42] In the matter of documentaries and fictions, Fellini has his own perfervid maxim: 'the only documentary that anyone can make is a documentary on himself'.[43] Even Fellini's most vivid commitment, to the old trope of the circus and the *commedia dell'arte* so dear to Picasso and others in the heyday of visual modernism, is for him a symbol for the interior voyaging carried on by the experiential self: 'The circus isn't just a show, it is an experience of life. It is a way of travelling through one's own life'.[44]

Just as Fellini has his non-travelling companions, who journey on his behalf simply by virtue of being with him, so Fagin also, though inversely, looks across to a small band of fellow-travellers (who are never quite there): Jean Rouch (in West Africa); Trinh T Minh-ha (in Africa, China and Vietnam); Chantelle Ackerman (in Russia); Chris Marker (in Guinea Bisau, Siberia and Japan). Even though the facets of displacement and generic layering woven together in Fagin's work take no hostages of imitation or resemblance, his work is perhaps closest in approach to Chris Marker's films, video-essays and fictional cine-novellas—from *Lettre de Sibérie* (1958) and *Sans Soleil* (1982) to *The Last Bolshevik* (1993). Both have made visual lacework with the old-style parameters of the voyage, explored the conditions of encounter with other places and the limits, pleasures, shocks and fantasies that attend the making and editing of moving images away from home.

But Marker puts in something more and leaves out something that is rather less than the densities folded into the visual-textual geographies double-boiled by Fagin in the stockpot of his video moves. Marker offers a more mannered performance of the symbolic self, emanating from a visual scene that is by turns oblique and definite. This 'less', or omission, has several elements: it is underlined—like the poetic 'more' of visual anthropology—in Marker's suggestion that the image might be a *madeleine*—the dissolving memory-taste of Proust, even if this little bite is piqued with 'humility' and fragile 'power' as he also claims.[45] And it is written through Marker's clearly marked (if ambiguously performed) positions as the diarist, the narrator, the writer-poet, the activist and the 'founder, editor and writer' for Editions de Seuil Planète.[46]

On the other hand, there is a 'more' caught up in a web of fabrications that fictionalise the subject positions of the Maker-Marker. These include exotic, invented, biographical details: Marker refers in one place to 'we Brazilians', and elsewhere to the 'we' who might have been born (for dramatic effect) in Ulan-Bator rather than a Parisian suburb. All these dispersed personae—with their ineffable origins and unflappable presents— are quite distinct (perhaps generationally as much as anything else) from Fagin's measured non-interventionism of the self. The aura encoded in Marker's vague, sometimes ironic, aggrandisements is entirely foreign to Fagin's finessed dissociation from almost all visible or sounded (and therefore, literal) self-inscription. Marker, in other words, simultaneously surrenders to the poetry of the other place, and reigns himself back with an intrusive, confessional, believable, diary-documentary voice. As a result, his pieces are strangely, pleasurably, but also easily, sutured, joining together the imaging of intangible others and the fantastic travels of Mandeville, with a lyrical, yet foot-firm, anecdotal, walk-and-talk-about, 'I'. As has been said of Rousseau (and we have seen of Fellini), it is almost as if 'places are so many figures of himself'.[47]

From the Box to the Net

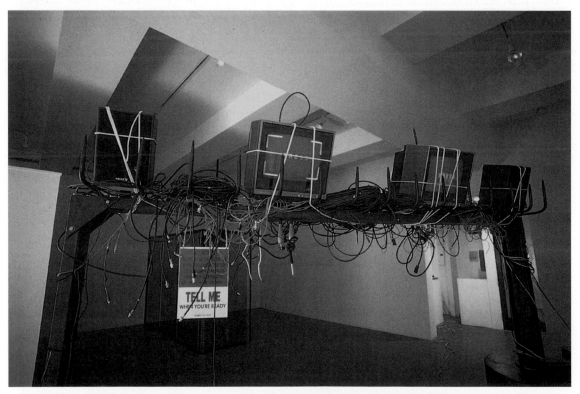

Julia Scher, *Tell Me When You're Ready*, 1994, installation from ***Derek Jarman, Craig Kapakjian, Julia Scher***, Andrea Rosen Gallery, New York (July 11–August 11, 1995). Courtesy Andrea Rosen Gallery, New York

Fagin's video-box (if not all that's in it) also stands somewhere at the end of that long tradition of cubing the world I discuss in Chapter 7. The linguistic 'mirrors' and visual 'nesting boxes' that threaten the discourse of visual anthropology dwell in Fagin's monitor-sized globe like fallen angels. But they also enframe it, for the box is the parenthesis, or square brackets, of video as it offers a dwelling place to a moving world. Among the boxes and containered spaces of the post-war art world, Fagin's TV face-to-place machine shares something with the jewelled interiority of Joseph Cornell's cluttered miniatures, but wants very little of the glossy perceptual apparatuses of Minimalism. Indeed, the short genealogy of boxed-up processes and selves that runs from Robert Morris' *Box with the Sound of its own Making* (1961) to his *I-Box* (1962) returns an obsession with making-time, and with the conditions of (phallic) selfhood utterly alien to the exchange mechanisms that move through people, territories, and histories in Fagin's videos.

Fagin's solitary box fights for its very existence in a world where the cubed image has become either ferociously engorged through multiplication, miniaturisation, installation, or has fallen into tragic or sublime enigma—two positions that often form a single switch. Its extension in singular depth contends with the superficial lateral spread of the TV image in the monitor-environments of 'video-art', and with the snapshot metaphoricity of recent photo-installations. In the work of Alfredo Jaar, for example, the quasi-reportorial photographic image has become a means of bearing political 'witness'—recently in Rwanda, Uganda and Zaire, following visits in August 1994. The results of this art-as-witness, shown at Galerie Lelong in New York (May–June 1995), are ordered in archival Minimalist-type boxes, which can't (or shouldn't) be opened. This gesture has its measure of effectiveness, but it follows the logic of the appropriated memorial image to its ultimate destiny in silence and withdrawal. The tragedy of the photographic *ars memoria* is sufficient to deny its visibility (though it can be read, and thus 'imagined', in the form of remaindered captions). Travel as tragedy-without-seeing is one quite logical product of the destiny of politically predetermined visuality. The result is a mummer-box, a pantomime cube covered by an art-world blindfold. As such, it takes its place alongside other species of altarpiece frontality and single-image iconicity, which offer little more than facades for the decorative sojourn of ideas and places. There is something inevitably religious (but not quite revelatory) in refuges, for they function either as graves for graven images, headstones for marking, or moments for ritual reflection.

Ritual is also the site in which static-image disquisition meets multi-image installational video. So pronounced is this intonation in the recent work of Gary Hill (highbrow criticism's favourite exponent of video art) that his citational chants and monitor montages have earned for him the epithet

'magic theorist'.[48] Layering Wittgenstein's *Remarks on Colour*, passages from Maurice Blanchot (*Beacon* and *And He Sat Down Beside Her*, 1990), and run-on excepts from Martin Heidegger's 'The Nature of Language' (in *Between Cinema and a Hard Place*, 1991)[49] among a little archive of lifted musings, theory becomes almost like a Gregorian chant here. It is a wallpaper sound-wrap for the blank, emotive neo-sublime that flickers through a winsome assemblage of hi-tec, variscale screens. The result is a kind of shadow-boxing match between neo-phenomenological theory and the evasive tonalities of video art. Sometimes the arena will be a little room, sometimes a confection of corridors and post-Minimalist labyrinths. In both conditions, the far-off, or exotic, is spectacularised not so much by virtue of its colourful otherness as by means of the internment of its image in a reception machine that makes the image votive, disjunct and finally abstract—that gathers all the retinal effects of the home-body-self-other-foreign-place into singular pop-up moments whose snatched natures are rendered even more detached by their febrile visualisation and their hushed interference with the viewing context. Recent discussion of Hill has foregrounded these developments, but not really attended to their implications, especially to the future of their allusion. In the process, speculative phenomenological experience is forced into incommensurable relationships with Deleuzian or Derridian theory, giving rise to strange disembodiments and counter-corporeal paradoxes. *Suspension of Disbelief (for Marine)* (1992), is held to 'offer a sensuous paradigm for an ecstatic transcendence of the physicality of direct sexuality'. Works take on the condition of a 'reliquary', subtend a 'self-contained form of reality',[50] or are claimed as counter-visual (in relation, for example, to Martin Jay's account of French philosophy and critical theory)[51], yet at the same time 'phenomenologically precise'.[52] The perceptual (imaginary) religiosity claimed for Hill operates in an aspirant virtuality (whose ether is text, spoken words, light, blankness, seen body-parts, machine-boxes, and post-Minimalist environments). By contrast, the encountered religious syncretisms, horror stories and bewitchments of Fagin's videos function in a system where virtuality always overlays place, and where knowledge is co-produced by location—not just by scrutiny, quotation and textual 'envisioning'.

Faces occasionally make their appearance in this entourage, most notably in Hill's *I Believe it is an Image in Light of the Other* (1991–92), where they are overlaid with text to form unreadable written visages. Such faces are a strange compound of pure light and print, blacks and whites, whose condition speaks more of their momentary entrapment in the box of images, than of their release into the rainbow net of dimensional possibilities. Such pixilated physiognomies offer the face only as a simulation of the cube. They are face-page-profiles. As we shall see—and as Fagin shows and Walter Benjamin has written—there are other, more profound, possibilities for the face-in-the-box.

Face-to-Place

...does the city possess its own facade? At which moment does the city show us its own face? (Paul Virilio)[53]

The geographies and displacements, commitments and pleasures layered together in the videos of Steve Fagin remind me before anything else of the concentration, intensity and spiralling sentences of Walter Benjamin—whose historical voice is filtered through the male narrator in *The Amazing Voyage*. It is not just that they both partake in the joys of the fragment, in browsing, details, cities, arcades, libraries, love-quests, disenchanted political engagement—among a myriad of shared likes. Nor that their work shares a passion for the nostalgias of the nineteenth century, the image-machines of mechanical reproduction, and the abandonment of wandering between places. Rather, there's something that is lodged in the foundations of their often baffling architectures of ideas, passions, places and positions: a certain dedication to what I want to call the 'face of the world' as it is caught on the move.

The space between Fagin and Benjamin converges on the face. Fagin offers a glimpse of what Benjamin identified in his theory and history as the very basis of the photographic image—its revolutionary aspect. Benjamin's writings arc sustained by three crucial forms of facial enunciation. The first is located in the general drift of his thought towards the articulation of a 'materialist physiognomics'. The second is more specific and is caught up in the several instances of the face-city as they are inscribed in Benjamin's strangely luminous 'city-portraits'. The third (the most literal and perhaps the least susceptible to critical elaboration) is founded on several kinds of identification of Benjamin with the face—both in his own essays and fragments, and in the critical literature discussing them. In this third form, which culminates in Derrida's suggestive formula, the Benjamin *front* (simultaneously his forehead, his forward-facing and his battle-zone), the writer somehow merges with his (self)portrait or his face. The writer is overlaid by his self, his song, and the desire and failure of the revolution, all at once. It is his critical epiphany.[54]

In these three forms (a recto, verso and sides, if you like) and their necessary intersections, the face lies at the centre of Benjamin's converging projects on the origins and social philosophy of modernity. It is one of the chief routes along which the writer might travel 'to attain' something much desired: what Benjamin termed 'a heightened graphic-ness [*Anschaulichkeit*]'.[55] It is a meeting point for Benjamin's attempt to provide a solution to the problems of historical materialism through a montage of citations and subjective-counter-subjective musings. For only in this way can a face be known. The fragments he constructed are the facets that make a facade: the ruinous architecture and the architectural ruins of the face of

modernity. The face is aligned with the focal length of Benjamin's dreams. Its parts are made up of their colours: profane illumination and mimetic experience; the critique of history and myth; and his ultimate dream, the dream of the nineteenth century from which we must awake.

In one of the few discussions of Benjamin that takes some account of the social coding, metaphoricity and subjective intensities of the face, Rolf Tiedemann points to his desire to use the face as a means to 'recover', to gain an impression of, 'the ever more rapid obsolescence of the inventions and innovations generated by capitalism's productive forces'. Such a recovery would brandish 'the appearances of the unsightly [rag-pickers, prostitutes, streets etc], *intentione recta*, the physiognomic way: by showing rags, as a montage of trash'. The face is an instrument that, when read by its commentators, renders visible something of the marginal and unconscious effect of capital and its movements. It is with these thoughts as a backdrop that Tiedemann identifies the central effort of Benjamin's work as a 'material physiognomics':

> Benjamin did not set out according to ideology critique; rather he gave way to the notion of materialist physiognomics, which he probably understood as a complement, or an extension of Marxist theory. Physiognomics infers the interior from the exterior, it decodes the whole from the detail, and it represents the general in the particular. Nominalistically speaking, it proceeds from the tangible object; inductively in the realm of the intuitive...[56]

This coupling of the materialism of one history with the form and scope of another reveals a shape, a corrective and a compulsion in Benjamin's understanding of the inherited past. But we should resist positioning the face according to a vulgar symptomology, a kind of facial determinism that sees the countenance as a mere scene of inscription for the crow-footed march of historical reality. The face is a multiplex screen of histories, causes and selves. It is a machine that simultaneously manufactures difference and mills identity.

Tiedemann argues further that the transition from the first to the second drafts of Benjamin's *Passagen-Werk* project (1927-40)— which entailed an effort 'to safeguard his work against the demands of historical materialism' — preserved 'motifs belonging to metaphysics and theology... in the physiognomic concept of the epoch's closing stage'.[57] He provides further arguments for Benjamin's concretion and specificity, modelled on the illuminations of the face:

> The abstractions of mere conceptual thinking were insufficient to demystify... [capitalism's abhorrent effects], such that a mimetic-intuitive

corrective was imposed to decipher the code of the universal in the image. Physiognomic thought was assigned the task of 'recognising the monuments of the bourgeoisie as ruins even before they have crumbled' (V:59). The prolegomena to a materialist physiognomics that can be gleaned from the *Passagen-Werk* counts among Benjamin's most prodigious conceptions. It is the programmatic harbinger of that aesthetic theory which Marxism has not been able to develop to this day.[58]

The face becomes an emblem of that still point of presentness that Benjamin argued was needed by historical materialism for its effectiveness to be made known. For Tiedemann, Benjamin 'speaks in direct theological terms in his interpretation of the modern as "the time of hell"':

The point is that the face of the world, that enormous head, never changes, certainly not in what is the newest, that this 'newest' remains the same in all its parts. This constitutes both the eternity of hell and the sadist's desire for innovation. To define the totality of the features by which the modern expresses itself means to represent hell. (V: 1010ff.)[59]

For Benjamin, the ultimate visage is the giant, demonic face of the world whose expressions—and attendant interpretations—are the very countenance of hell. Throughout Benjamin's writings, the face will reappear haunted by this satanic prototype. But when he returns to the *Passagen-Werk* project in 1934 he writes of its 'new face' (V: 1103), his own turn to a thought that was more sociological and political. The new face of social possibility replaces the fetish character of commodities, the phantasmagorias and lustres laid over the beguiling faces of the nineteenth century.

Part of this face, a special landscape-face, is also underlined in allegory, where 'the observer is confronted by the *facies hippocratica* of history as a petrified, primordial landscape. Everything about history that, from the beginning, has been untimely, sorrowful, unsuccessful, is expressed in a face—or rather a death's head'.[60] And the face has yet another special home in the photographic image, in the course of a description of which Benjamin offers one of his most celebrated physiognomic metaphors:

At the same time photography reveals in this material the physiognomic aspects of visual worlds which dwell in the smallest things, meaningful yet covert enough to find a hiding place in waking dreams, but which enlarged and capable of formulation, make the difference between technology and magic visible as a thoroughly historical variable.[61]

These moments of discussion constitute the armature for a materialist physiognomics, but the clearest profile of the face arrives for Benjamin (as

for Fagin) with the reception and experience of a foreign city—the Naples he wrote about in 1925, Moscow (1927), Marseilles (1929), and his book project *Berliner Kindheit um Neunzehnhundert?* (begun 1933). As Peter Szondi notes 'it is metaphor that makes Benjamin's city portraits what they are. It is the source of their magic and, in a very precise sense, their status as poetic writing'.[62] But if, as Szondi asserts, 'the metaphorist's glance proves to be that of the theologian's',[63] we should give priority, not as Szondi does to the displacements of the 'name' or the 'glass globes in which snow falls on a landscape' (Benjamin's 'favourite objects'), but to scrutinising the chief of all Benjamin's many metaphors of the city, the one that defines it first and foremost as a portrait, and more particularly as a face.

Szondi contends that Benjamin's *Städtebilder*, or city portraits, are combinations of memory and memoir, forms of childhood knowledge layered with its travesties. The face of one's own city is in this sense the face of the mother, at first seen as a mere extension of the body-self, then as a traumatic object outside the self. The foreign city is both a return to this fantasy ('foreign surroundings do not just replace the distance of childhood for the adult; they turn him into a child again')[64] and its opposite, a scene of pure difference, of exaggerated otherness, where the subject can wander without recognising his own origins and familial scenes. As an arena of the pleasure of non-recognition, this city offers the face of a stranger. Sometimes it is the face of erotic desire, as opposed to the face of maternal love. But it can rarely be the face of a companion, friend, confidant, a close-face, as the foreign city is by definition distant and of short acquaintance. The home city is a face of becoming, change, transition, passage; the foreign city is a theatre-set for the play of desire, and a short-circuit back to the traumas of the early self.

When the face of the city as desire is passed over by a paternal mask that presents the city as authority, order and serial repetition, the liberatory play of the desired, pleasured faces of the child and the lover are dissolved. Such is the case with Moscow's burgeoning image-cult of Lenin, which Benjamin details in the final pages of his essay, 'Moscow', and which were sprinkled throughout the entries in *Moscow Diary*: 'In corners and niches consecrated to Lenin, they [images of the leader] appear as busts; in the larger clubs, as bronze statues or reliefs; in offices, as life-size half-length portraits; in kitchens, laundry rooms, and storehouses as small photographs'.[65] Benjamin's attention to the face of city life merges here with the religious efficacy of the saintly face and the usurpation of this sign by the personality cults of totalitarianism. Not only do the figures of Lenin take over the 'corners and niches' traditionally reserved in the *izbar*, or village wooden house, for the worship of icons, but they also invade key material and generic orders of visual representation, specifically itemised by Benjamin as 'busts', 'bronze statues', 'reliefs', 'life-size... portraits', and 'small photographs'.

Benjamin catches the suffocating domination of the state-as-a-face (the ultimate territorial metaphor of the face, one fit to compete with the Face of God) even more immediately when he notes that 'since the selling of icons is considered a branch of the picture and paper trade, these booths with pictures of saints tend to be located near paper goods stands, so that everywhere they are flanked by pictures of Lenin, like a prisoner between two policemen'.[66]

Two unfathomable faces obsess Benjamin in his Moscow Diary, written in the winter of 1926–27: the face of Asja Lacis and the face of Moscow—the close-up, near-sighted, scrutinised, miniature city invented in Benjamin's incessant browsing and looking down, a city of shelves and gutters and toys. Benjamin notes the 'desperate details' of his courtship with Asja ('a Bolshevik Latvian from Riga'),[67] to whom his One-Way Street (1928) is dedicated, and whom he had met on the island of Capri in May 1924, encountered again in Berlin later the same year, and again in Riga in 1925. He is seduced, distracted and perhaps appalled by her face, which is the object of his most intense scrutiny: 'I barely hear what she is saying because I am examining her so intently'.[68] At the Prague restaurant he recalls 'we were sitting there face to face, musing about my departure, looking at each other ...'.[69] What he sees is 'not beautiful [but rather] wild... puffy from all the time she had spent bedridden';[70] her face is a modified rainbow of pale colours: 'Since the colour of her face, partly by nature, partly on account of her illness and the stress of the day, was also a yellow in which there was not the slightest trace of red, her entire appearance consisted of the gradations between three closely neighbouring colours'.[71]

Between the face of the object of desire and the tumultuous physiognomy of the quasi-revolutionary city, Benjamin locates himself in a drift of cross-identities.[72] For the intensity of the double face of Moscow Diary offers a refuge from theory, and a concomitant outpouring of immediacies and sensations. The face of Moscow is both a substitute for, and composite of, Benjamin's faciality. The dominance of the face provokes a relinquishment of abstraction and 'theory'. While a major incentive for his visit were various 'literary obligations' to 'render'... the "physiognomy" of Moscow' (which resulted in four publications in early 1927), it was as Benjamin noted, the 'situation'[73] of Moscow that most concerned him, its revolutionary present, its composure, texture and contemporary expression. In a letter to Martin Buber of February 23 1927, written after his return from Moscow (having nearly completed the Moscow essay for Die Kreatur) Benjamin spells out the counter-theoretical status accorded to his Moscow projects:

> My presentation will be devoid of all theory. In this fashion I hope to succeed in allowing the creatural to speak for itself: inasmuch as I have succeeded in seizing and rendering this very new and disorienting

language that echoes loudly through the resounding mask of an environment that has been totally transformed. I want to write a description of Moscow at the present moment in which 'all factuality is already theory' and which would therefore refrain from any deductive abstraction, from any prognostication, and even within certain limits from any judgement—all of which, I am absolutely convinced, cannot in this case be formulated on the basis of 'spiritual' data, but only on the basis of economic facts of which few people, even in Russia, have a sufficiently broad grasp. Moscow as it appears at the present reveals a full range of possibilities in schematic form: above all, the possibility that the Revolution might fail or succeed. In either case, something unforeseeable will result and its picture will be far different from any programmatic sketch one might draw of the future. The outlines of this are at present brutally and distinctly visible among the people and their environment.[74]

Allegory, photography, cities and selves, even the projects of materialism and of 'history' itself ('to write history means giving dates their physiognomy')[75] are each caught up under the auspices of the face. If we follow the trail of this metaphor of facial issuance, and pursue the 'carrying over' of facial attributes into the visual morphology of places, we must underline that this concern centres, precisely, on the tropic elaboration of the face, how its shapes, intensities and imaginations have been mapped onto the 'objective world'; carried over into regimes of identification, rapture, or distress at the perceptual conditions of a particular environment or social situation. While facial descriptors have been correlated with various aspects of the natural world since ancient times, more recent distributions of the metaphor of physiognomy respond to the popular acceptance, first of the discourses of physiognomy and caricature, and then of the photographic and filmic face. A crucial change is marked at the beginning of the nineteenth century, as the 'natural' conditions of the face-landscape machine give way to the constructed parameters of built or invented worlds (though its remainders are always visible). The two great repositories for the metaphor of physiognomy in the modern era are the environments of urbanism (the city-face) and the new technological environments of the photo-filmic face, both of which have been transposed into the virtual technologies of the 1990s.

At its furthest reach, this metaphorisation of the face of the world merges with the fetishistic Romantic imaginary traversed by Novalis' thousand 'portal[s] to the universe': 'anything that is strange, accidental, individual... A face, a star, a stretch of countryside, an old tree etc may make an epoch in our inner lives'.[76] But this is a Medusa's head of social physiognomy, whose infantile gaze and all-over erotic allure are sometimes

indulged but elsewhere carefully resisted—on behalf of their respective histories—by both Benjamin and Fagin. Neither wish to deny the inner life, and both are at times thrillingly overwhelmed by it (Benjamin in Moscow; Fagin in his first two tapes). But what they labour to achieve is some measure of the vivid social conjunctions of their presents, points of merger and rupture and pleasure in the discourses of social becoming.

I offer the face, threaded through the subtle machinery of Benjamin's thought, as a measure of the parametrology of the moving image; as a necessary complement to the propulsions of travel, distance and unknowing. It is not a coincidence that reimaginations of the face are crucial to the projects of several film and video makers whose paths we have already crossed. For Fellini the face was the absorptive surface of cinema itself, the black hole with white walls that collapsed film into the ceaseless imagining of passionately found character-subjects. For Trinh T Minh-ha, the face has an opposite centrality as the measure of a daring 'poetic' extension and simultaneous critique of ethnographic knowing, a showing of the instability of identity itself. For Chris Marker, as with one of the three aspects of Benjamin's thought, the face stands in a condition of allegorical, portrait-like representation: it stands in. Marker described *The Last Bolshevik* as a film that 'attempts to trace the portrait of this generation through the portrait of a friend'. Though crossed with stars and lovers this was also Walter Benjamin's effort in his *Moscow Diary*, written in the winter of 1926–27, a few years before Medvekin was sending his 'reality-shows' all around the Soviet Union in painted railroad cars. In Marker's *The Koumiko Mystery* (1965) the face of Koumiko Muraoka stands in for the unknowability of a culture, leading one viewer to write that 'Koumiko is never made to represent Japan, but she seems in the best passages to replace it'.[77]

For Fagin, as for Benjamin at his most persuasive, the face has a more sustained metaphorical presence. It is a 'real' metaphor that reaches between the social abstraction of theory and the instantiation of geographies and places. It stands for the vivacity of encounter, the shape and feel of a territory, even the welling-up of desires and poetries. But it is seldom literal and rarely fetishised. It can be sighted in the shoes of Imelda Marcos, the hats of the Ecuadorian Highlanders, the scattered sexuality of Lou Andreas-Salomé, or an anagram by Raymond Roussel. It is a place of making known by intensity, by visions and sounds, movements and unfaded references. It offers an almost magic making over—in the box—of the face-to-face as a face-to-place.

Fagin's fractured, layered or composite vision, of which his new physiognomy is just one part, contributes to the wider paradigm of cultural post-appropriation in the 1990s in several ways. Like many of the artists and theorists discussed here, Fagin's videos refuse the polarisations that attended the discourse of appropriation in the 80s. Above all, Fagin's images are never

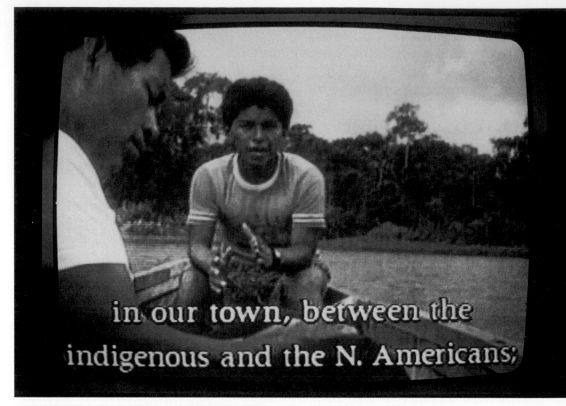

Steve Fagin, *Zero Degrees Latitude*, 1993, video still. Courtesy the artist

merely 'taken'. While resisting stringent reflexivity or mannered postmodern digression, they admit the self, the video-maker, his contexts, characters, assumptions — and errors — not only into the events or textures of the moving image, but into its structure. They find new forms and languages with which to open up the effects of colonialist history, religious codes, and non-western social rituals. And they attempt to find new spaces for cultural emergence, sometimes through the kinds of surprise and pleasure that can only emerge in situations of difference. Fagin's struggle is not over the politics of genre, but with genres of politics and social orders, and with the competition of representations that he finds, invents and merges. Most telling of all, perhaps, Fagin's project offers an uneasy, and uneven, response to the sweeping reconfigurations of anthropology and its recent interrogation of visual media, which have themselves been organised around its historical tendency uncritically to appropriate aspects of non-western cultures. As we have already seen of its filmic parameters, the project of pre-revisionist anthropology can be described as an effort to produce the most perfect (uninflected, 'objective', scientific, etc.) rendition of other peoples and places. It was predicated on a dream of the perfect copy, achieved through frictionless appropriation.

Curiously, the way that anthropological rethinking encounters the culture of appropriation is only to reject one kind of taking in favour of another. According to the most recent study of the relationship between film and anthropology, 'the future of an anthropological cinema may lie with an eclectic borrowing from fiction and art films rather than a slavish adherence to the norms of the documentary'.[78] This new melange is described as 'a well-articulated genre distinct from the conceptual limitations of realist documentary and broadcast journalism. It borrows conventions and techniques from the whole of cinema — fiction, documentary, animation, and experimental. A multitude of film styles vie for prominence — equal to the number of theoretical positions found in the field', including 'a critical approach that borrows selectively from film, communication, media and cultural studies'.[79] Could it be, however, that the exercise (actually termed a 'fantasy' by the author of these remarks, Jay Ruby) of bringing anthropology into creative contact with other film and intellectual genres — somewhat along the lines of what Rouch termed thirty years ago 'a shared anthropology',[80] has already been achieved in the work of Fagin and his fellow travellers, whom we have caught in the very act of staging the incorporation in reverse?

NOTES

1. This chapter is adapted from my concluding chapter of Steve Fagin (ed), *Talking With Your Mouth Full: Conversations with the Videos of Steve Fagin*, Duke University Press, Durham, North Carolina, 1998; a preliminary version appeared as 'Moving Images: On Travelling Film and Video', *Screen*, vol 37, no 4, winter 1996.

2. See especially 'Building, Dwelling, Thinking', in Martin Heidegger, *Poetry, Language, Thought*, trans Albert Hofstadter, Harper & Row, New York, 1971, pp 142–61. Here he writes, for example, that: 'To say that mortals are is to say that in dwelling they persist through spaces by virtue of their stay among things and locations' (p 157).

3. James Clifford, 'Travelling Cultures', in Lawrence Grossberg, Cary Nelson and Paula Treichler (eds), *Cultural Studies*, Routledge, London, 1992, pp 96–116.

4. Ibid, p 99

5. Ibid, p 101.

6. Ibid.

7. See James Clifford, *Writing Culture: The Poetics and Politics of Ethnography*, James Clifford and George E Marcus (eds), University of California Press, Berkeley, 1986.

8. Basil Wright, *The Long View*, Knopf, New York, 1974, p 502.

9. The fullest account of Jean Rouch's 'ethnographic film' is Paul Stoller's *The Cinematic Griot: the Ethnography of Jean Rouch*, University of

Chicago Press, Chicago, 1992. See also, *Visual Anthropology*, no 2 (3–4), 1989, special issue on 'The Cinema of Jean Rouch'.

10. See Stoller, *The Cinematic Griot*, op cit, pp 6, 162.

11. Ibid, Chapter 11, esp p 202.

12. Mary Catherine Bateson, *Media Anthropology: Informing Global Citizens*, Bergin and Garvey, Westport, Conn, 1994, p xiv.

13. See Karl Heider, *Ethnographic Film*, University of Texas Press, Austin, 1976. Flaherty's igloo is a reference to the 'home-improvement' sanctioned by Robert Flaherty when he had an igloo artificially enlarged during the shooting of *Nanook of the North* (1922) so that he would have room to film the domestic activities inside.

14. See Peter Ian Crawford, 'Film as Discourse: the Invention of Anthropological Realities' in Peter Ian Crawford and David Turton (eds), *Film as Ethnography*, Manchester University Press, Manchester, 1992.

15. Clifford, 'Travelling Cultures', op cit.

16. Dai Vaughan, 'The Aesthetics of Ambiguity', in *Film as Ethnography*, op cit, p 105.

17. For a discussion of the relationship between anthropology and fiction film in India see KN Salay, 'Visual Anthropology and Indian Fiction Films', in *Journal of Social Research*, vol 29, no 2, 1986, pp 1–41.

18. Trinh T Minh-ha, 'Professional Censorship', interview with Rob Stephenson in *Framer Framed*, Routledge, New York, 1992, (originally in *Millennium Film Journal*, no 19, Fall/Winter 1987–88), pp 217–18).

19. Trinh T Minh-ha, 'From a Hybrid Place', interview with Judith Mayne, in *Woman, Native, Other: Writing, Postcolonialism and Feminism*, Indiana University Press, Bloomington, 1989, p 137.

20. Ibid, p 148.

21. Trinh T Minh-ha, 'Film as Translation', interview with Scott MacDonald, in ibid, p 129. In *Naked Spaces* the soundtrack of three differentiated female voices offers a triple register of commentary—local/traditonal; personal; and voices imbued with 'Western logic'; see pp 127f.

22. Eric Michaels, *Bad Aboriginal Art: Tradition, Media and Technological Horizons*, University of Minnesota Press, Minneapolis, 1994.

23. David MacDougall, 'Complicities of Style', in *Film as Ethnography*, op cit, p 94.

24. See Béla Balázs, *Theory of the Film: Character and Growth of a New Art*, trans Edith Bone, Dover Publications, New York, 1970, esp Chapters VII, 'The Close-up' and VIII, 'The Face of Man'.

25. In the question of the representation of the faces of others, Trinh T Minh-ha has made an especially powerful intervention, going so far as to reverse MacDougall's suggestions. Her films are in a special sense both centred and decentred on the envisioning, particularising, fracturing and metaphoric relocation of faces, a process that she

foregrounds in the selection of stills that illustrate the film scripts and interviews in *Framer Framed*, and the cover of her collection of critical writings *Woman, Native, Other: Writing, Postcoloniality and Feminism*.

26. This phrase is the title of the first essay in *Woman, Native, Other*.

27. Clifford, 'Travelling Cultures', op cit, p 102.

28. See Patricia Mellencamp, 'Disastrous Events', in Steve Fagin (ed), *Talking With Your Mouth Full: Conversations with the Videos of Steve Fagin*, Duke University Press, Durham, North Carolina, 1998, pp 223–36.

29. Fagin's four major video works have been shown at the Whitney Biennial and at the Museum of Modern Art, New York, in a retrospective in 1993, as well as at festivals and academic venues in the US and Europe. These pieces combine ceaseless wit, complex forms of political engagement, visual irony and technical inventiveness with investigations of gender and ethnic identities, and First- and Third-World powers. Commentary on Fagin's work includes a revealing interview with Peter Wollen in *October* magazine ('An Interview with Steve Fagin', no 41, Summer 1987); discussion in *Camera Obscura* (Vivian Sobchack, 'The Occidental Tourist', no 24 October 1991); and in Patricia Mellencamp's *High Anxiety: Catastrophe, Scandal, Age, and Comedy*, Indiana University Press, Bloomington, 1992. These and other essays are published in *Talking With Your Mouth Full*, op cit.

30. For a wide-ranging discussion of the political, symbolic and social relativity of maps, see Denis Wood, *The Power of Maps*, Guilford Press, New York, 1992. I am here indebted to the discussion developed on pp 194–95.

31. The phrase is again from Clifford's essay, 'Travelling Cultures'. While I think I understand the motivation for what has become the quite generalised (almost always under-specified) demonisation of a set of ideas developed most notably by Gilles Deleuze and Félix Guattari in the two volumes of their *Capitalism and Schizophrenia*, I would also suggest that there is much that is radical and challenging in this discussion. For a summary of different formations of nomadological discourse (in anthropology, in literary travel writing and in critical theory) see my column, 'Here, There and Otherwise', *Artforum*, January 1989.

32. Clifford, op cit, p 108.

33. Ibid, p 99.

34. Raymond Carney, *American Dreaming: The Films of John Cassavetes and the American Experience*, University of California Press, Berkeley, 1985, p 301.

35. Michelangelo Antonioni, cited at http://www.openix.com/~danb/avventur.htm

36. Federico Fellini, 'Miscellany I—I'm a liar, but an honest one', in *Fellini on Fellini*, trans Isabel Quigley, Eyre Methuen, London, 1976, pp 53–54.

37. Fellini, in Giovanni Grazzini (ed), *Comments on Film*, trans Joseph Henry, The Press at California State University, Fresno, 1988, p 112.

38. Fellini, 'Rimini, My Home Town', in *Fellini on Fellini*, op cit, pp 32–33.

39. *Comments on Film*, op cit, p 115.

40. *Comments on Film*, op cit, p 141.

41. *Comments on Film*, op cit, p 143.

42. *Comments on Film*, op cit, pp 143–47.

43. Fellini, 'Why Clowns?', in *Fellini on Fellini*, op cit, p 120.

44. Ibid, p 121.

45. Chris Marker, *Immemory* proposal, January 1994, p 3, cited in Bill Horrigan, 'Another Likeness', in *Chris Marker: Silent Movie*, Wexner Center for the Arts, Columbus, Ohio, 1995, p 9.

46. A 'series of travelogues that blended impressionistic journalism with still photography', Museum of Modern Art, Department of Film, New York, notes for 'Chris Marker: A Video Selection', p 1.

47. JB Pontalis, cited in Georges Van Den Abbeele, *Travel as Metaphor: from Montaigne to Rousseau*, University of Minnesota Press, Minneapolis, 1992, p 120.

48. The term 'magic theorist' was used by Roberta Smith in a review of Hill's work in the *New York Times*, May 12 1995, p C23.

49. See Martin Heidegger, *On the Way to Language*, trans Peter Hertz (Section 2, 'The Nature of Language'), Harper, San Francisco, 1971.

50. Lynne Cook, 'Postscript: re-embodiment in alter-space', in *Gary Hill*, Henry Art Gallery, University of Washington, Seattle, 1994, pp 81–82.

51. Martin Jay, *Downcast Eyes: The Denigration of Vision in Twentieth Century French Thought*, University of California Press, Berkeley, 1993.

52. Bruce Ferguson, 'Deja vu and Deja Lui', in *Gary Hill* (1994), op cit, p 19. This claim aside, Ferguson offers a cogent account of the 'textual' orientation of Hill's work, discussing its commitment to time, sound and the 'choreography of space' as opposed to 'vision'—which allies his project with the conditions of speech (p 20). Insofar as this account accurately serves for Hill's work, I would suggest that it is not so much speech itself that might stand at the metaphoric intersection for the artist's work, as the conditions of possibility for speech—even as they are caught in a tangle of articulations. This has to be insisted upon precisely because of Hill's own commitment to what he phrases—in relation to *Beacon (Two versions of the imaginary)*—as 'the enchanting light of the beacon that seduces and leads to a shipwreck of consciousness' (p 24).

53. Paul Virilio, *Lost Dimension*, Semiotext(e), New York, 1991, p 12.

54. See Jacques Derrida, *The Truth in Painting*, trans Geoff Bennington and Ian McLeod, The University of Chicago Press, Chicago, 1987. In addition to Derrida's proposal of the Benjamin front, several other

writers develop an account of Benjamin in and as physiognomy. See Theodor Adorno, 'A Portrait of Walter Benjamin', in *Prisms*, trans Samuel and Shierry Weber, MIT Press, Cambridge, MA, 1981, pp 229–41; and Winifred Menninghaus, 'Walter Benjamin's Theory of Myth', in Gary Smith (ed), *On Walter Benjamin: Critical Essays and Recollections*, MIT Press, Cambridge, MA, 1988, pp 292ff: 'To reconstruct Benjamin's use of the term "myth" is to present a comprehensive portrait of his thought' (p 293). Menninghaus also refers to 'the physiognomy of Benjamin's thought' (p 293).

55. Rolf Tiedermann, 'Dialectics at a Standstill: Approaches to the *Passagen-Werk*', in Gary Smith (ed), *On Walter Benjamin: Critical Essays and Recollections*, MIT Press, Cambridge, MA, 1988, p. 265 (from N 2, 6).
56. Ibid, p 279.
57. Ibid, p 280.
58. Ibid, p 281.
59. Ibid, p 273.
60. Walter Benjamin, *The Origins of German Tragic Drama ('Allegory and Trauerspiel')*, New Left Books, London, 1977, p 166.
61. Walter Benjamin, 'A small history of photography', in *One-way Street and Other Writings*, trans E Jephcott and K Shorter, New Left Books, London, 1979, p 243–44. Also cited in Michael Taussig, *Mimesis and Alterity: A Particular History of the Senses*, Routledge, London, 1993, Chapter 2, 'The Physiognomic Aspects of Visual Worlds', p 24, where Taussig emphasises the tactile nature of physiognomy, not its facelikeness. Later in this study (p 81) he discusses Darwin's encounter with the Fuegians who imitate the ship's crew: 'It's as if the Fuegians can't help themselves, that their mimetic flair is more like an instinctual reflex than a faculty, an instinct for facing the unknown—and I mean facing. I mean sentience and copying in the face of strange faces. Note the way they are painted, especially the face, especially the eyes. Note the grimacing of the face that sets off a chain reaction between sailors and Fuegians'.
62. Peter Szondi, 'Walter Benjamin's City Portraits', (1962), trans Harvey Mendelsohn, in *On Walter Benjamin*, op cit, p 26. He notes further that 'as Proust himself came to realise, metaphor aided him in his search for lost time' (p 28); 'metaphor helps Benjamin paint his city portraits as miniatures, much like his preferred form, the fragment'. (p 28).
63. Ibid, p 30.
64. Ibid, p 22. Also: 'a foreign city can fulfill its secret task of turning the visitor into a child only if it appears as exotic and as picturesque as the child's own city appeared to him', p 23.
65. Benjamin, cited in ibid, p 25.
66. Benjamin, *Reflections*, p 102, cited in ibid, p 26.

67. Benjamin, *Moscow Diary*, ed Gary Smith, trans Richard Sieburth, Harvard University Press, Cambridge, Mass, 1986, pp 7, 8.

68. Ibid, p 21

69. Ibid, p 108

70. Ibid, p 9

71. Ibid, p 116

72. The face of Moscow and Asja's face are not the only faces that preoccupy Benjamin while he is in the city. Despite his explicit disavowal on failing to meet a friend, Gnedin, at the Proletkult Theatre, that 'it is conceivable that exhausted as I was, and given my poor memory for faces, I didn't recognise him in his coat and cap...' (p 88), Benjamin catalogues a dozen or more facial encounters. Of the poet and activist, Alexandr Illich Bezymensky he writes that 'the most curious thing about him is his long, apparently unarticulated face with its broad planes. His chin is far longer than any I have seen, except for the one on the invalid Grommer [Jakob Grommer, an assistant to Einstein who suffered from acromegaly], and it is barely cleft', (p 14); of 'the stationer who sits in hiding, enthroned behind her silver crates, an oriental veil of tinsel and cotton-wool Father Christmases drawn across her face' (p 23); of the face of Joseph Roth 'all creased with wrinkles and [with] the unpleasant look of a snoop' (p 30); of 'the physiological configuration of a small canvas by Marie Laurencin—the head of a woman, her hand extending into the painting, a flower rising out of it—[which] reminded me of Münchhausen and made his former love of Marie Laurencin obvious to me' (p 86); and of the German Consul General with his 'coarse... face... only superficially etched with intelligence...' (p 92). In relation to the unparticularised faces of the crowd, he indulges in an exoticist fantasy: 'the degree to which the exotic surges forth from the city is always astounding. I see as many Mongol faces as I wish every day in my hotel' (p 104). And when he reads to Asja, it is, of course, 'the section about wrinkles in *One-Way Street*' (p. 15).

73. Benjamin, *Moscow Diary*, op cit, p 5.

74. Ibid, pp 6–7. Benjamin reiterates these sentiments on p 47, where, in conversation with Reich, he notes that: 'mere convictions and abstract decisions were not enough, only concrete tasks and challenges could really help me make headway. Here he reminded me of my essays on cities ...'; and again on p 114, when back in Berlin.

75. Benjamin, N II, 2 of *Konvolut N*, 're the theory of knowledge, theory of progress'; cited in *On Walter Benjamin*, op cit, p 67.

76. Novalis, *Neue Fragmente*, no 259, cited in Werner Spies, *Max Ernst: Collages. The Invention of the Surrealist Universe*, trans John William Gabriel, Thames and Hudson, London, 1991, p 11.

77. Terence Rafferty, 'Marker Changes Trains', *Sight & Sound*, Autumn, 1984, p 285.

78. Jay Ruby, *Philosophical Toys: Explorations of Film and Anthropology*, chapter 6, 'Exposing yourself: Reflexivity, anthropology, and film', University of Chicago Press, forthcoming 2000; cited from http://snark.anth.virginia.edu/shadows/ruby-ms/

79. Ibid, in 'Towards an Anthropological Cinema—Some Conclusions and Possible Future', and introduction.

80. 'The idea of my film is to transform anthropology, the elder daughter of colonialism, a discipline reserved to those with power interrogating people without it. I want to replace it with a shared anthropology. That is to say, an anthropological dialogue between people belonging to different cultures, which to me is the discipline of human sciences for the future'. Jean Rouch, *Le Monde* (Paris) June 16, 1971; cited in ibid, introduction, as a headtext.

CHAPTER 5
Public Art and the Spectacle of Money:
On Art Rebate/Arte Reembolso, 1993

> *The author [Marcel Mauss] speaks of the thing given or exchanged, which is not inert, but always part of the giver ('to give something to somebody is always equivalent to giving something of one's own person'); he describes the gift as one element in a total system of obligations which are rigorously necessary and may cause war if disregarded, and which also contain a play or 'sportive' element; he mentions the 'guarantee' or token inherent in the object given, identified with the object itself and such as to constitute obligation 'in all possible societies'.*
>
> (Elvio Fachinelli)[1]

> *So money acts as a measure which, by making things commensurable, renders it possible to make them equal. Without exchange there could be no association, without equality there could be no exchange, without commensurability there could be no equality.*
>
> (Aristotle)[2]

If there were once gifts, as Elvio Fachinelli remarks, with their threat of war and thread of play, and then money, with its posture of Aristotelian equality and guarantee of social exchange, could it be that in the mid-1990s we entered into an era of the rebate? Remembering the giving systems of non-Western cultures, it is clear that such a possibility cuts through the foundations of Western liberalism, with its attendant fiscal moralities, and into the domain of post-capitalist circulation, with its spectacular inversions and invisible flows. The theory and performance of the rebate imagines a new nexus of social relationships predicated on the negative increments of capitalism's public record. As we follow this passage, the rebate emerges as both a critique and a renegotiation of the social 'commensurability' reckoned by Aristotle to arrive with the exchange system of money.

In the *Nicomachean Ethics*, Aristotle defines 'magnificence in spending' not as some kind of profligacy or inappropriate 'liberality', but as the 'suitable expenditure of wealth in large amounts'. Such expense should be properly relative to the conditions of the spender and the circumstances and objects of the expense, and without 'any fixed measure of quantity'. When there is propriety in these alignments, the magnificent subject becomes, says Aristotle, a 'connoisseur' with respect to his own social environment. Whether 'directed towards the equipping and dispatch of a religious-state embassy, dressing a chorus, fitting out a warship, or furnishing a banquet, the giver will have performed his giving correctly, and at the same time

Louis Hock, Elizabeth Sisco, David Avalos, from *Art Rebate/Arte Reembolso*, July 1993. Photographic documentation of site-specific event. Courtesy the artists

successfully 'reveal[ed] his character', if he spends 'not upon himself but on public objects' so that 'his gifts are a sort of dedication'.[3]

Beginning in July 1993, and continuing intermittently for several weeks, an untitled group of artists comprising filmmaker Louis Hock, photographer Liz Sisco, and Chicano artist David Avalos[4] distributed some 450 pencil-signed $10 bills to undocumented immigrant workers in Encinitas and other sites in the North County vicinity of San Diego, California. The bills were photocopied and a receipt form handed out to each recipient, who signed for a serially precise note. The money derived from a $5,000 commission awarded to the group by the Centro Cultural de la Raza and the Museum of Contemporary Art, San Diego, for the creation of a public art project as part of the exhibition 'La Frontera/The Border'. National Endowment for the Arts and Rockefeller Foundation grant monies underwrote part of the project costs.

A press release headed 'Tax Dollars Returned to Undocumented Taxpayers' claims that the project:

operates at the intersection of public space (the streets and the sidewalks), informational space (radio, television and print media) and the civic space between the public and government officials. It activates a discourse that reveals the shape of contemporary social thinking about immigrant labour. Conceptually, this art traces the network describing our economic community as it follows the circulation of the rebated $10 bills from the hands of the undocumented to the documented. *Arte-Reembolso/Art Rebate* is an art process that envisions public art as an engagement of the social imagination rather than the presentation of monumental objects.

The press release and interviews, editorials and statements made by the participants in *Art Rebate*, draw on the following claims and assumptions: working immigrants pay considerably more taxes than they consume in public services and welfare. The fact of their labour poses little or no threat to the job security of other local workers. The immigrants take jobs and accept standards that are below the expectation threshold of citizen-workers. It follows that they are unjustly scapegoated for the economic fallibility of the state.

What we encounter in these parameters is an almost perfect negative—or shadow economy—of Aristotle's model of public munificence, which has endured through the patronage systems of the West with remarkably few inflections for well over two millennia (several horizons of technological recalibration notwithstanding). Every term or indicator in the Aristotelian formulation has been inverted in *Art Rebate*. The project can thus be defined as the (officially) unsuitable redistribution of negative wealth—taken from the state, not bestowed upon it—in small amounts (and multiple instances) according to fixed measures of quantity (the $10 bills). The measure and propriety thought by Aristotle to extend between the contexts of the spender and the circumstances and objects of the expense is likewise collapsed by the groups' pantomime of fiscal recirculation, so that the spending is not on public objects but on illegal subjects, and results not in a monument or dedication, but rather in an ephemeral fold in an immodestly outsized economic system and a relay of media-driven misinterpretations within whose logical aporias the piece finally dwells.

The scope of these negatives extends even to the sanctioned types of social magnificence itemised by Aristotle. In *Art Rebate*, then, we witness not the clothing of a theatrical group but the undressing of the choric apparatus of the state-mythology by offstage, extra-civic figures, vivid only in their everyday appearance. We see not the augmentation of the instruments of sea-borne warfare, for example, but rather a gesture that chips a plank—or a splinter—out of taxborne naval spending (in the largest military entrepot in the world). We find not a sumptuous religious mission, but a tentative token

of secular reparation; not a spectacular feast, but a diverted promissory note, whose chief utility, as several critics noted, was to assist in basic provisioning.[5]

It follows that the agents of this inversion cannot be imagined as the splendid social 'connoisseurs' of Aristotle's reckoning, but rather as anti-object-makers who smuggle issues and innuendoes into the dark corners of public policy and force them as insinuations through the organs of social commentary. The group played the role of critic-artists not patron-connoisseurs. Yet their performance is subject to another form of inversion that should introduce a note of caution—or, at least, irregularity—into the symmetrical figures of the quasi-anonymous *Art Rebate* set against the manifestly honorific Public Gift. Aristotle writes that the act of public giving has a corollary in a revelation of good character that is confirmed by the decision to spend outside, not on, the self. Suggesting a last reversal here might imply that the *Art Rebate* group acts as surrogate social workers distributing someone else's money in a trade that, while it buys their own celebrity, at the same time renders the subjects of the rebate—the undocumented workers—inert or transparent at the centre of a swirl of exchanges, real and virtual.[6]

The Money Sign

Louis Hock, Elizabeth Sisco, David Avalos, from *Art Rebate/Arte Reembolso*, July 1993.
Photographic documentation of site-specific event. Courtesy the artists

With these signs of conventional wisdom in place as social silhouettes, I want to examine one of the key focal lengths of *Art Rebate*: its rearbitration of the money sign. For in addition to its sudden location in the politics and economics of migrant labour, *Art Rebate* also takes its place within the series of profiles through which twentieth-century art has loosely engaged with the theory and practice of money and the systemic and social operations of market capitalism. Let me mark some moments in this history.

In *Obligations pour la Roulette de Monte-Carlo* (*Monte Carlo Bond*, 1924), a work that arrives with Marcel Duchamp's relinquishment of 'opticality', we find him doing steerage on the wheel of fortune. Raising subscription bonds of 500 francs, Duchamp issued certificates of account in the form of coloured lithographs featuring a diagram of a roulette board and wheel fringed by twelve interest coupons (*coupons d'intérêt*) printed over a scripted feint background, on which `*Moustiquesdomestiquesdemistock*' is written in green letters 150 times. A Duchamp self-portrait—his head lathered with shaving foam and hair stiffened into a pair of devish horns — appears in the roulette wheel as a diabolic alter ego, doubled on his already gender-reversed persona, Rrose Sélavy, whose signature joins the countersignature `Marcel Duchamp' on thirty individually numbered copies. Written on the back of the bond are four 'clauses', 'extracted' from the Company Statutes, outlining its terms and conditions, including details of annual income payments, property rights, and so on. In a letter to Francis Picabia written from the Café de Paris in Monte Carlo in 1924, Duchamp emphasises the mechanical, repetitious character of his operation, its 'delicious monotony without the least emotion'. His effort is a kind of geometric abstraction, worked out between 'the red and the black figure', in which, as he so curiously puts it, he is 'sketching on chance'.[7]

The social and cultural parameters of this avant-garde bond need to be underlined. Duchamp dresses himself in the *haute couture* of the financial system, the carnival of excess and consumption represented by the casino at Monte Carlo. He evinces little interest in this wheel of fortune as a social construct, preferring to use the casino as a convenient abstract machine whose flows of capital and margins of profit he wishes to filter and interrupt. But *Monte Carlo Bond* and *Art Rebate* share one key strategy, though each imagines it differently: both take on the economic system through investment,[8] relying on the supplemental function of the market economy as a machine that makes a return (for profit). Duchamp raises the stakes in the investment process by virtue of his conjugation of stockholding with gaming. But for him, chance, investment and return are overlaid by system in that the predicate of *Monte Carlo Bond* is the triumph of gambling knowledge and technique over normative probability as the house is pitted against the player. The casino plays white in a regulated encounter with modelled similarities to the chess match.

Art Rebate, on the other hand, functions to desupplementise the circulation of money. Like Duchamp, Hock-Sisco-Avalos offer the signature as an inscription of presence. But while Duchamp's signature is a paradoxical affirmation of a founding subject who is also split and disguised, *Art Rebate* returns a double signature—the bills themselves are signed, and then the recipients sign for the bills. The rebate functions not as an ostensible increment to a rule-bound investment tied into the vicissitudes of 'the table' or 'market forces', but rather as a reparation that seeks to acknowledge the unaccounted contribution of an invisible sector of the tax-paying public, which is momentarily sedimented within the ceaseless flow of an abstract system. The piece allegorises that which is given back, but never accounted for.

The pseudo-monetary devil face of Duchamp looks forward, as *Art Rebate* looks back, onto Andy Warhol's serial re-presentations of dollar bills, gridded and accumulated like the faces of his American celebrities, which they also contain. Warhol's repetitions are cunningly mimetic. The rows of bills look like a forger's sheet: they take on the appearance of money before circulation. First made in 1962, they began as hand-stencilled images and were among the first works produced in Warhol's silkscreen technique. Accounts of his early career relate the legend according to which Warhol was searching at this time for another 'new' subject matter following his appropriation of comic-strip imagery in the late 1950s. Coming up with money marked the arrival of a profoundly different horizon for symbolic capital than that imagined, for example, in Mark Rothko's mythopoetic *Search for a Symbol* (1943), a painting that marks the Abstract Expressionist desire for an art subject fraught with biomorphic suggestion and bursting with metaphoric allusion. Seen in relation to the searches that preceded it, the conjunction of seriality, photography and banality at this moment is crucial for Warhol, crucial for the art of the 1960s, and represents a key moment in the visual elaboration of the money sign in the twentieth century.

Warhol chose the dollar bill and Campbell's soup cans as the icons of his seriality precisely because they were tokens of commercial iteration and everyday exchange. They were emblems of the new subject matter that stared you in the face. In this sense, they participate with the Fluxus conjugations that precede them, and the photorealism to come, as a central gesture in the US post-war articulation of the hypergeneric—the ultimate genre art, the generic raised to a flashpoint. Even a piece as conceptual and documentary as Robert Morris' *Money* (1969), in which $50,000 put up by a trustee was briefly invested in the stock market, takes its place in the tessellation of *trompe l'oeil* 'realities' that simulate the world as normality, and disdain, borrowing Baudrillard's formulation, the seductions of artifice.[9]

The suggestion that *Art Rebate* produced after-effects of postmodern simulation was noted in several newspaper reports. Responding to the handouts in the fields of Encinitas, one critic wrote that 'each new $10 bill

[is] as crisp and vivid as a work of hyperrealism'. Like Warhol, *Art Rebate* journeys into the obscene visibility of the money sign. But what Warhol simply appropriates, repeats and frames, the *Art Rebate* group fed back into the system that bore it. What is exhibited here is the whole issue of money—its release, holdups and hidden consequences, the teemimg archive of social pressures and exchanges that move it through our hands and into an infinity of others. Introduced and accepted some three centuries ago, paper money may be considered a key element of the differential specification of modernity. But it is only since the 1970s that gold convertibility has been abandoned in favour of an international monetary system. This system has progressively rendered visible parts of the money circulation system, such as checking and savings accounts, time deposits, money-market funds and the like, which had previously been unseen (or at least under-known) in a direct conversion economy in many respects still predicated on a literalist scale of weight and equivalence that Michel Foucault termed 'monetary substance'.[10]

If there is now an acknowledgement of postmodern money—which flows along the gradients between presence and absence (calibrated by expectation, probability, a futures market)—the differential functions of immigrant labour should also be recognised. If we can account for the abstractions of the financial machine as they filter through the new accountancy of virtual monies, so the insufficiencies and literalist irrealities of the immigrant labour question stand in need of critical reassessment. In both questions, what is unseen and unaccounted for still has vigorous social and economic effect. The present work attempts to force the sedimentation of an undocumented economy whose hitherto invisible balance sheet images the inverse of the media circus of reflex denigrations.

One of the few art-related projects that intervene in the postmodern reformulation of giving and reparation, Mike Kelley's post-appropriational work with craft objects offers a subtle exploration of the psychological binds of the gift. His accumulations of stuffed toy animals, dolls and rugs, led to reflection on the enormous investments of time in the production and then use of these profuse and singular objects. The result was *More Love Hours Than Can Ever Be Repaid* (1987), a cornucopic assemblage of handmade stuffed animals and afghans hashed together furry cheek to stringy jowl in a giddily giant fractal mosaic of gaudy, second-hand fabrics. The piece focuses Kelley's retort to the 1980s debates on commodification and the redemptive value argued for appropriation, which sometimes saw its preliminary 'taking' as the mere disguise of a 'gift':

> This is what initially led to my interest in homemade craft items, these being the objects already existing in popular usage that are constructed solely to be given away. Not to say that I believe that craft gifts themselves harbour utopian sentiments; all things have a price. The hidden burden of

Mike Kelley, *More Love Hours Than Can Ever Be Repaid* and *The Wages of Sin*, 1987, stuffed fabric toys and afghans on canvas with dried corn; wax candles on wood and metal base, 90 × 119.25 × 5 inches. © Whitney Museum of American Art, New York

the gift is that it calls for pay-back but the price is unspecified, repressed. The uncanny aura of the craft item is linked to time.[11]

Writing specifically of the address in *More Love Hours Than Can Ever be Repaid* to 'another form of false innocence... the innocence of the gift', Kelley elaborates on its giving routines:

In this piece, which is composed of a large number of handmade stuffed animals and fibreglass items, the toy is seen in the context of a system of exchange. Each gift given to a child carries with it the unspoken expectation of repayment. Nothing material can be given back since nothing is owned by the child. What must be given in repayment is itself 'love'. Love, however, has no fixed worth so the rate of exchange can never be set. Thus the child is put in the position of being a perpetual indentured servant, forever unable to pay back its debt.[12]

In the absence of craft's formal location, stranded outside a 'normative' exchange system, Kelley here opens up the signifying terrain of the craft object onto a psychological economy predicated on 'mysterious worth', intractable 'guilt', and 'emotional usury'.[13] In a thought that helps us understand his career-long commitment to both intensive and extensive reckoning with agendas that postmodernism often entertained on the surface, or in a political one dimension, Kelley explores the discrepancy between emotional and monetary value by separating 'junk' art from craft production. The former 'could be said to have value IN SPITE of its material; while the craft item could be said, like an icon, to have value BEYOND its material'.[13] The values of this 'beyond' were drawn out and recalibrated in other aspects of the three-part Chicago exhibition where *More Love Hours* was shown— notably in *Pay For Your Pleasure*, which evaluated the conjunction of criminality, art making and educational knowledge, and included a number of collection boxes for donations to victim's-rights organisations. 'Since no pleasure is for free—a little "guilt money" is in order', wrote Kelley. 'A small donation to a victim's rights organisation seems a proper penance to pay'.[14] Having pursued the psychology of the gift into the laboriously repressed time of the craft object, Kelley offers it a socially extensive reconfiguration as a reparational payment by the art-going public for its voyeuristic pleasures.

Public Knowledge

Duchamp wrote of 'delaying' ideas. Hock-Sisco-Avalos have found a means to funnel the production of their work into a gigantic scene of reception, from which point the 'work' takes off as debate. In a sense, this is post-Conceptualism at its most convincing (and least arcane). The group has assisted in the ready-made media convertibility of the project—which appeared on the front pages and in the editorial sections of more leading newspapers than almost any art adventure since the launching of Futurism in *Le Figaro* in 1909, or the orchestrated devotions to the Life and Death of Pollock and Warhol. Yet, they have done so while remaining almost anonymous, thus engendering a wholly opposite mode of media infiltration to the ghoulish cults of personality variously brokered by avant-garde publicists from Marinetti to Pop.

Reading through the extraordinary growth of media prostheses that supply the afterlife of the piece, it is striking that the *Art Rebate* group, their critical and correspondence column supporters, and the fiercest of their art-world and media antagonists share one notable convergence: all claim that the project has had the effect of turning things upside down. This attitude is surely one of many satellites fixed by the gravity of the avant-garde. Yet no longer are we confronted here by the kind of territorial expansionism according to which the artist or movement takes its gesture of practice a little further into the unknown. Instead, as we saw in the logical relationship

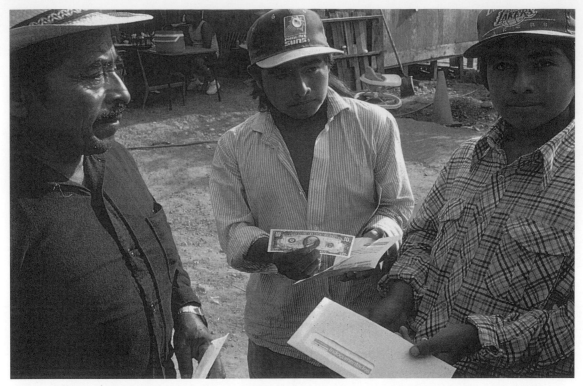

Louis Hock, Elizabeth Sisco, David Avalos, from *Art Rebate/Arte Reembolso*, July 1993. Photographic documentation of site-specific event. Courtesy the artists

between Aristotelian liberalism and the defaults of the rebate, inversion is the order of the day: the other is the subject; the recto is glimpsed when looking at the verso.

In a railing conjugation of war, domestic economics and art that denounces *Art Rebate* as 'the artists' version of the Pentagon's $600 toilet seat and the $7,000 coffeepot', an editorial in the *San Diego Union-Tribune* predicates its antipathy on a reversal of newspaper values, on what its writer designates as the palpable absurdity that the action should be 'front-page instead of art-page'.[16] It is unusual for the print media to produce a metacritique of its own spatial proprieties. But here an editorial from the sanctioned place of opinion in the middle of the paper takes on the task of controlling its precincts, adjudicating first between 'news' and 'art', front and back, top and bottom, and then between the relative value of 'real' and 'surplus' news.

This reversal, acknowledged by the institutional organ of the press that actually registers it, is one among many. As the group put it in the *Los Angeles Times*, 'the politicians are acting like performance artists and we're trying to be political'. 'The art', they continue, 'will ride these $10 bills

through the circuits of a failed economy, entering a space where politics is fiction and conceptual art is attacked for being politically real'.[17] The chain of these inversions is both crucial to the intervention in public art represented by *Art Rebate* and somewhat particular to the function of money. Michel Foucault noted that one of the founding reversals of modernity was a migration in understanding from the notion that 'the sign coins bore—the *valor impositus*—was merely the exact and transparent mark of the measure they constituted' to the idea that 'money (and the metal of which it is made) receives its value from its pure function as sign'.[18]

Art Rebate bears this system of reversals into our postmodernity. For the shape of such tropes of camera obscura inversion evinces a post-Conceptual, post-political world turned upside down. According to Marx, we recall, it was the fabrication of ideology by the status quo that caused the unfolding of 'normative' events and relationships to be understood as grounded, when they might, in fact, have been overturned, or left up in the air. But while abstraction, inversion and ideology are central problematics in *Art Rebate*, what turns things upside down here is not so much the making-seeming-being of the early capitalist state, but rather the entrapment of that inversion in the media machine of the 1990s, the informational hall of mirrors that simultaneously duplicates, corrugates and blinds. The new inversions of the global info-system are seldom fixed, little understood and often virtually perceived. Their unknowable efficiencies and mesmeric opportunism are symptomatic of what Anthony Giddens terms a culture of the 'management of risk'.[19] Under this dispensation, the model of inversion is no longer found in the machinery of the camera, but in the new dimensions of the hologram, or the tangles of the Web. *Art Rebate* catches a version of this risk on the rebound from its media locations, producing a momentary interference in its patterns of distribution. Using the means and provisions of the art world, the project invents a form of social sublimation by turning the improbable into news, without it first becoming 'art.'

These provisions oblige us to rethink the relationship of *Art Rebate* to the filament of public visual culture that reaches from traditional memorial statuary through the outdoor sculptural monumentalism of the mid-twentieth century, from the radical and populist public art projects of the 1960s and 1970s and the site-specific work of the 1970s and 1980s, to what has recently been termed 'New Genre Public Art'. If *Art Rebate's* relationship to the Aristotelian tradition and its vapour trail of classicist affirmations can be defined as logically antithetical, its position at the end of this genealogy is likewise locked in a fundamental dispute with the historical constitution of both 'public' and 'art'. To assess *Art Rebate's* management of this dispute, we can turn to two discussions of public art, organised around the seemingly antagonistic principles of the 'local' and the collaborative, on the one hand, and endemic 'violence', on the other. Lucy Lippard has gathered projects

from the more recent side of the tradition of public art under nine headings. These include the following categories:

3 site-specific outdoor artworks...
5 performances or rituals outside of traditional art spaces that call attention to places and their histories and problems, or to a larger community of identity and experience.
6 art that functions for environmental awareness...
7 direct, didactic political art that comments publicly on local or national issues, especially in the form of signage on transportation, in parks, on buildings, or by the road, which marks sites, events, and invisible histories...
8 portable public access radio, television, or print media...
9 actions and chain actions that travel, permeate whole towns or appear all over the country simultaneously to highlight or link current issues.[20]

Art Rebate is not the only recent project achieved in public space that seems to cut across all or most of these definitional brackets. But its multiple locations are more indeterminate than usual (Lippard lists earlier work by the group under heading number 7), enabling *Art Rebate* to enter into a form of what I will argue is constructive contradiction with the dominant rhetoric of activist art. Many critics share Lippard's commitment to the insinuation of public art with a 'resonant' notion of 'place' and to radicalised, but more-or-less traditional, forms of image production (and circulation). Jeff Kelley, for example, argues that the collaborative 'common work' of public art should be based on 'a rejection of abstraction and an embrace of the particular. Modernist utopianism dissolves into a landscape of what might be called a postmodern social realism. Abstract space becomes particular place'.[21]

But *Art Rebate* is not predicated on the production of images, whether pictorial, photographic, or for alternative TV. Instead it is brought into being by the mainstream media's construction, reception and misidentification of them. It is not fitted out with redemptive empathy for the loss of place. Instead, it diverts flower and fruit workers from their counter-Edenic labour, literally buying moments of their time by asking them to sign a pact with the devilish dollar. *Art Rebate* is less a ritualised performance than an inverted business transaction, ordered by its elemental figures: a desk, a chair, a pencil and a signature. It deliberately collides with and overlays the abstraction of Western systems of finance, 'documentation' and media flow with Conceptual minimisation of form and the grey 'indexical present' of the rebate scene.[22] Above all, the 'political' in *Art Rebate* is not 'direct' nor 'didactic'. Its 'commentary' is not shouted out from public signage, but fetched from the retaliatory clamour of real and art-world reaction. This move to force the surrogate completion of the work in an alien, even hostile,

environment—here, the mainstream media—is rare in contemporary art. However, writing of the strategies of abjection taken on in the 1990s, Hal Foster suggests that 'Just as the old transgressive Surrealist once called out for the priestly police, so an abject artist (like Andres Serrano) may call out for an evangelical senator (like Jesse Helms), who then completes the work, as it were, negatively'.[23] While the two projects share a similar diagram of reversal effects, among many conditions that separate it from Serrano's cultivation of scandal, *Art Rebate* sets out an intervention in the territory of giving, repairing and refunding that furnishes grounds for the work's extension in debate. With *Art Rebate*, the predicate of donation is borne into the media outcome, and effect becomes cause.

It follows, then, that while sharing a superficially similar connection to social 'sources', the giving of the rebate is different in kind from the 'generosity' invoked by Lippard. 'Art is or should be generous', she writes, 'but artists can only give what they receive from their sources. Believing as I do that connection to place is a necessary component of feeling close to people, to the earth, I wonder what will make it possible for artists to 'give' places back to people who can no longer see them'.[24] The locative commitment reaches a utopian crescendo in this formulation. Places themselves, Lippard suggests, should be the objects of giving in gestures symbolic of the ultimate reparation of humankind and the earth.

The conception of *Art Rebate*, the 'events' that constituted its 'action', and its complex afterlife in the media are ranged squarely against the idea that 'of all forms of art, public art is the most static, stable, and fixed in space'. Thought of in relation to the same logic, which suggests that 'the monument is a fixed, generally rigid object, designed to remain on its site for all time',[25] it is also counter-monumental. And it intervenes differently within—in fact it insists upon a rearticulation of—the relationship of art work to Habermas' notion of 'an ideal, utopian public sphere' somehow conceived against 'the real world of commerce and publicity'.[26]

One outcome of these differences may be found in the representation of violence, considered by WJT Mitchell to be 'repress[ed]' by public art, which 'veil[s] it with the stasis of monumentalised and pacified spaces'. Commenting on the production of 'images', Mitchell identifies three ways in which 'violence may be in some sense "encoded" in the concept and practise of public art':

(1) the image as an act or object of violence, itself doing violence to beholders, or 'suffering' violence as the target of vandalism, disfigurement, or demolition; (2) the image as a weapon of violence, a device for attack, coercion, incitement, or more subtle 'dislocations' of public spaces; (3) the image as a representation of violence, whether a realistic imitation of a violent act, or a monument, trophy, memorial, or other trace of past violence.[27]

Imagined and performed outside the tradition of image or object production, *Art Rebate* recasts Mitchell's categories of corporal violence perpetrated on physical bodies by precipitating new figures in the passive, ever-present violence of everyday discrimination. Far from glorifying the militaristic values of the state, or perpetuating the abstract violence of 'radical autonomy',[28] *Art Rebate* turns these values back against the power structures that bore them, replacing the signs of violence with the tokens of a relational reparation.

It is around the question of violence and its disapprobation that we can identify one of the more significant destinies of the critical conjunction set in motion by *Art Rebate* between media commentary, mainstream and corporate culture, and local, guerilla activism. By the end of the 1990s, more than half a decade after the rebate of dollar bills in North County, the domain within which Conceptual Art could be identified with aspects of public culture had expanded to such an extent that the equation appears almost commonplace. Now, partly because Conceptualism has a more settled and generalised location in recent visual history, and partly because the conditions of radical intervention have clearly shifted, Conceptual Art is readily identified with the opposite of direct or violent action, becoming the metaphoric code-name for a virtual politics of on-line disruption, blockage, shut-down, infiltration and counter-sloganisation. Writing in the *New York Times* of the new 'hacktivism', Amy Harmon, a software engineer who designed the FloodNet programme, anxiously distinguishes her commitment to 'denial of service attacks' from the real-world violence of terrorism on precisely these grounds. 'This isn't cyberterrorism', she observes, 'It's more like conceptual art'.[29]

In another register, *Art Rebate* also flirts with absurdity and reduction, teetering on the brink of its own dissolution. Its future-oriented abstraction threatens the social reality it seeks to underline, but is at the same time blended with utopian sentiment. Yet *Art Rebate*'s risks are generally reasoned. The group knows that you can't speak 'information' back to the new inversion, using the language of 'facts'; that you can't paint social oppression any more. You can't even photograph it. To film or document the undocumented is to surrender to the dangers of the new invisibility—people without paperwork, tax-payers without official incomes, media sound-bites without a common language. To hook a point in the hyperspace of public opinion, they seem to suggest, you have to go fly-fishing with social abandon. Here is an art of camouflage where nothing is covered up; a fickle portrayal of the nonrepresented. Theirs is not a hymn to the abandoned. Their sentimentality is actual, but accidental. They had to frighten the Left as well as appall the Right. The project had to be a fake before it was ever an original. Destined to use the media as a hallucinogen, it had to refuse normal means and proper ends. The greatest risk it ran was be seen as

trivial and ineffective in relation to the systems it appropriated and the groups it engaged—migrant laborers, media commentators, the principles of taxation, the world of art.

What's most surprising, perhaps, is that in this Northwest Passage through the labyrinth of media complicity, *Art Rebate* also flirted with the fixed-rate interest of visual modernism. In one sense the project is as minimal and self-reflexive as the paintings of Morris Louis (which represented the apogee of formalist value, according to Clement Greenberg and Michael Fried). *Art Rebate* had to go out into the info-world as magically as Louis soaked his paint into the canvas. They share a common staining. Both leveraged the artist-critic relationship into the necessities of connoisseurship as they were borne into their unknowable reach by the co-productive theorising of critics and commentators. Both were offered—and received—as immaculate finalities (they were the 'last word'—in formal abstraction, and artistic 'irresponsibility') and impossible fictions (one celebrated the surface by retreating inside it, the other compensated for invisible taxation by turning its assumptions inside out).

Look at it another way and you see the double funnel of the perspective diagram reaching between the inner eye and the outer object. An instrumental cultural politics is not rejected here. It is assumed. This is an art action as social intervention: risking atrophy and courting dissolution, knowingly simulating the aura of avant-gardism, flaunting surface gesture in the face of historical depth, the pitch of the piece still comes through. Even as it problematises the social clarities of what it seeks to challenge, *Art Rebate* helps us re-imagine the parameters of a cultural politics for the 1990s. Like Duchamp and his progeny they gamble without being poker-faced. In this work, the regime of avant-garde appropriation and its 1970s denouement have been stretched like a hologram, from all sides. Art-world funding, public art, critical opinion, newspaper commentary, real and virtual money—and money as a visual sign—have all been appropriated. But the project does not consist in the re-presentation or relocation of any of these borrowed parts. It declares itself, instead, in the sum of their subtractions, as what is left over when they have all been taken away. Forcing us to witness the whirlwind of conflicting strategies that make up the social correlative of appropriation itself, *Art Rebate* came as close as anything I can imagine to a gesture of post-appropriation—a subterfuge of taking where everything appropriated is inseparable from that which is given back. Remembering Bataille's distinction between excretory heterogenety and appropriational incorporation, it is clear that *Art Rebate*'s 'heedless expenditure' is one of the 'certain fanciful uses of money'[30] that exposes the violence inflicted on the underside of the social body.

NOTES

1. Elvio Fachinelli, 'Anal Money-time' (1965), trans Tom Nairn in Jon Halliday and Peter Fuller (eds), *The Psychology of Gambling*, Harper and Row, New York, 1974, p 293.

2. *The Ethics of Aristotle: The Nicomachean Ethics Translated*, ed and trans JAK Thomson, Barnes and Noble, New York, 1953, Book 5, Chapter 5, p 134.

3. Ibid, Book 4, Chapter 2, pp 99–102.

4. For a useful account of previous public art collaborations by this group and a number of other San Diego artists, see Robert L Pincus, 'The Invisible Town Square: Artists' Collaborations and Media Dramas in America's Biggest Border Town', in Nina Felshin (ed), *But is it Art?: The Spirit of Art as Activism*, Bay Press, Seattle, Washington, 1995, pp 31–49.

5. Critics—hostile and supportive—noted the immediate use-value of the rebated bills. Disparaging what he terms the 'arts-babble' of the project description, George F Will, for example, writes: 'It was also lunch, as some recipients rushed to a food truck to buy tacos with their windfalls': 'The Interaction of Space and Tacos', *San Diego Union-Tribune*, Sunday 22 August 1993, editorial page, G-2, from the Washington Post Writers Group.

6. Several critics underline the perceived neglect by the *Art Rebate* group of the kind of community preparation, involvement and follow-up that would have allowed the project to function as something more than a momentary interlude of surprise—or shock—and minor good fortune for the undocumented workers themselves. Michael Kimmelman finds in this lack the grounds for a sweeping dismissal: 'By all accounts, that publicity stunt had nothing to do with serious collaboration between the artists and the workers; both as social service and as a mediation on the problems at the Mexican-American border it was laughably meagre. Its real audience was the art world and its critics, among whom the gesture of giving away public money for the arts had precisely the intended incendiary effect. Had it not provoked a response from that group, the whole gesture would have been, on the face of it, empty': 'Of Candy Bars, Parades and Public Art', *New York Times*, 26 September 1993, section H.

7. *The Writings of Marcel Duchamp*, Michel Sanouillet and Elmer Peterson (eds), Da Capo, New York, 1973, p 187.

8. Duchamp was not the only artist to investigate the art of investment. Robert Morris' *Money* (1969) was one of a number of Conceptual projects from the late 1960s and 1970s that foregrounded the operations of market capital. Among younger artists, Linda Pollack's *The Art of Investment*, performed at the Dutch Art Fair (KunstRAI) in 1994, used

an art subsidy granted by the Dutch government as capital to be invested on the basis of advice solicited from seven Dutch financial experts during public interviews conducted in the course of the fair.

9. The work, consisting of correspondence and the stock certificate, was made for the 'Anti-Illusion' exhibition at the Whitney Museum in New York, and was cited in various debates on the status of the art 'object' in the late 1960s and early 1970s.

10. See Michel Foucault, *The Order of Things: An Archeology of the Human Sciences*, Tavistock, London, 1970, Chapter 6, 'Exchanging', esp pp 168-69.

11. Mike Kelley, 'In The Image of Man', statement for 'The Carnegie International', Carnegie Museum of Art, Pittsburgh, 1991, (cited from artist's ms, p 1).

12. Kelley, 'Three projects by Mike Kelley at the Renaissance Society at the University of Chicago: *Half A Man*; *From My Institution to Yours*; *Pay for Your Pleasure*', in *Whitewalls* (a magazine of writings by artists), no 20, Fall 1988, pp 9–10. In 'Mike Kelley's Line', an essay in the catalogue for the above exhibition (4 May—30 June 1988), Howard Singerman underlines the emotional bind of the home-crafted gift: 'What is asked for in exchange for this excessive value is appreciation, devotion, love', (p 10).

13. Kelley, 'In the Image of Man', op cit, p 1.

14. Ibid.

15. Kelley, 'Three projects by Mike Kelley', op cit, p 12.

16. *San Diego Union-Tribune*, 5 August 1993.

17. *Los Angeles Times*, 23 August 1993. The same point is made by David Avalos in Robert L Pincus, '"Rebate" Gives Good Return for a Minor Investment', *San Diego Union-Tribune*, 22 August 1993, E1, E8. In a different context, Guillermo Gómez-Peña suggests a similar exchange: 'Joseph Beuys prophesied it in the seventies: art will become politics and politics will become art. And so it happened in the second half of the eighties. Amid abrupt changes in the political cartography, a mysterious convergence of performance art and politics began to occur. Politicians and activists borrowed performance techniques, while performance artists began to mix experimental art with direct political action'. Introduction to 'Track IV: Performance Politics or Political Performance Art' of 'From Art-Mageddon to Gringostroka: A Manifesto Against Censorship', in *Mapping the Terrain: New Genre Public Art*, Suzanne Lacy (ed), Bay Press, Seattle, Washington, 1995, p 99. For further examples of this reversal from street protests in Eastern Europe, see John C Welchman, 'APROPOS: Tune In, Take Off', *Art/Text*, no 57, May–July 1997, pp 29–31; and chapter 9 of the present study.

18. Foucault, op cit, p 176.

19. Anthony Giddens, lecture at the University of California, San Diego, February 1993.

20. Lucy R Lippard, 'Looking Around: Where We Are, Where We Could Be', in *Mapping the Terrain*, pp 122–23.

21. Jeff Kelley, 'Common Work', in *Mapping the Terrain*, op cit, pp 147–48.

22. Adrian Piper laments the relative ineffectualness of 'global political art', which, 'however forceful, original or eloquent it may be... is often too removed from the indexical present to situate the viewer, him or herself, in the causal network of political responsibility'. Adrian Piper, 'Xenophobia and the Indexical Present', in *Reimagining America: The Arts of Social Change*, Mark O'Brian and Craig Little (eds), New Society, Philadelphia, PA, 1990, p 285; also cited by Arlene Raven in 'Word of Honor', in *Mapping the Terrain*, op cit, p 167.

23. Hal Foster, 'Obscene, Abject, Traumatic', *October*, no 78, Fall 1996, p 116.

24. Lippard, 'Looking Around', in *Mapping the Terrain*, op cit, p 129.

25. WJT Mitchell, 'The Violence of Public Art: Do the Right Thing', in *Picture Theory: Essays on Verbal and Visual Representation*, University of Chicago Press, Chicago, 1994, p 183.

26. Ibid. Introducing a discussion of the relationship between public art and commercial film, Mitchell is here characterising—though not necessarily accepting—Habermas' distinction between a 'culture-debating' public (associated with the former) and a 'culture-consuming' public (associated with the latter).

27. Ibid, p 381.

28. This term is used by Suzi Gablik in 'Connective Aesthetics: Art After Individualism', in *Mapping the Terrain,* op cit. See, eg, p 79: 'What the *Tilted Arc* controversy forces us to consider is whether art that is centred on notions of pure freedom and radical autonomy, and subsequently inserted into the public sphere without regard for the relationship it has to other people, to the community, or any consideration except the pursuit of art, can contribute to the common good'.

29. Amy Harman, '"Hacktivists" of All Persuasions Take Their Struggle to the Web', *New York Times*, Saturday 31 October 1998, p A6.

30. Georges Bataille, 'The Use Value of DAF de Sade, in Allan Stoekl (ed), *Visions of Excess: Selected Writings 1927–1939*, trans Stoekl, with Carl R Lovitt and Donald M Leslie Jr, University of Minnesota Press, Minneapolis, 1985, p 94.

CHAPTER 6

'Peeping Over the Wall': Narcissism in the 1990s, 1995

*The beauties of the Parthenon, Venuses, Nymphs, Narcissuses are so
many lies.*

(Pablo Picasso)[1]

This chapter and the range of work it assembles are configured around
images of the self and its substitutes, a focus almost unthinkable in any other
decade of this century—except, perhaps, for the first. Not until the 1990s
could so many different artists allow themselves so many measures for facing
and reproducing their selves, intimating, at the same time, that the means
and materials of this self-reflection were somehow enmeshed with the most
current elements of contemporary culture. Jean Clair announced at the 1995
Venice Biennale that 'more than anything else, the 1900s has been the
century of the self-portrait and not the abstract', and in the 1990s, a vision of
narcissism arrives as a cultural condition that is also supplied with critical
edge. For the first time in a generation, assemblages of inwardness help us
better to understand not just selves and their constitution, but also the
relocations and exchanges between selves—their geographies, desires and
pleasures, their losses, terrors, failures, absurdities, and their social
extension.

Such possibilities have not always been available. A few provocative
instances aside—Henri Rousseau's *Myself: Portrait Landscape* (1890); James
Ensor's *Self Portrait Surrounded by Masks* (1899);[2] Max Beckmann's
Expressionist visages; Marcel Duchamp's cross-gendered other-self, Rrose
Sélavy—the iconic self portrait was sanctioned only intermittently in modern
art until the strident social selves of Andy Warhol and the performative faces
of Bruce Nauman, where the current move towards narcissism implicitly
begins. A filament of extrovert self-imaging runs from the later 1960s
through the 1980s, associated with several, seemingly opposed, dramas of
self-presentation: the body-based performance work of the later 1960s and
1970s, much of it associated with women artists; the self-circulating,
'intrasubjectivity' of first-generation video art; the bravado personas of the
predominantly male Neo-Expressionists; and the diffidently othered substitute
selves of Cindy Sherman and Barbara Kruger. Work in all these tendencies
has been linked to narcissism. Lucy Lippard explicitly contends against the
attribution of narcissism to the woman artist who uses her own face and
body: 'She is a narcissist, and Vito Acconci with his romantic image and
pimply back, is an artist'.[3] The work of Francisco Clemente, Julian Schnabel
and the rest has often been described as 'narcissistic at base'.[4] As Craig
Owens noted when he aligned the appropriative stylisations of the later 1970s

with the wider 'collective Narcissism' identified by Richard Sennett and Christopher Lasch during the same years, the self-image and its social possibilities are suffocated in this movement by a wayward historicism and repetitive pastiche that results in the disfigurement, even 'mutilation', of the past.[5] These polemics and ascriptions aside, I want to argue that it is only in the 1990s that narcissism emerges from the shadows and superficial reflections of its former condition as self-obsession to offer suggestive new forms of cultural negotiation with selfhood and identity.

The self-scrutinies of the 1990s are worked out in reaction to important legacies of self-interrogation and self-expression. Two strands seem especially relevant. These are, first, the facial releases and the politics of inclusion and distinction articulated in the feminist and postcolonial discourses of the 1960s and 1970s. But while these debates granted crucial new opportunities for the representation of female bodies and their sexualities, by the turn of the 1980s, images of both female and non-Western self-identities were still haunted by stereotypes of whiteness and masculinity they could never represent, nor mimic. Adrian Piper's 'vigorous analysis of self-identity'[6] carried out across her writings and in works such as *Self-Portrait Exaggerating my Negroid Features* (1981), and the awkward self-images of Rasheed Araeen make this painfully, sometimes comically, clear. In 1978–79, Araeen produced a cowering self-portrait that ironically questioned its very reason for being: *How Could One Paint a Self-Portrait?* He responds to this cleverly neutral, sanctimonious interrogation in his 'Ethnic Drawings', a series of felt-pen and pencil 'portraits' made in 1982 on casual cardboard supports. The second of these replaces the deprecated coloured head with a face-building calligraphic script (using rhymes and satires about ethnicity) written in Urdu and English. What results is a self, made up of textual slurs, that matches the earlier self confected from evasive pictorial slurries. In both cases, the presentation of the non-Western face is only possible as the signs of its erasure, contamination and ridicule are made visible. Araeen's facial-self is caught wryly, painfully, destructively crossing itself out.

The second legacy derives from the corporatist prevarications of the Me-Generation associated with the art-world boom years of the mid and later 1980s. Negotiating with these pasts—in which narcissism was still understood as an indulgence, a fetish or a social cul-de-sac—the 1990s have shown that it is both possible and effective to look inside the self in order to understand through it. The new observance and reconstruction of the self, however, has not been carried on under slogans such as the 'personal is political', though it has not necessarily forgotten them. It has, instead, recognised the worth of examining the formation of selfhood in the global and technological present. There are risks in this, of course: the risk of nostalgia (both technical and emotive); the risks of secrecy, psychic immanence and social melancholy;

and the risk that lies at the centre of all narcissism, that of getting stuck on the infinitely reflective surfaces of the self. But there are also gains. For a new permission to examine the make-up of selfhood may clear a space for a different kind of visual knowledge, reacting to some of the political delusions of always 'speaking for' or othering others, even in the act of striving to include them. Sigmund Freud once noted that 'at bottom the self-criticism of conscience coincides with the self-observation on which it is based'.[7] I want to suggest that there is another side to the psychological formalism of continual self-reflection. The works discussed below offer different but related negotiations with what I want to term 'constructive internality', showing that in the end, the intensities, comedies and dissents of self-reflective selves are no less (though no more) important than multiple, exterior, others.

Outside the confines of the art world there is some sanction for the claim that the visual self-presentation associated with narcissism emerged as somewhat reticent, veiled, and even shameful in the early years of the century. In a sense, narcissism had to become a clinical condition, and then a social vice, before it could emerge as anything like a legitimate arena of artistic inquiry. The sanction, as we will shortly see, comes from Freud, the first modern thinker to explore the concept of narcissism, and the first to set it on a long journey of extension from the psychological to the social worlds. Let me briefly outline several moments in the unfolding of narcissism—the Western history of self-seeing, self-love and self-obsession. These I gather as signposts along its route from a classical myth to a clinical condition, and then from a metaphor for cultural introspection to a significant condition of representation in the 1990s.

It is important that the myth of narcissism and the ideas to which it gave rise are irresistibly Greek. While he never used the term narcissism or alluded to its mythology, Aristotle was probably the first philosopher to associate love of the self with loving friendship for another, going so far as to designate a 'friend' as 'really ... another self.'[8] But when Hellenic culture withered, almost everything in the narcissistic imagination that was ambiguously beautiful or visually energetic faded with it. Such was the fate of narcissism for more than a thousand years in post-classical Western culture. Dominated by Christian ideals (and prerequisites) of self-abnegation, ascetic denial and mortification, this culture was predicated on a world-view of guilt and atonement. The New Testament injunction to 'love thyself' was drowned out by endless historical examples of abjection and the disavowal of the flesh as temptation. Outside the Western world, the Zen concept of 'self-suffering', however, is radically different, for it carries with it no ulterior sense of judgement or reckoning. Zen, claims DT Suzuki, 'is free from egotism' and from 'fantasies' alike.[9] Like Christianity, it gives rise to a culture where narcissism can hardly be imagined—but it may also be said to breed a spirituality in which narcissism has no edges and knows no bounds.

Around the genre of portraiture and in the wider history of art, large claims have been made for the place of narcissism and the figure after which it is named. Pascal Bonafoux once asked whether 'the self-portrait is nothing other than the recurrent portrait of Narcissus, a monotonous repetition'. He also reminds us that in Book II of his *De Pittura* (1436), Alberti claimed—in a grand metaphorical flourish—that Narcissus should be identified with the very origins of painting: 'Narcissus changed into a flower had been the inventor of painting; and, moreover, if painting is the flower of all art, the whole story of Narcissus is relevant here. Will you declare that painting is anything other than this manner of embracing with art—this very surface of the spring?'[10] Asserting—without quite establishing—the legendary designation of Narcissus as the first painter, Alberti appears more interested in an effectual definition of art according to which painting is seen as a manner of embracing with a surface. The self-reference caught-up in the Narcissus myth is transferred in Alberti's trope from a tangible image of selfhood (Narcissus' reflection) to an extensive attribute of the artist, as the painter's self is inscribed on the canvas through a signature, manner or style that will truthfully reflect him.

But Alberti's provocative suggestion that art might be a platform for self-loving style was not the most common thought about narcissism in pre-Enlightenment Europe. Within the Neo-classicism of the Renaissance, notions of a transparently social and thickly psychological self lay at the very centre of the humanist project. The imaged self was a way of showing and declaiming the world. In this context, the Renaissance portrait was generically anti-narcissistic, for, even as it seduced with intimations of subjective depth, it offered the self as a gorgeously specific object and not as an interior. It was not until the Romantic movement—the great engine that drew culture back to the reflective, self-loving self—that the inside fully came out. Even here, a natural, self-sustaining outer self was often more thought, pictured and solicited than the inner image. In the American tradition, Ralph Waldo Emerson's essay on 'Self-Reliance' (1841) is a classic statement of counter-traditionalist retreat into the certainties and truths of the natural self. Inveighing against the established exterior conventions of family, government, customs and traditions he writes, 'you will soon love what is dictated by your nature'.[11] The true locus of love, duty, responsibility and action is the unmediated self. While Emerson's responsible, abstract naturalism is different in kind from Jean-Jacques Rousseau's willful counter-statism, both share the substitution of the self for the sanctioned accretion of laws, manners and customs. Yet the inner self here is not an image, it is a resource, a location, a reservoir of socially uncontaminated proper actions, which is why it is more honoured than loved by the Romantic essayists (and perhaps more loved than honoured by the Romantic poets).

In any account of narcissism, clearly the most significant intervention is Freud's development of the term as a kind of allegory for the withdrawal of the psychological self from the world of needs and objects. Freud lays emphasis on several interactive levels of narcissistic behavior, which can be convened under two developmental phases. The first is a 'primary infantile narcissism'.[12] Here, the pre-symbolic child is concerned entirely with gratification, and is unable to distinguish between need, want and pleasure. Primary narcissism serves, somewhat uneasily, as the model narcissistic state to which subsequent, secondary, or modified, narcissisms unwittingly aspire, or to which they involuntarily return. Freud even hints that there may be a state of pre-primary, or amniotic, narcissism corresponding to the supposed equilibrium of the foetus in the womb. In this state, needs, wants and pleasures arrive simultaneously.

Secondary narcissisms are altogether more complex and allusive. Indeed, in his later writings, Freud uses the conditions of non-infantile narcissism very much as a switching point for revising his theories of the ego, the libido and neuroses in general. Freud's sexualised narcissism is staged as the ego's attachment to objects is replaced by the libido's retreat into the pleasurable surfaces of the self. Such a sexual retreat has inevitable consequences for the theory of the libido, in that it imagines the separation between an ego-libido and an object-libido. It also has consequences for moral discourse, as Freud characterises altruism as distinct from the libido 'in its lack of desire for sexual gratification in the object'. Narcissism apparently shares this withdrawal from object-gratification. As Freud rethinks the formations of neuroses in general, and moves away from his earlier emphasis on hysteria, the mechanisms of narcissism are associated with an expanding number of conditions, including melancholy (the melancholic 'withdraws [his] libido from the object... by... narcissistic identification').[13] Narcissism also appears as the purported opposite and potential cause of paranoia, which Freud interprets as a 'defence against homosexual libido'.[14] Implicit here is the strained identification of narcissism with same-sex love in general.[15]

In the end, Freud determines that though pervasive, narcissism and its neuroses are particularly difficult to analyse: for unlike 'transference neuroses' they exhibit 'insuperable resistance'. Narcissism is thought of as a peculiarly modern condition of the psyche. Its theorisation takes place on the borderline between psychiatry and psychoanalysis; and its rule systems and operations, if subject to any identifiable condition, are governed by 'ambivalence'.[16] It is in this provisional and uncertain context that Freud alluringly describes his efforts to see and record the narcissistic condition in terms of a schoolboy voyeur 'peeping over the wall'.[17] Not only does Freud catch himself in the act of stealing a glance at a perhaps forbidden, or unknowably prohibited, scene, but much of the libidinous narcissistic retreat he discusses is thought, written and supposedly experienced through sight

itself—through the intervention of specular exchange. The seeing and envisioning of the self are thus crucial factors or pathways for the narcissistic experience—despite the fact that the faculty of sight is 'the last of the senses to develop in the foetus, only in fact gaining its true importance for the survival of the neonate sometime after birth'. Such specularity is, then, double-edged. Narcissism acts through sight, the most elevated and 'civilised' of the senses, and one that Freud associated with 'a concomitant repression of sexual and aggressive drives and the radical separation of "higher" spiritual and mental faculties from the "lower" functions of the body'.[18] But the act of seeing and dwelling with the self is at the same time associated with regression to the pleasurable sightless totality of the womb. This ambivalence is clearly caught by Freud as he works out his theory of narcissism. He writes of the activities of incessant watching, criticising, comparing, noting at the same time how we might be subject to the 'delusion of observation'. In the end, the perfect theatre for the seeing-self is located in dream-work as, for Freud, it is the sleeper who most perfectly reproduces 'the primal state of the libido-distribution'—'that of absolute narcissism'.[19] On the other hand, Freud leaves open the possibility that the activity of self-imaging (which may—or may not—be quite distinct from narcissistic self-absorption) might be one of the 'restitutive' efforts of libidinal counter-investment that stage a resistance to the foreclosures of narcissism. Indeed, Freud conceives of the artist as an introverted, borderline neurotic, who is, at the same time, able to blaze a trail 'from phantasy back again to reality'. Almost perversely, artists elaborate their 'day-dreams... so that they lose that personal note which grates upon strange ears...'[20] Representing the self is inevitably dangerous in these very terms, for it risks—and sometimes courts—that grating upon strange ears (or rubbing of unknown eyes) that Freud claims is its communicative responsibility and aesthetic power. The self-image is a special instance of the auto-analytic, quasi-narcissistic, negotiation between real worlds and dream worlds.

Without necessarily subscribing to Freud's limited and generalised understanding of art, the association of narcissism with the making (and makers) of art work offers an important vantage-point from which to view our subject. This conjunction was developed by post-Freudian social theorists, including Herbert Marcuse who draws it out more explicitly in order to confer upon art a social privilege that is autonomous and, finally, redemptive. For Marcuse the attitudes symbolised by the musicality of Orpheus and the disinterested self-absorption of Narcissus are emblematic of the 'aesthetic dimension' in general. Implicit in Marcuse's reinvention of Freudian narcissism is the notion that while all artists turn in on themselves in the process of making art, there is a particular intensity, a heightened 'aesthetic', when this turning-in issues in self-representation. Marcuse's liberating aesthetic narcissism is not the only post-Freudian reckoning with the social implications

of the narcissistic tradition. Other theorists and historians have cast narcissism in an altogether less elevated light. Christopher Lasch argues that the myriad twentieth-century symptoms of social introversion and self-obsession he rehearses, result not in a separate, redemptive realm of aesthetic practice, but rather in a bankrupt 'culture of narcissism' whose products (whether the art works of Warhol, the writings of Beckett, or the 'liberated' school curricula of the 1960s and 1970s) knowingly and reductively cut themselves off from any meaningful shared public discourse.[21] In a similar vein, Richard Sennett viewed the rise of modern narcissism as a primary symptom of what he famously termed 'the fall of public man'. The explicit civic humanism that lies behind these critiques of narcissism is based on a nostalgic, pre-technological dream-world ruled over by an abstract democratic norm. They do not understand the compulsion and necessity of looking through the singularity of the self. The image that most closely corresponds to the social vision they defend, is, of course, the finely rendered, transparently articulated, public persona—the socially redirected modern afterlife of the Renaissance portrait. This chapter will make the case for different forms of negotiation with the self, and its public and private faces. The Renaissance figure becomes a ghost that haunts the forms and disguises of the postmodern self as its imitative rationality is questioned and reconjugated.

Clearing a critical space in which to examine the new narcissism of the 1990s is not an easy matter. For after the cultural broadsides delivered by Lasch and the nostalgic aggrandisements of the Neo-Expressionists, narcissism became a by-word for complacent inwardness and asocial self-obsession, emerging as a general category of abuse levelled against almost any movement, artist or milieu whose work and assumptions were in some sense 'closed', coded or simply specific. Thus, the turn in the later 1980s and 1990s towards work in video, installation, performance and photography that was confessional, diaristic, or otherwise self-reflexive, was attended by criticism that explicitly refuted its narcissistic conditions.[22] Such conclusions often reconvened the categories of earlier writing, notably Rosalind Krauss' association of both the 'content' and 'structure' of first-generation video art with 'the routines of narcissism'.[23] Among critics who helped define the issues of the 1980s and early 1990s, Hal Foster, in particular, issued a succession of warnings about the danger of cultural inwardness and hermeticism. Turning on differently formulated charges of narcissism, these were correlated with many of the tendencies he identified in New York-exhibited art during the last fifteen years. They found, perhaps, their ultimate horizon in the implicit separation of this work from what Foster notes, in Franz Fanon's formulation, was '"the obscene narcissism" of [colonial and neocolonial] Europe'.[24] Thus, newer institutionally critical and site-specific work, by artists such as Fred Wilson and Andrea Fraser, developed after the initiatives of Michael Asher, Hans Haacke and others, are founded on a

'deconstructive-ethnographic approach' that 'can become a gambit, an insider game that renders the institution not more open and public but more hermetic and narcissistic, a place for initiates only where a contemptuous criticality is rehearsed'. This potential shortcoming is analogous to the aestheticisation of appropriation art, and its surrender to spectacle.[25] Even the wider 'ethnographic turn in art and criticism' (Foster mentions work by Renée Green, Adrian Piper, Lothar Baumgarten, James Luna, Jimmie Durham, Repo History and Edgar Heap of Birds, among others) is vulnerable to 'a reductive over-identification with the other', a reflexivity that 'can lead to a hermeticism, even a narcissism, in which other is obscured, the self pronounced'.[26]

While Foster delivers narcissism as a warning against 'ethnographic', institutional and personal closures, other critics turn his charges back against the entire foundations of socially motivated critical postmodernism. Jeremy Gilbert-Rolfe castigates the narcissistic self-reference of the practitioners of identity politics in the 1980s—many of them associated with appropriationism—a tendency he described elsewhere as a form of political realism: 'Whenever the left encounters anything truly interesting these days [he is writing in 1990] it shies away from it because it cannot immediately see itself *in* it', he claims. 'Thus do we now find narcissism where there was once a methodology of liberation...'[27] In this reading, the issues of self-constitution and otherness, so crucial to New York criticism in the 1980s, are reinterpreted as formalised rituals of self-identity. But such blanket reascriptions of narcissism operate on both sides of this negative advocacy. Jack Pierson contends for what he terms 'the universal nature of narcissism',[28] while a number of European critics, including Umberto Galimberti, have correlated the entire era of electronic technology with the destruction of the id and the exaggerated growth of narcissistic ego.[29]

At the same time, Craig Owens and others following him, looked to more specific issues, detecting, for example, a socially critical emphasis in work on the deconstruction of the image of the narcissistic woman. Owens suggests that the phallic maternality of Dara Birnbaum's *Technology/Transformation: Wonder Woman* (1978–79) is critical not just of the circulation of mass-cultural imagery, but that, through its mobilisation of 'the Freudian trope of the narcissistic woman', it activates 'the Lacanian "theme" of femininity as contained spectacle'.[30] A decade later, in an explicit attempt to move beyond the 'binary deconstructions of 1980s feminist appropriation art', Amelia Jones reallocates the relationship between narcissism and femininsm, suggesting that the presentational format of Lauren Lesko's *Eyeful* (1991) 'forces the viewer to confront... [three blown-up 'images of little girls appropriated from early twentieth-century postcards'] in a narcissistic exchange of representational identities'.[31] The brevity of these references, the telling triangulation that Owens sets up between femininity,

narcissism and the metaphorical (the Freudian 'trope' and Lacanian 'theme'), and Jones' implication of the spectator in the procession of selves, alerts us not just to the limitations of such encapsulated criticism, but also to the complexities caught up in the designation, representation, gender-coding and critical reception of narcissism. For narcissism can no longer be thought of simply as an allusive or veiled demonstration of a psychoanalytic trope, or as an agent of exchange among representational identities (though we will encounter it in both these forms, and the second, in particular, opens up important new dimensions).

In the mid-1990s a number of new formulations attempted to address different critical—and liberatory—experiences in narcissistic representation. For, if 'modernism's domain of pleasure is the space of auto-referentiality',[32] one aspect of recent postmodern reaction has been to shift such pleasured self-reference from the image/object to the artist/subject. Not surprisingly, perhaps, several of these, including the exhibition for which sections of this discussion served as an introduction, were staged in southern California. These interventions reject the generalities and literalism of the 1980s summed up in Karen Carson's exhibition 'Abstract Narcissism' (1988), in which acrylic paintings of recessional architectures were collaged with mirror fragments, crudely forcing the viewer to enter a labyrinth of reflected selfhood.[33] The most assertive revisionism arrived with the exhibition 'Narcissistic Disturbance', put on at the gallery of the Otis College of Art and Design in early 1995. Proposing the 'celebration' rather than 'judgement' of 'individualised pleasures', it was premised on the 'corruption' of the 'link between narrative and material' in 'the current personal work', advocating instead a return to a supposedly positive ('not... negative') form of 'personality disintegration' retrieved from Freud's 'original narcissism', which curator Michael Cohen defined as 'a state of pre-ego anarchy where the body, its image and the libidinal instincts can be satisfied without unity or need of another'.[34] The some fourteen artists exhibited (including Janine Antoni, Yayoi Kusama, Bob Flanagan and Sheree Rose, Larry Johnson, Sean Landers, Richard Hawkins, Yasumasa Morimura, and Lyle Ashton Harris and Iké Udé) were situated, then, within a trenchant 'reconsideration of the polymorphous "perversions"—sadism, masochism, exhibitionism, scopophilia etc', which offered 'alternate models to the limited channels of desire initiated by the Oedipal triangle'.[35] What 'Narcissistic Disturbance' put forward was, in the end, less a set of models, than a grouping of fragmentary instances and experiences, and, with a couple of exceptions, not so much an un-negative 'index' as a mix of postures and uncamouflaged social and sexual taboos. However, several issues relevant to the wider contexts considered here emerge from the exhibition and its catalogue.

First, the vaunting of anarchic primary narcissism gives rise to the idea of an 'intraspecist space', located 'beyond the principle of sexual identity',

and inhabited by uncoupled, counter-heterosexual technobodies and transvestite identities.[36] Notable among these are Lyle Ashton Harris' performative photographs, which map out a 'self-reflexive racialised space'[37] based on what Harris has termed 'redemptive narcissism'.[38] This 'self-love is a form of resistance to the tyranny of mediocrity', Harris stated. 'I see the mirror not only as the site of trauma and death—Narcissus falling in to drown—but as a space for rigorous meditation, cleansing and recuperation.'[39] Harris flaunts the naked, made-up or cross-dressed body not just as a site of display and dissipated masquerade, but also as a zone of reparation and special reflection for queer identities. Secondly, the permissions granted by narcissistic destabilisation are held to offer a retort to the symbolic deconstruction of 1980s appropriation. Thus Larry Johnson deals not with quotations but 'plagiarisms from the mass-media sensurround... over against the proper recycling of citation, plagiarism figures as a form of improper burial or texticide in which the original puts in ghost appearances'.[40] As often in the rhetoric that defends the exhibition, extremist suggestion, in this instance of plagiarism's textual murderousness, is, in fact, mitigated by the final conventionality of the proposed subversion. For, the proposition that appropriated material goes on to haunt the signifying structures of its new location was made by critics, including Douglas Crimp, as well as by the artists themselves, in the first stages of the rephotography movement.[41] Thirdly, Catherine Liu, reading the work of Sean Landers and Richard Hawkins, usefully reminds us that a key aspect of the recent relationship of art and narcissism also involves a rejection or sublimation of narcissism itself, an engagement, as she puts it 'with failure on the level of narcissism', or (with Landers) a documentary narcissism that surrenders its 'claim to narcissistic inaccessibility'.[42]

Predictably, 'Narcissistic Disturbance' was criticised for its 'dysfunctional' surrender to polymorphous instincts and desires, and a concomitant lack of social responsibility—and even of the 'disruptiveness'[43] it proclaimed. However, it purposefully flouted the checks and balances surrounding questions of reflexivity and subject-positions proposed by Foster (who explicitly cautioned against 'promoting... disturbance' as 'a masquerade'[44]), and offered a corrective to the quietism of the confessional idioms of the 1990s. But disturbance is only one of the cultural effects of the new narcissism. I noted in the introduction that Julia Kristeva defended the appropriation of popular images on the grounds that their restitution might have a 'therapeutic', even sacral, impact. Taking an unusual longer view across the twentieth century, she grounds this contention in the possibility that modernism can be identified with a kind of pre-narcissistic culture intent on the 'pulverisation' of images, while postmodernism embraces a form of narcissistic 'gathering together' of what previously could only be split.[45] Others too have called for culture in the 1990s to 'locate a new

confessional style' and find ways to 're-enter the self'.[46] The search for points of entry into refreshed understandings of the self has been diverse. In the new media they range from a willing surrender to the collaborative filtering systems of the Internet, which engender a hybrid form of 'prosthetic ego',[47] to the hidden, or non-declarative, self-absorption of the agents of autonomous 'sovereign media', whose 'apparently narcissistic behaviour bears witness to their self-confidence, which is not broadcast'.[48] Elsewhere, we encounter relays and deflections that creatively circumnavigate older constitutions of the self. Thus Brian Wallis notes of recent work by Janine Antoni, Charles Ray and Jana Sterbak that 'their seemingly narcissistic focus on the self is deflected through imitation, replication, and temporal slippages that question the very nature of reality and our access to it'.[49] Assisted by arguments and suggestions in the rethinking of narcissism after Freud and by hints in the art world of a powerfully reimagined interest in the self, I want to map some of the intensities and ambitions of this 'seeming narcissism' more closely.

Like Freud, the artists I consider here are also peeping over the wall; but they do so in order to see themselves more clearly. We look at them in the act of this seeing, though we do not always see them directly. We encounter little of the expressive, unmediated selfhood of mid-twentieth-century portraiture. We are not confronted by either the exterior anguish and inordinate presence of Max Beckmann or Francis Bacon, or the interior sensations notated by Wassily Kandinsky, and differently, by Jackson Pollock. We are not witnesses to the savage dislocation, mechanisation and final obliteration of the face taken on in Cubism, Dada and avant-garde abstraction. What we see instead are disguises, interferences, multiplications, magnifications and diminutions of the imaged self. These artists have built walls around the look and idea of self hood and they, and we, must stretch our necks to take it in. I want to begin by facing the wall itself—the thing that is posed so forcefully in front of the self, the matter we must look over. Freud's wall is simultaneously a boundary, a threshold and an obstacle. It is the opposite of the shiny mirror in which the self sees and recognises itself on the way to socialisation. The wall and the mirror are important metaphors: one reflects the viewer back, the other you have to climb (or peep) over. They stand in for the means, or style, of shifting from one aspect of the self to another. The mirror offers a frictionless (though reversed) return. The wall, on the other hand, needs to be circumvented, or seen over—and the resulting view, according to Freud, is not so much of the self itself, but of a concept or a condition of looking at the self, available only in the embrace of narcissism.

The self-interrogative art of the 1990s is framed by a transformation of Freud's wall into the domes, rotundas and installational spaces of Barbara Bloom's *The Reign of Narcissism* (1990), the most elaborate recent attempt to

Barbara Bloom, *The Reign of Narcissism*, **1989**, installation detail, Jay Gorney Modern Art, September 1989. Collection of the Museum of Contemporary Art, Los Angeles. Courtesy Jay Gorney. Modern Art, New York. Photo: Gorney, Bravin & Lee, New York

reorganise the co-ordinates of narcissistic envisioning in the tradition of postmodern appropriation. Part of what one critic identified as 'a factory for the production of narcissism',[50] *The Reign of Narcissism* consolidates Bloom's abiding interest in a complex relay of parts. Its thirteen sections ('The Collection'; 'The Narcissus Vase'; 'The Chairs'; 'The Vanity Mirrors'; 'The Busts'; 'The Signatures'; 'The Self Portrait Reliefs'; 'The Silhouettes'; 'The Books'; 'The Chocolates'; 'The Tea Cups'; 'The Cameo Portraits'; 'The Tombstones') were arranged in an octagonal space designed for the Württembergischer Kunstverein, Stuttgart, the first of its three major exhibition venues. Bloom unfolds a narcissistic symbology confected with appropriated or refashioned domestic structures and household appurtenances, and framed by the diversely generative conditions of collecting and the finality of death. The accompanying 'Guide Book', or 'Führer', reprints multiple versions of the Narcissus myth, by Ovid, Pausanius and Plotinus, and sets a wide range of appropriated texts—from Bruce

Chatwin and Gabriele D'Annunzio to Ernst Gombrich and Anna Akhmatova—
and para-illustrational art works and photographs—including botanical
specimens, banknotes and paintings by Velázquez, Caravaggio and Titian—
with the found and fabricated objects that focus the thematic sectors. Bloom's
face, or her metonymic body-parts and effects (teeth, signatures), become
attractors that attach to a defining repertoire of common utensils (tea-cups,
chairs, vases), image types (busts, silhouettes, self-portrait reliefs, cameo
portraits), or special, narcissistic objects (mirrors, books). Her self-image is
thus multiply marked on shell cameos, porcelain-ware, *hors d'oeuvres* and
cakes, 'BB chocolates', a soap bar and champagne labels, a 'restyled
silhouette of Goethe's sister', chair upholstery, an 'ornamental plaster relief
restyled to depict the muse measuring [and painting] her own face', as well
as on hypothetical grave-slabs, a variety of 'classically restyled' portrait busts,
and an ice cast of the artist's head.[51] The artist interpolates herself into
plural scenes of aesthetic and domestic ritual. The bust, for example,
becomes a device that assists in the make-over and fixing of the self, shifting
across a range of signifying registers that render it as a memorial, a transient
inscription, a collectible object and an aesthetic ideal. She supplies an
afterlife for the postmodernity of narcissism, causing it literally to bloom with
herself. For *The Reign of Narcissism* is the swansong of appropriation,
channelling its cut-out logic, appositional allusion and historical recycling
onto the opaquely repetitive surfaces of the self. Appropriation is made-over
as a giant, projective fantasy of the artistic ego, which, somewhat in the
manner of Alberti's all-inclusive metaphor, disputes the very possibility of
non-self-referential representation.

 If there is a dominant visual code shared by other artists of the new
narcissism, it can be located within and against the many traditions of
realism, or mirror imaging that culminated in the Renaissance and unfolded
in its wake. But 'mirroring', we could say, is replaced here by 'walling'. From
Audrey Flack's goddess *Islandia, Goddess of the Healing Waters* (1988) to the
diffidently posed medievalism of Judy Fox's *The Virgin Mary* (1993); from the
orientalised Pre-Raphaelitism of Yasumasa Morimura's luscious photographs,
to the deceptively spare presentational selves of John Currin's paintings or
Charles Ray's sculptures, we encounter an incessant dialogue with the
leading stylistic realisms of visual history. Currin, who once proposed that
the 'subject of a painting is always the author, the artist', offers a formula
that tellingly articulates the dialogue between the self and the real: referring
to one of his images, he described it as executed in a form of 'realist drag'.[52]
Sometimes, these dialogues are more explicit. David Baze's *Self-Portrait with
Lemon* (1991) allies a Hopperesque technique with a renovated ambivalence
that looks back to the new figuralism of the later 1970s and 1980s. Deploying
an altogether different set of allusions, we encounter a deliberately
modernised Renaissance posture in Brett Bigbee's *Foreside* (1993). The

casually dressed 'everyday' figure is presented in a squarely frontal, fifteenth-century pose, standing against a window that gives a landscape view, wearing headgear symbolising his station, the thumb and index finger of his right hand bearing an emblematic floral sign. Yet this is a picture whose symbols quietly refuse to reveal their referents. Drained of decorative allure, realistically robbed of profusion and supplemental detail, *Foreside* itself becomes a sign for a dimly glimpsed subject seen in front of the wall of its sober context.

Other artists explicitly court comparison with the traditions of Renaissance representation only to cast shadows on its willful clarity. Dan McCleary has long endeavoured to pit Renaissance compositional formats and their associated virtues against the look and the inferences of LA cool. Sidestepping the allures of super-realism, Anne Harris conjures up meticulously rendered images of self-doubt and equivocation. Her *Self-Portrait with Bridal Veil* (1994) suggests both the opaqueness and transparency of self-envisioning, at the same time hinting that the marriage might be that between the artist-painter and the bridal self-image. But the 'beautiful bride', with her wrinkles and sunken cheeks, is also menaced by the frankness of her rendering—a form of self-declaration that has little to do with the fulsome and benign literalness of the sixteenth century. Susan Hauptman's charcoal and pastel self-portraits are also sustained by bravado technique and minimal contextual interference. As with Harris' selves, we are driven into an unremitting encounter with the artist-protagonist from which we emerge with the uncanny sense of having met with a refracted subject. Hauptman lays down luminous charcoal webs driven by the flourishes of a dissenting eye—one that refuses with dream-like precision to see the self outside its own projections. The visionary product might be lightly androgenised, faintly mutated, sensually buckled by a smudge of pastel enlargement, or unimaginably distracted. Her personhoods are always caught up in a restrained symbolic environment and costumed with pantomime exactitude. They are the sediments of an ecstatic introspection that knows desire is always uneasily suspended between self-knowledge and self-performance.

These works suggest that whether we like it or not, portrait-like images of the self are still made and measured in relation to the stereotype of the Renaissance portrait, with its plenary detail and superficial virtuosity. In a sense, all faces are pitted against the ideal, luminous particularity of the faces and contexts made by Raphael, Leonardo and Titian (and by the photographic revolution that stole Realism's thunder). Their vivid morphologies, assertive self-presence, and ineffable 'reality' are little theologies of the face and stand at the apogee of the tradition of likeness: they are likeness-as-being.[53] Yet, whether in the temporal-textual self-portraiture of Montaigne's *Essays* (1580) in the contra-portraits of

Arcimboldo, or in later Romantic and modernist reconfigurations of the social and private body, there have always been resistances to the Renaissance norm. Indeed the perfection and exactness supposedly aspired to in this measure can be said to evade, diminish and misrepresent key issues in facial becoming and contextual personhood that are better understood (and visualised) in non-Renaissance-type productions of the face. Instead of the vivid social and somatic epiphanies celebrated in histories of the portrait, even the Renaissance face encodes certain subjections and refusals consistent with the mimetic eclipse of complex selfhood.

Around the edges of the Renaissance—in the writings of Montaigne, in the vegetal faces of Arcimboldo, in Dutch genre painting, and in the faces of absolute power (on coins, medals, and canvas) made for the Sun King, Louis XIV—there were a number of counter-forces that (thought together) can be seen as contestations of the natural magic faces of the Renaissance tradition. These faces speak out against those that are soft and transparent, knowable, safe, perfectly real and perfectly imaginary in their perfectly real and perfectly imaginary theatrical spaces of perfectly imaginary depth and fullness. Montaigne and Arcimboldo explore the surfaces and depths, the histories and materials, the absences and postures that inhabit and make up the face. For them, the face's magic and its death, its singularity and its necessary profusion, its incantation and its implosion, are all inseparable from its imaged, auratic, presence. As we look more closely at the faces before us, it becomes apparent that the selves they offer are mediated by a number of conscious interferences. While the history of Realism is always a record of its codes, strategies and knowing seductions, the new narcissism, coming as it does in the wake of the many forms of reversion to the body that have characterised the art world's response to the Minimalism and Conceptualism of the 1960s and 1970s, is forced to reckon with the cumulative effect of Realism's impingement on bodies and selves. I want to outline what seem to me the major modes of interference run by the new work between the humanist icon of the Renaissance portrait and later counter-realist recodings of the human figure as a social, or sublime, or fractured, or expressive self.

The simplest and most obvious departure from the representation of a single, 'individual', body in an appropriate, particularised space (its natural context, or locale) takes place through multiplication. The body or self might be doubled (as in James Croak's *Twins* (1989), or its key body-parts isolated and pluralised—as in the scavenged photographic faces of Gwen Akin and Allan Ludwig's *The Women Series* (1993), or the grid of acrylic-painted plaster figures assembled in the mock-formality of Matthew Freedman's *Self-Portraits with Underwear Pulled up too High* (1995).

Bruce Nauman's *Ten Heads Circle/Up and Down* (1990) combines both doubling and multiplication, but sets this splitting, additive logic in an

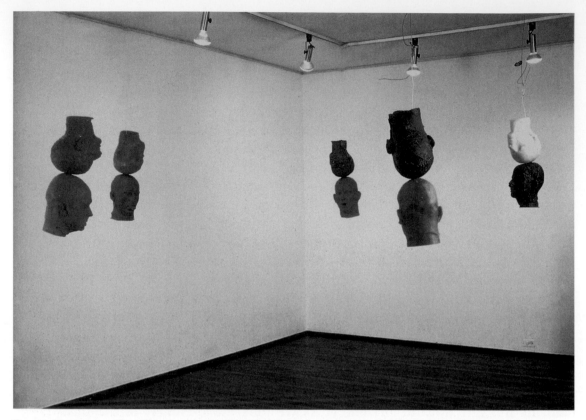

Bruce Nauman, *Ten Heads Circle/Up and Down*, 1990, wax and wire, each head 12 × 9 × 6 inches. Courtesy Leo Castelli Gallery, New York

important history of survival for the face during the Minimalist and Conceptualist drought years for body-based representation. *Ten Heads* consists of ten suspended wax heads (the maximum number to date for the artist's multiplication), discomfortingly arranged head-to-head in coloured pairs, and configured as an inward-facing circle. Nauman made a number of pieces using hollow, cast-wax heads at the beginning of the 1990s. The heads themselves were based on three models (Andrew, Julie and Rinde—whose names frequently appear in the titles of the works, along with literal information concerning the disposition and context of the heads). As with much of Nauman's work, the headpieces are offered as a kind of open installational series. Sometimes they are hung singly; sometimes they meet in pairs (eg 'plug to nose'—the plug refers to the breathing plug inserted in the models' noses during the application of alginate casting material to the live head); sometimes the heads are stacked, sometimes tripled; sometimes they are reversed, sometimes spinning; sometimes they are mounted on blocks; sometimes installed with other objects, including TV monitors. There are also epoxy resin and fibreglass variants, cast from the same moulds. And related

works (such as *Shadow Puppet Spinning Head*, 1990) use 'real' heads, both right-side-up and inverted, configured in analogous positions on videotape.

These recent attentions to the human head cap a quarter of a century of investigation into the coining of identities, and the double-binds of the expressive facial self. Beginning in the mid- and later 1960s with *Self-Portrait as a Fountain* (1966) and his body-part series (such as *From Hand to Mouth*, 1967), Nauman scrutinised the appearance of the head and face in virtually all the media and materials with which he experimented. The production and imaging of faces was both the subject and object of *First Hologram Series: Making Faces (A–K)* (1968). Around 1969 he made films and videos, including *Lip Sync* (1969), a sixty-minute video of a mouth and neck viewed upside-down and accompanied by a non-synchronised soundtrack, and *Pulling Mouth*, an eight-minute, 16mm film of 'Slo-Mo' contortions that home in on grotesquely expressive dislocations of the face. Even in the 1970s and early 1980s, when Nauman was more interested first in the making of spatial contexts and then in the coloured visualisation of text, actor-driven video pieces such as the forty-minute long *Elke Allowing the Floor to Rise up Over Her, Face Up* (1973), insist on the performative imbrication of the face in the unfolding drama of dimensions. The powerful *Clown Torture* videos produced after 1987 offer a disturbing culmination for these celluloid and pixilated heads. Finally, the conditions of facial exchange are humorously literalised, and once again doubled, in neon works from the mid-1980s, including *Double Slap in the Face* (1985) and *Double Poke in the Eye II* (1985).[54] *Ten Heads* both pluralises and tones down the genealogy of facial types at the end of this little tradition. The heads here are real, but replicated, replacing unitary or paired expressive subjects with suspended waxen moments. The piece thus tames and controls the issuance of exaggerated, satirical or humorous facial gestures that preceded it. The high, contrasting colours of the clown's painted cheeks or the neon stick figures are replaced by single waxy hues. Everyday actions and iterated distortion are replaced by hangman-like suspension. Performance is taken over by the surrogate; dialogue by silent, circular, face-to-face encounters; and screen-trapped flatness by the simultaneous palpability and disguise of the life-mask. Nauman's ten heads are doubled, replicated, multiplied and gathered in a narcissistic circle where they quietly ironise the self-consuming gazes of the self.

Already announced in the work of Nauman, another form of dislocation for the represented subject arrives in various kinds of material extension. While some of these selves are painted or sculpted using oil, acrylic, plaster, stone or wood, others resist, or disdain, normative media, preferring instead to reallocate the meaning of their images in dialogue with its physical constitution. Thus James Croak's newly born boy *Twins* are cast in dirt, an arresting and unlikely material to stand in for the fragility of post-natal flesh. The moment of human arrival, or delivery, is thus clearly associated with its

finality and end in a dust-to-dust intimation of mortality. As Freud suggested, the narcissistic condition (where self-love replaces object-love) may merge ambiguously with the death drive. Ken Aptekar admixes sand-blasted glass and bolts and applies them to his painted wooden surfaces, loading them with an incongruously effective texture that simultaneously underlines and traduces the transparency (glass), and constructedness (bolts) of the image. Mirror parts and wall parts, symbols of reflection and opacity, are viscerally overlaid in the articulation of the self. Like Nauman, Victor Henderson uses wax to achieve similar sensations of provisionality and softness. Simulating the expressive textures of Van Gogh he works up his *Self-Portrait* (1990) in encaustic (a mixture of wax and pigment); while, as we have seen, Nauman's cut-off waxen heads provoke the obliqueness and suspension of communicative exchange, even as they simulate the co-ordinates of the flesh and come together in a self-communing circle.

Janine Antoni works up her portrait busts in common, malleable substances, including soap and chocolate. She draws attention to the relay between materials and image through titles (such as *Lick and Lather*), that refer to the processes and effects of her self-effacement. The chocolate face

Janine Antoni, *Lick and Lather* (detail), 1993–1994, 7 soap and 7 chocolate self-portrait busts, each bust 24×16×13 inches. Courtesy the artist and Luhring Augustine Gallery, New York

had its features partly eroded by incessant licking, while her soap bust was lathered down by the rubbing actions of her own body submerged in water. These pieces have been described as explicitly narcissistic in that they are 'about [the] self-pleasure in which a woman (an artist) performs acts for her own delight' while at the same time rejecting 'the viewer.'[55] This description, I think, both hits and misses the effects of Antoni's work, and the sites of its collision and aversion converge, of course, on narcissism itself. For what is alluded to in this comment is a residual, old-order narcissism, still vestigially attached to the asocial self-indulgence castigated by Lasch and others. But Antoni's actions are not as simply self-pleasuring as this account suggests. If they entailed gratification it would have been somewhat masochistic: the artist's lips and other body parts were blistered and chafed by the friction of her subtractive performance. Rather than a manifestation of narcissism, Antoni's is an action of narcissistic disavowal: she does not give but actually takes away the self-image.[56] The piece also offers to interrogate the visual drives of narcissism, for it does not double up the artist's face by looking, it de-moulds it by touch. Further, the almost scandalous tactility solicited by these gestures continues a long tradition of dispute with Renaissance optical space, contributing to a critique of the perspectival persona.[57]

Beginning in the first years of the 1990s, Tim Hawkinson reinvented the spatial co-ordinates of his body in an eclectic series of works that inflated his image in a latex body-cast (*Balloon Self-Portrait*, 1993); photographically mapped his visible volumes (*Humongolus*, 1995); tracked down other body-surfaces hidden from view (*Blindspots*, 1991); and, using numbering devices, audio rigs and writing machines, variously counted up, sounded out and signed off (*Signature*, 1993). Looking back to Jean Tinguely's incontinent machines, the bodily processes of Morris and Nauman, and the obsessive hammering time-pieces of Jonathon Barofsky, the result is a prodigal compendium of post-Duchampian templates for the quixotic recalibration of self-identity.[58]

Disruptions of scale make up a third form of intervention between the represented body and the viewer. The 250 silver prints of women's faces assembled by Gwen Akin and Allan Ludwig in *The Women Series* (1992–) are locked in oval, moulded-resin frames, and clustered in a circuit board of photo-portraits, ranging from locket to hand-mirror size. Such a gendered collectivity suspends the self in the framework of known and anonymous others. In *Monitor* (1994) David Deutsch produces an even more miniaturised cluster of personages, arranged in a dense tessellation of frames in a diffident *trompe l'oeil*, suggesting their alignment around the curves of a cupola—a place traditionally reserved in ecclesiastical architecture for the face of God. Substituting magnification for diminution, and in the process debating with both, Viola Frey and Chuck Close offer a commentary on the body or face (respectively) as a colossus. Frey's ceramic sculpture, *Artist's*

Mind/World View (1994) poses two trudging figures on either side of a globe that rises only as high as their midriffs. Each man has a second, smaller, head sprouting from his own at an angle that seems to correct his stoop. These St. Christophers of the artistic imagination are failed Atlantids, stuck in a tableau of gigantic compromises as they converge on a world they may have dropped (or fantasised). Close's *Self-Portrait*, a 72-colour silkscreen made in 1995, confronts us with the giant painted face of the artist, explosively confected from a gridwork of hundreds of little squares, each invaded by a blurry burst of pigment. The association of these minimal units reveals a greater whole whose distorted visage somewhat resembles the fumbled resolution of over-enlarged photographs. Yet these are cyclopean faces that put painting itself in the place of the eye. The many, fractured cells that make up this engorged but dissident likeness are abstract units, meaningless outside of the larger-than-life point of view after which they can be read as a resemblance. Other works, including the faceless and bodyless traces of Hawkinson's *Signature* (1993), disrupt the corporeal discreetness of the portrait tradition by the addition of writing, text and language. Ken Aptekar inscribes the title *So, What Kind of Name is That, Aptekar?* (1994) in cursive white letters that stretch diagonally from top left to bottom right across the wooden support, each word occupying its own line. Near to the 'is' in this textual sequence, Aptekar has written the false signature 'Rembrandt' (in black). The self, the name, the signature, the model and the precedent are locked in a stylistic cross-dressing with the clothes of history.

If words are inscribed on the painted representation in Aptekar's image, they are literally written on the body by the Russian artists Rimma Gerlovina and Valery Gerlovin. The Gerlovins have detoured the Russian Futurist device of painting faces (with Rayonist or linear designs),[59] reinventing the face as a pink board for the display of labels, titles, split words, assisted letters, chemical symbols, diagrams, drawings, simulated body-parts and mythological names. In *Vintage* (1990), Rimma Gerlovina sports a Bacchic wig got up with red and white supermarket grapes. The word 'vintage' is written in restrained, sans-serif script on her forehead; but the letter 't' is formed as a cross whose intersection arrives above the word, and whose base extends to the tip of Gerlovina's nose. This effectively slices up the word 'vintage' into 'vin' (the French for wine) and 'age'. Such additions of fruit and text to the photographed face allude not only to the pleasured indulgences of Greek mythological tradition, but also to the fantastic organic portraits of the Viennese court painter, Arcimboldo.

The allusion to Arcimboldo, and the bringing together of fruit, the face and language, is not fortuitous. For the series of composite heads produced by this entertainer and stager of performances in the course of some 25 years (1562–87) spent at the court of the Hapsburg Emperors in Vienna and Prague, may be said to signal the parodic death of the Renaissance-type

portrait. Like the Gerlovins, Roland Barthes interprets this demise in relation to a new set of ideas (and visualisations) about language: 'baroque representation', he notes, 'turns on language and its formulas... under [Arcimboldo's] picture hums the vague music of such ready-made phrases as *Le style, c'est l'homme*... The dish reveals the cook, etc'.[60] The Gerlovins have transformed the captions, or titles, suggested by Barthes, that underline the image, into literal inscriptions, allowing the fractured word itself to substitute for Arcimboldo's mosaic of legibly interlocking alien parts. If, for Arcimboldo, a portrait identity is both given and taken away as 'the parts of speech are transmuted into objects',[61] the Gerlovins have made the leading object of identity, the face, into a screen that houses the parts of speech. What Barthes interprets as a grotesque or 'monstrous' progression 'from all substances to the human face'[62] signalled a new and dangerous mortality for the front of the head. No longer did it function as a bright, mirrored vessel for the social soul. Instead, it was made up of the teeming, profligate, shifting, inexorable parts of nature (fruits, leaves and fauna). While the Gerlovins' photographs foreground the play of face and text, their muted fancy-dress of landscaped cheekbones and grape-gorged tresses also suggests the masquerading of the self. Masquerade is, perhaps, the most complex of the interventions in the representation of the self that we encounter in the artists of the new narcissism. It thrives on several of the effects we have already outlined, and mixes promiscuously with them. It splits and pluralises the self into self-images, and adds the self to the images of others; it overcodes the self with more signs and references than it can rightly bear; it parodies the self, making it bigger or smaller, on a whim; it costumes the self with giddy disguises; and it offers the self as a tiny vector in a fantastically outsized image-world.

As with other effects of the interrogative narcissism of the 1990s, the theatrical opacity of the self was already a key issue in the 1980s. Early in her career, Cindy Sherman, the mother of postmodern masquerade and author of its Neo-Baroque extension, expressed her anxiety that the meaning of her photographs would be trapped in a circuit of reference to the self that joined the photographer with her subjects: 'I have this enormous fear of being misinterpreted, of people thinking the photos are about me, that I'm really vain and narcissistic'.[65] By the mid-1980s, her relentlessly various photographic personae cease to take their places in a quasi-filmic succession of female alter egos. Instead, they cross genders, becoming monks and 'curly haired' men in *Untitled (# 207)* (1988) and *Untitled (# 201)* (1989), they are de-humanised as mannequins and sex-dolls; and they are replaced by the marks and excremental traces of their animate embodiments. These pieces act out the ghost story of narcissistic identification. They substitute hallucination for reflection; sexual trauma for the onanistic beatitudes of classical self-absorption; and rough, disembodied violence for the smooth

textures of obsessional containment. Just as the Gerlovins' work can be sited only between the categories of textual interruption and masquerade, so Sherman's later work looks towards a final form of interference with the self that goes further than the distortions and disguises discussed above. In this form, interference becomes denial, disturbance becomes replacement, and selfhood is reconfigured as transference. Her selves are subject to a type of doubled representation that is not merely doubled-up, or pluralised. Instead, they are imaged through that which is already an image, and/or an object: they are opaquely substituted by a surrogate. In Sherman's photographs from the mid-1980s, in David Baze's *Aficionados* (1993), in Masamuri's artistic restagings of the self, and (rather more implicitly) in the other effects of standing-in and self-substitution, we encounter a powerful and threatening representation of the self achieved only through its rupture, dissolve and reparation.

Mannequins, dolls and other surrogate-selves are sent out to do battle and suffer the looks of others in place of the self, which is symbolically present in them. Dennis Oppenheim, Charles Ray, Kim Dingle and Judy Fox have all made simulated, post-super-realist figures that precipitate an uncanny deliverance of the body from images of the perfectly real. Hal Foster helps us to connect the narcissistic self with the uncanny effects of its representation, noting the function of the 'mannequin, doll, or dummy as a disguised self-portrait' whose paranoias are hinted at by Freud in his essay 'The Uncanny' and its reading of ETA Hoffmann's story 'The Sandman'.[64] The mannequin is the primary symbol of a space of in-betweens that configures the self and the other, love and death, narcissistic retreat and uncanny disquiet.

In the mid-1970s, Dennis Oppenheim used the surrogate figure as a means of renegotiating his previous commitments to the Earth and the Body. *Theme for a Major Hit* (1974) poses a two-foot-high, machine-operated puppet bearing the artist's features as a replacement for the 'natural' or performative self. Along with Warhol's repetitive annexation of the public visage of celebrities (including himself), and Nauman's interrogation of the subject conditions of head-to-head exchange, Oppenheim's puppet is one of the founding gestures of self-substitution and reinvention on which the new narcissism is based. It is also one of the most complex. For although perhaps the earliest example of post-Conceptual surrogacy, *Theme for a Major Hit* stages several horizons of self-performance not taken up in the predominantly static substitutions of the younger artists discussed here. Its musical and kinetic components look forward to the experiments with identity that would follow in the videos and installations of the 1980s. And its pivotal location in the development of Oppenheim's work between the early 'Earth' and 'Body' pieces and the later 'Machines', 'Factories', 'Assembly Lines' and 'Stations', suggests that the puppet/mannequin is both a literal

starting point and a nostalgic machine for any enquiry into the arcane switch-system of selfhood.

The insolent painted porcelain infants made by Kim Dingle and the quizzically lugubrious terracotta children of Judy Fox operate in a more physicalised critical space. Looking back to the aftermath of self-recognition, they seem to suggest that the young child's narcissism is a charade of costumes, postures and forms got up only for the object-pleasuring of the little self, and then overcoded by rage or religion. Yet in the act of looking, bigger selves are taken in. Fox's children are crossed with folk histories and spiritual traditions—the young Eve, the little Buddha, the infant Jesus, a gangly *Cinderella* (1991)—while Dingle's look stubbornly forward to the social destiny of racially (and otherwise) conflicted selves. Dressed in pure white baptism dresses, sporting lacy ankle socks and shiny black shoes, the white child (wearing eye-glasses with the prescription lenses of the artist) and the black child, who is her other and her pair, are lodged in a kind of Surrealist nursery complete with toddler-tarnished wallpaper and toy targets. The more traumatic violence of Dingle's earlier painted children—imaged duking it out in the dirt—is sequestered in *Priss' Room* (1994) with its milder, though more psychotic, pugilism of puckered lips, small clenched fists and bulldog stances. Wearing faces summoned up, then gripped, by anger, these irate icons enact the pure transfer of potential violence. The pacific narcissism of a beautiful, contemplative self is here turned inside out as an American infant surrenders all reflective control of her image.

David Baze intervenes differently in the process of surrogate representation by producing an image not just of the self as a mannequin, but, in addition, of the self as puppeteer. This preliminary doubling of the doll-master relationship is doubled once again (and regendered in the process) as it is staged next to a representation of Baze's spouse controlling his likeness, just as his representation is shown in control of hers. This folding and cross-reference between control and subjection emblematises the circular limits of narcissistic absorption as the self that is lost to the world of action, and volition becomes just another manipulated item in the world of objects. Two Japanese-born artists, Masami Teraoka and Katsura Funakoshi, think through opposite sides of the relationship between social and solipsistic selves. Teraoka collides the 'Floating World Pictures' of the nineteenth-century Japanese Ukiyo-e school with comic-book scenery and California Pop. His *Hanauma Bay Series* (1984) satirises the obsessive routines of Japanese tourists, whose gaze onto a world of cultural and geographic difference succeeds only in replicating (videoed) images of themselves. In *Los Angeles Sushi Ghost Tales: Fish Woman and the Artist II* (1979)—another work configured in his signature cinemascope format—Teraoka teams a self-image with a 'monstrous version of Mother Nature', setting both in a sushi bar, complete with an ecologically critical menu.[65] Narcissus' self-obsession

precipitated his death and transfiguration into a flower; but the artists who follow in his wake are both invigorated and corrupted by their encounters with the natural world. Transferred from the outside to satisfy and construct the body, foods are crucial natural objects that even the artist-narcissist cannot disavow. For Teraoka they are a leading metaphor of the constitution of the self by a compromised and partly disabled nature.

The spare camphor wood, marble busts and lithe figureheads of Funakoshi are replete with benign but unnerving statuary reserve. Their quasi-narcissistic self-absorption crosses individual, contemplative retreat with a kind of timeless, placeless extension. In this sense, they are dream-persons caught between traditional funerary commemoration[66] and vivid, contemporary becoming, between borrowed surrogacy and found selfhood, between Europe and Asia. The title *Silent Mirror* (1989) helps us to see further, for it suggests a mirror that cannot speak (or reflect), offering another reminder of the narcissistic refusal of mimetic representation and of the drive to peep over the mirror/wall that we have associated with introspective imaging. The surrogate restraint of Funakoshi meets the teeming substitutes of Sherman, Fox, Dingle and others at 180 degrees.

But if postmodern masquerade needs a father, it has surely found one in the Japanese artist Yasumasa Morimura. Morimura's masquerading self is fetishistically grafted onto the icons of Western art history, whose picture surfaces become the new mirror, or glassy waters, for the artist's narcissistic attachments. Within the limits of its cultural paradigm—that of an exchange between a Japanese subject and the Western visual canon—Morimura's narcissism has a polymorphous extension that recalls Freud's description of primary narcissistic experience. It is excessive, mimetic, vampiric and trans-gendered. The self stands in—promiscuously, happily, mesmerically, but with no trace of expressive irony—for historical figures, known and anonymous, for minor characters, for famous beauties, for national types, for black and for white; his face even merges with the multiply obsessional apples of a Cézanne still life. And in *Mother (Judith II)* (1991), he crosses Cranach and Arcimboldo, 'with Judith's face turning into a light green cabbage, and Holofernes recast as a still life with potato-head',[67] suggesting a perverse identification with the head that cuts heads off, and the cut-off head it works on (Judith and Holofernes). The vegetable mask may be the final form of narcissistic disillusionment, as Morimura's narcissism imagines a self that is all-seeing, visually garrulous and insouciantly critical. He explores the outer edges of self-absorption as it merges with hectic transference. It is thus that his work manages to be cautiously deadpan, manically expressive, racially corrective and willfully and indulgently theatrical—all at the same time.

I have introduced some of the ways in which recent art resists—and toys with—the identificatory and symbolic portrait, and with the artists' identities and symbolic selves. The cultural politics of self-representation and the

Yasumasa Morimura, *Mother (Judith II)*, 1991, colour photograph on canvas, edition of 3, 260 × 180 cm. Courtesy the artist and Luhring Augustine Gallery, New York

curious, often contradictory, history of narcissism come together through a series of dialogues and defections, echoes and allusions. A work by the Gerlovins makes this humorously (and literally), clear. *Echo* (1989) shows the three-quarters profile face of Rimma, her forehead written over with the word 'ech$_2$o' and her left cheek cradled by three hands each bearing the chemical symbol for water (H_2O). The triple hands of the photographic figure stand in for the medium of narcissistic representation itself: they are the water in which Narcissus sees his darling image. The phantom hand might be his face; or it might represent his preliminary re-emergence from the water that painted him and caught him up in delirious self-love. These artists' hands are the wall of representation itself, the very place, and the very means, of imaging. But they are also signs of self-absorption, reflection, and delusion, as fickle and transparent as water itself.

The narcissism of the 1990s is carried into the world by the delayed, repeated, voyeuristic nature of its reception. With the lessons of postmodernism behind them, these artists know that the polarity between productive and destructive forms of narcissistic making is necessarily a false

one. The selves and others they negotiate are often obsessional: they perform their delusions, they enact their multiplicities, and they live out their interiorities. They know, above all, that nothing is ever quite what it seems, especially the self. But although we are confronted here by doubling, the uncanny, complex temporalities and disturbed imitation, a 'critical model of the posthumanist subject' is not always, or exclusively, founded in 'anxiety'[68] or 'disturbance'; nor does it only reference 'the body as horror' or excess.[69] Sometimes it is critical through pleasuring, and sometimes it is centred (if only for a moment). Narcissism is another name for such focus and pleasures—even the paradoxical pleasures of rage, anger or delirium. At the same time, narcissism is the seeming equal and possible opposite of abstraction. Full of self-reference, formal indulgence and the surrenders of seeing closely, preoccupied with surfaces and reflections, the self and not the other, it is also a space in which conscience begins, where the orbit of objects is decayed, and where all forms of facing onto the world start out.

NOTES

1. 'Conversation avec Picasso' (with Christian Zervos), *Cahiers d'Art*, vol X, nos 7–10, Paris, 1935, pp 173–8; trans in AH Barr Jr, *Picasso: Forty Years of his Art*, Museum of Modern Art, New York, 1939, p 18.
2. *Le peintre entouré de masques* or *Autoportrait aux masques* (1899) is just one of a series of the self-representations that in many senses focused Ensor's work, culminating in paintings from the 1930s such as *Grand autoportrait aux masques* (1935); *Petit autoportrait aux masques* (1936); *Moi et mon milieu* (1939); and *Moi, ma couleur et mes attribus* (1919).
3. Lucy Lippard, 'European and American Women's Body Art', in *From the Center*, EP Dutton & Co, New York, 1976, p 125.
4. Thomas Lawson, 'Last Exit: Painting', *Artforum*, vol 20, no 2, October 1981, p 42.
5. Craig Owens, 'Honor, Power, and the Love of Women', *Art in America*, vol 71, no 1, January 1983, p 9.
6. Lawrence Rinder, in the pamphlet accompanying 'Matrix/Berkeley 130', University Art Museum, Berkeley, August to November 1989, np.
7. Sigmund Freud, 'On Narcissism: An Introduction' in Andrew P Morrison (ed), *Essential Papers on Narcissism*, New York University Press, New York, 1986, p 38.
8. Aristotle, *Nicomachean Ethics*, trans. Martin Ostwald, Bobbs-Merrill, New York, 1962, p 253.
9. DT Suzuki, *Essays in Zen Buddhism: First Series*, Grove Press, New York, 1961, (1949), pp 345, 317.
10. Pascal Bonafoux, *Portraits of the Artist: The Self-Portrait in Painting*, Skira/Rizzoli, Geneva/New York, 1985, pp 8, 19.

11. *The Selected Writings of Ralph Waldo Emerson*, 'The Modern Library', Random House, New York, 1949, p 160.

12. Freud, *A General Introduction to Psychoanalysis*, trans Joan Riviere, Simon & Schuster [Pocket Books], New York, 1952, p. 426.

13. Ibid, p 434.

14. Ibid, p 433.

15. Actually, not in general, for lesbianism appears unthinkable even within the unfortunate identification suggested in this, one of Freud's more dubious throwaway asides.

16. Freud, *A General Introduction*, op cit, p 434.

17. The title alludes to Freud's phrase in *A General Introduction* where he writes of his attempt to 'peep over the wall of narcissism' (p 431) in an effort to understand the crucial role played by narcissistic neuroses as against the 'hysterical' or 'transference neuroses', privileged in his earlier studies.

18. Martin Jay, *Downcast Eyes: The Denigration of Vision in Twentieth Century French Thought*, University of California Press, Berkeley, 1993, pp 6, 222; the context is a discussion of Freud's *Civilisation and its Discontents* (1930).

19. Freud, op cit, p 424.

20. Ibid, p 384.

21. Christopher Lasch, *The Culture of Narcissism: American Life in an Age of Diminishing Expectations*, Norton, New York, 1979.

22. See, for example, Sydney Pokorny's review of Kerri Scharlin's 'Diary' at Wooster Gardens, New York, *Artforum*, vol 35, May 1997, pp 110–11. Among other self-referring projects, Scharlin solicited articles about her self-persona from magazine writers, commissioned police sketch-artists to render her, filled-in for Barbie in a children's colouring book, and invited six TV producers to develop five-minute episodes about a conceptual artist called 'Kerri'. Pokorny finds in the totality of these activities not a critique of the mediated 'personality', but a 'grating narcissism': 'Despite Scharlin's claim to investigate the creation of "identity" and the nature of "public image-making", her work reveals no deep truths about either; it merely underscores the grating narcissism of her entire project' (p 111). Scharlin reportedly acknowledges that her work circulates around a repetitive narcissism, and even associates its 'success' with her insistent postures of social internality: 'Does my work succeed because people identify with my narcissism?' (cited on p 111). In 1996, the exhibition 'Videoscan' was held to reveal the retreat of recent video art, on the model of contemporary advertising cultures, back to the narcissistic conditions associated with it by Rosalind Krauss; see Catherine Elwes' review, in *Art Monthly*, no 196, May 1996, pp 8–11. A milder, almost neutral, commentary on the new narcissism has attended

exhibitions by other artists. Pipilotta Rist's videos, exhibited at the Chisenhale Gallery in London, were described as 'lulling', 'seductive', 'repetitive' and 'narcissistic' by Gilda Williams, *Art Monthly*, no 197, June 1996, pp 34–35. Stephan Balkenhol's works have been described as 'sculptures of narcissism': see Wolf-Gunter Thiel, '"Stephan Balkenhol" sculptures of narcissism', *Flash Art* (International Edition), no 191, November/December, 1996, pp 76–78.

23. Rosalind Krauss, 'Video: The Structure of Narcissism', *October*, no 1, Spring 1976. See also 'Notes on the Index: Part I', in *The Originality of the Avant-Garde and Other Modernist Myths*, MIT Press, Cambridge, Mass, 1985, p 196.

24. Hal Foster, 'The Artist as Ethnographer', in *The Return of the Real*, MIT Press, Cambridge, Mass, 1996, p 216. This essay also looks back to the Surrealist conjunction of 'anthropology, art, and politics': 'then as now self-othering can flip into self-absorption, in which the project of an "ethnographic self-fashioning" becomes the practice of narcissistic self-refurbishing' (p 180).

25. Ibid, p 196. Foster writes that 'Just as appropriation art in the 1980s became an aesthetic genre, even a media spectacle, so new site-specific work often seems a museum event in which the institution imports critique, whether as a show of tolerance or for the purpose of inoculation (against a critique undertaken by the institution, within the institution)' (p.191).

26. Ibid, pp 202–03.

27. Jeremy Gilbert-Rolfe, 'Seriousness and Difficulty in Contemporary Art and Criticism' in *Beyond Piety: Critical Essays on the Visual Arts*, 1986–1993, Cambridge University Press, Cambridge, 1995, pp 31–32. For further discussion of Gilbert-Rolfe's attack on 'political realism', see my review of *Beyond Piety* in *Art History* (London), vol 20, no 3, September 1997, pp 489–92.

28. See Veralyn Behenna, 'Jack Pierson: Triumphs of the Real' (interview), *Flash Art*, (International Edition), no 175, March/April 1994, pp 88–90.

29. Umberto Galimberti (interview with Luciana Sica), 'Der neue narzissismus', *Du*, no 6, June 1995, pp 52–53.

30. Craig Owens, 'The Discourse of Others: Feminists and Postmodernism', in Hal Foster (ed), *The Anti-Aesthetic: Essays on Postmodern Culture*, Bay Press, Post Townsend, WA, 1983, p 72. Owens' point is echoed by Kate Linker, who notes that 'Birnbaum's *Wonder Woman* and [Judith] Barry's *Casual Shopper*... are figures of narcissism, the one 'the phallic mother' of television spectacle, the other the ideologised consumer seeking personal completeness, and libidinal pleasure, through the purchase of material objects': 'Eluding Definition', *Artforum*, vol 23, no 4, December 1984, p 67.

31. Amelia Jones, 'Negotiating Difference(s) in Contemporary Art', in Richard Hertz (ed), *Theories of Contemporary Art*, Prentice Hall, Engelwood Cliffs, NJ, 1993, 2nd ed, pp 204–05.

32. Krauss, 'The Originality of the Avant-Garde', in *The Originality of the Avant-Garde,* op cit, p 161.

33. See Brian Butler's review, *Artweek*, June 25 1988, p 3. 'Abstract Narcissism' was at the Rosamund Felsen Gallery, Los Angeles.

34. Michael Cohen, in *Narcissistic Disturbance*, Otis Gallery, Otis College of Art & Design, Los Angeles, February 4–April 1, 1995, pp 5, 15.

35. Ibid, p 15. The other artists in the exhibition were: Nancy Barton, Louise Deidrich, Keith Edmier, Victor Estrada, Jeff Koons and Collier Schorr.

36. Laurence A Rickels, 'The art of psy fi' in ibid, pp 18–22.

37. Ibid, p 22.

38. Michael Cohen, interview with Lyle Ashton Harris, *Flash Art* (International Edition), no 188, May/June 1996, p 107.

39. Ibid.

40. Rickels, op cit, p 20.

41. See Introduction, above, pp 12, 14, 41, 46, 52–53.

42. Catherine Liu, 'Disturbing Narcissism', in *Narcissistic Disturbance*, op cit, p 26.

43. See eg Rossetta Brooks' review, *Artforum*, vol 33, Summer 1995, p 112, in which she criticises the exhibition for parading a dysfunctional narcissism that never achieves the disruptiveness for which it strives.

44. Foster, op cit, p 180.

45. Julia Kristeva, 'Interview with Catherine Franblin', *Flash Art*, no 126, February–March 1986, pp 44–47.

46. Attempting to redress the social passivity of what he terms an 'audience culture' increasingly locked into mechanisms of 'erasure and forgetfulness', Norman Kline suggests the need to reformulate 'a public style, despite the loss of public spaces', as well as a 'confessional style' based on re-entering the self: postscript 'July 1992' to 'The Audience Culture', in Richard Hertz (ed), *Theories of Contemporary Art*, Prentice Hall, Engelwood Cliffs, NJ, 1993, p 256.

47. See Jon Ippolito, 'Turning Aesthetics to Prosthetics', in *Art Journal*, (special issue: 'Digital Reflections: The Dialogue of Art and Technology'), vol 56, no 3, Fall 1997, pp 69–70.

48. Geert Lovink, 'The Data Dandy and Sovereign Media: An Introduction to the Media Theory of ADILKNO', *Leonardo*, vol 56, Fall, 1997, p. 60. Further aspects of this media theory are discussed in Chapter 9.

49. Brian Wallis, 'Anxious Bodies', in Judith Tannenbaum, *PerForms: Janine Antoni, Charles Ray, Jana Sterbak,* Institute of Contemporary Art, University of Pennsylvania, Philadelphia, 1995, p 11.

50. Mira Schor, 'You Can't Leave Home Without It', *Artforum*, vol 30, no 1, October 1991, p 114.

51. Barbara Bloom's *The Reign of Narcissism* was shown at the Würtembergischer Kunstverein, Stuttgart, the Kunsthalle, Zürich, and the Serpentine Gallery, London (the three institutions also co-published the 'Guide Book') between February and September 1990. For the references in the text, see the 'Guide Book', pp 117, 128, 160–61, 166–67, 176, 188, 191, 193.

52. John Currin, cited in *John Currin: Oeuvres/Works 1989–1995*, Fonds Regional d'Art Contemporain, Limousin, Limoges, France, 1995, p 38. John Zisser underlines the association of Currin's images of women with self-portraiture, referring to *Johnstone* (1990) as 'not that far from self-portraiture'; see 'Losses in Translation: Three Young Painters Give an Unfamiliar Edge to Portraiture', *Arts Magazine*, October 1990, p 104.

53. In *The Portrait in the Renaissance*, Phaidon, London, 1966, John Pope-Hennessy identifies the many layers of focus on the face in the Renaissance, many of them predicated on his claim that it was in this period that 'proper records of the human face' emerge for the first time. He writes of Botticelli's neo-Platonic investment in the 'kernel of personality', its 'poetic essence' (p 29); of 'Carpaccio's interest in the human face as a visual phenomenon' (p 22); of Rossellino's 'anatomical exactitude' (he was possibly the first artist to make use of the life cast); of Mantegna's development of 'a painting style based on the Roman bust' (p 86); of Leonardo's invention of 'the autonomous portrait' in the 1480s; of Raphael's 'psychologically truthful image based on conscious analysis of character' (p 113); of the achievement by Albrecht Dürer of new effects of psychological depth, culminating in his final self-portrait, which occupies a 'crucial place in the transition from the portrait as description to the portrait as encephalograph' (p 130). Even in the later Renaissance tradition, in which he claims 'ambivalence is the essence' of its attitudes to the portrait (p 132), Georgione's 'haze of literary romance' (p 136) and El Greco's culmination of Renaissance 'spiritual expression' (p 153) are interpreted as deviant only to clinch some hidden aspect of the paradigm of presence. Thus Michelangelo's self-portrait in the Duomo in Florence (the *Pietà*) is only 'willfully distorted to reveal the inner man'. The ineffability of the Renaissance real has simply shifted from the exterior to the interior of the subject.

54. The recent Catalogue Raisonné in *Bruce Nauman*, Walker Art Center, Minneapolis, 1994, offers useful descriptions and photographs of these and related works. Technical details of the casting of the heads are offered on p 311, in relation to *Andrew Head/Julie Head on Wax* (1989), apparently the first of the cast wax head pieces.

55. Bonnie Clearwater, catalogue essay, in *The Art of Seduction*, The Center Gallery, Miami-Dade Community College, Wolfson Campus, 1994, np.

56. In an interview with Laura Cottingham, 'Biting sums up my relationship to art history', *Flash Art*, Summer 1993, pp 104–05, Antoni notes that it is not necessarily the 'giving of pleasure, but of experience' that constitutes her point of beginning. The distance between self-referential pleasure and the testing of experience (which may or may not be pleasured) marks out some of the space between Lasch's views on cultural narcissism and the self-reflective projects considered here.

57. According to Gilles Deleuze and Félix Guattari it was 'Alöis Riegl who... gave fundamental aesthetic status to the couple, close vision—haptic space': *A Thousand Plateaus: Capitalism and Schizophrenia II*, trans Brian Massumi, University of Minnesota Press, Minnesota, 1987, pp 492–93. For the art connoisseur Bernard Berenson, however, 'tactile values' were the highest form of Renaissance representation, offering a plastic simulation of the dimensional world.

58. See Michael Duncan, 'Recycling the Self', *Art in America*, vol 85, no 5, May 1997, pp 112–15.

59. See Ilya Zdanevich and Mikhail Larionov, 'Why we paint ourselves: A Futurist Manifesto, 1913', in John E Bowlt (ed and trans), *Russian art of the Avant-garde: Theory and criticism 1902–1934*, Viking, New York, 1976, pp 79–83.

60. Roland Barthes, 'Arcimboldo, or Magician and Rhétoriquer', trans Richard Howard, in *The Responsibility of Forms: Critical Essays on Music, Art and Representation*, Hill and Wang, NY, 1985, p 132.

61. Ibid, p 134.

62. 'The principle of Arcimboldesque "monsters" is, in short, that Nature does not stop': ibid, p 147.

63. Cindy Sherman, 'Untitled Statement' (1982), in *Documenta 7*, Kassel, 1982, p 411.

64. Hal Foster, *Compulsive Beauty*, MIT Press, Cambridge, Mass, 1993, p 70.

65. See *Masami Teraoka*, Jacksonville Art Museum, Jacksonville, 1983, np.

66. Maria Porges suggests a stylistic connection between Funakoshi's sculptures and both European Romanesque and Japanese religious sculpture. She also notes that they take on attributes of 'funerary portraits': 'Katsura Funakoshi: Gazing into the Middle Distance', in *Katsura Funakoshi: New Works*, Stephen Wirtz Gallery, San Francisco, 1993, pp 4–5.

67. For a provocative account of the interpretations of Morimura, see Norman Bryson, 'Morimura: Three Readings', *Art & Text*, no 52, 1995, pp 74–79.

68. These terms, which mesh with some of the strategies discussed here, are put forward by Brian Wallis in 'Anxious Bodies', op cit. Following Judith Butler, Wallis argues that it is the 'repetitive and the performative structure of gender' that might best be employed 'to propose a critical model of the posthumanist subject', p 20. That

'anxiety', 'creepiness', 'duplicity, hidden agendas [and] incompletion' are often associated with recent self-representation is confirmed by Charles Ray in discussions with Dennis Cooper and Lucinda Barnes; see *Charles Ray*, Newport Harbor Museum, California,1990, esp p 32.

69. This is Norman Bryson's formulation of a movement in Cindy Sherman's work from the postmodern claim that 'all is representation' to the corporeal shock of 'the body as horror', in Elizabeth Bronfen, Zdenek and Martin Schwander (eds), *Cindy Sherman*, Schirmer Art Books, Munich, 1995, p 25. See also, 'House of Wax' in Rosalind Krauss, *Cindy Sherman, 1975–1993*, Rizzoli, New York, 1993. Bryson is interested, here, in situations that present 'the reverse of the body's subsumption into discourse... the body as symbolically recalcitrant' as it stumbles or falls out of order, p 219.

CHAPTER 7

Parametrology: From the White Cube to the Rainbow Net, 1996

Against the history of aesthetics (coming from esthesis, meaning 'unmeasured'), metrology, or 'the science of measurement', allows us to observe the history of referents and successive standards...

(Paul Virilio)[1]

If my sculpture is good it is because it is geometric... cubic truth [la raison cubique], not appearance, is the mistress of things.

(Auguste Rodin)[2]

The third [chromatic scheme sketched in on strips of celluloid] is composed of seven colours, the seven colours of the solar spectrum in the form of small cubes arranged initially on a horizontal line at the bottom of the screen against a black background. These move in small jerks, grouping together, crashing against each other, shattering and reforming, diminishing and enlarging, forming columns and lines, interpenetrating, deforming, etc.

(Bruno Corra)[3]

What endurance, perfection, symmetry, and order it commands, the cube. Surfaces, frames, environments, landscapes, even figures and faces, are all made over in its image. If Leonardo's Man reached out to the flat edges of a circle and square, the modernist personage extends its digits into the corners of a cube. The cube has been the building block of visual modernity, its stretch marks, our DNA. The cube stands at the allegorical centre of modernism, as a six-sided metaphor for its inception, its envelope, its institutional visibility, its lost dimensions, its continental drift, and its unyielding extension. Tower blocks, city blocks, colonial grids, power blocks—its scales measured the outreach of modernity from art to life. Now, in the 1990s, they may have fallen from our eyes; now, finally, we can see that we have loved the cube to death—even as we dwell among the virtual forms of its afterlife.

Meditating on its origin and discursive migrations, I will follow the cube from its visual renderings in the early twentieth century, through the incorporation of cubic logic as the lynchpin of modernism's geometries, to its emergence in the later 1960s and 1970s—most persuasively, perhaps in Brian O'Doherty's essay 'Inside the White Cube' (1976)—as a key symbolic structure in the art world's institutionalism. The White Cube was modernism's final format, the place within which its dimensions were

measured out most purely and perfectly. I want to explore the dispersal and reconfiguration of this iconic space, suggesting how the cube was deflated, parodied, contested and exploded, and then how it has been hyper-appropriated and undone. I am also concerned with the symbolic shift that engenders the cube's impossible antithesis—a counter-monumental, unenclosed, polyvalent space of becoming, which I term 'the Rainbow Net'. The shredded cube of the Rainbow Net is associated, above all, with the medialisation of contemporary culture, and it is under this heading, in Chapter 9, that I will set out my remarks on the crucial constituency of media and new technology in the art of the 1990s.

Putting aside the flimsy cubic crate of David's *The Death of Marat*, and other neo-Classical geometries, it is only at the end of the nineteenth century and in the first years of the twentieth that the cube sets out in earnest on its modernist journey. Despite his reputation for burnished Expressionism and molten surfaces, Rodin places an unexpected—and unprecedented—premium on what he terms 'geometric... cubic truth', a condition conceived against mere 'appearance' and exalted as 'the mistress of things'. Above all, Rodin associated this truth with works that sought for a kind of abstract emotivism as they took on the project of physicalising thought. He writes of *The Thinker*'s 'cubified silhouette', which 'stabilises the strong diagonals of the feet, shoulders, and knees, thereby giving the whole a powerful projection'; and of how, in *Thought* (a marble sculpture from 1886) 'a woman's head resting atop a roughed-out cube of marble... singles out the mysterious expression of the human personality by means of the physical person down to the last details'.[4]

But the inaugural images of modernism's cube-driven dream world were the 'little cubes' of Picasso and Braque, made in 1908 and 1909. Taking off from Provençal housing and the early modern factories at Horta de Ebro and L'Estaque (for example Braque's Rio-Tinto factories) these ambitious, muddy-brown and ochre blocks were interpolated from the spatial disjunctions of Paul Cézanne, and colloquially named after a critical encounter at an exhibition.[5] The cubing of space was, of course, a conceptual misnomer in which the wrapping or folding-up of the represented environment into look-alike geometric units was confused with the 'passage' of objects into multi-perspectival scenes. Yet, the dimensional disputes of this new formal strategy precipitated the standard discourse on transgressive rupture and avant-garde renovation. Cubism became a vernacular shorthand (or a foundational language) for the stylistic revolution of visual modernism. It gave rise to the winded, second-dimensional cubism of Mondrian, ordered the syntax of modernist sculpture, and purportedly underwrote virtually everything in the modernist-formalist tradition for the next half century—including definitive aspects of Surrealism and Abstract Expressionism—deemed worthy of perpetuating its stylistic destiny.

The cube, then, began its journey interlocked with the geometrism of the modern movement, with all that promoted its abstract angularities, grids, armatures and hard edges. Yet it could never be completely collapsed into the flat net of always-potential volume suggested, as Rosalind Krauss has argued, by the 'silent... stringency', the declarative yet repressive antirealism, of the grid.[6] Nor is it reasonable to suggest that the cube fulfilled the agenda of the square as the 'ultimate form of [modernist] self-reflexiveness'.[7] For while it was opposed to everything that was opposite to the grid, to all the accumulated limpness invested in art-making from the drooping time-pieces of Salvador Dalí to the flaccid sculptures of Claes Oldenburg and the rag-dolls of Mike Kelley, the cube fought back, not for self-referentiality, but for extension.

Standing at the head of the cube's modernist destiny was the Minimalist neo-Cubism of the 1960s, glimpsed in the boxes of Donald Judd and fulfilled—as well as perhaps dissipated—in the cubic iterations of Sol LeWitt. By the mid-1960s, cubes had infiltrated everywhere in the art world. 'In 1967', wrote one observer, 'the art magazines were full of sleek cubic forms'.[8] Around this time, LeWitt developed a language of modular cube-based structures whose Secret Book and Final Directory is still in progress. But LeWitt's cubic environments (we encounter their alter personae in Robert Smithson's *Entropic Landscape* (1970) were always—somewhat—more than mere extrapolations, or quasi-mathematical enactments. LeWitt's cube-ism is not just a rational epistemology of the cube, nor merely a mystical feint. It is both, sometimes more, and occasionally neither. Krauss was one of the first critics to resist the ascription of LeWitt's geometries to an abstract rationality that saw them as 'The Look of Thought',[9] or to a progressivist art history that viewed them as part of the climax of Western abstraction. Instead, she contended, the artist's forms were 'obsessional', set out in 'regimented but meaningless lines' like children's 'babble', and demonstrative not of pure visual reason, but 'of a kind of mad obstinacy' as 'design spin[s] out of control'.[10]

Aligning LeWitt with 'absurdist Nominalism',[11] or what Gilles Deleuze has termed Samuel Beckett's aesthetic of 'exhaustion',[12] shows that the fragility, drama and instability of the cube played key supporting roles next to its celebrity status at the turn of the 1970s. For, in addition to their pristine forms and hypervisibility, some of LeWitt's cubes, including *Buried Cube containing an object of importance but little value*, and *Five Part Variations with Hidden Cubes* (both 1968), are also covert or lapsed. Some are imaginary or unfinished (*Variations of Incomplete Open Cubes*, 1974). 'Box Show', at the Byron Gallery, New York, 1968, which offered an internal panorama of the cube, and LeWitt's book *CUBE* (1990), with its 511 photographs of a single cube 'using nine light sources and all their combinations', which fetishised its surfaces, make the cube into scopophilic

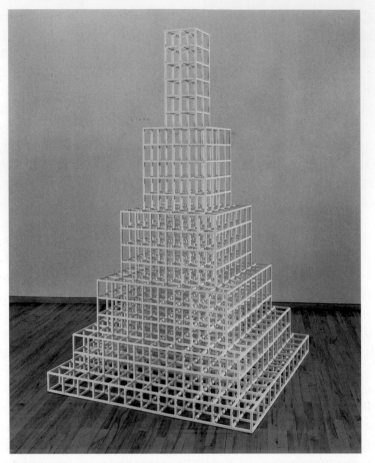

Sol LeWitt, *12 × 12 × 1 to 2 × 2 × 6,* **1990**, white painted wood, 99 × 57.5 × 57.5 inches. Courtesy John Weber Gallery, New York. Photo: F. Scruton

environments. Others, including the *Tower Block* structures, are seriously knowing urban parodies. Considered as an infinite series, LeWitt's cubes participated in the first cubic net.

Judd's body- or art work-scaled cubes, on the other hand, masqueraded as assertions of the specificity of objects co-produced by the experiences of an active viewership whose perceptual fields they variously interrupted and extended. Of the several softnesses that fell against the synthetic sides of the untitled Minimalist container, the most significant were not the cushiony surfaces of Pop, but the softness of life itself. Cubist life was an art-life that touched the world strangely in places where no one could really see. The comforts of this life were threatened not so much by the simulated smoothness of vinyl or the soft-time of Surrealism, but by the malleability of bodies and the un-time of the reinvented category of 'real-life'.

Before its apogee in the 1960s, the cube, of course, had precipitated a hundred agonies, embraces and refusals. Its auras were bright enough, as Roberto Matta put it, to set off 'rages that move in tender parallels'. Matta

and Alberto Giacometti stand on either side of the Surrealist disavowal of the cube. For while Giacometti explored the catastrophic correlation between the cube and the head (a two-decade project revealingly examined in Georges Didi-Huberman's *Le cube et le visage*),[13] Matta ventures the vertiginous dissolve of the cube after the Surrealist tradition of counter-cubic biomorphism. He recorded his birth from the global cubic womb of modernity as producing 'one of those who came from the four corners of the earth to work with Le Corbusier'. The psychological morphologies of his signature works were predicated on the implosion of an external, cubic logic, and the demoralisation of architecture in a newly spun network of 'strange mucous webs'. Trapped, early on by 'the vertigo of equal sides', Matta spat invective against the edges of his geometric cell and proclaimed the 'need for walls like wet sheets which change their shapes to match our psychological fears'.[14] These white, wet, mutable sheets become shrouds for the ghost-like emanations of a psychological para-Cubism. Embossed with thoughts and actions, they emblematise the spectral, folded machineries of a pataphysics at war with 'the epidermis of people and things'.[15]

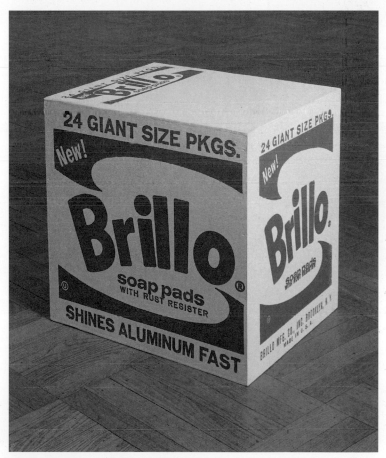

Andy Warhol, *Brillo,* **1964,** painted wood, 17 × 17 × 14 inches. Courtesy Leo Castelli Gallery, New York. Photo: Rudolph Burckhardt

Richard Serra, *One Ton Prop (House of Cards)*, 1969, lead, 48 × 55 × 55 inches. Courtesy Leo Castelli Gallery, New York. Photo: Peter Moore

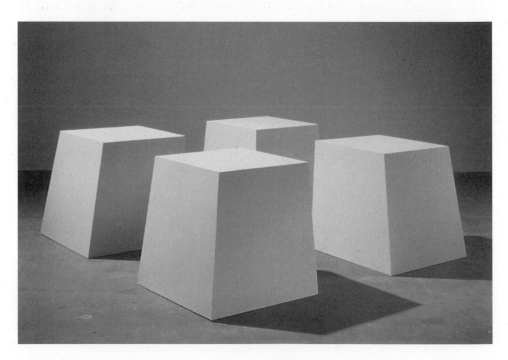

Robert Morris, *Battered Cubes*, 1965–1988, painted steel, 36 × 36 × 36 each. Courtesy Leo Castelli Gallery, New York

From Allan Kaprow's Happenings, to the body-enactments of early Performance, and the landscape extrapolations of Earth art, the 1960s released a torrential flood of challenges to the social and morphological constraints of the cube. Yet even activities that seemed to challenge cubic space most radically at the same time reached back to the binding destinies of post-Cubist art. The hangover is one of the most abiding effects of the cube. The structuring of Kaprow's Happenings—emphatically signalled in his *18 Happenings in Six Parts* (1959, at the Reuben Gallery, New York City)—is a perfect example of this retrenchment. The overarching cube, in its proliferation as a 'matrix', acts as a signifying shell for the correct deportment of containerised life. In an associated, though more literal, fashion, Process is allegorically entombed in Robert Morris' *Box with the Sound of its Own Making* (1961), where sound becomes the hidden face connected with the para-Cubist outside. Walter de Maria's *Lightening Field* (1977) offers a gridded re-cubing of the environment with the hidden surface of the cube turned to the heavens, where it is cunningly supplied and redrawn by a finger of lightening from the sky. Perhaps the only earthwork that really challenged the decorum of the cube was Robert Smithson's *Spiral Jetty* (1970), whose place, decay and dimensions represent the triumph and endgame of the cube's greatest spectre, the entropic curve.

As the reverberations of these stretched cubes were dying away in the mid-1970s, a third phase of the cube provoked a crucial moment of interment and resurrection. I refer, of course, to the interior-scaled White Cube of the gallery space or museum interior, which, at the moment it was identified, named and described, emerged as the symbolic form of an institutional critique that would constitute the final, literal, destiny of the cube. Undermining the mode of existence of this cubed cube was quickly identified with the deconstruction of aesthetic neutrality: for here modernism begins to do itself out of business. If Morris boxes up the artifactual history of the object, Hans Haacke cubes, first, the processes of the environment (an ecological Cubism) in his *Condensation Cube* (1963–65), and then, twenty years later, social and economic processes that puncture the walls of the White Cube and desecrate its hallowed objects with the impurities of corporate and political syntax (*Global Marketing*, 1986). In the institutionally critical work of the 1970s the dimensional dependencies of the cube, including, among other parameters, its colour and its temperature, are knowingly interrogated. In *Frost and Defrost* (1979), Daniel Buren takes on the refrigeration of formal values in the 'cubic freezer': 'The rooms A & B before being touched are frosted (white cubes)'.[16] The work intervenes to remove, rematerialise (with Buren's signature striped paper), reposition and incrementally replace the ceiling panels of each of the two rooms, so that 'at the last day of this exhibition the previous aspect of the gallery returns to frosted white cubes, a cubic freezer'.

Hans Haacke, *Condensation Cube*, 1963–1965, acrylic, water, light, draft, environmental temperature. Courtesy John Weber Gallery, New York

Hans Haacke, *Grass Cube*, 1967, mixed media. Courtesy John Weber Gallery, New York

Hans Haacke, *U.S. Isolation Box, Grenada*, **1983**, mixed media, 244 × 244 × 244 cm. Courtesy John Weber Gallery, New York. Photo: Hans Haacke

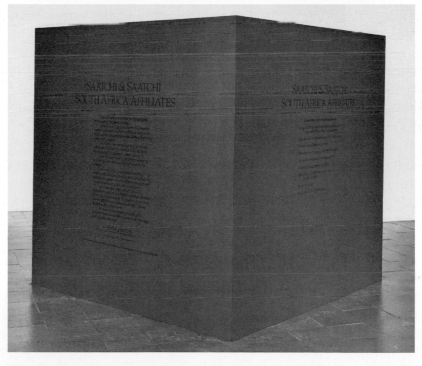

Hans Haacke, *Global Marketing*, **1986**, wood, sheet metal, silkscreen, 80 × 80 × 80 inches. Courtesy John Weber Gallery, New York

I want to spend a little time inside this newly frigid space, by returning to Brian O'Doherty's two-part article, 'Inside the White Cube', first published in *Artforum* in February and April 1976.[17] O'Doherty's discussion perfectly emblematises the final moment of becoming for the cube. Cubic space has emerged as brilliantly white, perfectly thin and ultra-solid. Stretched out into a pristine surround-wrap for the finalities of the modern movement, it undergoes an inside-out reversal symbolising the simultaneous fullness, decline and coming nullity of the modernist sign. O'Doherty sketches a critique of the 'evenly lighted "cell"' (p 24) that was quietly crucial to the otherwise prolix operationality of the modernist tradition. Reclaiming the history, emergence and contemporaneity of the gallery space as a decisive frame for visual modernism, the 'isolated', 'subtractive' space of the 'ideal gallery', the White Cube itself, is flooded with the conditions of semantic minimisation. The White Cube is the zero-economy of the space of display. The art object enclosed in this purportedly neutral space seems to be delivered as a function of its own interiority. O'Doherty insists on the ideological value of such studied neutrality, comparing it to other conventional social spaces written-through by a 'repetitive', 'closed system' of values: the White Cube possesses 'some of the sanctity of the church, the formality of the courtroom [and] the mystique of the experimental laboratory joins with chic design to produce a unique chamber of aesthetics' (p 24). O'Doherty's concentration on the—undoubted—significance of the wall and the frame in the construction of modernist aesthetic space, allows him, however, to neglect the dimensional measurements of the cube. He offers instead a version of the modernist story according to which invincible pressures are brought to bear on the 'portable window' of conventional, framed-off, academic space. The result is that 'formal composition' is disrupted, and the frame rendered 'equivocal' and 'parenthetical' by the 'edge-to-edge' horizons, and 'ambiguous surfaces' of pictures by Courbet, Caspar David Friedrich and Whistler, among others.

In this account, the paintings of Claude Monet are decisive. O'Doherty calls him 'the great inventor' (p 27)—though exclusively by virtue of his 'doubled and somewhat opposing stress on the edge', which, he claims, is 'the prelude to the definition of painting as a self-sufficient object' (p 27). While the technology and teleology of flatness literalised in the picture plane and the infinite parables of its modernist afterlife are outlined and ironised in this account, the opportunity of reading differently through the privileged genealogies of flatness and modernism is refused. At stake here is a place for the redisposition of the (necessary) irony that veins O'Doherty's account, and its conversion into a counter-analysis. That place is made of several sides, including inner bodies, writing and virtual objects—ideas of things that come together in the Rainbow Net.

O'Doherty's influentially succinct account of the contextual parameters of visual modernism was not the first discussion of the critical and institutional

limitations of the modernist gallery space, and of its important refusals of textuality and other contaminations. In the introduction to his *Assemblage, Environments and Happenings*, Allan Kaprow discusses the difficulties of accommodating the counter-compositional work he describes in the 'world unto itself' of the 'flat wall and the cubic enframement of the room':[18]

> For as each new exhibition of this recent work has proven, it is becoming harder and harder to arrange a show without compromising present needs with older methods. The work never looks right; it fits uncomfortably within the glaring geometry of the gallery box, and some artists have already tried camouflage of various kinds in an attempt to obliterate this discrepancy.[19]

The uncomfortableness of the 'ruled enframement' of the gallery gave rise to a dispute with painting that was simultaneously a conflict with the exhibition arena. New names were needed for the doubly new 'environments' that ensued. In response, Kaprow describes the 'large body of diverse compositions referred to as Combines (Robert Rauschenberg's name for his own work), Neo-Dada, or Assemblage'.[20] Just as the gallery had been an expression of the images it subtended—'the room has always been a frame or format too'—so, the new art of assemblage had to be scored and renominated in its own textual and environmental field. Thus, while the cubic room becomes the new frame of high modernism, the White Cube encloses further defamation of the avant-garde project. Its placelessness and para-contextuality subsume and domesticate the territorial disputes of the avant-garde, rendering them static and etherialised on the wall.

Reading O'Doherty with Kaprow—and subsequent accounts of the inheritances and futures of the cube—it becomes apparent that the former has collapsed the critique of modernist space, the ideology of its contextless extension and the ever-more faintly registered absurdities of its self-reflexivity into a counter-textualist shadow play. In the concluding paragraph of 'Inside the White Cube', even 'wit and cogency' are deemed to be held over as a function of 'surface, mural and wall'. 'Written clarifications' (perhaps criticism, or artists' statements, but also titles and names) are simply vanquished in this process by the guarantees of formal intelligence. The gallery becomes, in effect, a 'ready-made' installation; the wall, a screen memory of the unconscious of modernism; and modernist theory emerges as the victor in a mock battle over its own ironisation.

How can we find a way to negotiate with the aftermath of this skirmish? What destiny can we imagine for the White Cube in its final, conflictual incarnation as a cipher or blank, and as an absolute contexts? Several questions need to be posed. First, could there be another form of conjunction between the zero-economy and the museum/exhibition? Such an intersection would have to move beyond the ineffable transcendence courted by Abstract

Expressionism, beyond the inexorable, nihilism of Reinhardt that parodied it, and also beyond the gestalt reductionism of the Minimalists. As perhaps only Malevich did before, it would have to use the zero as a material and as a strategy. There is one location among the heady reformations of visual practice in the late 1960s and early 1970s that attempts such a negotiation. In his dialogue with Allan Kaprow on the question 'What is a Museum?', Robert Smithson speaks of 'the nullity implied in the museum' and of his interest

> for the most part in what's not happening, that area between events which could be called the gap. This gap exists in the blank and void regions or settings that we never look at. A museum devoted to different kinds of emptiness could be developed. The emptiness could be defined by that actual emptiness of art. Installations should empty rooms, not fill them.[21]

Here, Kaprow's commitment to alternative sites for the cultivation of semi-matrixed action, and the renegotiation of compositionality it entails, is shouted down by the decompositional emptying-out of form, material, ideas and finally of the museum itself. The guiding principles for such evacuation are found in Smithson's catalogue of 'minuses': the 'Minus Twelve' that embraces 'Uselessness', 'Entropy', 'Absence', 'Inaccessibility', 'Emptiness', 'Inertia', 'Futility', 'Blindness', 'Stillness', 'Equivalence', 'Dislocation', and 'Forgetfulness' (each of which preside over four further considerations).[22]

Beginning with emptiness (though going much further as we will shortly see), Smithson's void-museum turns the traditional space of exhibition inside out. The pressure of the museum-machine that represents culture by transforming its 'materials into art objects'[23] is redirected onto the institution itself. The maintenance of generic order between 'objects' labelled for display, the space between those objects (real and imaginary) and the space that encloses them, are refused as the insides and the outsides of the museological chamber are exchanged and disrupted. This is a clear warning that the thought that might join the spaces of the zero-museum and the name would have to be an apocalyptic vision—one in which the European (compositional) tradition implodes into silence, where pictures are surrogate windows opening onto nothing more than blanks. In this scene, the viewer would be blind and senseless. Perception itself would be lost to a crisis precipitated by the excuses of abstraction. The museum would be a crypt in which the lost residues of painting, sculpture and architecture are interred. The silence of the gallery would triumph over its whiteness, which would be lost under an unending aura of bright colours as the cube is vanquished by the rainbow effect. Solids and space itself would be undifferentiated, subject to inexorable flatness and fade-out. The museum melts down, becoming a ubiquitous surface that substitutes for all the old surfaces it once contained.

Finally, it is transformed into 'an untitled collection of generalisations that immobilise the eye'. How could all this be imagined?

Robert Smithson provides the only way out:

> Visiting a museum is like going from void to void. Hallways lead the viewer to things once called 'pictures' and 'statues'. Anachronisms hang and protrude from every angle. Themes without meanings press on the eye. Multifarious nothings permute into false windows (frames) that open up onto a variety of blanks. Stale images cancel one's perception and deviate one's motivation. Blind and senseless, one continues wandering around the remains of Europe... Many try to hide this perceptual falling out by calling it abstract. Abstraction is everybody's zero but nobody's nought. Museums are tombs, and it looks like everything is turning into a museum. Painting, sculpture and architecture are finished, but the art habit continues. Art settles into a stupendous inertia. Silence supplied the dominant chord. Bright colours conceal the abyss that holds the museum together. Every solid is a bit of clogged air or space. Things flatten and fade. The museum spreads its surfaces everywhere, and becomes an untitled collection of generalisations that immobilise the eye.[24]

In light of Smithson's entropic galvanisation of art's empty spaces, we must interrogate the territorialisation of the cube. For in all its disguises, even in the attenuated volumetric circuits of Mondrian, and in the building sequence of its scales—from painted surface to blunt volume to containerised space—the cube has been associated with what Jacques Derrida called the *parergon*, the beyond-the-work, intimations of a visual scene that went further than a flat surface subtended by a frame. The dark side of the cube, perhaps the side it stands on, the facet that faces away, has always been the site of a bleed into the 'real world'. The cubic galaxies of the experimental Constructivists escaped by this under-side trap door to the production world of the Soviet 1920s—which manufactured the cube into a teacup. In a milieu of hatches and facets, the movement from one plane to an imagination of, or a physical insistence on, six and their undecidable in-betweens is the half-cube (1-2, 2-1) knight's move of visual modernity.

The lingering retrenchment of post-Minimalist form, even behind the mask of institutional critique, during the late 1980s and early 1990s, makes it useful to look for the recent destinies, and perhaps the final death, of the disciplinary cubic space that dominated the critical architecture of modernism. Negotiating its losses, staring at the punishment it inflicted, I want to venture beyond the implosion of the cube, finding a way to colour and proliferate its nets. For the cube is a leading model of the 'decay of visible markers, the loss of sensible referents, the disintegration of various

"standards'" of which Paul Virilio writes.[25] In the aftermath of the White Cube, I want to ask if we can invent a 'parametrology' that somehow measures the 'lost dimensions' itemised by Virilio—or whether we can at least put a tail on them and map their lines of flight. We now know that the cube loves two things. Both are passions invested in its split beginnings as analysis and synthesis. It loves abstraction and it loves specificity. Its joining at the hip of those extremes is one of the measures of the cube's great success, and the main source of inspiration for its lustrous after-lives. But these wings of Cubism were often folded together in an instant, transmitted simultaneously (the great avant-garde slogan of the 1910s), in a snapshot image-fix. Their partialities were gathered up in a static field with intimations of the backward and the beyond. In the post-Cubist retreats that attended the new Call to Order of the late 1970s and early 1980s, psychoanalytic and theory-based abstractions, and the production-knowledges of Western-style Marxisms, substituted for the smooth spaces of generalisation and the striated space of the particular. The oppressed, trans-ethnic Everywoman captioning some feminist photographies, and the art exchange value analyses of Hans Haacke emblematise the corners of this replayed overlay.

If Mallarmé's throw of a typographical die ('un coup de dés') was a bedchamber for the primal scene of cubic modernism, the return and repeated deflection of the cube becomes the ghost story of visual postmodernism. We find it turned inside-out, its whiteness, smoothness and restraint lost to allusion, profusion and allegorical domesticity, in Ilya Kabakov's fantasy apartments such as *Ten Characters* (1988) or *He Lost His Mind, Undressed, Ran Away Naked* (1990). Their 'radical erasures of the white cube' are set out in melted, phantom boxes that 'warmed' one observer's 'white-cube-frozen heart'. We can see it diagonally sectioned in the unending half-volumes of Haim Steinbach's commodity-bearing shelves. We detect its spectral presence in Jeff Koon's tanks and Peter Halley's diagrammatic cell-cubes, which feed on the Foucauldian critique of modernity's institutional Cubism. We can observe its mild defamation in the thrown gauntlet that predicates the stuff of installation art filling the White Cube with contraband narratives, counter-architectures, prefabricated sidings and tool-kit facets—among a whole litany of pseudo-cubes-in-cubes. And we see it again in one of the preferred items of 1980s art-world exchange. For the simulated film-still is a post-Cubist *nature-morte*, a literal still-life that is interfered with not stylistically but through the cube-making knight's moves of the critical imagination. Both offer hallucinations of another dimension, whether an imagined volumetric world or a desired social one. Appropriation is another measure of the synthetic face of Cubism, that colliding of sides to articulate another object. Just as the collaged art work is a fugal exercise of confected spaces, mixed with material infill from the non-painted world, so

appropriation is made up of a system of takes and collisions that thrives on an abstract geometry of opinion.

Faced with the hallucination of blinding absence in Smithson's museum-cube, it was somewhat inevitable that succeeding generations, engaging once more with galleries, institutions and alternative spaces, should reinvent the avant-garde by attaching themselves to the discourse of the negative, while at the same time attempting to puncture their evenly lighted cells with appeals to the greater, extra-artistic image-world that lay everywhere beyond its confines. Hermetic experiences of subjective, formal, gestalt and even conceptual immersion in the work of art, were replaced by sustained recourse to the infinite flicker of mediated signs. The minuses of Smithson's zero museum were doubly recast: as ambient social critique, whose referent was the late capitalist system; and as a series of strategies of deferral, obliquity, simulation, whose predicate was always defection from something—authorship, identity, 'art', expression—everything, in the end, except value (both economic and 'critical'), the ultimate referent of the defining system itself.

Charles Ray's hollowed-out cubes made in the mid-1980s are emblematic of this moment. In *Pepto-Bismol in Marble Box* (1988) a 38-inch marble cube was filled with some 10 gallons of the pink stomach medicine (anticipating its more elaborate deployment by Korean-American artist Cody Choi, discussed in Chapter 8). The veined, high-art envelope is made-over as a giant geometric intestine, a holding tank for floods of indigestive balm that masquerades as a cure for the ailments of art's insides. Outcropping belligerently in the gallery space, *Ink Box* (1986) consisted of an excavated steel cube, brim-full with printer's ink, and coloured with automobile paint. Read as a 'tour-de-force of the perceptually oriented thought puzzles to which Ray devoted his attention in the late 80s', its uncanny surface tension stands ready to despoil the cube and its ambience in an accident that is forever on hold by virtue of the audience's seemly virtue.[27] Here, the cube offers sanctuary to a deep well of unconsolidated writing, or it nurtures an oil slick that threatens to soil the whiteness of the greater cube in which it sits. The top face of Ray's cube bears with it, then, an intimation of rupture and overflow, and its meniscus gathers in all the textures and non-delineation of the biomorphic tradition. But for now, everything in this surrogate *noli me tangere* of the 1980s is held back in a static equilibrium whose essential predicate is the foreclosure of physical interaction. The cube finds itself on the edge.

In the 1990s, however, the cube rolls over again, its ghostly work played out once more as never-ended. New consistencies for the six-sided figure embrace much more than a kind of re-gendered neo-Minimalism[28]—though Minimalism's heavy symmetries have been effectively parodied, softened and shadowed. Something of this redirection was suggested by women artists

working in the 1970s. Jackie Windsor's *Fifty-Fifty* (1975), for example, offers the cube as a kind of open-work crate made with nailed strips of wood, which bears with it references to house-building projects undertaken by the artist with her father. Though implicit, such references to collaboration, domesticity and family are at odds with the objectivity, perceptual relativity and new materialities of masculine Minimalism. In an uncanny premonition of the dangers and confusions in the passage from the cube to the rainbow, Suzanne Harris' installation, *Won for the One* (1974), recently recreated in New York, consisted of an approximately 300 pound plate glass cube suspended 4 feet above the gallery floor. Lit on three sides by red, yellow and green bulbs, the cube absorbed and subtracted the colours, depositing them as a filtered white shadow under its hovering bulk.[29] Transforming the cube into an inverse prism, Harris allegorised its transparency and weightlessness. She precipitated its capacity for stealthy exchange by turning the cube into a quietly appalling machine of neutrality.

The recent generation insists on a more ironic, even corrosive, relationship to the gestalt volumes of late 1960s geometry, and can be associated only loosely with the gendered collectivity of a 'neo-Minimalism'. Sometimes the parody is explicit, as in Rachel Lachowicz's wax and lipstick demi-cube, *Sarah* (1992), which apes the leaden equilibrium of Richard Serra's *House of Cards*. In *Gnaw* (1992), two 600 pound cubes cast in chocolate and lard, Janine Antoni fights back against the knowing totality of the cube by lightly consuming its form and devouring its shape.[30] 'Minimalism', she suggests, 'introduced fabrication—that process remained prevalent during the 80s. My cubes are poured, chewed, spit out, melted down, and recast by me'.[31] In a similar vein, Sarah Prud'homme wittily deaccessions the perceptualism of the 1960s, using the cube as console for the four-cornered entrapment of a disembodied eye. That dimension of the cube measured from the pictorial landscapes of Picasso and Braque to the defining structures of the modernist city is crossed with a new-found fullness of negative space in the work of Rachel Whiteread. Whiteread precipitates the projected shadows and volumetric undersides of household objects, joining these cubic nets with the greater, solidified space of the house that holds them. In the process, the White Cube, always metaphorised as a hollow space, has thickened into a massive concrete block, edged with period decoration. The total of everything that exceeds, or blemishes, the perfect cube—an imaginary solid displacing the ultimate 'gallery'—including mouldings, lintels, fireplaces, fixtures etc, is recast as the palpable syntax of domestic space, a set of remainders that shift us once again from geometry to accommodation.

Elsewhere, the cube comes back tied up by the nets that—some day— might exorcise it. All-seeing, multi-celled and ubiquitous, offering a proliferation of 'unnecessary' views, and hazy rewinds, it comes back in the

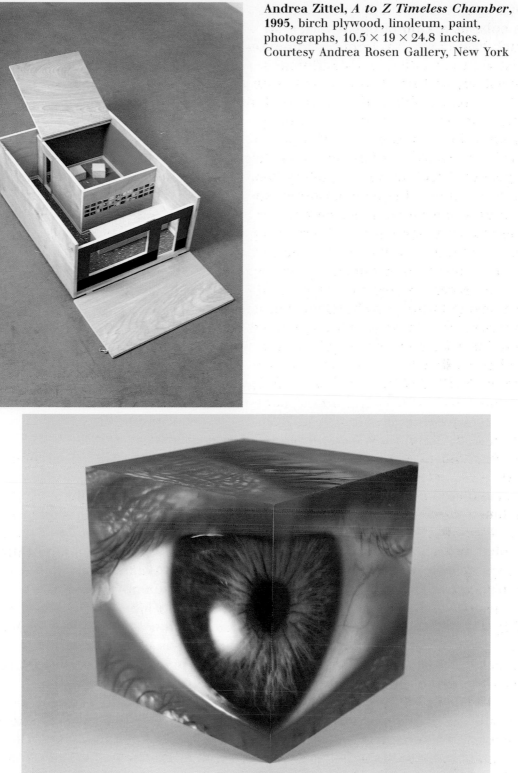

Andrea Zittel, *A to Z Timeless Chamber,*
1995, birch plywood, linoleum, paint,
photographs, 10.5 × 19 × 24.8 inches.
Courtesy Andrea Rosen Gallery, New York

Sarah Prud'homme, *Eye,* **1993,** C-prints on plexi glass, 9 × 9 × 9 inches. Courtesy the artist

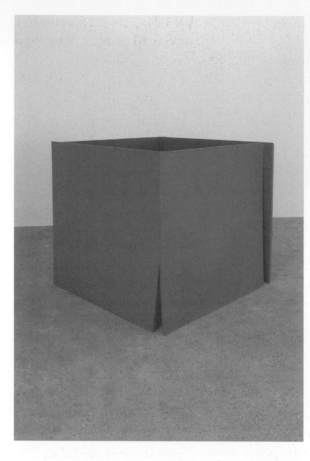

Rachel Lachowicz, *Sarah*, **1992**, lipstick
with wax, 48 × 48 × 48 inches. Courtesy
Shoshana Wayne Gallery

TV box. It comes back as comeback, as the palpitating organ of
institutionalised seeing. We are left with the task of looking at its dirty feeds,
binding-up the eye, trussing it with lines and leashes that fight against its
adopted geometry. Such efforts are felt in *Dusted* (1998), the cubic projection
theatre by Peter Sarkisan; in Sarah Prud'homme's eye-cube, which splits pupil
and retina at right angles across its leading edge; and with special vigour in
the scan-you-and-play-back rigs of Julia Scher's post-Cubist surveillance
environments. Or, to see it from another side, the new lines that we take
for a walk around the cube are the three dimensions of art, life and design—
each of which are made (present), related (past) and imagined (future).

The work of Andrea Zittel suggests that their intersection is the
vanishing point of the cube. Her installations illusionistically recreate a
laboratory, a showroom and a dwelling. Her cubes stack up as 'cleansing
chambers', carpet furnitures, home-box-offices, or Lilliputian valises. How
else could the cube function simultaneously as a 'prototype', an encyclopedia
(*A to Z Administrative Series,* circa 1994–95), and as a cathedral for the
anonymous brides and bachelors of mail-order art?

These skirmishes with the cube in the 1990s bring into focus three other sides of its postmodern unfolding. The first, in the photography and inscribed sculptures of Ian Hamilton Finlay, sets the cube in an appropriated philosophical history of Beautiful Forms and terrestial correlates. The second, crossing LeWitt's quizzical literalness with new instalments of mathematical absurdity, relentlessly pursues the logic of cubic structure in fractal proliferations that engineer the disappearance of its volume and the limitless complexity of its envelope. *The Fractal Cube* (1992) of Serge Salat and Françoise Labbé is envisioned as a quasi-infinite net whose relentless abstraction joins with Finlay's colourless, occult Neo-Classicism to put the rainbow forever on hold. Finally, I suggest several moments of false promise for the Rainbow Net, as well as a number of resitings of the cube, in the work of Adrian Piper, Mona Hatoum and Rasheed Araeen, where we can glimpse some aspects of its emergence.

Finlay's book *Talismans and Signifiers* (1984) places each of twenty photographic images of cubes, quasi-cubes and inscribed stones, culminating in a 'rusticated cube', against one or more citations from (or, occasionally, commentaries on) an array of cosmologists, alchemists and philosophers: Proclus, Vitulio, Porphyry, Vitruvius, Thomas Taylor, Plato, Heraclitus, Iamblichus, Shaftesbury, Sallustius, John Dee, Hegel, Wittgenstein, Plotinus, Henry More, Erigena and Ocellus Lucanus.[32] The assemblage of quotations positions the cube in relation to form, beauty, order, harmony and chaos; assigns it, after Plato, to the earth, 'the most immobile of the four bodies [fire, earth, water, air]'; and pursues the paradox of the sphere-in-a-cube, symbolically represented by the facial inscription of Finlay's cubic objects with dots and letters. The briefer second part of the book, 'sphere into cube', treats these twenty images and texts as a kind of QED rebus that introduces three drawings of the earth: in its condition as a sphere, as a 'sphere with horizons' and as a cube: for, 'as an element of the universe the earth is a sphere; as a concept or as the principle of stability the earth is a cube'. In a gesture that quite eclipses modernist conjugations of the sphere and cube (such as the comparative equality suggested by Umberto Boccioni: 'a cube and a sphere are equal as far as their potential is concerned'[33]), Finlay appropriates then folds together the speculative geometries of the Western tradition, playing the role of a latterday magus who conjures the cube as a giant, global surrogate, which squares all history as formal abstraction.[34]

What Finlay does to the past in the name of an ideal singularity, Serge Salat and Françoise Labbé attempt to map onto an uncertain future by appealing to an explosive grid of multiplicities. Bringing together modern theories of infinity (after Georg Cantor), of logical self-reference (after Gödel's theorum of incompleteness), of the 'geometric formulation of objects whose contours are locally non-linear (Mandelbrot's fractals)', as well as ideas derived from Leibniz (and after him, Gilles Deleuze) about the subdivision of

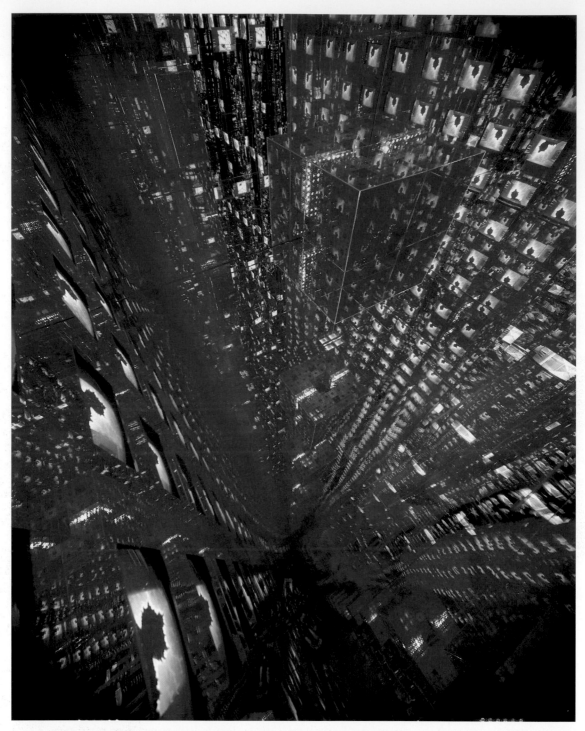

Serge Salat/Françoise Labbé, *Aleph 9, Virtual Cube II, Singapore*, **1994.** Photo: Didier Boy de la Tour

matter in folds, and recent chaos theory, they work to project the grid-pattern of Renaissance perspective into a space having the increased dimensions and complexity described by contemporary mathematics.[35] *The Fractal Cube* turns the cube backwards and forwards against itself, confining the virtual infinite in a finite loop, and 'creating a border which is an infinitely layered fold'. It develops from the surface 'subtractions of smaller and smaller squares' associated with Sierpinski's carpet ('a figure whose surface tends towards zero but whose contour, enveloping all the holes, tends towards the infinite') and the three-dimensional formats of Menger's sponge ('a cube of evanescent volume with an infinitely folded envelope, a surface growing out of scale to envelop a reality that is vanishing, an infinity of folds on the surface of an infinitely complex void').[36] Leaving aside the historical lacunae and theoretical ellisions that underlie the move from Renaissance grids to the fractal net, several consequences, each unveiled in Salat and Labbé's metaphorical choices, arise from the graphic realisation of their 'vanishing cubes'.

The first of these recasts the neo-Futurist envisaging of the cube not just as an 'absurdity', but as a form of mathematical self-love. For 'fractal objects are composed of beings made up of other beings, objects whose parts are identical with the whole'. Their 'auto-similarity or invariance of scale' is staged in a situation where 'each fragment of infinite space contains a mirror of the entirety of infinite space'[37]: the cube becomes a hyperspatial figure of abstract, disembodied narcissism, inseparable from the spectacle of its own replication and referenceless 'complexity'. A second consequence leads this formation of the cube back to the cosmological speculations that bracket Finlay's *Talismans and Signifiers with Sphere into Cube*. The ramifying uncertainties of the fractal cube are likened by its creators to 'a whirlwind of shapes' that 'disappears into the depth of darkness', a journey of geometric dissipation suggesting that, in the end, 'the cube has become a cloud'.[38] As with the greyscales of Finlay's stones and inscriptions, so the fractal cube is split only outside the domain of the colour spectrum. This shared failure of reference in two projects that offer the cube first as the solid symbolic shell of the earth, and, secondly, as the spectre of infinity and container of all shapes and forms, is a figure of lost dimensions that can only be redeemed in the Rainbow Net.

That I have backed into it negatively is symptomatic, for the Rainbow Net is an impossible fiction, a metaphor of colours, promise and proliferation, the locationless place where histories, aesthetics and diversities might overlap, for a moment at least, in projects that remember the conditions of art—even if they are staged across public or political spaces where its Western theorisation is mostly forgotten. Everything in—and around—the Rainbow Net is vulnerable: to over-inscription (the entrapment of the 'net'), to ephemerality, arching over-extension, immateriality (ever the lot of the rainbow), and to the global abstractions and local particularity discussed in Chapter 9. What is achieved under its bow is always against the odds.

The insinuation of the rainbow and the cube has a long history, reaching back at least as far as the experimental, celluloid 'colour symphonies' of Bruno Corra, made and defended around 1912 in loose association with the Futurist movement. Corra ascribed each of seven cubes, 'arranged initially on a horizontal line at the bottom of the screen against a black background', to one of 'the seven colours of the solar spectrum'. The subsequent movement of the cubes, erratic and 'jerky', colliding and 'crashing' together, threatened to dissolve their solidity and order, as they were shattered, reformed, diminished and enlarged, turned into columns and lines, interpenetrated and deformed.[39] Corra was concerned not only to batter his cubes with colour and movement, making them submissive to the spectrum they serially mimicked, but also to explode the rainbow itself. In a film called *The Rainbow*, '[t]he colours of the rainbow constitute the dominant theme, which appears occasionally in different forms and with ever-increasing intensity until it finally explodes with dazzling violence'.[40] While conjugated, then similarly destroyed in the 'chromatic drama' of this avant-garde experiment, the figures of the cube and the rainbow also map the allegorical extremities of the ends of modernism and possible reorientations of the postmodern. More than mere opposites or intractable adversaries, the remainders or premonitions of one are laced into the designs of the other. Their folded relationship in the 1990s is nowhere clearer than in a number of feints, or false rainbows, that attempt to fire the cube into a colourful orbit, but risk, like the Orphists and Futurists, simply fetishising it as a polychrome spectacle. We should remember Robert Smithson's caution that 'a vacant white room with lights is still a submission to the neutral'.[41]

Prominent among these feints are three forms of faking evanescence: the use of powerful new technologies—associated especially with lasers, holography, and virtual reality—for the production of visual events; the manufacture of simulated or para-meteorological rainbows; and the correlation of the many-coloured sign with nostalgia for the last moment of multichrome history—the Technicolor, psychedelic 60s. We glimpse the first form, merging—artificially—with the second, in Hiro Yamagata's *Element*, a laser installation put on at the Fred Hoffman Gallery in Los Angeles between November 1997 and February 1998. In preparation for the spectacle, according to an eyewitness account, the ceiling of a 2,500 square foot room was covered with holographic film, and 650 mirrored cubes were hung from it. Then a 25-watt argon/krypton laser was routed through 1,500 feet of fibre-optic cable, firing multicoloured beams of light that splintered into 'an orgiastic display of rainbow effects'. The result was pure art-world *son et lumière* (minus the *son*), whose spectacular retreat from its immediate audience, and wider public, was noted by several observers.[42] This spectacle, crossed with the drier, more confining logic of *The Fractal Cube*, has an inverted popular-cultural correlate in Vincenzo Natalie's film, *Cube* (1998). The narrative follows six characters

trapped in an endless series of cubes from which they can escape (just as Salat and Labbé attempt to retreat from Renaissance perspective) only by following a mathematical formula. Impersonating a fractal cell, the labyrinthine cube at the centre of the movie is a severe Minimalist form, made from white, frosted Plexiglas (recalling Buren's cubic freezer), its walls decorated with black patterns and diagrams. In the process of what one reviewer termed 'gleaming the cube', 'the main cube was illuminated with fields of 1,200 100-watt light bulbs with the addition of Kino Flos, 5ks, and 1k space lights'.[43] Flooding it with overbearing waves of bright, white light (as Ray inundated it from the inside with Pepto Bismol and printer's ink) the cube becomes a motile prison enclosing infinite vistas of calculated menace.[44] The whiteness, florescence, Plexiglas and exterior perceptual relativism associated with the Minimalist object are amplified and turned upside-down; as the audience is taken hostage inside the cube, space itself is relative (not its perception), and rationality becomes the escape hatch.

Creating rainbows also has its advocates among younger installation and performance artists, as well as in a kind of post-Earth Art elementalism. In a recent interview, Anya Gallaccio spoke of a project to bisect a space with a real rainbow held in the vapour of a curtain of water. It is uncertain whether the result would be a confirmation of, or an antidote to, an art of 'disappointment'[45] that turns another face towards the demoralisation of the cube. Gallaccio's exhibition, 'Intensities and Surfaces', at Wapping Pumping Station, London, (February/March 1996) presented a 34-ton block of ice in which half a ton of salt was embedded, causing the frozen cube to melt from the inside: so that as the cube dissolves, the rainbow rises. Less ambiguous is Seth Riskin's persona, the 'Rainbow Man', adopted for an interactive light and dance performance. In a text dated March 1995, Riskin described the piece, based on 'direct interaction with sunlight', as follows: 'During the performance my body is surrounded by a fine mist of water, which allows me effectively to carry rainbows with me as I perform in bright sunlight. As I move I am able to choreograph the position of the droplets in relation to the sun and the observers. This allows me to choreograph the creation of the rainbow, which, in turn, inspires the movement I perform'. Five mist-producing devices, water jets using compressed nitrogen and water, were fastened to Riskin's wrists, ankles and the back of his head, producing droplets in the range 0.10 mm to 0.05 mm in diameter, 'the size range necessary for a rainbow'. This 'arrangement of the jets on the body allows for five separate 360 degree rainbows'.[46] Posing himself as seed for the weather, and feeding back the engineered event as lord of his dance, Riskin creates a performance that is part New Age reverie, part ecological theatre, with the rainbow cast as altar, synthesiser and stage.

Finally, a number of younger artists have ironically crossed the natural rainbow with the polychrome stripes of recent history focused through the

prism of light-effects. Michael Smith and Joshua White, for example, turned the Lauren Wittels Gallery in New York into an office and showroom for MUSCO, 'a fictional lighting company that supplied equipment for psychedelic light shows in the 1960s, discos in the 70s, and corporations in the 1980s'.[47] In another New York gallery, Piotr Uklanski installed a grid of multicoloured lights whose flashes were correlated with various club rhythms, conjuring a retro-vision of the disco-era and crossing this with intimations of modernism's colouristic imagination. The gallery floor, then, 'could have been the Ur-dance floor of the 70s, except that its colour scheme and careful gridding suggested a hybrid of Dan Flavin, Victor Vasarely and Piet Mondrian'.[48]

I want to conclude by turning to three instances in which the logic of the cube is lightly braided with the Rainbow Net. This is achieved not by appealing to technology, nature, or historicist psychedelia, but rather by turning the faces of the cube towards the visions of outside and inside worlds it always implicitly neglected, or abstracted. The first of these crosses the gendered Neo-Minimalism of the 1990s with a stringent commentary on ethnic and racial objectification. In *What It's Like, What It Is, No 3* (1991), Adrian Piper installed 'a roughly man-sized white box' at the centre of a 'Minimalist arena' that was itself a 'pure white cube'. Each of the four visible sides of the box contained a monitor on which part-images of an African-American male appeared—a head, a face, a back, and so on. These body fragments were accompanied by a voice-over that asserted negative conditions for the figure's definition: 'I'm not horny. I'm not scary. I'm not shiftless. I'm not lazy. I'm not servile'. As David Deitcher remarks, the work 'takes as a found object the museum-ready aesthetics of Minimalism' only to treat it like a Trojan Horse.[49] By posing the male African-American body as a series of disconnected parts vocalised with cancelled stereotypes, and emerging from the core of a cube-within-a-cube, Piper strikes at the heart of the cube's whiteness, precision and repetition. In *Black Box White Box* (1993), made in response to the Los Angeles riots following the Rodney King verdict, Piper continues her critical dialogue with the cube, filling it here with contemporary urgency. Two identical cubicles, each $8 \times 8 \times 8$ inches, one painted white, the other black, were 'poised' in what one critic termed 'the deconstructive space'[50] of the gallery (New Langton Arts in San Francisco). Both cubicles contained a chair, a shelf with a box of tissues and a screen. In the white cubicle the screen was a flush-mounted TV monitor repeatedly playing George Halliday's video of King being beaten. In the black cube there was a light box, which alternated between showing an image of the beaten King, and dissolving this to reveal an interrogation-type light that turned the light box into a mirrored surface reflecting back the viewer's image.[51]

In another ex-examination of the logic by which the cube is appropriated and recast from the Western avant-garde, Rasheed Araeen's *To*

Rasheed Araeen, *To Whom It May Concern*, 1996, steel scaffolding poles, coloured, 12 × 13 × 13 meters. Courtesy the artist

Whom it May Concern (1996), a near-cubic structure (its dimensions were 33 × 39 × 39 feet) made from steel scaffolding poles and put up in the garden of London's Serpentine Gallery, wryly poses a key question for the post-appropriationists of the 1990s. The question, of course, is that of address itself. For the title, *To Whom it May Concern*, apes the anonymous formality of the English-language business letter, while using the materials of the construction site to fabricate a knowingly post-Minimalist object in the precincts of an art institution. Guy Brett reads the work as 'an almost faultless demonstration of the Minimalist aesthetic of eschewing emotion, symbolism and rhetoric and insisting on the reality of the thing itself', which bears with it aspects of 'political statement, self-portrait and abstract universality'.[52] The latticework of steel, lightly lit up with accents of pink and yellowish paint smeared on the brackets and connectors and overlaid with haphazard coatings from the poles' previous outings, is set in a semi-pastoral environment of green grass and blue-grey sky. Thinned, hollowed, and colour-coded, a structure made out of structure-making supplements,

addressed only to those whom it might concern and quietly underwritten by the formal language of art as perception, the cube starts out on its metaphorical journey to the Rainbow Net.

A related circumvention of the cube, bound up in a new 'visceral geometry',[53] is offered in the post-Minimalist boxes of the Lebanese-born, British-based artist, Mona Hatoum. In *Socle du Monde* (*Pedestal of the World*, 1992–93), conceived after Piero Manzoni's 1961 work of the same title, she rigged up a quasi-cubic wooden shell, fitting it with steel plates and magnets, and covering the entire skin with iron filings. The cube emerges coated with an iron fleece of metal pieces, galvanised into quasi-Op Art patterns by the force of magnetic fields. Hatoum founds her piece on a literal and ironic base that reaches for the world with Finlay-like extension. Ventured as a structure that supports and displays nothing less than the globe itself, the cube is envisaged by Hatoum as a furry envelope of particles held together by a constellation of attractions and repulsions. Paula Harper reminds us that the contexts of *Socle du Monde* are also global in their reach. For it is not just the Western modernist traditions of the cube—and their irreverent debunking by Manzoni's generation—that are at stake here. Cubic structures or symbols in Islamic culture, for example, must also be read across the pedestal, and Harper points to the intricately woven surfaces of the 10th century AD mausoleum of Ismael Samani in Bukhara and the kaaba holding the sacred stone at Mecca.[54]

Mona Hatoum, *Corps Etranger (Foreign Body)*, 1994, video installation, Musée National D'Art Moderne, Paris, 350 × 300 × 300. Courtesy Tate Britain, London

Hatoum's *Corps Etranger* is a tubular room with a circular floor screen whose 'viewing chamber is a pure white cylinder'.[55] While endoscopic and coloscopic probes harvest internal images of the body, insinuating themselves in the unending capillaries of the gut, we hardly notice that the surface exterior (the nude) is quietly transformed into the body as a white column. We see this as we are hunched in an embryonic stoop inside the cylinder, peering down at the screen. The edgeless and embodied endless column of postmodernity is meted out one way while the viscous ribbons of an inside self are pulled like endless rabbits from a video hat. This is our second allegory for the unfolding of the cube. For overlaid on the victory of the pure modernist cylinder over the pure modernist cube is the inside story of a never-ending reddish rainbow-coloured quest for inner dimensions.

NOTES

1. Paul Virilio, *The Lost Dimension*, trans Daniele Moshenberg, Semiotext(e), New York, 1991, p 36.
2. Auguste Rodin, cited by Albert Elsen in *Rodin's Thinker and the Dilemmas of Modern Public Sculpture*, Yale University Press, 1985, New Haven and London, p 11 (from Camille Mauclair, *Auguste Rodin*, p 66); see also Judith Claudel's description of Rodin's maxim: 'The sense of the cube is the mistress of things and not appearance', in *Rodin: Sa vie glorieuse, sa vie inconnue*, Bernard Grasset, Paris, 1950, p 401 (cited in Elsen fn 7, p 164).
3. Bruno Corra, 'Abstract Cinema—Chromatic Music' (1912) in Umbro Apollonio (ed), *Futurist Manifestos*, Thames and Hudson, London, 1973, p 69.
4. Elsen, op cit, pp 48, 122.
5. Louis Vauxcelles, *Gil Blas*, 14 November 1908, reviewing an exhibition of 27 of Braque's recent paintings at the Daniel Kahnweiler Gallery in Paris.
6. Rosalind Krauss, 'Grids', in *The Origin of the Avant-Garde and Other Modernist Myths*, MIT Press, Cambridge, Mass, 1985, p 9.
7. I would thus disagree (at least over the parenthesis) with Chrissie Illes' introduction to *Sol LeWitt: Structures 1962–1993*, Museum of Modern Art, Oxford, 1993, where she cites Benjamin Buchloh ('Conceptual Art 1962–1969', *October*, no 55, Winter 1990), claiming that 'the square (and its three dimensional equivalent, the cube) is the ultimate form of self-reflexiveness, incessantly pointing to itself as a spatial perimeter, plane, surface and support'.
8. Kim Levin, 'Farewell to Modernism', *Arts Magazine*, October 1979; reprinted in Richard Hertz (ed), *Theories of Contemporary Art*, Prentice Hall, Engelwood Cliffs, NJ, 1995, p 4.

9. The allusion is to Donald Kuspit, 'Sol LeWitt: The Look of Thought', *Art in America*, vol LXIII, September/October 1975.

10. Rosalind Krauss, 'LeWitt in Progress', in *The Originality of the Avant-Garde and Other Modernist Myths*, MIT Press, Cambridge, Mass, 1985, pp 252–54.

11. Ibid, p 256.

12. In 'The Exhausted' (1992), Deleuze wrote that 'The combinatorial is the art or science of exhausting the possible through inclusive disjunctions'; in *Essays Critical and Clinical*, trans Daniel W Smith and Michael A Greco, University of Minnesota Press, Minneapolis, 1997, p 154.

13. See Georges Didi-Huberman, *Le cube et le visage: autour d'une sculpture d'Alberto Giacometti*, Macula, Paris, 1993.

14. Roberto Matta, 'Sensitive Mathematics' Architecture of Time', in *Minotaure,* no 11, 1938; trans and reprinted in G Ferrari (ed), *Entretiens Morphologiques: Notebook No 1, 1936-1944*, Sistan, London, 1987, p 208.

15. Matta, 'Inscape', 1938; trans and reprinted in ibid, p 219.

16. Daniel Buren, 'Frost and Defrost', at the Otis Art Institute Gallery, Los Angeles, 28 January—4 March 1979.

17. Brian O'Doherty, 'Inside the White Cube: Notes on the Gallery Space', Part I, *Artforum*, February 1976; Part II, 'The Eye and the Spectator, April 1976. This discussion of O'Doherty is adapted from the Epilogue of my *Invisible Colors: A Visual History of Titles*, Yale University Press, London, 1997.

18. Allan Kaprow, *Assemblage, Environments and Happenings*, Abrams, New York, nd, p 152.

19. Ibid, p 153.

20. Ibid, p 154.

21. Robert Smithson, 'What is a Museum? (A Dialogue between Allan Kaprow and Robert Smithson)', in Nancy Holt (ed), *The Writings of Robert Smithson*, New York University Press, New York, 1979, p 60.

22. Smithson, 'Minus Twelve', in ibid, p 81; this text was first published as the final contribution to Gregory Battcock (ed), *Minimal Art: A Critical Anthology*, Dutton, New York, 1968, pp 402–06.

23. Svetlana Alpers, 'The Museum as a Way of Seeing, in Ivan Karp and Steven D Lavine (eds), *Exhibiting Cultures: The Poetics and Politics of Museum Display*, Smithsonian Institution Press, Washington DC, 1991, p 31.

24. Smithson, 'Some Void Thoughts on Museums', in *Writings*, op cit, p 58.

25. Paul Virilio, *The Lost Dimension*, op cit, back cover.

26. Mira Schor, 'You Can't Leave Home Without it', *Artforum*, vol 30, no 1, September 1991, pp 119, 116. Schor's article discusses the infiltration and domestic refurbishment of the White Cube in installation art of the 1970s and 1980s. See also, Jeff Weinstein, 'Art in Residence', *Artforum*, vol 36, no 7, March 1997, pp 60–67.

27. Virginia Rutledge, 'Ray's Reality Hybrids', *Art in America*, vol 86, no 11, November 1998, p 99.

28. As suggested, perhaps, in the Museum of Modern Art's 'Sense and Sensibility: Women Artists and Minimalism in the Nineties', New York, June–September 1994.

29. *Won for the One* was recreated at the Lance Fung Gallery, New York. See Michael Kline's review, *Sculpture*, vol 17, no 4, April 1998, pp 75–76.

30. Both works were included in 'The Art of Seduction', The Center Gallery, Miami-Dade Community College, (Wolfson Campus), Miami, 20 January–4 March 1994.

31. Interview with Laura Cottingham, 'Biting sums up my relationship to art history', *Flash Art*, Summer 1993, pp 104–05. Antoni continues: 'But I've been reading Donald Judd and I'm astonished how, in defining themselves, the minimalists disregarded and tried to destroy all other art practices and standpoints...' (p 104).

32. Ian Hamilton Finlay, 'Talismans and Signifiers with Sphere into Cube', Graeme Murray Gallery, Edinburgh, 1984.

33. Umberto Boccioni, 'Absolute Motion + Relative Motion = Dynamism' (1914), in Umbro Apollonio (ed), *Futurist Manifestos*, Thames and Hudson, London, 1973, p 151: 'In the case of a cube observed alongside a sphere, the horizontal and perpendicular stasis of the cube does battle with the ideal global rotation (force-lines) of the sphere, since a cube and a sphere are equal as far as their potential is concerned'.

34. Finlay's interest in the generation of a sphere from a cube is shared by Robert Wilson, among others. A sequence at the end of 'Where Everything is Music', the first part of the computer-animated, 70mm, 3-D, film/digital opera, *Monsters of Grace* (design and visual concept by Wilson, in collaboration with the Keiser-Walczak Construction Company, music by Philip Glass, and lyrics adopted from Jalaluddin Rumi; premier at Royce Hall, University of California, Los Angeles, 15 April 1998), images the metamorphosis of a simulated 3-D cube into a globe.

35. Serge Salat and Françoise Labbé, *Vanishing Cubes/Metamorphose du Cube*, The Art Museum of Seoul Arts Center, Seoul, Korea, 1992, pp 14f.

36. Ibid, pp 24, 30.

37. Ibid, pp 28, 30.

38. Ibid, pp 24, 30.

39. Corra, op cit.

40. Ibid.

41. Robert Smithson, 'Cultural Confinement', *Artforum*, October 1972; reprinted in *Writings*, op cit, pp 132–33.

42. My description is based on Carmine Iannaccone's review in *Art Issues*, no 52, March/April 1998, p 44. She notes that Yamagata 'has made an environment for a large social spectacle, but he has left the people out'.

43. Mark Dillon, 'Gleaming the Cube', *American Cinematographer*, vol 79, March 1998, pp 16f.

44. See Philip Strick's review in *Sight & Sound*, ns 8, no 11, November 1998, p 44.

45. Louisa Buck, interview with Anya Gallaccio, *Art Newspaper*, vol 9, no 80, April 1998, p 13.

46. See Seth Riskin, 'Rainbow Man: an Interactive Light and Dance Performance', *Leonardo*, vol 28, no 4, 1995, pp 327–28; this section of the journal is associated with the Belgium-based SolArt Global Network.

47. See Tom Moody's review, *Artforum*, vol 35, May 1997, pp 111–12.

48. Joshua Dector, review of Piotr Ulkanski at the Gavin Brown Gallery, New York, November 1996, *Artforum*, vol 35 April 1997, p 95.

49. David Deitcher, 'Art on the Installation Plan', *Artforum*, vol 30, no 4, January 1992, pp 82–83. Deitcher notes further that 'Piper confronts and effectively deconstructs the art history with which museums in general, and the Museum of Modern Art in particular, have been most comfortable'.

50. Ann Bremner, catalogue text for *Black Box White Box*, New Langton Arts, San Francisco, 1993. This formulation is revealing, for it suggests that in certain circumstances, exhibition space itself is not only critical but already 'deconstructive'. Without at the same time passing judgment on Piper's installation, I want firmly to resist this idea on the grounds that it takes its place in the post-appropriation rhetoric of implicit, assumed or unargued deconstruction I outlined in the introduction.

51. *Black Box White Box* was commissioned for the Wexner Center for the Arts, The Ohio State University, for the exhibition 'Will/Power', 26 September—27 December 1992.

52. Guy Brett, 'Abstract Activist', *Art in America*, vol 86, no 2, February 1998, pp 80, 85.

53. Paula Harper, 'Visceral Geometry', *Art in America*, vol 86, no 9, September 1998, pp 106-11.

54. Ibid.

55. *Rites of Passage: Art for the End of the Century*, Stuart Morgan and Frances Morris, Tate Gallery, London, 1995, p 103.

CHAPTER 8

Culture/Cuts: Post-Appropriation in the Work of Cody Hyun Choi, 1998

What makes my Thinker *think is that he thinks not only with his brain, with his knitted brow, his distended nostrils and compressed lips, but with every muscle of his arms, back, and legs, with his clenched fist and gripping toes.*

(Auguste Rodin)[1]

How hard it is to digest one's fellow men! First principle: to summon one's courage as in misfortune, to fall to boldly, to admire oneself in the process, to grit one's teeth on one's repugnance, and to swallow one's nausea.

(Nietzsche)[2]

From the beginning of the 1990s, Cody Choi has impetuously fabricated his own visceral legend. Now, at the end of the millennium, he stares himself down as it creates him back. Choi relocated with his family from Seoul, Korea, to the US at the age of 22, and his story is founded in the collision and fragmentation of cultures, in the disturbance, sublimation and reallocation of a shifted sexuality, and in the ironic armament he musters to wage surrogate war with the titanic period icons of Western visual culture—classical Greek sculpture, Michelangelo, Auguste Rodin. No legend can be sustained without propaganda, and Choi accordingly delivers himself as his own talent and promoter in what he terms the *Golden Boy Poster*. Against the background of an auratic sun, hovering clouds, a crowing cock and sprigs of pink and white blossom, dressed in a black shirt and sporting a paisley bandanna, Cody proffers a fresh bottle of the magic medicine that acts as his bodily panacea, sculptural medium, and artistic totem. Pepto-Bismol is the symbolic fluid of his Legend; its pink protection and intimations of a future perfect are his armour and grail. But Cody's Legend is clearly not a simple fable of cross-cultural becoming. Nor does it in any way depend on the multi-cultural fairy-tale of happy assimilation and hyphenated identity. Instead, Cody's Legend manages to be simultaneously self-deprecating, violently assertive and socially interrogative.

The *Golden Boy Poster* bears the subtitle 'Heidegger in Bagsvaerd Church', an allusion, notes Choi, to the German philosopher's attempted reconciliation of nature and mind. Heidegger's restorative negotiation between objects and subjects offers a form of 'healing' that Choi both negates

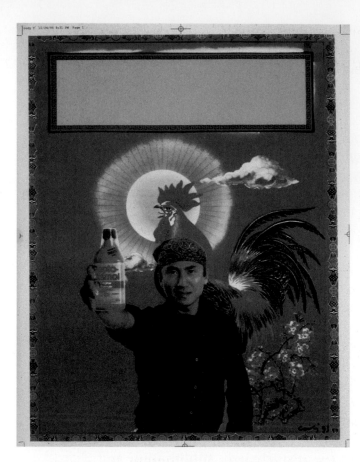

Cody Choi, *Golden Boy Poster (yellow)*, 1987–1993, C-print, 11×14 inches. Courtesy the artist

and amplifies. For while the artist insists that Heidegger 'and his heart' suggest a 'good model for my heart', the Heidegger reference remains liminal in a poster format that deliberately makes itself available for a 'misreading' of Choi's self-declaration as 'superficial or exotic'.[2] Its aping of Asian folklore motifs stars Choi as Golden Boy, an incarnation not of some Daliesque Great Masturbator, whose critical paranoia is fearfully split between self and others and fixated on the onanistic symbology of the biological world, but as the incarnation of a Great Reconciler germinating an impossible Unity at the screech of a never-to-be new dawn.

Some beginnings for the ideas glimpsed and debunked in the cosmetic gleam of the *Golden Boy Poster* emerge in a number of paintings made by Choi while studying with Mike Kelley at Art Center, Pasadena in the late 1980s. One of his first uses of Pepto-Bismol arrives in a series called 'The Hit and Overlay' (1986–90), which use the liquid as a medium applied to US Army blankets. *Pant Soiler* (1990) is a process-painting for which Choi harvested faecal matter from a new-born baby at a local hospital, pasted it onto a sheet of paper, then buried it for two years before extracting the decaying remains from the ground and mounting it on canvas as a 'painting'.

The result is a mischievous Rousseauian combine, which merges a purely 'uneducated' product with the paradigm artifact of aesthetic acculturation, or what Choi refers to as 'educated beauty'.[3]

HEAD A^MPUTATE
GENITALIA
BREAST A^MPUTA
TE MILK
KNEE A^MPUTAT
E STANDING
PENIS A^MPUTA
TE SPERMAT
OZOON
WAIST A^MPUT
ATE DRESS

Another initiative behind Choi's sculptural assemblages of corporal exchange was delivered with a blast in his *Bad Drawing* (1992–93), a gory ink-on-paper chorus of bodily severances, whose crude lettering is spiked with thin vertical trails of excess run-off, and interrupted by repetitively amended spelling mistakes in the shock-word, 'A^MPUTATE', which slices between listed body-parts, fluids and accoutrements, and is itself literally split as it runs on from line to line. Streaking this strangely fixated post-Conceptual poem with the appalling triple logic of decapitation, emasculation and mutilation, Choi poses sexual pessimism at the extremity of his violent foreboding. But such violence is the difficult, perhaps confounding, preface, and not the tragic conclusion, of Choi's bodily expedition. His subsequent work plays out another side of these gruesome castrative fantasies, bringing its repertoire of cuts up against a subtly blunted carnival of appropriations, memorials, excremental stand-ins and inter-cultural personae.

Perhaps they begin in earnest with *Cody's Ego Shop* (1994)—dubbed 'The Macho Tower' by the artist—a little skyscraper of 66 tied boxes bored into with the negative outlines of the artist's genitalia. These are topped by a small replica of Albrecht Dürer's *Praying Hands* (1508), wrapped in a transparent plastic bag, hung with Choi's discarded cotton socks, accompanied by a hidden tape loop of lascivious male laughter, and wafted by drafts from an industrial fan. The commerce of smells, hot sexuality and cooling breeze mixes with peals of lewd, disembodied laughter and the liberatory sublimation of the praying hands to form a 'desiring machine'.[4] The sensate flows that fuel the machine are typically redolent signs of male sexual surplus, which Choi turns on and off against their point of origin in his chamber of precipitated libido.

Cody Choi, *Cody's Ego Shop*, 1994, wood, banding strap, aluminium, plastic, cotton socks, steel, industrial fan, cassette player, sound, 40 × 40 × 97 inches. Courtesy the artist

These flows merge with a set of historical references, important for Choi's work as a whole, to the multiple production of cultural stereotypes. The sensual elements of unadulterated machismo that pervade the *Ego Shop* carry with them intimations of two key moments in Korean national memory. The first is the so-called 'Butcher's Ethic', the coarse, ribald masculinism associated with the rural and working classes during the pre-modern Chosun Dynasty. The second, layered onto this, but subject to the inter-cultural displacements of postcolonial experience, refers to the reattribution of such behaviours to US popular culture in the 1960s. Choi's work reaches across these shifting categories, trespassing along the phantasmal divide between residual dynastic machismo, its transference onto Western culture (and back again) and the real-time conflicted desires of male sexuality.

Cody's Legend, Freud's Shit Box and *Cody's Legend, Genghis Khan's Shit Box* (both 1994) refract the intensities of the *Ego Shop* in an exchange

system of father figures and proper names relayed through an abstruse symbolism of medicines, receptacles and conceptual sanitation.[5] For the Freud piece, Choi had himself life-cast from head to toe in candle wax, striking the pose of Michelangelo's *David*, a work originally intended for an elevated location on the Florence Cathedral. The culturally recoded figure has his left foot planted in a tin Korean wash-basin filled with Pepto-Bismol, while a contoured circumference proportional to Choi's upper inside thighs and lower back has been excised from the strapped-up wooden pedestal (Choi refers to it as a 'shit box'),[6] allowing the artist to bend into the voided space as if seated on a Western-style toilet. Like the stretchers of a canvas— and the toilet bowl itself—the pedestal is for Choi an 'oppression structure',[7] which he works with and against in a schizo-analytical exchange of physical and psychic energies. As in his later works, the shit box/pedestal is severed in two, infiltrated with a cut-out body-part, then forced together using straps and clamps whose bonding agency symbolises Choi's struggle to repatriate the split. The bands and vices are 'gears' that conjoin the boxes as contradictions. Either in a gallery exhibition or in his studio, Choi will 'activate' the cut-outs performatively by depositing his body energy into the boxes and saving it there as a metaphorical residue.

In the Ghengis Khan version, Choi assumes the unassisted squatting position of a non-Western lavatory-user within the hollow shit box/pedestal, in which position his head protrudes through a differently shaped orifice. Binary oppositions between East and West are parodied here in a pantomime of bathroom etiquette, bodily switches and decontextualised rituals of medicine and hygiene. Yet, Choi seems to suggest, any redemptive reversal, any hard-won escape-route from the hothouse of ethnic and cultural stereotypes, is more likely to remain desired, even delusional, than to issue in some social amelioration. For the shit boxes form a pair with the legendary Choi, relaying inverse presentations of the artist as subordinate and hero, dizzying us in a spin of homage, debasement and substitution. *Scamps, Scram #1* and *#2* (1994) is a doubled installation of differently sized, body-perforated, aluminum and wooden boxes, stacked horizontally on the floor. Building a kind of 'self-portrait in energy levels', Choi began by cutting out the shape of his head from a designated 'head-box', then placing his head inside for three hours, in both conscious and dormitory states. The process was repeated with a palm-box (into which Choi placed his hands for 30 minutes while seated 'like a frog'); an abdomen-box (in which he stored 40 minutes of energy generated by flipping over onto his stomach); a penis-box (energised with a 20-minute insertion analogous to an episode of sexual intercourse); a big-toe-box (replete with direction-oriented movement energy); and, finally, a heel-box (forming a model of the transfer-point that conducts energy from the walking body to the traversed environment). Set within Choi's boxed energy field is a breast-box, taken from fellow-artist

Janine Antoni, who occupied her box for 20 minutes (to lend lactative energy—and transgendered incorporation—to the male-dominant portrait).[8]

The amputative process so starkly poeticised in *Bad Drawing* is revisualised in *Scamps, Scram* as a series of pre-emptive cuts that staunch the flows and connectedness of the organic body, relocating its energies in isolation boxes emblazoned with the negative likenesses of the energy-bearing (and energy-producing) part. Choi is clearly looking back—to the machinic portraits of Francis Picabia and the mechanical eroticism of Marcel Duchamp—and forward—to the 'desiring machines' and organless bodies proposed by Gilles Deleuze and Félix Guattari. From the Dadaists, he has absorbed the parody-effects of mechanistic subversion, from Deleuze and Guattari, something of the rhizomous, refracting logic and anti-Oedipal drive of schizoanalysis. But Choi has in no way reduced these points of contact to diagrams or illustrations. He resists, for example, the anarchic, dysfunctional deconstruction of mechano-morphic rationality proffered by the Dadaists, and deliberately holds on to his own precipitated subjectivity as the addition of borderline energies willfully deposited in his holding tanks.

Choi's dialogue with the body-without-organs and the desiring machine is more complex. What he shares with the thought of Deleuze—apart from common strategies of the cut, the 'schizoanalysis' of the philospher and the cut-out body parts and larger deracination of the artist—is a perception of the art work as a kind of symptom. Such symptoms are not reducible to the legible traces of a particular unhealthy body, nor are they simply the sum or system of traces left by a particular disease. Instead, as Deleuze has argued intermittently throughout his writings, the art work may be staged as a configuration of affective devices that together constitute a new symptomological field, a new way of seeing or thinking the experiences of life.[9] 'Non-organic vitality', writes Deleuze, flows through bodies that are 'organically defective' and the body-without-organs emerges as 'an affective, intensive, anarchist body that consists solely of poles, zones, thresholds, and gradients'.[10] When Choi states, then, that the 'disruption in the flow of desire' engendered by his amputated boxes 'leads to the border of the physical order'[11] he appears to inscribe his own regime of cuts within that system of 'intensive... thresholds and gradients' appealed to by Deleuze.

The closest approach to such disembodiment, 'disorder' and 'visceral unconsciousness',[12] arrives in *Box Animal Face* (1994), a series of works assembled from cut-out plywood boxes, clamps and binding straps that Choi supplies with random subtitles ('face', 'crazy', 'stinky' etc). Choi's alliance of these evacuations with the counter-human conditions of a 'becoming-animal' also allows us to locate an important genealogy for the virtual body in the tradition of corporal surrogates mapped out in the Western and international art worlds from Hans Bellmer to Cindy Sherman and Yasumasa Morimura.

But Choi's work seems precisely caught between two fundamental artistic tendencies—or symptoms of counter-organic life—attended to by Deleuze: those, like the meatish images of Francis Bacon or DH Lawrence's 'defectives', which pulverise and dissect the organic body; and those, like the pictographic bodies of Paul Klee or pre-active characters of Samuel Beckett, for whom the abstract virtuality of possible bodies is explored to the point of exhaustion, a limit-term that allows that which is non-organic to offer up thresholds. For Choi, however, there is an energy, or potential, within his (or any) constituent organs, that may be decanted from them and unironically stored. This energy, or power, is more literal than a Deleuzian account might hold. It is also irreducibly predicated on a non-Western conception of body-energy that cannot, perhaps, even be cut into—or out of—Deleuze's particular system of cuts.[13]

Before turning to another visualisation of the body-self, this time filtered through the shadows and phantoms of Cody's selected highlights of Western art, Choi backed away from the 'oppressive' demeanour of the somatic image, attempting instead to interrogate the corporeal attributes of pictorial materials themselves. In *The Cliché (Edge Painting)* (1995), the blank modernist gallery space itself becomes an 'oppression structure', and Choi's painting-objects inhabit the 'dead zone' of the corners. The results are demonic, post-Minimalist ribbons of colour fixed to stretcher bars, bound with neat, staple-like lengths of canvas cloth, and then framed. Lodged at the gallery's edges, these horizontal beams look like outsized military decorations or giant, psychedelic barcodes. From a distance, they seem to emit an unfathomably coded message of digital signs, as if the eviscerated lexicon of painting's body were sending out a smoke signal whose coloured puffs coalesce into a linear rainbow of pictorial possibilities.

In *Cody Choi: The Thinker*, an installation at Deitch Projects in New York (1996–97),[14] seven coarsely textured, hunched-over thinkers, their bodies patched together with layers of toilet tissue drenched in Pepto-Bismol, congregate in perverse mental isolation atop stark, plywood pedestals that resemble simple packing crates. In his startling rendition of one of the world's most famous sculptures, Choi offers a brazen and arresting reassessment of visual modernity's privileged conjugation of the Western mind and body. Attending carefully to the development and cultural implications of *The Thinker* project will allow us to follow the post-appropriative logic of Choi's work, and also grants us access to some of the wider issues he raises (and flouts) around the inter-acculturated body and the philosophy of digestion. Choi's intervention is locked in compulsive dialogue with both the material and conceptual attributes, and the social and historical co-ordinates of Rodin's signature figure. The surfaces of Rodin's *Thinker*, themselves offered in a Michelangelesque refrain of scorched bronze and simmering clay, are answered by the declamatory outrage of

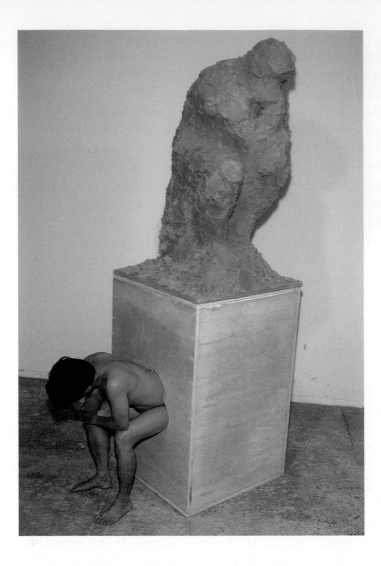

Cody Choi, *The Thinker*, 1996,
toilet paper, Pepto-Bismol,
wood, body of the artist.
Courtesy the artist

Choi's puce-pink, Pepto Bismol *papier-mâché*. Forged from throwaway scrolls
of garish, semi-liquefied squares, using some 2,500 rolls of paper and 20,000
bottles of stomach medicine,[15] Choi's *Thinkers* stage a corrosive retort to the
expressive grandiloquence and exquisite torsion proffered by the French
master. Mannered, formal modulation—rendering the pensive lineaments of
the face, lean frame, tensed muscles, and palpable, exaggerated physiology,
with its amplified extremities—gives way to a body-landscape of furrowed
precipitates and lava-like accretions, rising up in a lumpen conglomerate of
starchy, angular ridges.

Choi, then, dramatically blurs *The Thinker*'s corporal contours, and
defuses its iconography. The specially hewn rocky perch confected by Rodin
to echo the thrust-out Z-shape of his subject is submerged under the
hindquarters of Choi's thinking surrogate, from which it is virtually indistinct;
while the startling, tactile declension of his hand and jaw is dissolved by

Choi in a proliferating pulpy mush. Subject to a kind of brutish, reverse cosmetic surgery, Rodin's confidently administered subjectivity and populist pretension are cunningly approximated in Choi's parodic, socially misbegotten hulk. Larger cultural associations are embedded in Rodin's *The Thinker*, and Choi's installation allows us to think through their bowdlerised reconfiguration. The work was originally conceived as a central figure in Rodin's commission from the French government in 1880 to produce a bronze portal on the theme of Dante for the projected Palais des Arts Décoratifs, and in Rodin's first versions *The Thinker* presided over the domains of dreaming and creativity, while suspended above (or before) *The Gates of Hell*. The sculptor's initial conception of the figure saw him as the contemplative image of Dante Alighieri, with whom critics correlated *The Thinker* long after Rodin had imagined 'another thinker', this time: 'a naked man seated upon a rock, his feet drawn under him, his fist against his teeth, he dreams. The fertile thought slowly elaborates itself within his brain. He is no longer dreamer, he is creator'.[16]

In a set of illustrations to Charles Baudelaire's *Les Fleurs du Mal*, commissioned in 1887, Rodin layered the vivid, imagining body of the dreamer and creator with the idea of the seduced soul of the poet, recasting *The Thinker* as a drawing set alongside the poem 'Les Bijoux'. Following MZ Shroder's account of the image of the artist in French Romanticism, Albert Elsen suggests that the double title, *Le Penseur: Le Poète*, used for the exhibition of *The Thinker* at the Gallerie Georges Petit in 1889, may invest the work with something akin to Victor Hugo's notion of the 'active' and 'supreme' contemplation of the visionary thinker as a magus, while at the same time identifying it as 'Rodin's spiritual self-portrait as a worker-poet'.[17]

Whether or not he was aware of all the colours in the spectrum of Romantic and historical references that spin from *The Thinker*, Choi's zestful appropriation seems to recast them—humorously, aggressively, disarmingly—one by one, and one for all. The shimmering poetic dream now registers as a gaudy nightmare; cosmic intuition is reduced to prosaic bodily functions; while the multiplication and serial variance of his clustered *Thinkers* debunks the singular authority and unique consciousness of Thought itself. If Rodin traced in the sculpture his own self-presence figured as a worker-poet, then Choi too—at once literally and yet indiscernibly—poses his own body in the role of thinker, nonchalantly cross-dressing the non-Western proportions of an Asian-American artist in the lingering doubt of expressive agency. And, just as Rodin's thinker turns his back on the voluptuous temptations of the flesh—whether the lustful bodies of Hell or the bejewelled temptress of Baudelaire's poem—so Choi's crudely reflective personae hyper-ventilate with the bubble-gum hysteria of inter-ethnic sexual doubt.

While these choric antitheses take centre stage in the theatre of irony, disparagement and cultural confusion set out in Choi's installation, it is

important that the social contexts of Rodin's 'original', and its subsequent critical reading, offer striking premonitions of almost every inference in the later artist's provocation. Scale and multiplicity, public display, scatological misreadings, and debates over finish, site, the body and the figure's cultural connotations, were all announced—and disputed—by the early 1900s. It is the historical layering of these primal scenes of equivocation with Choi's rhetorical exaggerations that gives his appropriated Rodin a more effective critical posture than would mere mimicry or caricature, pure outrage, or other more normative forms of assisted citation.[18] The huge success of *The Thinker* as an image conjoining muscular masculinity and the visualisation of thought rendered Rodin's work a cliché almost from the first. It was subject to 'vulgar' caricature and commercial appropriation a short while after its public presentation,[19] a process that came to a head on Madison Avenue in the US post-war boom, as the advertising industry exploited *The Thinker*'s vogue as an icon of popular Existentialism. As he had in *Cody's Legend*, *Freud's Shit Box*, *Cody's Legend*, *Genghis Khan's Shit Box* and *Cody's Ego Shop*, Choi creates a performative intervention in the base of his *Thinker* (in the face that flanks the right side of the elevated figure, at 90 degrees), cutting out a scalloped entry hole patterned on his lower torso, in which he poses his own naked body as a meditative adjunct to the pink thinker, a gesture that cuts off his rear end, doubling the plywood pedestal as a cubic toilet stall. The schoolboy humour underlying this irreverent association of *The Thinker* with bathroom posture was, in fact, vented in the original work's first reviews. The *Chroniques d'Art* noted caustically that 'One must have the aesthetic culture of an Aurignacian or find oneself under the influence of several bottles of whiskey in order to accept the symbol of Thought in this attitude of a constipated man exerting himself on a chamber pot'.[20] Joining with a cascade of crude publicity-driven annexations, the bowel-movement interpretation reached a climax—where it also returns to the idea of the *penseur*—in 'The Thinking Man's Crossword Toilet Tissue (for brains and bottoms)', manufactured by Poynter Products of Cincinnati.[21]

Problems of enlargement and multiplication were worked through by Rodin and his workshops from the first appearance of *The Thinker* in 1880, to an edition that served as the artist's tombstone following his death in 1917, and throughout the history of the sculpture's worldwide diffusion. Beginning with the 27-inch version intended for the *Gates of Hell, The Thinker* was produced and received within an intricate regime of reproductions and transformations, including sketches, maquettes, terracotta models and drawings, as well as the plaster, wax and finally large bronze versions made for Rodin by the professional *réducteur*, Henri Lebossé, with a pantograph-like proportional enlargement device. There was even a pirated version of *The Thinker*, cast for an exhibition in Berlin, not by the lost-wax technique in the foundry of AA Hébard, as sanctioned by Rodin, but using the cheaper,

coarser sand-casting method,[22] which promoted significant textural defections from the smoother idiom.

Choi builds up the surface of his surrogate *Thinkers* from increments of tissue, at the same time beating their general profile into zany gestalt submission to an over-familiar form. From his early works on, Rodin too was associated with capricious counter-Academic modelling, formal indistinction and sculptural travesty. In 1877, a critic disparaged *The Age of Bronze* as a mere 'study, rather than a statue',[23] and the headless, armless *The Walking Man* (1877–78) is a crucial prototype of the 'damaged' body whose expressive incompletion dismantles 'the old values of identity, assertive ego, moral message rhetorically communicated, completeness of parts and finish, and stability'.[24] Other works, especially the large *Balzac* (1897), whose 'features are brutally reduced to an untempered sequence of lumps and hollows', were themselves interpreted as 'gross caricature[s]',[25] whose defection from the properly legible face mandated in the tradition of moral physiognomy was, in its time, every bit as egregious as Choi's own retreat from the long-established, then long-faded, convictions of Rodinesque modernism. Conservative critics, indeed, had a field day with the Balzac, likening Rodin's figure to 'a sack of coal, a menhir, a phantom, a colossal foetus and a shapeless lava'[26]—among other squibs and put-downs. As with the perceptual basis of nineteenth-century caricature—a reading process still residual in Choi's pimpish masquerade—each of these facetious analogies was generated not at random but according to the interpolation of a visual correlate as the over-generalised outline of the sculpture was diverted from its known referent (the celebrated writer) to an unlikely and pejorative, but necessarily possible, similar-shape analogue. In each case, the artist's supposed anti-naturalistic lack is ironically rewarded with a defamatory signifying surplus.

The *Thinker* project is not exhausted by its caustically engrained relationship to these debates around the formation of modern sculpture. What are really at stake among the congregation of seven Pepto Bismol surrogates are ideas and experiences of the body's digestion of culture, and of thought as a physiological process. Rodin was obsessed with the passage in the thinking body from physical effort to conceptualisation, and in order to comprehend and express it, he parcels up the body's energies into strategic parts:

> Nature gives my model, life and thought; the nostrils breathe, the heart beats, the lungs inhale, the being thinks, and feels, has pains and joys, ambitions, passions and emotions. These I must express. What makes my *Thinker* think is that he thinks not only with his brain, with his knitted brow, his distended nostrils and compressed lips, but with every muscle of his arms, back, and legs, with his clenched fist and gripping toes.[27]

While Rodin's itemisation of bodily expenditure is strung together in a crescendo of organic continuities, and counts on the healthy, expressive transcendence of thought as it wells up within and around the body, his breathless list of parts, coupled with their intensive agencies, offers a premonition of Choi's catalogue of counter-organic severance. But Choi takes us further into the conjunction and rupture between minds and bodies, for the final question raised by the *Thinker* installation—and by Choi's work as a whole—is how we can navigate through what Mike Kelley terms a 'dyspeptic universe'.[28] To move forward in this journey, we must turn to a crucial point of origin for Deleuze's crossing of the clinical and critical.

It is Nietzsche the 'culture doctor'[29] who gives us perhaps the most suggestive map of the relational field that relays between philosophy (thinking), culture and the body as they are each, if variously, predicated on digestion, their proximities adjudicated by philosophical diagnosis. For Nietzsche, interpretation may be understood through a privileged gastroenterological metaphor according to which the body ceaselessly assimilates, absorbs, reduces and incorporates that which is foreign to it. This active consumption is staged in the face of the philosopher's fear of its (now literal) processes 'beneath the skin: bloody masses, full intestines, viscera, all those sucking, pumping monsters—formless or ugly or grotesque, and unpleasant to smell on top of that!'[30] Nietzsche's consternation about the 'aesthetic' of 'the human being under the skin' is not just reversed by Choi in some celebration of bodily internality—as might be argued for the paintings of Francis Bacon. Instead, Choi re-metaphorises Nietzsche's tropes, building 'formless', 'ugly' and 'grotesque' 'monsters' that are, simultaneously, paragons of high culture and covert images of the artist's body; insisting on the active energies of 'sucking and pumping' (and siphoning them off); flaunting body-smells, and intimating bodily fluids that for Nietzsche only 'awaken shame'; and finally packaging the result in a pink-hued parody of Nietzsche's fearful 'bloody masses'.

Nietzsche also correlates digestive assimilation with nationalities and their differences, reserving a severe disparagement for a 'German nation' that is fundamentally 'dyspeptic', incapable of exercising proper dietary regulation, hobbled by a debilitating gastronomic democracy 'which finds everything tasty'. Choi, of course, works from the other side of this divide, playing the part of the foreign body who is putatively accorded 'equal rights', and then supposedly (ideally) broken down by the enzymes of acculturation. He could say, with Nietzsche's interlocutor in one of his *Assorted Opinions and Maxims* that 'Society's stomach is stronger than mine, it can digest me'.[31] In a sense, Choi's objects are products of his own cross-cultural digestion that refuse to be repatriated—to go quietly—back to their bodily point of origin. The repertoire of cuts set out in and around a forest of shit-boxes can now be seen as a defence against the terrible choices of Choi's art:

that it be relentlessly fed back into the originating body, layered into it like arty tissue; or that it be voided excrementally and forever lost or abandoned.

By creating falsely pink, hi-art bodies synthesised from the great digestive balm of American popular culture, Choi stages his retort to Nietzsche's plea for the smooth, subtle, measured digestion proper to the morality of what he calls a 'joyful belly'. In this way, he unravels his own form of late twentieth century 'medicynicism',[32] extending the ironic dimensions of what commentators already identified in Nietzsche as 'burlesque'.[33] The genealogical spiral between Choi and Nietzsche continues to wind: if, for Nietzsche, culture is a form of digestive incorporation, one response to modernity's bombardment of the individual with an indigestible torrent of objects and impressions is the development of that specific form of 'adaptation' that the philosopher terms 'appropriation'. The Nietzschean idea of appropriation as a defence mechanism, perhaps analogous to evolutionary adaptation, brandished by the individual in the face of an onslaught of sensations that cannot be interpreted/digested one by one, helps us to understand the combination of compulsions and singularities that attend Choi's modifications of Michelangelo and Rodin. Finally, the bleed in Nietzsche from the digestive functions of the individual body to the plural enterology of the body politic links the concepts of assimilation and tyranny in a manner that clarifies another of Choi's preoccupations: that of somehow delivering the self through the machinations of cross-cultural normalisation. 'Assimilating', wrote Nietzsche, 'means already making a foreign thing similar to oneself, tyrannising it'.[34]

Situating Choi's work among the post-Conceptual and neo-performative body-based art practices of the last decade—or within and against the new generation of Asian-American artists—poses a number of problems, for Choi presents himself as almost unknowably lost in the splice between cultures, then belligerently occupies the gap. Unwilling, on the one hand, to think of himself as a relocated diasporic alien, blindly committed to the 'international' art language of the postmodern body, and wholly uninterested, on the other, in the soft re-Asianising or the Western make-over of Amy Tan or Ang Lee, Choi rejects both Korea-first ghettoisation, and any easy concession to the Western hegemony over contemporary visual culture. He also resists various forms of 'nostalgia' (for home among Korean-Americans, for social change in the Min Joong movement in Korea) identified in a recent New York exhibition of Korean and Korean-American art,[35] developing instead an oeuvre unflinching in its lack of sentimentality, predicated on the losses, disequilibriums and schizoid gains at the decentred centre of the split between Korea/America.

Among artists working in the West, perhaps only Michael Joo cohabits as assertively in this defining schism. His *PCP (Prophylactic Cure Palliative)* (1992), works through a range of issues not dissimilar to those mapped out

here for Choi: both invent an ironically remedial symptomatics for hybridised immigrant experience; and both activate a number of the same cultural symbols and signals—*PCP*, for example, deploys casts of Pepto-Bismol and Prozac containers as supports for Joo's series of caged bug lights. While more concerned with differential histories of art than the reimagination of science, Choi, like Joo, contributes to what the late Alice Yang termed 'a new type of process art for the 1990s' focused through attention to 'the measures of science, the categories of race, and the expenditure of energy'.[36] But what finally sets Choi apart, even from Joo's arresting entomological conundrum, is an unremitting fixation on the reconfigured body—as a cluster of abstractions, amputations, energy nodes, boundary points, and non-organic emergences.

Like the Japanese artist Yasumasa Morimura, Choi's body-selves are fetishistically grafted onto the icons of Western art history.[37] But Choi's surrogates are differently formed—and predicated. While Morimura cunningly camouflages himself within the masterpieces of Western art by outrageous—but quasi-invisible—acts of cross-dressing and self-miniaturisation, Choi either leaves his own body absurdly intact, or willfully abandons it in the series of negative part-objects cut into the pedestals and boxes of his installations. As we saw in Chapter 6, Morimura's masquerades invest more squarely in a replay of the artist's narcissistic attachments, crossing them with a polymorphous extension that recalls Freud's description of primary narcissistic experience. Within his parade of cosmetically assisted selves—historical, desiring, pictorial, anonymous, even vegetable—Morimura also raises questions of the 'cut', even if these are usually more literal and less conceptually developed than in Choi's work—where they signal a set of defining actions. The cut in *Mother (Judith II)* (1991), for example, is the severing blow of a cabbage-faced Judith that decapitates the potato-head of Holofernes. Weaving wickedly in and out of art and history, such severances run along the technical edge of a hyper-collage of promiscuous substitutions whose filament is the artist's self.

Choi's bodily self, on the other hand, is not posed like a masquerade in a flurry of pictorial effects or historical grafts. Instead, it is returned either as a literal substitute or an index of absent fetishised parts—a process that operates rather like the accumulation of framed body elements in Magritte's painting—only in reverse. We begin to understand the powerful relational spaces that Choi has opened up. In art-world terms, the flatulence of abjection might be considered the agonistic opposite of masquerade's dressing-up. But any drift in Choi's installations toward 1980s-style abjection is foreclosed by the deliberative vigour of the artist's cultural disequilibrium, the perversely crisp logic of his body cut-outs, and, above all, by the adamant refusal of his machines of desire to deflate or lie down.

NOTES

1. Auguste Rodin, in conversation with a Canadian newspaper reporter, cited by Albert E Elsen in *Rodin's Thinker and the Dilemmas of Modern Public Sculpture*, Yale University Press, New Haven and London, 1985, p 29; originally in *Saturday Night*, Toronto, 1 December 1917.

2. Nietzsche, *The Gay Science*; cited in Eric Blondel, *Nietzsche: The Body and Culture*, trans Seán Hand, Stanford University Press, Stanford, CA, 1991, pp 224–25.

2. Letter to the author, 2 June 1998.

3. Ibid.

4. This description and the installation details of *Cody's Ego Shop* (1994), derive from an undated text by the artist.

5. In the text describing this piece, Choi insists, for example, that the Pepto-Bismol stands for 'heterosexual love'.

6. Letter to the author, op cit.

7. Ibid.

8. Choi describes the material constitution of *Scamps, Scram* and some of the issues it raises in ibid.

9. Other recent art practices, including Damien Hirst's *Pharmacy*, are also convened around this symptomological design; and, though seldom Deleuzian in reach or sophistication, the critical practice of a cultural symptomology is now well-established; see also Marjorie Garber, *Symptoms of Culture*, Routledge, London, 1998.

10. Gilles Deleuze, 'To Have Done with Judgement', in *Essays Critical and Clinical*, trans Daniel W Smith and Michael A Greco, Minneapolis, University of Minnesota Press, 1997, p 131. This summary of the body-without-organs arises in the context of a discussion of the 'defective' bodies of DH Lawrence. Smith's introduction offers a useful outline of the relationship between Deleuze's writings and the idea of a critical 'symptomology'; see pp xvi–xvii, xxi, li, 177 nn 25, 26.

11. Letter to the author, op cit.

12. These are Choi's terms, from ibid.

13. Readings in the Tao have influenced the artist since 1996, letter to the author, op cit.

14. *Cody Choi: The Thinker*, Deitch Projects, New York, 7 December 1996–4 January 1997.

15. Press release, Deitch Projects, December 1996. In his letter to the author, op cit, Choi further discusses the labour-intensive parameters of the project, noting that due to the painstaking, additive nature of his technique, and the need to wait for several hours while each layer dried, the seven pieces in the exhibition took around eight months of continuous work.

16. Cited by Elsen in *Rodin's Thinker*, op cit., p 29.

17. Ibid, p 59.

18. The casual criticism offered by Michael Kimmelman in a review of *The Thinker*, *New York Times*, 20 December 1996, in which he suggests that Choi's exhibition is 'a one-liner of a show', seems, then, precisely wrong. I would argue to the contrary that the density and range of referential exchange mobilised by the artist (between East and West, libido and alter-ego, mind and body) constitutes an unusually effective retort to what I term elsewhere the 'unitary deconstruction' of much 1980s appropriation art: see 'News from No-place: Ideology, Photography and the Other', Chapter 7 of *Modernism Relocated: Towards a Cultural Studies of Visual Modernity*, Allen & Unwin, Sydney, 1995; and my summary of this work in the introduction to the present volume, pp 21–23.

19. Part three of Elsen's *Rodin's Thinker*, op cit, offers some early examples of the caricatural wit (and 'vulgarity'), and commercial appropriation, to which Rodin's sculpture was subjected—including a nationalist broadside on the cover of the May 11, 1907 edition of *Le Rire*, and an advertisement for Onoto fountain pens in the December 1908 issue of *L'Illustration*; see pp 145–46.

20. Cited in Elsen, *Rodin's Thinker*, op cit, p 134 (with no date or attribution).

21. An image of this product is reproduced in ibid, p 148.

22. The matter is briefly alluded to by Elsen in ibid, p 85, where he cites a letter of 9 February 1905, presumably from Hébard to Rodin, complaining about the exhibition of the sand-cast *Thinker* at Keller and Reiner in Berlin.

23. Elsen, *Rodin*, Secker & Warburg, London, 1974, p 22.

24. Ibid, p 32.

25. Ibid, p 101.

26. Ibid, p 103.

27. Rodin; see note 1.

28. See Mike Kelley, 'Dyspeptic Universe: Cody Hyun Choi's Pepto-Bismol Paintings', in *Farewell to the 20th Century: Cody Choi* (ex cat) Kukje Gallery, Seoul, Korea and Deitch Projects, New York, 1998.

29. Eric Blondel, *Nietzsche: The Body and Culture*, op cit, p 226. Blondel offers probably the fullest discussion to date of the corporeal dimensions of Nietzsche's thought. Chapter 9, 'The Body and Metaphors', pp 201-38, is especially useful, and some of his examples are followed in my discussion, below.

30. Nietzsche, *The Will to Power*, trans W Kaufmann, Vintage Books, New York, 1967, section 906; cited in ibid, p 220.

31. Nietzsche, 'Assorted Opinions and Maxims', in *Human, All Too Human*, trans RJ Hollingdale, Cambridge University Press, Cambridge, 1986, section 152; cited in ibid, p 229.

32. Nietzsche, *Daybreak*, trans RJ Hollingdale, Cambridge University Press, Cambridge, 1982, section 203; cited in ibid, p 228. The German term is *medicynisch*, combining *zynisch* (cynical) and *medizinisch* (medical).

33. See Blondel, *Nietzsche: The Body and Culture*, op cit.

34. Nietzsche, *La volonté de puissance*, trans G Bisanquis, Gallimard, Paris, 1947, vol 1, p 198.

35. 'Across the Pacific: Contemporary Korean and Korean American Art', Queens Museum, New York, 15 October 1993–9 January 1994. In her review, 'Hybrid Identities', *Art in America*, vol 82, 1 September 1994, Eleanor Heartney suggests that nostalgia permeates the work of both Korean and Korean-American artists; see p 47.

36. Alice Yang, "MSG: The Processed Art of Michael Joo" in Jonathan Hay and Mimi Young (eds), *Why Asia?: Contemporary Asian and Asian American Art*, New York University Press, New York, 1998, p 23.

37. This discussion of Morimura is adapted from John Welchman, 'Peeping Over the Wall', in *Narcissism: Artists Reflect Themselves*, California Center for the Arts Museum, Escondido, 1996, pp 23–24; see also Chapter 6.

CHAPTER 9
Some Horizons of Medialisation: The Rainbow Net, 1999

'The modern world', wrote Gilles Deleuze, 'is that in which information replaces nature'.[1] I want to consider several horizons that intersect with the scene of this crucial loss—or exchange—reflecting on how various theorists of the media have staged the consequences of this defining aspect of the post-war Western world. I am also interested in two further questions, which I raise rather than respond to in detail: how this crucial scenography is played out in that aspect of visual culture we call the 'art world'; and how, in a technology-driven para-social formation that I term the 'Rainbow Net', Western-originated media technologies and their theories participate in new forms of globalisation, but also in the restructuring of local communities and events. While the Rainbow Net precipitates the demise of the modernist cube, we must never forget that the new images it imagines and produces start out on their journey armed with a formless proliferation predicated on its postmodern extension: for 'Digital technology has no form—look at your computers, they are all the same. They have no mechanism, they are just boxes of tiny silicon cubes'.[2]

Among philosophers and social and political scientists in the late nineteenth and early twentieth centuries, there were two dominant readings of the impact of technology and new media. Positivist and some pragmatic philosophies regarded the growth of mass production, and, to a lesser extent, mass media as generally democratising and ameliorative, arguing that machines and reproductive technologies would be developed and harnessed for the common good. In this reading, the arrival of the electric light bulb or the invention and marketing of radio were held as loosely analogous in their social effects to improvements in sanitation or medical science. This positivist assessment is shared by those, including Habermas, who, with reservations and provisos, argue for the strategic importance and consensual benefits of post-Enlightenment rationality. Ranged against this reading are a wide variety of scepticisms—and pessimisms—concerning the ownership, diffusion and social and psychological effects of technologies and the proliferation of communications media. Western Marxists, neo-Humanists, Existentialists and social scientists have all contended against the economic disequilibriums, alienation and coercive manipulability engendered by the organisations and interests controlling the development of mass culture—monopoly capital, corporations, media elites, advertising and broadcast executives. They have also warned against the irreversible envelopment of the modern world in its infrastructure and support-systems—transit routes, airports, TV, PR, ads, the music, fashion and entertainment 'industries', and more recently—and literally—the World Wide Web. In a thought that was developed by his students, notably Herbert Marcuse, Martin Heidegger, for example, disputed

the notion that technological development might be value-neutral, insisting, to the contrary, that it 'unfolds a specific character of domination'.[5]

While reactions in the art world to industrialisation and the rise of media and information technologies can be aligned on similar axes, this aspect of visual culture tended to exaggerate, parody or ignore the processes of medialisation. The lust for speed, automobiles and warfare that underwrote the technophilia of the Futurists, for example, clearly bears little relation to Habermas' commitment to rational progress and democratic dialogue. Machines, newspapers and photographs, some of the leading instruments in the first wave of modernity's media revolution, were incorporated, interrogated and ironised in the art works of the Cubists, Dadaists and Surrealists. Picasso and Braque intervened between the consumable topicality and sequential coherence of the daily newspaper, diverting its resources from the replication of opinion and information to a domain of private or scatological allusions, and exploiting its flat, typographical ground to conjure effects of volume, overlap and new formal morphologies. According to Thomas Crow, such efforts, like those of modernist visual culture at large, are predicated on always-recuperable forms of social negation.[4] Thus, while an avant-garde method or gesture might momentarily intervene across the domains and products of media/technology—or even dispute with them—their final effects are always levelled, reduced and recycled as medialised events. This suggestion has several consequences: first, the spiral of recuperability between mass and high cultures commences with the first waves of medialised acceleration at the turn of the century. Secondly, the fundamental critical relation of negativity supposedly established between the art object and the media system/product is only negative for a short time, before becoming equivocal, neutral, and then non-existent.

Similar forms of transient negation are caught up in the machine portraits of Francis Picabia, which collide the diagrammatic intestines of impossible, abbreviated or dysfunctional machines with signs and notations that obliquely stand in for the subjects of his representations. In the more politically radical context of the Soviet Union, Vladimir Tatlin's *Monument to the Third International* (1919), intended as a gigantic radio transmitter, is an icon of the brief rapprochement between avant-garde design and the medialisation of the state. The USSR, in fact, provides us with an important precedent in theories and practices of the media, for unlike the cut-and-paste dislocations of Cubist collage, or Filippo Marinetti's leveraged capture of the front page of *Le Figaro* for the publication of the inaugural Futurist manifesto in 1909, the Productivist eclipse of the category of art also announces the end of the media—well in advance of Baudrillard's 'requiem': for communication and its technologies ultimately become both mouthpiece and outreach arm of the state. They are the prosthetic extension of central

governance, bearing in themselves a simulated life-world of social duty, civic conscience and normative regulation, accompanied by sanctioned etiquettes of pleasure. In this form, all aspects of the media—print, radio, public graphics—are purely configured as ideology.

The tentative annexations and parodies of media culture by the historical avant-garde, and the co-extension of art and media as ideology in the USSR, form an essential background to the acceleration of new technologies and media following World War II. I want to turn to a sequence of theories and practices developed since the 1960s, beginning with the first popular-intellectual theory of the US media in the work of Marshall McLuhan. Elements of Picabia's introjection of the machine world are carried over in the techno-humanism of Marshall McLuhan, for in his address to the media, offered at the apogee of the post-war consumer boom, McLuhan understands the proliferation of media products, institutions and images as a folded system of bodies and spaces subject to the simultaneous pressures of expansion and contraction. On the one hand, the circulation of electronic media is figured as a particular form of corporeal extension, as 'our central nervous system' reaches outward to create an emerging universal collective consciousness. What results, on the other hand, is the progressive 'abolition' of 'both space and time' as they are locked in an anthropomorphic global 'embrace'.[5] The double trope operative here—a tentacular multiplication of para-dermic wiring and the hug-like enfolding of the world it enables—is founded on a somatically originated, non-remote telepathy. It is not simply that the body reaches out into space, for such extensions characterised what McLuhan terms the 'mechanical ages'. Instead, what takes place in the newly accelerated electronic dispensation is a relay between human subcutaneous circuitry and the ends of the earth—resulting in a new exchange system that can only be characterised as a kind of inner-bodily englobalisation.[6] Excavating this logic some quarter of a century after its first pronouncement allows us to reconfigure McLuhan's leading media-metaphors. The distinction between 'hot' and 'cold' becomes a measure of the difference between mammalian and reptilian circulations, so that while movies, radio and writing are hot-blooded, the telephone, TV, and the avant-garde itself are becoming-reptile, they are 'cool and primitive', electronically 'retribalised' to furnish the 'promise of depth involvement and integral expression'.[7] At the same time, the famous global village is really the transistorised portrait of the future face of the mediated world, its physiognomic gestalt.[8]

McLuhan may have offered the first quasi-systematic theory of a para-human technological utopia, but this strain of thought has been recurrent since the 1960s. We encounter it in the sanitised communal enthusiasm of Al Gore and other techno-political boosters rolling down the information superhighway. And it has emerged more recently in European accounts of the new media, such as the theory of 'collective intelligence' proposed by

Pierre Lévy. Deploying a cluster of quasi-evolutionary, anthropomorphic terms not dissimilar to McLuhan's, Lévy writes that 'hominisation, the process of the emergence of the human species, is not over. In fact it seems to be sharply accelerating'.[9] In *The Society of the Spectacle* (1966), Guy Debord proposes what seems like an antithetical possibility, cutting through the connective tissue that sutures McLuhan's post-romantic techno-humanism, and disputing with the McLuhanite vision of the 'integral decentralism' of the automatic era.[10] Workers' production, he claims, gives rise to 'forces independent of themselves', so that 'all time, all space becomes foreign to them [the workers] as their own alienated products accumulate'.[11] For Debord, the spectacular society driven by image accumulations is founded on radical fragmentation and incessant social separation, as well as by negations, not giant reincarnations, of both individual and collective bodies. It is precisely the foreclosure of all kinds of circulation predicated on an organicist model that Debord associates with spectacular dissemination.

McLuhan's projected incorporation and Debord's mediated abstraction form two strategic responses to the proliferation of image worlds in the 1960s. Their different reaches, contexts and assumptions offer us a measure for exchanges in the media system in the first wave of its accelerated growth: between Europe and America, optimism and pessimism, control and liberation, bodies and machines. Debord writes at the end of a tradition of Marxian critique, in which the exteriority of a technologically driven, image-based culture, recursively embedded in government institutions, mega-corporate structures and global communications policies, finally dissolves in the hyper-extension of the spectacle. While the Situationist interventions, or *détournements* proposed by Debord and others seemed to resist the high culturalism of the Frankfurt School (at least of Adorno and Max Horkheimer), the ineffability of the absent machine that produces the spectacle is tinged with the same sense of loss that led Adorno to associate the new regime of media images with technocratic oppression and Horkheimer to lament 'the disappearance of the inner life'[12] engendered by the rise of mass culture. In this context, the practice of art becomes unimaginable outside its negative capacity to strike back against the evacuations of the media world. Facing onto the 'omnipotence of technics' and everywhere undermined by the dictates of the 'amusement industry', the world's 'last works of art' can only communicate by denouncing 'the prevailing forms of communication as instruments of destruction'.[13] The absolute engulfment of society by the spectacle is thus both pair and predicate of the 'absolute resistance' to mass culture so passionately appealed to—in the 1930s at least—by Horkheimer.[14]

How can we negotiate the space between the demonic rituals of what Hans Magnus Enzensberger termed 'the consciousness industry',[15] and McLuhan's commitment to a technologically prosthetic human intelligence

invested in a global 'single consciousness', and fuelled by 'spiritual form[s] of information'?[16] And how can we connect this passage with the epiphenomenon we call the 'art world'? The Frankfurt School is prepared to posit the death of art at the hands of a culture industry whose doubled visage it decodes with unfaltering logic. According to Adorno 'the physiognomy of the culture industry is essentially a mixture of streamlining, photographic hardness and precision on the one hand, and individualistic residues, sentimentality and an already disposed and adapted romanticism on the other'.[17] McLuhan, by contrast, interprets the face of the new info-world as that of an artist. Not only will the procedures of automation suddenly 'threaten' us 'with a liberation that taxes our inner resources of self-employment and imaginative participation in society', but mass technologisation becomes 'a fate that calls men to the role of artist in society'.[18] In a final gesture of de-differentiation, McLuhan imagines the simultaneous end and triumph of art in a universal artistic body whose being is a function of its technological becoming.

Just as Adorno and the Frankfurt School suggested that art activities should be reallocated from the Marxist super-structure by virtue of their transformatory potential, so postmodern media theorists such as Jean Baudrillard and Jean-François Lyotard contend that media and communications should be reinscribed with contestatory aspects of the productive values overlooked by classic Marxism. Baudrillard describes the regime of 'pseudo-events' and 'neo-reality' attending the 'generalised substitution of the code for the reference that defines mass-media consumption' in clearly McLuhanite language, which is veined, in turn, with the attributes of the spectacle. Such events are produced in media-driven exchanges that filter, fragment and re-elaborate them 'into the material of finished and combined signs analogous to the finished objects of industrial production'. 'Makeup on the face', Baudrillard continues, 'undergoes the same operation: the systematic substitution of its real but imperfect features by a network of abstract and coherent messages made up of technical elements and a code of prescribed significations (the code of "beauty")'.[19] While Baudrillard exposes McLuhan's 'delirious tribal optimism' and 'technological idealism',[20] he attempts to graft his mediumisation theory onto the social pessimism of post-Marxist, post-Frankfurt School critique. The media become, momentarily at least, an abstract, coercive system that 'disarticulates the real'.[21] While written at the very beginning of the social extension of computer technologies, Lyotard's account of the postmodern condition is predicated, in part, on the specific conjugation of media and technology. According to Andrew Feenberg, 'the emergence of information technology' underlines Lyotard's discussion of 'the social generalisation of the crisis of narration. The computer serves here as a symbol of all these new technologies, whether they be electronic, biological, or managerial'.[22]

In the art world, the enigmatic expressions of Pop ('whose smile sums up its whole ambiguity: it is not the smile of critical distance, but the smile of collusion')[23] give way to the uncoloured regime of the Conceptual period (roughly from the later 1960s to the end of the 1970s). Media images, devices and technologies are now subject to various forms of austere, ghostlike, metaphysical fixation. The media manipulations of Pop, with their play, irony and cynicism, and the perceptual terrain of Minimalist materialities, were replaced by 'an informational, documentary idiom... unencumbered and obscured by formal considerations'.[24] The Conceptual programme released a field of abstract para-systems, numerical mapping projects, absurdist or self-referential data-bases (including Hanne Darboven's *One Century in One Year*, of 1971, and Art & Language's 'Index' pieces), and a defining set of exchanges between language, print, publication, reproduction, philosophies and the category of 'art'. Remoteness, abstraction and other effects of the *grisaille* imaginary predominated: On Kawara dispatched self-affirmatory telegrams, while Keith Arnatt offered a 'digital countdown system', which logged (and offered for sale) the duration of his exhibition in seconds. In most of these projects, the media world is short-circuited by the greyscales of amateur production. Importantly, it never functioned, as it would unstoppably a decade and a half later, as a vast arena of colour, allure and seduction. Conventional home-product media were deployed as instruments and recoding devices of homemade episodes, events and clipped narratives. These include Joseph Kosuth's negative photostats; the typed lists and propositions of Robert Barry, Lawrence Weiner and John Baldessari; the 'Art by Telephone' exhibition at the Museum of Contemporary Art, Chicago (1969); and Petr Stembera's *Handpieces: Daily Activities, Typewriting* (1971–72).

Key aspects of the media scene in and around the Conceptual art moment were annexed only in order to defer or sublimate the wave of techno-positivism that at much the same time began to dominate in the new electro-industrial sectors. Barry, Weiner and many others used old-fashioned manual typewriters to produced faded, half-hit words and sentences, which were often indented to give them the look and feel of poetic lineation. Indexing, cross-referencing and other effects of systematicity were deployed with what can best be described as parodic seriousness. Likewise, the documentary photographies used to record actions, events, situations, locations and installations were often casual, or 'amateur', quite resisting the gloss and allure of the commercial image world of Condé Nast and Madison Avenue. Very often, a media device was literally suspended in its own circulation, as in Robert Morris' *Box with the Sound of its own Making* (1961), Dan Grahams' *Roll* (1970), in which the artist videos himself in a prone position in a mirrored environment, or Christine Kozlov's *Information: No Theory* (1969), which consisted of a recorder with a continuous tape loop set to record all the ambient sound in a room, then to record over that, and

From the *Image World: Art & Media Culture* exhibition at the Whitney Museum of
American Art, 8 November 1989–18 February 1990. Left to right: Frank Majore, Jack
Goldstein, Silvia Kolbowski, Jeff Koons, Bruce Naumann, Ashley Bickerton, Gretchen Bender
Photo: Geofrey Clements

so on. Obsessed by the storage, dissemination and definition of information,
the first Conceptual generation chose as its dominant media modality the
database or para-informational system.[25]

The 'Image World' exhibition, put on at the Whitney Museum of
American Art, New York, in 1989, stands at the end of the quantifying
tradition of the West's technological imagination. This might have been the
last moment when the impact of the media world could be thought of in the
quasi-perspectival terms of distance, magnification and increased gradations
of scale. Tinged with McLuhanite scaling, the central message of 'Image
World' appeals to a grand narrative of recombinant quanta, to a promiscuous
acceleration in the production of media objects, which cascade down onto a
passively receptive world with the frequency and palpability of raindrops.
The media image-object thus saturates, then inundates, the adjacent worlds
of everyday life with its 'overpowering presence', filling up and displacing it
with incessant unitary increments.[26] The very title of Marvin Heiferman's
catalogue essay, 'Everywhere, All the Time, for Everybody', announces the

ideal of a torrential, unyielding displacement, as the space-time of the media-image pursues the impossible dream of becoming co-equivalent with *all* production and exchange. Heiferman peppers his account with parcels of this statistical cataclysm: 'This morning, 260,000 billboards will line the roads to work. This afternoon, 11,520 newspapers and 11,556 periodicals will be available for sale. And when the sun sets again, 21, 689 theatres and 1,548 drive-ins will project movies; 27,000 video outlets will rent tapes; 162 million television sets will each play for 7 hours; and 41 million photographs will have been taken. Tomorrow, there will be more'.[27] What results is a less suggestive version of Proust's vision of the daily newspaper as 'miraculous, multipliable bread, which is at the same time one and ten thousand'. [28] The media world in this account is a giant external force, which inexorably infiltrates and consumes our environment: it becomes the final extension of the modernist spatial paradigm of 'simultaneity', touted by the Futurists in the 1910s.

1989 might also be thought of as the last moment in which the annexation, appropriation and (uncommentaried) re-presentation of media images could be counted as 'critical'. In 1989, it was still possible to believe—indeed in avant-garde circles in New York it was perhaps necessary to believe—that the reorganisation and retransmission of advertisements, film stills, TV serials, even of (reproductions of) art works themselves, could effectively change or denounce the social and economic power structures that supply the image world. Horkheimer's 'absolute resistance' has withered into contingent restructuring. It is in this sense that the Whitney essayists emphasise the 'narcotic magic', the compulsion and seductive power of media images, suggesting, at the same time—in the face of their inevitable 'entrancement'—that artistic response has become institutionalised or academicised.[29] A number of consequences arise from this species of media-bombardment theory. First, in addition to—or, more likely, in place of—its critique, appropriation delivers a measure of the reflexive seduction of the media image (its somatic perfections, gloss, sound-bite sophistication and sensual or consumerist appeal). Secondly, the assumed criticality of responses to the flood of media images must be secured within a faked communality—there must be a shared or assumed oppositional utopia to answer to the flimsy, dystopic extensions of media representation. This consensus took the form of an under-articulated Socialism that conveniently forgot most of the activist logic underlying its own gestures. It was in other words a kind of Socialism without a referent. Thirdly, 'critical' media appropriation merely performed one version of the many consumptions precisely intended by the places of origin of the media image—corporations, ad agencies, TV and media companies, Hollywood moguls.

The legacy of 'Image World' is an inevitable place of reckoning for artists working in the Western and para-Western exhibition systems in the

late 1990s. It is no longer possible to caption-back at a graphic landscape dominated by mindless commodity jingles, or to question the stability and typology of media-assisted formations of personal identities in the contiguously pluralised manner of Cindy Sherman. The medialised world is now faster, more disjunct, more occasional, more accessible, blinder and more obsolete than even the most reckless Neo-Futurists of the 1980s imagined. The hiding-places of the 'real' cannot linger under the fabrication of the image. A number of artists working in Northern and Eastern Europe have shown us how such realisations produce savage reactions against the techno-humanism and art etiquettes of the Western fast-track. Such fall-out includes the becoming-animal of Oleg Kulik who snarls, bites and destroys like a demonic medium lost in pre-communicational time. Environmental salvationalism gives way to the frayed ecologies of Ulf Rollof; design is converted from space to duration by Järg Geismar; Nedko Solakov's impertinent installations, unevenly poised between 'resignation and rebelliousness',[30] are half unfurled by the collaborative production of the viewer's imagination; and Peter Kogler revisits the electronic constituencies of the human head, crossing it with subtly measured doses of pattern, repetition and material transference.

Thinking through the decade after 'Image World', I want to return to the idea of the Rainbow Net (introduced in Chapter 7)—a conceptual antithesis to everything collected under the late modernist notion of the White Cube. The Rainbow Net is an imaginary icon that governs the spaces of proliferation and interactivity. To the closures of the cube, the encrypting of the aesthetically discrete object in ideally featureless, critically sanctioned commercial or institutional space, it emblematises the folded hyperspace of the interface. Here, the solidity of the cube is foreclosed by the unending virtual flatness of the pixel. From the White Cube as an assemblage of six closed, uninflected sides, subtending the primal space of modernity, I want to move across to the permeable stitching and nodal reconnaissance of the net, a structure-flow that simultaneously contains, exchanges and proliferates. The condensed metaphoricity of the cube gives way to the infinite syntagm of the associative chain. Its colourless subtraction is replaced by an infinity of scales and shades: the ineffable white correlate is now apparent only as what is almost impossible, at the end of the simultaneous appearance of all colours. Despite the teleology encoded in the rainbow, and symbolised in the fabled pot of gold found at the end of its lustrous arc, the Rainbow Net must be thought of neither as a social panacea, nor as a parable of global democracy. The Rainbow Net is the nerve system of a machine that cannot be imagined outside of its multiplications. The Rainbow Net has superseded the techno-futurism of ever-increasing speed, for speed is its predicate and never its destiny, its object of consumption, not an addition or a blur. One stripe of the Rainbow Net marks the final eclipse of the time-differential

staged in the accelerated drift of the history of media technologies toward non-professional deployments. It was not until some half a century after the invention of cumbersome, chemically dependent, photographic machines that Eastman Kodak brought out the Brownie camera (1888). The succession of reversions to local, individual or domestic scenes of image-production and image-based tasking—from amateur cameras, Polaroids, dispensable cheapies, to home movies, video cameras, PC home/desktop-publishing and home-shopping/banking/entertainment—has, in general, been staged with smaller and smaller increments between the original corporate or institutional machines and mass-produced, common variants. Even though the Internet was developed within the giant paradigms of the state-corporate, military-industrial complex, its initial conceptualisation was always an instrument of strategic decentralisation, while many of its surprising new resources have been discovered, extended and fed back by DIY users and counter-culture hackers. We are living at the limit-terms of this incremental diminution.

While I don't want to restrict the net to its metaphorical signs, a number of recent projects emblematise the extension and reconceptualisation to which it refers by convening nets as permeable ecological meshes, electronic hyper-grids or urban systems. Each of these three strands separated from the infinity that make up its futures, is accompanied by a symbolic colour, say, green or grey. Twisted together they form the polychrome profusion of the Rainbow Net. I am thinking, for example, of the green net cast by Helen Meyer Harrison and Newton Harrison over land between the Humber and Mersey estuaries in the UK.[31]

Looking to establish an 'ecological domain' between the East and West coasts of the United Kingdom, the Harrisons' *Casting a Green Net: Can it be we are Seeing a Dragon?* (1998) refocuses public art as 'issue specific rather than site specific', at the same time crossing it with the quasi-mythological dimension of the dragon, invoked through a quirky combination of fortune and formalism as the shape of the suggested domain resembled the much-imaged victim of St George. This open-ended, multidisciplinary research project, based on dialogues among scientists, activisits, artists and the community, conjugates history and mythology with a commitment to a better future. Another formation of the Rainbow Net arrived with Martin Kippenberger's project, *Metro Net*, initiated in 1993, which offers a parodic shell-structure, complete with simulated entrances, exits, and ventilation shafts, for the development of a universal subway network.[32] Whether negotiating with ecological or transit systems, such initiatives usually have multiple locations, complex social inscriptions, and plural authorship. They embrace not only different forms and materials, but also layered domains of social knowledge and political action. They usually take place in public space, but cannot always be identified with even the most recent inflections

Newton and Helen Harrison, *Casting a Green Net: Can it be we are Seeing a Dragon?,*
1998, map on linen, with pastel and oil pencil. Courtesy the artists

of 'public art'. At the same time, they are haunted by networked adversaries,
system-based, medialised strategies that attempt to drain the colour and
flatten the arc of the Rainbow Net, even as they fleetingly pass through it. In
the tropic terms indulged in here, one of these dimmers can be identified in
the Washington DC-based National Empowerment Television (NET),
launched on 6 December 1993, by the right-wing Free Congress Foundation,
and probably the first TV channel to be owned and run by a political body.[33]

While the Internet, or the World Wide Web, is, of course, a privileged
referent for the medialisation of the late 1990s, it has no monopoly, even
over the processes it apparently invents or engenders. Organised, as Sadie
Plant puts it, in a 'new anarchitecture of self-assembling systems', this net
develops as hyper-growths and tentacular extensions embedded in a quasi-
autonomous proliferation that gives rise to an impossible 'tangle of
unintended consequences' caught 'in a mass of nets and world-wide webs'.[34]
The scientific origins (and prospects), social circulation, global reach, and
cultural implications of this net are the subject of intense current debate and

futurist speculation. For some, the Internet offers a poisonous embrace of entrapment and artistic limitation. Simon Penny, for example, cautions that engineering-based computer technologies represent the late-capitalist completion of the Western disparagement of the body, that 'the modern serial-processing computer can be thought of as an assembly-line for digital data', and that the new electronic environment is a product of corporatist reductionism, the scientific separation of functions and neo-capitalist maximisations of efficiency, speed and profit.[35] For others, the Internet makes up the fabric of a new prosthetic mesh that enables those it surrounds or incorporates to practise the 'postbiological faculty' of 'cyberception'. For 'the cybernet, the sum of all the interactive computer-mediated systems and telematic networks in the world, is part of our sensory apparatus.'[36] Beyond its roles in storage, image dissemination, public access and scholarly retrieval, the various 'art-like' interactions of MUDs (Multi-user Domains) and commercial offerings such as Myst,[37] and more recently Massive Multiplayer On-line Role-playing Games, suggest that its dominant aesthetic register is a 'consumer-led... fantasy-oriented cyberspace in which the history of... art... has become a data-source for style games.'[38] On the other hand, the Internet's capacity to pluralise, categorise and reallocate, provides the basis for a mechanisation of subjective experience and the distribution of what has been termed a 'customised aesthetics' based on non-exclusionary principles and collaborative filtering.[39]

Another reaction to our networked environment, based on a corrosive participation in broadcast and new media that simultaneously rejects and transforms them, thinks the Internet against itself and inverts its corporate foundations through hacking, piracy and the temporary circulation of marginal zines. Such activity takes a lead from the work of Hakim Bey, who contests the 'tight networks' of the 'corrective media' in favour of Temporary Autonomous Zones (TAZs) that are immediate, 'vague', maintenance-free, and unconstructed, so that 'opposite the Internet he places the Counter-Net and the Unofficial Web'.[40] In this move towards counter-medialisation the net becomes a rainbow and the rainbow a net, as each is seen through the other and 'the lines of the net are dissolved in an astral mist'.[41] The 'sovereign media' that result from this vision are 'transrational' ('like their global peers'), thrive on 'total decontrol', enter into 'a secret pact with noise, the father of all information', and present themselves as spectra that are unnervingly switched on and off for no apparent reason. One moment 'the shape in which they appear can never shine in its full lustre', so the rainbow fades. In another, the data-dandy, dressed in 'ruby-encrusted butterfly goggles', wearing 'pink stockings' and dedicated to hermeneutic anarchism and the desecration of information, admires 'the hideously fresh and cheerful colours of Swatch and Benetton (florescent as well as natural)'.[42] And the rainbow mocks itself.

Geert Lovink, *Radio Patapoe*. Courtesy Geert Lovink

Dissident dauphin of the sovereign media, Geert Lovink's persona of the data dandy presides over the eclipse of appropriation as it passes slowly behind the rainbow. Radio Patapoe, successor of Amsterdam's Radio Death, commits only to the dissemination of 'serious anti-information' based, in part, on a degraded appropriation, or doggie scavanging, as its hybrid mixmasters go 'rummaging in others' audio and visual archives'. They dissent from any commitment to reallocate the universe of received information according to the logic of the station, the audience, the revenue base or controlling interests: 'Humanity is in possession of a universal archive that the officials maintain may be unpacked only in a historically responsible way'. Flouting this prescription, Papatoe also mocks the etiquettes of the soundbite and the information parcel and works to defeat the air-time apportionments of the stringent broadcast economy, finding 'room for extended versions as well as sampled quotations'.[43] Despite acting out the risks of boredom, surprise, repetition and random withdrawal, this final refuge for the practice of appropriation—just like the founding gestures in the 1970s—is haunted by the disarming special effects of its own invisibility or social irreality. For according to ADILKNO, hackers, cyberpunks and data dandies 'can only be conjured up as ghosts'.[44]

Paul Johnson, *Binocular Projector v2.0*, **1999**, flashlights, cups, 2 portable vcd players, warranty information, 2 modified lcd monitors, molded resin casts, and magnifying glasses. Courtesy the artist

The pursuit of the Rainbow Net is not predicated on hot-wired pluralism, Virilian vertigo or theoretical Neo-Futurism. Consider one of the most crucial conditions through which, for better and for worse, criticism and art work have been produced in the 1990s: the idea of border cultures and the profusion of debates in cultural studies and the social sciences about the collapse of global-local space.[45] As I have discussed elsewhere,[46] borders have become super-abundant, definitional tropes, ever-ready relay-machines for manufacture of sanctioned difference. They are encoded in the military metaphor of territorial transgression and violence that supplies the founding Western concept of the avant-garde, as well as its twentieth-century destinies; they are the chief protagonists of synthetic postmodern theory; they have a reformulated presence, or carefully negotiated absence, in the contestatory critical spaces imagined by theorists such as Derrida ('Living On—BORDER-LINES'), Deleuze (the smooth space of the nomadic), Irigaray (the feminine as 'threshold'), and others. They are residual emblems of dissolution in the

protestation of transnational economic space and the 'new internationalism' of the visual arts. The vast, long, straight geometric border-lines of imperial cartography (while still almost everywhere monstrously visible and ever more vigilantly monitored) have been miniaturised into the hyphens of para-global ethnicities. Borders, then, have come to symbolise the transitional, transgressional, imbricated conditions associated with sexual, performative, virtual and social selves that resist—as they can and as they are unevenly able to—the historic closures of gender, household, exchangelessness, and, more unevenly still, the inscriptions of race and class. One is in danger of course of being blinded by the prismatic split of so many subjects and locations; and it is clear that the limits of borders must be tested. When they become immeasurable, or ineffably multiple, borders are no longer borders, but imaginary projections miming only the lines of their inventors.

There are several responses to the cultures of our bordered-global moment. Some contend against the soul-crushing militancy of transnational corporate expansion, refusing the social detraditionalisation that often attends it, and surrendering to the allures of localism or particularism. This view might be defended, nurtured, or incubated by a neo-paternalist West, but also mounted against it in defiance. Within (perhaps in despite of) a range of critiques—based on media, local feminisms, and new articulations of community, among others—the art defended here might be personal, expressive, self-declarative, and/or restoratively neo-traditional. Another side of this renewed attention looks to what Michel Foucault called the 'essentially *local* character of criticism', and 'the *insurrection of subjugated knowledges*'. At the end of the 1990s, much of the knowledge that revolts from the non-Western 'peripheries' does not assert itself—literally at least—as insurrection, but neither is it always received in an easy dissolve through the soft revolution of the World Wide Web. What Foucault noted of the margins of French—or Western—thought in his 1976 lecture is delivered in teeming genealogies of popular knowledge now in formation around the world. These are 'non-centralised', even 'disqualified', arrangements, 'whose validity is not dependent on the approval of established regimes of thought'. Moreover, they often emerge 'disguised within the body of functionalist and systematising theory' (to which we should add, colonial and postcolonial logics), and may entirely lack the delicacies of unanimity or consensual expression.[47]

Some—we would have to call them historical postmodernists—celebrate the reflex layering and appropriational retorts staged between global products and messages, and local environments. This is symbolised as well as anything by the Coke bottle among the Kalahari (*The Gods Must be Crazy*, dir Jamie Uys, 1981). But it embraces that whole index of premonitory spectacles, a sort of low-grade curio-show of emblematised cultural dislocations, from the merchandised Islamic Christmases of Malaysia or Indonesia, to Malboro packs woven into Afghan carpets, and MTV-style

Indian rock set to empty Hinglish (Hindi-English) lyrics. The self-conscious art forms preferred in this dispensation range from the fetishistic recasting of these already appropriated variants, to works that offer them up but also mobilise some form of commentary on the capital and informational trade routes that splice them together. Gayatri Spivak sounds an urgent cautionary note about the rhetoric of 'transnational postmodernity' that underwrites many of these hybrid incorporations. Her commitment to a 'de(con)structive pedagogy' that is as attentive to local as to global issues, suggests a final horizon for the renegotiation of the 'unitary deconstruction' we earlier identified in the first phase of New York postmodern appropriation.[48] Others (including myself) have offered to diagnose the stretches and collisions of embordered practice in relation to Western cultural theories or privileged geo-political locations. We would select our favourite border-caution (say, Donna Haraway's),[49] then pronounce on our favoured borders, based on fluids, thresholds, nomads and the like. When redeemed from abstraction (when and if) this *doxa* is returned to sanction the complexly pleasured politics of those whose works in which we believe (or which fit our concepts best).

There's no final frontier here, but at the end of the 1990s we have made contact with another set of conditions. The elasticity of the fold, and the spiral of feedbacks, between global and non-terrestrial (satellite, wireless, etc) conditions and local experiences gives rise to dramatic new spaces of social and political empowerment and cultural possibility (as well, of course, as new means for repression). Their rapid transit delivers a fractalisation of received values and results in profound inversions in the emancipatory political etiquettes of the West. Nowhere is this more perversely visible than in the hyperventilating capitalism of the post-Socialist world (Russia, China, Eastern Europe). While, as I have insisted, it is not just a question of speed, our new dispensation is caught up in a phase of extraordinary and perhaps unprecedented acceleration. Wherever you look, revolutionary changes (either predicated on 'events', such as the counter-revolutions in the former Soviet Union and Eastern Europe; or 'eventual', that is, founded in trickle-change time) are hosting new cross-overs forged from the compounding of information, circulation, change and cultural strategy. Yet despite the episodes of recent years (the street protests in Serbia, with their charades of animal democracy and conceptual street theatre, the Peruvian hostage crisis), there will be fewer conventional political 'events', or, if they are not fewer in number, they will have less impact in the face of what is inexorably replacing them—shifts in economic, cultural, even political flow. The torrential power of knowledge and commodity-flow disdains, somewhat unequally, both First-World codes of transaction conduct and rest-of-the-world centralisation. But flows are never 'free', as historical postmodernism briefly imagined, nor are they reducible according to the post-Marxist, or

even Freudian, models we have inherited. In the new flow-causes, globalisation is predicated on the triumph of spatial diminution and the concomitant loss of time. Such a loss is explicitly a perversion, for good or evil, for it assists in the transference of available attention to disconnected fragments of circulated knowledge.

The total system offers other perverse formations, including the 'found morality' or 'democratic enablement' that arises from shifts and increments of knowledge in and as capital. So we can now talk not of Nixon, but Motorola in China, of a situation where the reflex emergence of a middle class, made up at first of former Communist functionaries with access to the corridors between legislative power and foreign investment, will disseminate new ideas, with their unknowable fractions of democratic potential, through the purchase and social use of cellular phones connected by more or less inviolable global satellite technologies. Something similar might be said about the profusion of pirated materials (videos, CDs, software, games); though here the circulation of simulated products—which deflate rather than expand the transnational corporate profit-base—acts against the Western shell-structure of patents and copyright as it proportionately benefits local pirates and consumers. At the same time, it permits the flow of music, lyrics and information, otherwise taboo or prohibitively expensive. We should recall student protesters in Bulgaria imitating law-makers in the besieged parliament;[50] and the spectacle of Serbian democratic doggie-walking, in January 1997, when a teeming menagerie of pets and livestock—from goldfish to Yorkshire Terriers—were paraded around downtown Belgrade to emblematise democracy and freedom of movement. Animal rights were proffered in a pantomime of human rights as this latter-day Parliament of Fowls literalised the barnyard allegory of Orwell's *1984*.

It is across such contexts that the critic must look for the 'marvels and progress'[51] bizarrely subsistent under the juggernaut of global production-consumption. Don't think that the post-avant-garde of the art world (if it makes sense any more to use these terms) has no role to play. We might recall the differential intervention of the controversial *Art Rebate* project staged in the Summer of 1993 (discussed in Chapter 5), which interrogated the malformation of tax-paying-illegal-immigrant workers sedimented into an official black economy over the most porous—and policed—border in the world: San Diego-Tijuana.[52] Here, the invisible economy is photographed and televised, while in the media, art criticism is grudgingly reallocated from the Arts Section to the front page and the editorial. One way of speaking to the invisible is by precipitating a gesture of conceptual inversion. Call these moments the exquisite corpses of turbulence, or feedback, cracks in the inexorability of the global flow. This form of searching and rethinking imagines new bodily identities and exchange, re-ritualises community participation, promotes guerilla media, hack-back and remote locality

broadcasting, builds snares for asset-reallocation and capacity building, dares to invent redemptive tourism, and reconvenes cultural practice in the global-social sphere. If there is one thing these activities share in common it is that they refuse the hold of appropriation: they attempt something more than securing a portion of the ready-made world and holding it hostage to fashion or theoretical critique. From one side, it's a little bit like the reinvention of carnival in virtual space, riding the carousels of the Rainbow Net. From another it's to participate in—to turn on to—what Trinh T Minh-ha has called 'a matter of tuning'.[53] Listening, practicing, aligning, interweaving the self with others and their communities, participating in accord: the transition from appropriation is beginning to be complete.

NOTES

1. Gilles Deleuze, *Cinema 2: The Time-Image*, trans Hugh Tomlinson and Robert Galeta, Athlone Press, London, 1989, p 269.
2. Richard Wright, 'Soft Future', *Variant*, no 14, Summer 1993, p 7.
3. Martin Heidegger, cited in Andrew Feenberg, *Alternate Modernity: The Technical Turn in Philosophy and Social Theory*, University of California Press, Berkeley, 1995, p 24.
4. See Thomas Crow, 'Modernism and Mass Culture in the Visual Arts', in Benjamin HD Buchloh, Serge Guillbault and David Solkin (eds), *Modernism and Modernity*, (The Vancouver Conference Papers), Nova Scotia College of Art and Design, Halifax, Nova Scotia, 1983. Here Crow writes that 'modernist negation proceeds from a productive confusion within the "normal" hierarchy of cultural legitimacy' (p 251), and that: 'Mass culture, which is just another way of saying culture under developed capitalism, displays both moments of negation and an ultimately overwhelming recuperative inertia. Modernism exits in the tension between these two opposed movements' (p 256).
5. Marshall McLuhan, Introduction to *Understanding Media: The Extensions of Man*, McGraw-Hill, New York, 1964, pp 3–4.
6. As well as supplying the subtitle to his most famous collection of essays, McLuhan's idea of the media as 'extensions of man', sounds like a refrain throughout his writings. In 'The Gadget Lover', for example, he writes: 'With the arrival of electric technology, man extended, or set outside himself, a live model of the central nervous system itself'; in ibid, p 43.
7. McLuhan 'Media Hot and Cold', in ibid, pp 27, 24.
8. 'In the electric age we wear all mankind as our skin', 'The Gadget Lover', in ibid, p 47. See also the conclusion of 'Media as Translators': 'might not our current translation of our entire lives into the spiritual form of information seem to make of the entire globe, and of the human family, a single consciousness'. In ibid, p 61.

9. Pierre Lévy, *Collective Intelligence: Mankind's Emerging World in Cyberspace*, trans Robert Bonanno, Plenum, New York, 1997, p xxiv. In the Foreword, Eugene Provenzo describes Lévy's 'neo-humanist' project as 'arguably the first full-scale utopian text of the computer era', p x.

10. McLuhan, 'The Medium is the Message', in *Understanding Media*, op cit, p 8.

11. Guy Debord, *The Society of the Spectacle* (1966), trans Donald Nicholson-Smith, Zone Books, New York, 1997, thesis 31, p 23.

12. Max Horkheimer, 'Art and Mass Culture', in *Critical Theory: Selected Essays*, Seabury Press, New York, 1972, p 277.

13. Ibid, pp 280, 290, 279.

14. Ibid, p 280. Horkheimer continued explicitly to associate society under National Socialism with what Otto Kirchheimer termed, in the last article published in *Zeitschrift für Sozialforschung*, the 'system of technological rationality'. From the preface (1968), in ibid, p x. 'It seems to me', he continues, 'that everything depends on these sentences being true of the past but not of the future'.

15. See Hans Magnus Enzensberger, *The Consciousness Industry*, Seabury Press, New York, 1974.

16. See note 4.

17. Theodor Adorno, 'Culture Industry Reconsidered' (1964/1967), trans Anson G Rabinach, *New German Critique*, vol 6, Fall 1975, p 15.

18. 'Automation', in *Understanding Media*, op cit, p 358.

19. Jean Baudrillard, 'Mass Media Culture', in Paul Foss and Julian Pefanis Sydney (eds and trans)*Revenge of the Crystal: Selected Writings on the Modern Object and its Destiny, 1968-1983* Pluto Press, 1990, p 92. The Ninth section of this essay is captioned 'The Medium is the Message', while the sixth discusses the 'Gadget'. On p 89, Baudrillard links 'fragmentation and spectacularisation' as two aspects of *'the message of message consumption'*, which promotes 'the misrecognition of the world'.

20. Baudrillard, 'Requiem for the Media', in *For a Critique of the Political Economy of the Sign*, trans Charles Levin, Telos Press, St Louis, MO, 1981, pp 172, 175.

21. 'Mass Media Culture', op cit, p 88. The terms are conjoined with provisional acceptance of McLuhan's thesis in the first paragraph of section 9 of Baudrillard's essay, 'The Medium is the Message', op cit.

22. Andrew Feenberg, *Alternate Modernity: The Technical Turn in Philosophy and Social Theory*, University of California Press, Berkeley, 1995, p 128.

23. Baudrillard, 'Mass Media Culture', op cit, p 87.

24. Lucy Lippard, *Six Years: The Dematerialization of the Art Object from 1966 to 1972*, Praeger, NY, 1973, p 263.

25. For an account of what I describe as the definitional unconscious of visual modernism and the recurrent trope of the envisioned dictionary or archive, see John Welchman, 'Modernisme à Larouse', Chapter 1 of *Modernism Relocated: Towards a Cultural Studies of Visual Modernity*, Allen & Unwin, Sydney, 1995.

26. *Image World: Art and Media Culture,* Whitney Museum of American Art, New York, 1989, introduction, p 13.

27. Ibid, p 17.

28. Marcel Proust, *A la recherche du temps perdu*, (1913-27), cited in Jonathan Benthall, *Science and Technology in Art Today*, Praeger, New York, 1972, p 21.

29. See Lisa Philips, 'Art and Media Culture', in *Image World*, op cit, p 70.

30. Interview with Boris Danailov in *Flash Art* (International Edition), no 171, Summer 1993, p 98.

31. See Malcolm Miles, 'A Green and Pleasant Land?: Ecological Art in the UK', *Public Art Review*, vol 10, no 1, Fall/Winter, 1998, pp 26-29, which discusses Helen Meyer Harrison and Newton Harrison's *Casting a Green Net: Can it be we are Seeing a Dragon?.*

32. See Owen Drolet, 'Kippenberger's "Metro Net" at Metro Pictures' *Flash Art* (International Edition), no 197, November/December 1997, p 56.

33. See Anna Elizabeth Williams, 'Satellite dish', *Afterimage*, vol 21, April 1994, p 4.

34. Sadie Plant, 'No Plans', in *Architectural Design* (special issue on cyberspace), vol 65, November/December 1995, pp 36–37.

35. Simon Penny, 'The Virtualization of Art Practice: Body Knowledge and the Engineering World View', in *Art Journal*, 'Digital Reflections: The Dialogue of Art and Technology', vol 56, no 3, Fall 1997, pp 30–33.

36. Roy Ascott, 'The Architecture of Cyberception', in *Architectural Design*, op cit, p 38.

37. Developed by Rand and Robyn Miller, Myst (released in late 1993 for Macs, early 1994 for Windows) and its sequel Riven (1997) are popular, graphically sophisticated, puzzle-solving adventure games which locate the player on a quasi-mythical island.

38. Celia Larner and Ian Hunter, 'Hyper-aesthetics: The Audience is the Work', in *Architectural Design*, op cit, p 26.

39. See Jon Ippolito, 'Turning Aesthetics to Prosthetics', in *Art Journal*, op cit, pp 69f.

40. Geert Lovink, 'The Data Dandy and Sovereign Media: An Introduction to the Media Theory of ADILKNO', *Leonardo*, vol 56, Fall 1997, pp 60, 58.

41. Ibid, p 59.

42. Ibid, pp 63–64.

43. Ibid, p 60.

44. Ibid, p 64.

45. The thoughts developed below were first outlined in Welchman, 'Apropos: Tune In, Take Off', *Art & Text*, Sydney/Los Angeles, no 57, May–July 1997.

46. See Welchman (ed), *Rethinking Borders*, University of Minnesota Press/Macmillan, Minneapolis/London, 1996.

47. See Michel Foucault, lecture delivered in Paris, 7 January 1976, in *Power/knowledge: selected interviews and other writings, 1972-1977* Colin Gordon (ed & trans), Pantheon Books, New York, 1980.

48. Gayatri Spivak, 'Who Claims Alterity?', in Barbara Kruger and Phil Mariani (eds), *Remaking History: DIA Art Foundation Discussions in Contemporary Culture*, no 4, Bay Press, Seattle, 1989, pp 269–92.

49. 'The stakes in the border war have been the territories of production, reproduction, and imagination. This... is an argument for pleasure in the confusion of boundaries and for responsibility in their construction', Donna Haraway, 'A Manifesto for Cyborgs: Science, Technology and Socialist Feminism', in *Simians, cyborgs, and women: the reinvention of nature*, Routledge, New York, 1991.

50. See William Greider, *One World, Ready or Not: The Manic Logic of Global Capitalism*, Simon and Schuster, New York, 1997.

51. Matthew Miller, review of ibid, *New York Times*, Book Review,18 January 1997, p 12.

52. See Welchman 'Bait or Tackle: An Assisted Commentary on *Art Rebate/Arte Reembolso*', *Art & Text*, Sydney, no 48, May 1994.

53. Trinh T Minh-ha, 'An Acoustic Journey', in *Rethinking Borders*, op cit, pp 11–16.

Index